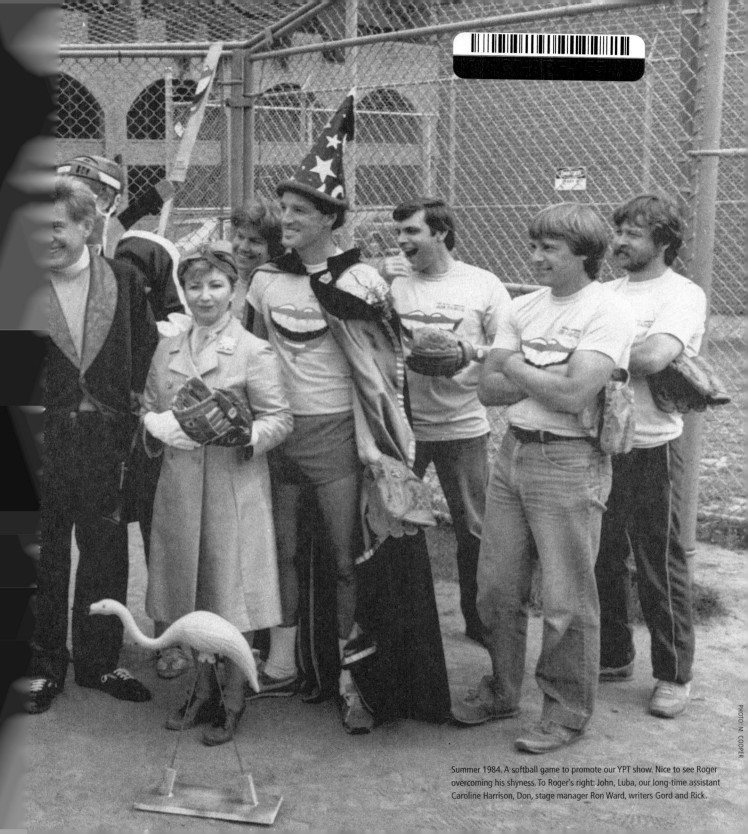

Summer 1984. A softball game to promote our YPT show. Nice to see Roger overcoming his shyness. To Roger's right: John, Luba, our long-time assistant Caroline Harrison, Don, stage manager Ron Ward, writers Gord and Rick.

AIR FARCE

40 YEARS OF FLYING BY THE SEAT OF OUR PANTS

DON FERGUSON/ROGER ABBOTT

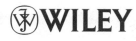

WILEY

John Wiley & Sons Canada, Ltd.

Air Farce: 40 Years of Flying by the Seat of Our Pants was represented by Arnold Gosewich Literary Agency, Toronto, Ont.

Library and Archives Canada Cataloguing in Publication Data

Ferguson, Don, 1946–
 Air Farce : 40 years of flying by the seat of our pants / Don Ferguson and Roger Abbott.

Includes index.
ISBN 978-1-118034-26-2

 1. Royal Canadian Air Farce (Comedy group).
2. Radio comedies—Canada. 3. Television comedies—Canada.
I. Abbott, Roger II. Title.

PN1992.8.C66F47 2011 791.45'6170971 C2011-906100-7

Wiley publishes in a variety of print and electronic formats and by print-on-demand. Some material included with standard print versions of this book may not be included in e-books or in print-on-demand. For more information about Wiley products, visit www.wiley.com.

ISBN 978-1-118-03675-4- (ePub); 978-1-118-03673-0 (eMobi); 978-1-118-03674-7 (ePDF)

Editorial & Production Credits
Executive Editor: Don Loney
Managing Editor: Alison Maclean
Production Editor: Lindsay Humphreys
Interior design and typesetting: Diana Sullada
Cover design: Diana Sullada

Cover photos: Front: iStockphoto; Thinkstock
Back (top to bottom): M. Cooper, John Morgan, unknown, Russ Martin
Author photo: S.J. Wilson

Printer: Friesens Printing Ltd.

John Wiley & Sons Canada, Ltd.
6045 Freemont Blvd.
Mississauga, Ontario
L5R 4J3

Printed in Canada

-1 2 3 4 5 FP 15 14 13 12 11

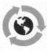

ENVIRONMENTAL BENEFITS STATEMENT

John Wiley & Sons - Canada saved the following resources by printing the pages of this book on chlorine free paper made with 100% post-consumer waste.

TREES	WATER	ENERGY	SOLID WASTE	GREENHOUSE GASES
514	235,202	209	14,910	52,159
FULLY GROWN	GALLONS	MILLION BTUs	POUNDS	POUNDS

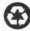

Environmental impact estimates were made using the Environmental Paper Network Paper Calculator. For more information visit www.papercalculator.org.

ACKNOWLEDGEMENTS

My first thanks go to Roberta and Sarah, especially Roberta, who for years put up with the long hours and absences required by my work, never more so than during the months writing this book, when we'd hoped--and I'd promised--that long hours would be a thing of the past.

Thanks also to the talented and irrepressible Kevin Wallis, who helped enormously with the picture research; to the wonderful Lucy Stewart, who keep her steady hand on the Air Farce tiller no matter what headwinds we face; and the irreplaceable Nora Cooper, who keep the Air Farce office running smoothly through it all.

And finally, thanks to our listener and viewers, who kept all of us motivat at *Air Farce* for more than thirty-five years. You've been our biggest inspirati You're the reason we do it and we owe yo the biggest thanks of all.

CONTENTS

Raising the Roof's 2003 celebrity spokesmen

INTRODUCTION

On November 4, 2010, at a lunch with our publisher in the Studio Café at the Four Seasons Hotel in Toronto, Roger and I signed the contract to write this book. We looked forward to writing it but were also thinking, "Oh God, what have we got ourselves into this time?" Telling the history of Air Farce would not be easy; the story began in 1970—even earlier if we started it when we met, in 1959.

Roger had caught a cold in Paris in August that developed into pneumonia in September. Two months later, he still wasn't feeling 100 per cent, and with our annual *Air Farce New Year's Eve* special already having begun production for CBC, we knew we wouldn't really get around to doing any writing until mid-January. Before signing the contract, we'd asked Bill Brioux to interview colleagues so that the story of Air Farce would contain voices other than our own; on November 17 we met Bill to confirm our arrangement in the same restaurant where we'd signed our contract with the publisher. This time we paid for lunch.

We were optimistic. The book deadline was June and we hoped to submit the manuscript well in advance. The contract specified 90,000 words, 45,000 each. Write 1,000 words a day, 5 days a week, and we'll be done by the end of March. Piece of cake. Care for another glass of wine?

Roger had a chronic condition and it seemed to flare up in November, and even more so in the new year. He was fatigued. He had to pause midway when he climbed two flights of stairs. His friends worried, but Roger assured the few of us who knew of his condition that scheduled minor surgery would soon resolve the matter. In February, we were well behind our self-imposed schedule, and with the prospect of him requiring bed rest after surgery, we finally became sufficiently alarmed to knuckle down to work. We delivered our first batch to the publisher—40,000 words—on the day he went into hospital, March 14, 2011.

Neither of us suspected that I would finish the book alone.

Roger died on March 26, and after that *Royal Canadian Air Farce: 40 Years of Flying by the Seat of our Pants* became a different book than the one we planned. It's still, I hope, an enjoyable, informative, and entertaining read about Air Farce, but now the joy and optimism of Air Farce's youthful beginnings feel tinged by the sadness of what was to come. Youth gives way to maturity (not too much maturity) and eventually to final departures. John Morgan died in 2004, and now Roger. I recently described the process of finishing the book as "a happy walk down a dark corridor." But that was wrong. It was a walk, sometimes sad but mostly very happy, down a country road on a bright sunny day with five or six, sometimes a dozen, much-loved friends and colleagues.

— Don Ferguson

The N.D.G. BOYS

OR TIED FOR FIFTH

PHOTO: ANDREW MACNAUGHTAN

Roger and Don

In the early days of Quebec's "Quiet Revolution," Premier Jean Lesage launched a province-wide search for Quebec's most manly citizen. Soon the field was reduced to two finalists, a handsome young bodybuilder from Montreal and a scrawny forty-year-old from La Malbaie. On the eve of St. Jean Baptiste, Quebec's national day, the premier met them in his office to choose the winner. The bodybuilder could bench-press 250 kilograms, tear a phone book in half, and with a chain tied around his waist pull a Greyhound bus carrying forty-three seniors on a church picnic to the top of Mont Royal. Manly indeed. The premier was impressed. He turned to the scrawny finalist and asked him what his manly accomplishments were. He replied that he was the father of twenty-two children. The premier didn't hesitate. "Twenty-two children? This is what Quebec needs! Congratulations! You are the winner of the manliest man contest! You should be proud of your achievement." "Well," said the scrawny fellow, "it's not bad for a priest, from a small town, with no car."

Often when we've felt particularly chuffed about something--great ratings for a TV show, or a fundraiser performance that went through the roof, or finding ourselves being offered some special honour—we've looked at each other and said, "Not bad for a couple of boys from N.D.G."

N.D.G. is, more properly, the west-end Montreal district of Notre Dame de Grace, named for the imposing francophone Catholic church of the same name, on the street of the same name, in the district of the same name. But in our day, everyone called the area N.D.G. (It was also said to stand for "No Damned Good.") Being in the west end of the city, between Westmount and Montreal West, N.D.G. was more anglophone than francophone (or "English" and "French" as we said in those days).

At the very western reach of N.D.G. was the large and leafy campus of Loyola College, founded downtown by Jesuit priests in 1896, and relocated to the N.D.G. property—a 50-acre farm that had raised melons and pumpkins—in 1916. The architecture was that classic British university aesthetic, with gracious buildings, an ivy-covered central tower, and of course a chapel, all spread out over the spacious land.

In 1959, the Ferguson family lived on nearby Benny Avenue, not a long walk, and an even shorter bus ride, from Loyola. In Montreal in those days, people didn't ask where you lived—they asked which parish you belonged to. The Fergusons belonged to St. Monica's parish.

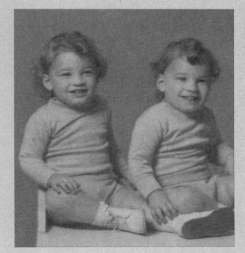

Age one, David left, Don right.

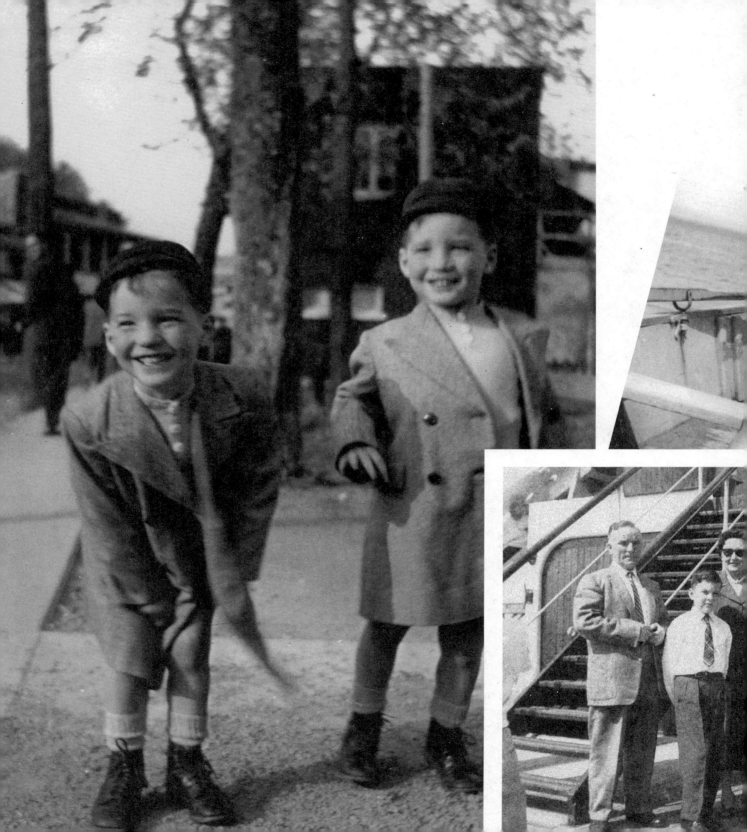

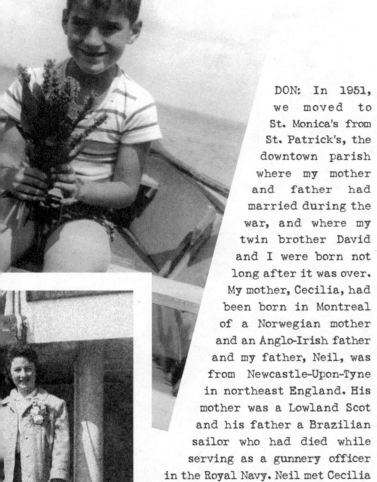

(*Clockwise from far left*) Don left and David right share a laugh; Don with flowers for mom; Roger age one, taken in Leasowe, England; Roger's Grade 2 school picture; Bill, Roger, Betty and Jackie aboard ship for a return visit to England in 1956.

DON: In 1951, we moved to St. Monica's from St. Patrick's, the downtown parish where my mother and father had married during the war, and where my twin brother David and I were born not long after it was over. My mother, Cecilia, had been born in Montreal of a Norwegian mother and an Anglo-Irish father and my father, Neil, was from Newcastle-Upon-Tyne in northeast England. His mother was a Lowland Scot and his father a Brazilian sailor who had died while serving as a gunnery officer in the Royal Navy. Neil met Cecilia in Montreal during the Second World War. Neil was a flight-lieutenant in the RCAF--"the real Air Farce," he used to tell me. In 1943, he flew into Montreal needing a place to stay, and asked the airport bus driver for suggestions. The driver took him to his mother's boarding house, where he met the driver's sister. Six weeks later they were married. (You think people make hastier decisions these days?)

None of our childhood friends could tell David and me apart, so we were both called Twinny, which drove our father bananas. Occasionally, in school, we'd switch classrooms for fun. Only our closest friends ever knew who was who.

Montreal was roughly divided in half. In broad scope, the eastern half spoke French and had bigger churches, most of them Catholic. The western half mostly spoke English and, of them, half were Catholic and half either Protestant or Jewish. Language and religion were important.

The Abbott family lived on Second Avenue in Rosemount, in the city's east end, and belonged to St. Dominic's parish. Parents Bill and Betty, daughter Jackie, and son Roger had arrived in Canada in May, 1953, travelling by boat from Britain, looking forward to new opportunities in the young Dominion.

In 1953, post-war England was still struggling to get back on its feet. Food was still rationed—families were allowed to buy only a few ounces of meat each week, a certain number of eggs, and children could have no more than a quarter-pound of sweets and candies. The economy was weak, so the Abbotts looked to Australia or Canada for their future. They lived in the small community of Leasowe, on Cheshire's Wirral Peninsula, just outside Birkenhead, and across the Mersey River from Liverpool. Bill, a marine engineer, had the

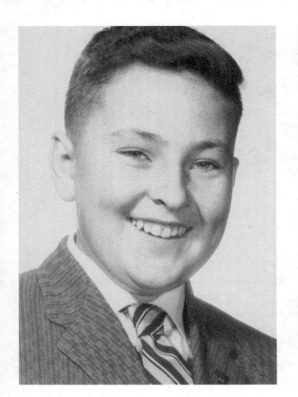

opportunity of a job at Canadian Vickers, the Montreal shipbuilders, and soon there was a "For Sale" sign in front of their semi-detached house and four one-way tickets to Canada were booked with the Cunard Line.

ROGER: Life in the new city was different and unexpected--it was huge, modern, bustling; there were two languages, and the lifestyle was partly American, partly French, and partly British. Everybody spoke with what sounded like an American accent. There was no rationing. I turned seven years old that first summer in Montreal, and that fall I was enrolled in Grade Two at St. Dominic's parish school. I did well in school, although my English accent had to be punched out of me in the school yard. It wasn't good to have a snooty English accent in a Canadian city, so I quickly learned to impersonate a Canadian voice. And I had my first taste of theatre in the parish's annual St. Patrick's Day concert, step-dancing to "The Irish Washerwoman" and singing "Cockles and Mussels, Alive, Alive-oh," without knowing what either a cockle or a mussel actually was.

Every spring in Montreal, a ritual intellectual culling of twelve-year-old English Catholic schoolboys took place, and 1959 was no different. As had happened for more than half a century, those with good marks were singled out by their teachers to write the scholarship exam to the city's best English educational institution, Loyola College High School. Their parents were informed by letter, and would make sure their sons were delivered to Loyola at the appropriate day and time. Only two boys from St. Dominic's were recommended and accepted for the exams; one of them was Roger. Across the city, a handful of boys were recommended from St. Monica's; two of them were Dave and Don Ferguson.

Loyola College had its origins in Montreal's elite French school, Collège Ste-Marie, in 1848, when the Jesuit priests who ran it opened an English Section with thirteen students. In 1896, the English Section moved and became Loyola College, and by 1916 it had moved again to its present location. After the First World War, thirty-six precisely spaced saplings had been planted along the road at the front of the school to honour the thirty-six Loyola boys who had died during the fighting, and by May of 1959, the thirty-six majestic, mature maple trees were in full, fresh leaf as Montreal's brightest English Catholic school lads trudged up the steps of the college where they were handed the toughest exam questions they'd ever seen. English Grammar, Spelling, Math, General Knowledge, and of course Religion, were all quizzed and tested, the answers to be written in a blue-covered booklet of ruled foolscap paper. This was the first time either of us had encountered the word "foolscap." It was part of the Loyola way. A topic was also given for a short creative composition. The six boys who achieved the six highest exam scores would be offered scholarships, their annual tuition paid either in full or in half, in honour of their high academic standing.

June was almost over when identical letters arrived at the Ferguson and Abbott homes, from the principal of Loyola College High School. We had tied for fifth in the examination results. The

highest three candidates were awarded full scholarships to Loyola, valued at a substantial $1,000 in those days, while the next three—including us—were awarded half scholarships.

On Saturday morning, June 27, 1959, the six winners gathered on the main steps of Loyola, under the tower, to meet each other and be photographed. Don had turned thirteen a month earlier, Roger would turn thirteen in two weeks. And that's how, and when, and why we first met.

> DON: I was struck by how assured Roger was. A confident, three-quarter-scale adult. Practically a grownup. I used to say that when I first met him, he was forty. But he didn't get older. He stayed forty until he was in his early twenties and then started getting younger. He grew younger ever after.

By the end of the summer, the Abbott family had moved to Madison Avenue, just two blocks away from the Fergusons on Benny Avenue. We were now officially "two boys from N.D.G." The four-year high school course began in September, 1959.

We were both assigned to "First High B," one of the five first-year classrooms. But "1B" was unlike any classroom anyone had ever seen. The homeroom teacher was a Jesuit priest, John Hodgins, SJ, who spoke with a soft, slight accent from his native Maine, and who viewed the education of youth as encompassing much more than the basics.

For starters, the classroom walls were painted what today would be called "a designer shade" of robin's-egg blue, with cream trim. Instead of a general-issue school clock, a genuine Black Forest cuckoo clock hung on the front wall. At the top of each hour, the mechanics would whir, a chime would sound, a little door would open and the cuckoo would leap out to call the hours. You can imagine that 11:00 a.m. and noon became festive times every day for a room full of 13-year-old boys.

Instead of penmanship cards and health posters on the wall, there were framed watercolours of Florence, Venice, Paris, and London. And sitting on plinths around the room were small bronze or marble sculptures. There was a statue of the naked winged Mercury, and *The Wrestlers*, their marble bums in the air, was a daily and irresistible target of spitballs. Father Hodgins kindly pretended not to notice. He was a world traveller who, every two years, took a few dozen students on the famous Loyola Tour of Europe, where he introduced those who could afford it to the beauties of art, architecture, cuisine, and history. Neither of us could afford it, but Hodgins made certain to bring some of that art and history into the classroom environment.

On our first day in the classroom, still astonished by our surroundings, and too awed to giggle when the cuckoo popped out every half-hour, Father Hodgins began the year by telling us that "Once a little boy sat right here and heard his own heart beating, for it was his first day at Loyola. But he worked and thought and prayed and dreamed wonderful dreams. And that boy is today the new Governor General of Canada."

Sure enough, on September 15, a Loyola graduate named Georges Vanier had become Governor General. In his own rather subtle yet broad way, Father Hodgins was making clear what would be expected of us: that we would work, think, pray, and dream, and one day become leaders of our country.

The Monitor, Montreal, Thursday, July 2, 1959

Loyola names scholarship winners

HENRY SERDONG

MICHAEL CZERNY

EDWARD HAYES

ANDREW ZALESKI

ROGER ABBOTT

DONALD FERGUSON

The names of successful candidates for Loyola High School scholarships were announced recently by the Dean of Loyola High School, Rev. Kenneth Casey, SJ. Of the 172 who wrote the scholarship examinations, six were granted scholarships.

Full scholarships for the four year high school course were awarded to Henry Serdong, Michael Czerny and Edward Hayes; half scholarships went to Andrew Zaleski, Roger Abbott and Donald Ferguson. A full scholarship for tuition is valued at $1,000.

The examinations included spelling, mathematics, English grammar, original composition and general knowledge. They were open to any student from an English-speaking parish of Montreal who had satisfactorily completed the Seventh Grade of a standard Grammar School.

In addition to the six who were awarded scholarships, ten other students received honorable mentions and became eligible to enter Loyola High School without writing the entrance examinations.

Michael Czerny became a Jesuit priest after high school.
A lifelong friend, he officiated at Roger's memorial mass.

Hodgins had many traditions. He was our homeroom teacher, as well as our Latin, English, Elocution and French teacher and on Thursday, he taught every period but one. That day was the best of the week because the afternoon became story time. Hodgins would tell us to clear our desks, get comfortable, and relax. Then he'd take a book from his personal classroom library and start reading to us. He began with *The Yearling*, a novel by the American writer Marjorie Kinnan Rawlings, set in backwoods Florida. A boy named Jody adopts a forest fawn, the yearling, whom he calls Flag. Jody and Flag grow to adolescence, and inevitably, heart-breaking decisions must be made.

Father Hodgins was a brilliant reader. We sat quietly and listened raptly, often with lumps in our throats. The raw emotion as the story progressed each week brought tears to everybody's eyes at one time or another.

Hodgins was entertaining us, bonding with us, instilling a love for words and stories, tempting our imaginations, and teaching us that it was acceptable to feel and express emotions. As the year went on, boys were gradually encouraged to read in his stead. We were becoming public speakers without even realizing it.

Hodgins was feisty and guarded his classroom and the corridor outside it with gimlet-eyed vigilance. One day we watched, thrilled, as he went toe to toe with a fellow priest, the hated, feared, and sadistic Father Connolly, vice-principal and prefect of discipline, over the placement of a large, new garbage can. Father Connolly had had the temerity to place the monstrosity, a canister four feet tall and thirty inches across, in the corridor smack outside our door. Hodgins would move it away, Connolly would move it back. Back and forth they shoved the offending receptacle, tempers rising, faces reddening,

until finally Hodgins, his black robe flying, hurled it down a flight of stairs where it crashed into the Junior Building's heavy wooden exit doors. The work of the Lord had been done. The loathed garbage canister was never seen in our corridor again.

Later in the year, Hodgins took us all to the Montreal Museum of Fine Arts, where he'd arranged for Arthur Lismer to give us a personal tour. Dr. Lismer was one of the original Group of Seven Canadian landscape artists, and here was this Canadian icon, showing us what to look for in a painting and how we might react to art, and offering us the opportunity to appreciate a new visual world.

Being one of "Hodgins' Boys" was a special privilege that we barely understood at the time, but what a lifetime gift it became.

Don and Roger, plus Don's brother Dave, went on to share the "2A" classroom the next year. It was another stimulating year, although so much more conventional in comparison to 1B. Both Latin and Greek, as well as French, were on the curriculum, so our language skills were well stimulated, and Public Speaking—the ability to make a speech, to be confident in front of a group, perhaps even be motivational—was a weekly course, part of the Jesuit system of turning young boys into tomorrow's leaders.

For our third and fourth years, Don remained in the "A" stream, and got to study Physics and more Greek. Roger, who was spending too much time working on the school newspaper and failed to maintain grades as high as Don's, moved on to a faintly less rigorous class, with more emphasis on Chemistry and Geography.

At Loyola, Roger easily established a rapport with boys a grade or two higher and immersed himself in various campus publications, including the annual yearbook. In the yearbook, to disguise the fact that not all the advertising space had been sold, unsold quarter pages

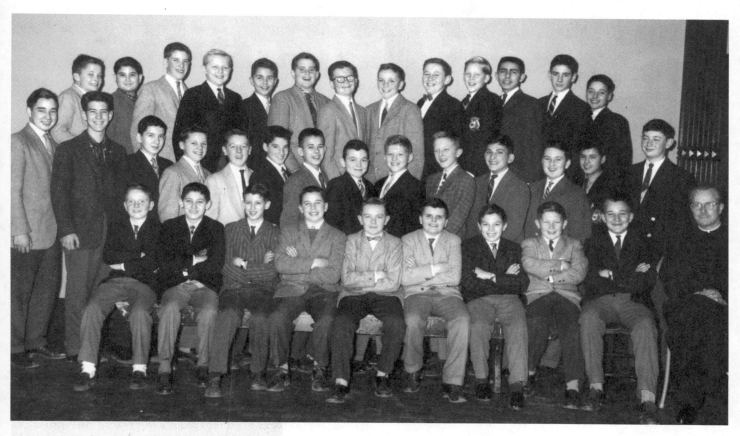

1959 Loyola High School Class 1B. In the second row, Don is sixth from the left, Roger is third from the right.

TOP ROW: T. Machnik, F. Rius, D. Byrne, S. Lenard, S. Rinfret, R. Newman, F. Briggs, L. Doray, G. Askwith, R. Hackett, P. Morency, R. Flynn, R. Grudev.

SECOND ROW: F. Parent, A. Rau, D. Gagnier, A. McDougall, D. McConomy, D. Ferguson, T. Sears, E. Hayes, H. Soborka, P. Pagnuelo, M. Courville, R. Abbott, G. Ken, C. Gendron.

FIRST ROW: N. Calafiore, M. Gagnon, F. McNally, M. Clarke, D. McGuire, S. Fitzpatrick, S. Waters, P. Oesch, D. Thomson. Fr. J. F. Hodgins, S.J.

customarily appeared as "Compliments of a Friend." Every year, in an effort to sabotage this custom, Roger would substitute the phrase with "Compliments of a Fiend." Alas, the printers always caught—and corrected—it.

Loyola was small. In the Junior Building, an arm that ran east off of the north end of the Central Building, approximately 400 boys attended the high school, while in the Central Building, 1,500 attended college. At the south of end of the Central Building was the Tower, which housed college academic offices, the switchboard, and the Jesuit residence. The switchboard was right out of the movies.

An operator sat before rows of sockets and transferred incoming calls to the requested party by pulling up a line with a plug on the end and sticking it into the correct socket, literally plugging people in. The switchboard also handled calls from parishioners of St. Ignatius Church, the local parish church which the Jesuits ran in addition to the high school and college. Just as all roads led to Rome, so too did all telephone calls to and from the high school, college, and local parish run through the Jesuit switchboard. Roger and his friend Patrick Conlon got part-time jobs at the switchboard, and made the most of it.

Official Loyola High School graduation photos.
Suave Roger, Dreamy Don.

PATRICK: From 1959 to 1961, Roger and I took turns running the Loyola switchboard evenings and weekends, earning two dollars an hour for shifts that ranged from four to twelve hours in length. Daytime through the week it was busy, but nights and weekends were very quiet--and very boring. At night, we felt we were sitting in a lit cage, positioned to one side of a large, gloomy entrance hall. To keep each other amused, one of us would usually hang around while the other was on duty. There was a phone booth down the hall that made call-sharing easy by simply opening two line keys at the same time!

We entertained ourselves any way we could think of. A favourite was to ignore the instruction to always greet callers with "Loyola College" and instead introduce special-occasion embroidery like, "Good evening, it's Holy Thursday at Loyola College" (solemn tone), and "Happy New Year from your friends at Loyola College" (cheerful), and "*Bonjour, Banque Canadienne Nationale*" (when we felt like confusing callers). We used invented voices that we hoped would sound like very old Jesuits with a booze problem.

We also pawed through the mail and opened letters that looked interesting. We would read them, trade speculative comments, tape them closed and scrawl "*Ouvrit par erreur*" across the back of the envelope.

We couldn't resist eavesdropping on any incoming call that started on an intriguing note--including one between a senior Jesuit administrator and his secretary at home that was clearly building to a tryst.

Our switchboard career came to an end shortly after we discovered that pulling back the line key on a caller produced a sonic insult somewhere between a buzz and a squawk. It sounded like "b-a-a-rf" and that's what we called it. It became our secret weapon. We used it arbitrarily on callers we just didn't like, including a cranky Bell Telephone Company repairman that I "barfed" repeatedly one day when he was responding to complaints about a weird noise coming from the switchboard. Dumb move. He reported the source of the noise to the priest in charge of our employment, who promptly fired me. Roger resigned soon after, always a loyal friend.

For young teenage boys, attending an all-boys high school provided close contact with the wildly different individuals who served the Lord as members of the Society of Jesus. We had some fascinating, beloved, and entertaining teachers.

There was Father Cass, who spent every spare moment digging up dandelions in the quadrangle, with which, it was rumoured, he made special Jesuit wine. And Father Breslin, who made Latin and Greek puns. And Father Granville, who taught us the art of mental prayer—out loud. We saw Father Mac, drunk at ten in the morning, trying to use the urinals in the Junior Building locker room and shooting wildly wide of the mark. Pissing and missing. It was all part of our high school education.

The entire student population of 400 all knew each other, and tended to encounter each other every day, likely being in the same class or on the same team, or in the same group or society. Almost fifty years later, lifetime friends from our Loyola days remain in touch. And wherever we took Air Farce across Canada, or on occasional trips into the United States and overseas, we would always find a fellow ex-Loyolan saying hello.

Don played some sports (soccer, basketball) but his activities also included the Drama society. Roger wasn't athletically inclined, and preferred editing the yearbook and the student newspaper, and participating in the Drama and Debating societies, as well as being class president. We both worked on a Drama Society production of Reginald Rose's *Twelve Angry Men*—its all-male cast perfect for a boys' high school. Roger played one of the jurors; Don was on the makeup team.

* * *

Having graduated from high school ("Commencement," in Loyola terms) in the fall of 1963, we each carried on to the beginning of a four-year Bachelor of Arts course on the same campus, at Loyola College. College life would prove to have many more distractions, offering much more than academic courses to lively minds.

College Loyolists

IN WHICH THE BOYS FROM N.D.G. TUNE IN AND FLUNK OUT

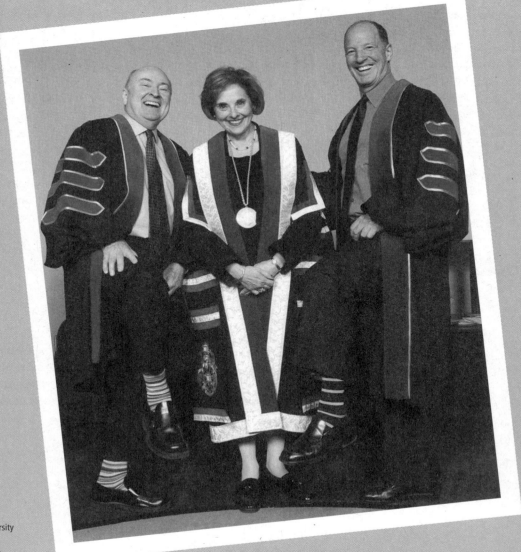

They earned their stripes! Concordia University President Dr. Judith Woodsworth welcomes newly minted Doctors Abbott and Ferguson in June 2009.

PHOTO: LUIGI D'ASTOLFO

The times were about to change, as the sixties took hold and the post-war baby boomers developed a new sense of social justice and teenage activism. In 1963, the role of the United States in the long-running Vietnam War escalated wildly, as did anti-war protests, and young Americans began their secret trips across the Canadian border to escape the military draft. The Civil Rights march on Washington drew 250,000 demonstrators for Martin Luther King's "I have a dream" speech. Dr. Timothy Leary was fired from Harvard University for experimenting with psychedelic drugs. Bob Dylan's "Blowin' in the Wind" became a generation's anthem. The Rolling Stones and The Beatles emerged in Britain, taking rock'n'roll to a new level—and hair to new lengths.

Much too close to home, the *Front de libération du Québec* set off its first bombs. The terrorist-style activities of the group were devoted to ending cultural and economic oppression by the wealthy Anglo merchant class, to releasing the grip of the Catholic church, and ultimately to the independence of Quebec from Canada.

And stunningly, on November 22, the charismatic U.S. president, John F. Kennedy, was assassinated in Dallas, Texas. Every person of our generation remembers where they were that day: we were both involved with the Loyola College Drama Society's production of Ben Jonson's *Volpone*. The play had run for three nights, and was planned to go for two more when the world was stopped in its tracks by the Kennedy killing. All of us on the entire campus were dumbfounded, huddled together for reassurance, glued to televisions for days, as events unfolded before our eyes, and we tried to come to terms with this shocking end to an age of innocence.

As the academic year unfolded, Roger found plenty of interesting opportunities outside the classroom. Working on the yearbook, being in on the ground floor of the new "Radio Loyola" campus station, and appearing in a spring Drama Society production of Dylan Thomas's *Under Milk Wood*.

All these activities, plus a penchant for sleeping late in the morning, interfered with Roger's academic schedule. After skipping weeks and weeks of a large English class, he managed to make an appearance one morning. The course, conducted by Dr. Michael Blanar, always began with a brisk roll call, and Blanar had long learned to rush past the first name on the alphabetical roll. As Dr. Blanar called "Abbott" without pausing for a response and moved on to "Anderson," Roger jumped in with a perfectly timed "here." Blanar stopped, in shock. The auditorium burst into applause.

The results at the end of the year were not pretty. An average grade of 32 per cent, the low mark being 7 per cent for Classics 121, the high being 50 per cent for French 120. And stamped at the bottom of the report: "Failed."

Bill and Betty were understandably not pleased. Roger applied to repeat Arts I at Loyola. The repeat year fared no better, and was

mercifully shorter. Radio Loyola continued to intrigue, and the fall began with Drama Society preparations to produce an original play by our fellow student Jim Hassinger, entitled *Exit, Pursued by a Bear*—the phrase being a stage direction from Shakespeare's *The Winter's Tale*. Roger was publicity director, Don was doing makeup again and appearing onstage as The Master of the Hounds—the casting based on his ability to play trumpet.

Next, we both moved on to helping plan and execute the Canadian University Drama League Festival, which Loyola and Sir George Williams University were co-hosting in February, 1965. Over four nights, fourteen one-act productions were presented from universities in Ontario, Quebec, and the Maritimes in the Loyola campus theatre. Roger did his usual publicity and printing; Don was on the technical staff. As artsy as the festival might sound, you can imagine that every night really came alive after the closing curtain, at the nearby Raphael Motel ("one hundred deluxe units, all with telephone and television"). With over a hundred out-of-town university actors, directors, stage managers, and designers, plus a few dozen Loyola and Sir George organizers and production staff, a large volume of beer, cocktails, and smaller amounts of something very new to all of us—weed—were consumed late into the night and early into the morning.

By then, Roger had seen the mid-term results for his attempted repeat of Freshman Arts, and they were no better than the previous year's. Staying on at school made no sense, enjoyable as all the extracurricular activities were.

ROGER: I'd developed an obsession for working in radio, and the father of my high school and college pal, Patrick Conlon, was doing the morning show at Montreal's CKGM Radio. Patrick had begged him to pass along to management some creative promotion ideas I had for the station, in case there were any jobs coming open. There weren't. But amazingly, the day the Drama Festival ended, I got a phone call to come down to the station and meet the chief technical operator, Gary Duguay. "I know you want to do promotion," he said, "but the trick is to get in on the ground floor, and we have an immediate opening for a technical operator." I asked what that involved. "You sit in the control room and play the records and commercials for the announcer, handle the phone calls, and pretty well do anything anyone tells you to do." I was already doing this at Radio Loyola, and thought I could handle it. How immediate is this opening?" I asked. "You start tomorrow," said Gary. Sunday, February 14, noon to six p.m. "There'll be lots of Valentine songs. The announcer is Gil Christy."

Gary and I shook hands, I went home and told my stunned parents that I was quitting college and starting a job in radio. This was the equivalent of saying "I'm resigning from civilization to join the circus, but I'm still going to live here with you."

And thus ended my academic days, and began my career in broadcasting, which has continued ever since.

Don followed a different path in his university career.

DON: I got through the first year of university by the skin of my teeth. Math was my bugaboo. Trigonometry and Intermediate Algebra, stuff kids learn in high school now, I just couldn't get through my head. Failed Math 101 at mid-term, failed the final, took the supplemental exam in the summer, failed that, too. Had to repeat the course the following year, failed at mid-term, and didn't quite make the grade on the final that year, either. The mark on my exam paper read "48 + 2 = Pass." Mercifully, the examiner who graded me realized I was never going to catch on, so boot the guy out, kick him upstairs, maybe he'll find courses where he has some ability.

In second year, I brought more troubles on myself. Having squeaked out of first year, I decided I could skip even more classes, which came back to bite me when the same Dr. Michael Blanar, who Roger shocked by turning up for class, failed me for lack of attendance, even though I'd done all the course work and passed the final exam. I could have squeaked through with only one failed course, but I'd also done something stupid during the final exams. I liked Classics, did well in class, but for some reason, I elected to write the final exam under the *nom de plume* Norbert Ferguson. Don't ask me why; must

have seemed like a fun idea at the time, and with Loyola's small student population I knew I could always straighten it out later if there was a problem. And naturally, there was a problem. When I got my results mid-way through the summer, the Classics course was listed as "Did Not Write Final Exam." With a failed English course and a missing Classics course, that meant a failed year. I'd have to repeat it. Lesson learned. Goof with the system at your own risk.

A year later, I spent much of the summer working with my friend Henry Sobotka on the university handbook. Henry had decided that the traditional guide to campus clubs and activities was a boring waste of ink. He had a different idea. Scrap the pages where campus clubs explained the obvious-- the chess club played chess--and instead load the handbook with information about issues. After all, students came here to broaden their minds, didn't they? So that year the handbook appeared on campus with comprehensive articles about the Vietnam War, abortion, women's rights, racism, consumerism, Quebec politics, and marijuana. The school authorities confiscated the entire print run and we narrowly escaped expulsion.

Not an auspicious beginning to my third year. And I compounded my troubles by switching my major from English to the trendy new discipline on campus, Communications Arts, the brainchild

of Father Jack O'Brien, an ambitious up-and-comer who was a heretofore unknown species: the corporate Jesuit. The guy and the courses he taught were all smoke-and-mirrors, community college how-to job training and career tips dressed up in academic folderol. The kicker for me came the day O'Brien used class time to criticize an article that had caused a minor kerfuffle when it appeared in the campus newspaper. I was editor of the paper and was astonished that O'Brien, who hadn't been involved and knew none of the facts, began attacking the choices we'd made at the paper. He wasn't merely misinformed--he was utterly uninformed. I quit the course in disgust, and the school soon after. When January came, I was at loose ends.

It was 1967: Montreal buzzed as it got ready to host the World's Fair. Roger, working at CKGM, wangled Don a job as a technician, then the two of us moved to CFMB, Canada's first multicultural radio station, with programs in languages other than just French or English. It was owned by an émigré named Casimir Stanczykowski, who proudly claimed the call letters CFMB stood for "Canada's Finest, Montreal's Best." The scuttlebutt at the station was that they stood for something much less savoury that involved Montreal boys. In any case, we spent less than a year there. Ralph Kirchen, the program director at CFMB who'd hired us, had subsequently landed a job as station manager at CHIN, a Toronto multicultural radio station owned by the "unofficial mayor of Little Italy," Johnny Lombardi, and he asked us to join him. So,

in March we headed down the road to Toronto, found an apartment, and started at CHIN.

Roger took on the double duties of operations manager and promotion director. Don split his time between technical operations and writing local news. The station's newsreaders generally had great voices and tons of experience and had landed at CHIN after losing the battle of the bottle at better stations. Like most radio newsrooms, there were two sources of news. For national and international stories, you couldn't beat the Canadian Press teletype service, colloquially referred to as "rip and read"; for local stories you relied on newsroom copy, which usually consisted of *Toronto Star* and *Toronto Telegram* articles that had been sufficiently changed to disguise the source.

Roger had challenging and interesting work that came with the increased responsibility of holding down two jobs, but Don floundered. CHIN had a "dawn-to-dusk" licence, which meant it only broadcast during daylight hours, a handicap if you wanted the usual mainstream audience, but not if you were multicultural. Recent immigrants, who wanted programming in Italian, or Polish, or Portuguese, listened to CHIN because they didn't have any other source. The most important part of Don's job was to turn the station on in the morning, which in the middle of summer meant waking at four-thirty and firing up the transmitter at five. Unfortunately, Don has never been a morning person.

ROGER: I worked nine to five; Don worked from five a.m. until early afternoon. Don had trouble falling asleep anytime before one a.m., so even with the occasional afternoon nap he was permanently exhausted. Eventually, he had three alarm clocks in his bedroom, one on a night table,

one in a dresser drawer, and one under his bed, all set within five minutes of each other. That way, he couldn't simply throw out a hand to shut off the alarm by his bed and fall back to sleep. He actually had to get up and move around his room in order to reach the clocks and turn them off. He became an expert at opening drawers, crawling under his bed and turning off the alarms without ever waking up. He was constantly late and more than once had to work his way through a crowd of Italian men--labourers up for an early start--who had gathered outside the station to find out why their favourite morning show wasn't on.

It was also the summer of peace and love, and various outdoor music events began popping up in Toronto. At one of them, Don turned to me and said, "You know, I have to do something different. I feel as if I'm missing my generation."

DON: I was clearly unfit for the responsibility of opening up the radio station in the morning, and after giving me multiple second chances, Ralph Kirchen faced the inevitable and fired me. I knew it was coming, but I was crushed. It was my first job away from home and I'd failed. But I was also relieved, and glad to be set free. Roger stayed on in Toronto for another year, while I high-tailed it back to Montreal.

With some friends I moved into an apartment on rue Berri, a couple of blocks east of St. Denis in Montreal's east end. It was the top floor of a three-storey walk-up that gave access to the roof through a trap door in the bathroom ceiling. We hauled up a cheap rug, a sofa, and a chair, and spent many an afternoon on the roof sitting in the sun, drinking beer, smoking weed, and talking, talking, talking. About the world, our lives, what lay ahead, our dreams, our hopes, about the general excitement of just being alive. From our rooftop, we could see around us the domes of six parish churches that floated above the uniform height of the surrounding neighbourhoods, block after block after block of three-storey row housing. Church domes had floated over Montreal neighbourhoods for generations and created a sense of permanence and calm. What a gorgeous, peaceful sight. Ah, Montreal, it was good to be back.

Because it was 1967, centennial projects were all the rage. Ottawa encouraged everyone to get into the spirit, and hundreds of thousands of Canadians celebrated in their own unique, unofficial ways. We decided to celebrate by dropping acid 100 times. That's a lot of LSD, and because it takes a couple of days to recover from it and because we started late in the year, even though we sometimes doubled up doses on subsequent

days, we didn't finish until the spring of 1968. Happy birthday, Canada!

That first winter back, I came home one evening to the apartment that I was sharing with a woman friend to discover two young men sitting in the kitchen with her. They were deserters from the U.S. Army. Three nights earlier, they were in Washington State waiting to ship out the next morning to Vietnam, when they decided to bolt. They'd ridden a Greyhound across the country to the University of Massachusetts, where one of them, Jeff, had gone to school. At U Mass they attended an anti-war meeting in one of the dorms, explained their situation, and the students passed the hat. With a few hundred dollars between them, they took another bus to Montreal, and now they were in our kitchen.

In quick order, our rue Berri apartment became a transit point for deserters. Some stayed a night and moved on. Some, like Jeff, stayed for a year. The first deserters were genuinely sad cases. Young men swept up by their government to fight a foreign war that fewer and fewer Americans supported, and who came north to escape a future they wanted no part of. But once the pipeline was open, all manner of flotsam and jetsam began to use it. Soon we had petty criminals and drug users--no doubt the kind of soldier the U.S Army was glad to be rid of--knocking on our door. The worst were the drug users. One, who called himself Christian Harrison (we never did learn his real name), caused serious trouble.

One night, after a few too many at a bar on Crescent Street, Christian stepped onto rue Ste-Catherine to hail a cab. He saw an empty police car idling at the curb, hopped in and started to drive himself home. Fifteen minutes later he was in jail, where he sweated bullets waiting for his criminal past in Vancouver and Oregon to catch up with him. But no criminal record came up and he was turned loose in the morning. (No charges were laid for the theft of the police car--too embarrassing.)

Christian's most dangerous stunt involved an attempt at dealing. I came home late from school

(I'd returned to finish the last two years of my degree) and found Christian in the apartment. Unusual--he was normally out seeking oblivion in the evening. With him were two young men, university students.

DON: Hi Christian, what's up?

CHRISTIAN: Just waiting for a couple of guys to come over.

DON: Who are you guys?

STUDENTS: We're just waiting with Christian.

DON: What are you guys up to?
(Nervous looks all around.)

CHRISTIAN: As soon as the other guys get here, we'll clear out.

DON: You son of a bitch, you're doing a deal. Pick up the phone and call it off. You know the rules, absolutely no dealing. Call it off.

CHRISTIAN: I can't. It's too late. They're on the way.

DON: I'm not here, I'm going to bed, tomorrow you pack your bags and get out.

Furious, I went into my bedroom, slammed the door and crawled into bed.

Two minutes later, the doorbell rings. I hear Christian go downstairs to let his visitors in. Next sound: excited voices shouting, many heavy feet thundering up the stairs. "Oh crap," I think, "the cops. We're being busted." I pull the covers over my head and tell myself, "You're unconscious."

Suddenly the voices are in the main room, right outside my door, and they are very loud, French and French-accented English on one side, panicked English on the other. I hear furniture shoved around, a table overturned, the phone ripped off the wall. The door to my bedroom flies open and light fills the room. A hand grabs my shoulder and shakes me roughly. "I'm unconscious," I remind myself. I fall out of bed onto the floor and the man at the end of the hand says, "This one's passed out." He leaves me alone and returns to the main room. I risk opening an eye. There are three of them, and at least one has a gun. A voice demands, "Five grand. Where's the money? Give us the money!" These aren't cops! Stupid Christian has set up a rip-off.

CHRISTIAN: I don't have it here. You think I'm stupid?

ME (quietly, to self): Yes, I do. Very stupid.

BAD GUY: Take us to the money. Come with us.

CHRISTIAN: No way. You're gonna shoot me there, shoot me here instead.

ME (quietly, to self): No, please take him with you and shoot him there.

I hear the sound of something hard on something soft, a metal pipe or gun butt against flesh, followed by whimpering. And then it's over. The

feet fly out of the apartment, down the stairs and out into the street. I come out of my room. The main room is in total disarray. All the furniture has been pulled away from the walls, the dining table is on its side, the coffee table upside down, the phone lies on the floor, loose wires protrude from the wall. And in the centre of the chaos stands Christian and his two university dealers wearing nothing but their underwear, having been stripped almost naked while the thieves ripped apart their clothes looking for the money. But they didn't get it. The dealers had folded and tucked their thousand dollar bills into their underpants, surmising correctly that no macho thief would dream of putting his hands there.

During 1968, anti-war sentiment heated up. A carload of us drove to Washington to protest at the Pentagon. At the U.S. border, we were asked our destination. New York, we said, to visit friends. We passed without comment. The U.S. government must have had no idea how many people would turn up at the Pentagon, because when we got there, security was light and we made it all the way to the front doors before being held back. Two of our group actually got inside and were escorted out. We sat on the parking apron along with thousands of other young people--mostly Americans, who had a lot

more at stake than we did--and stayed through the night. Every so often one of the young soldiers lined up between us and the Pentagon would throw down his weapon and join us, and a huge cheer would fill the air. But by sunrise, cold, hungry, and in need of a bathroom, the crowd began to feel that it had made its point and gradually departed. By mid-morning, the plaza was empty, you'd never know there'd been a demonstration at all.

There were rallies at George Washington University, where without fail every single university professor who stood up to talk about his (they were all men) reasons for opposing the Vietnam war began by saying, "I am not now, nor have I ever been a member of the Communist Party." How different was Canada, how much more open, where this kind of paranoia didn't exist. How awful for adults of conviction to feel the need to deny an affiliation they never had with an organization they didn't even believe in. Land of the free, indeed. That was the most frightening aspect of the whole Pentagon weekend.

Somehow, through all this, I managed to return to university--eternal gratitude to my parents, who never gave up on me, but continued to support their errant son with kindness, patience, and love--and I finally managed to graduate in

1970, only three years later than planned, and with some life experience under my belt. And with an honours degree, no less!

In June 2009, fifty years after we first met on the front steps of Loyola College High School, Concordia University—created by the merger of Loyola College and Sir George Williams University—awarded honorary Doctors of Laws degrees to us. While Don was acknowledged as an alumnus and graduate, Roger was discreetly listed as a previous "attendee."

Dr. Abbott and Dr. Ferguson. Not bad for a couple of boys from N.D.G.

Don and Roger receiving degrees with Concordia Chancellor David O'Brien

Overtures in Radioland

AN INTRODUCTION TO THE AIRWAVES AND TWO MEN OF INFINITE JEST

In the air everywhere...
Dans le vent, à tout instant.

CKGM

Radio Montréal • AM 980 • FM Stereo 97.7

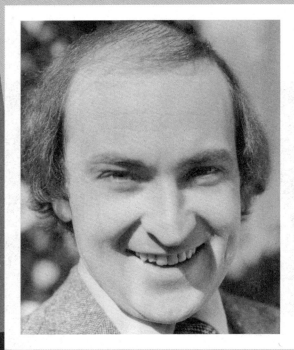

(*Left*) A poster for CKGM Radio in Montreal in 1969, when Roger became the station's operations manager at the age of 23; (*Above*) Roger in 1973.

Behind every beginning there's at least one other beginning. Behind Air Farce the television series, there was the radio series, and before that, The Jest Society, which was our original improvisational stage show. And even before that was Funny You Should Say That!, a CBC Radio series conceived and written by Martin Bronstein and John Morgan in Montreal, in the giddy, heady summer of Expo 67. It was a classic half-hour radio comedy-variety format, in the tradition of BBC comedies, or even The Jack Benny Show or Wayne & Shuster's radio days. There was always a musical number halfway through, a responsive studio audience, a variety of voices and sound effects, and a mix of comedy sketches and monologues.

But let's begin our story in the winter of 1969-70. Roger was going through a personal season of discontent. He was in his second tour of duty at Montreal's CKGM Radio, serving as operations manager and doing a job he loved—interacting with the on-air talent, keeping an ear on the music, scheduling the staff, keeping the live 24-hour operation running smoothly. The station had begun life as Montreal's screaming Top 40 fun-house in 1959— our first year in high school—bringing rock-around-the-clock to a city and a generation that was starved for it. Then they added phone-in talk to attract adult listeners and watered down the rock to compete with the two "hello-mom-in-the-kitchen" stations, and in Expo year—1967—went split personality: phone-in talk from 9:00 p.m. through 4:00 p.m., then Top 40 hits 4:00–9:00 p.m. and all weekend long.

Roger had worked there right out of college—after dropping out of college, that is—in 1965 and 1966, then moved on to two other stations, and returned to CKGM in 1968. By then, its programming was a hodgepodge, often falling to third place in the ratings among the three English stations.

ROGER: One of my responsibilities was scheduling technical operations, because all the phone-in shows required a technical operator to screen the incoming calls, roll the commercials, and be prepared to press the "delete" button on the seven-second delay system if someone started swearing. To fill in for a few shifts each week, I hired Don, who was back at Loyola College as a slightly adult student.

He was operating for the notorious hot-line host Pat Burns one night, about to break for the 10:00 p.m. newscast, when he got a control-room signal over the Motorola two-way radio from our roving news cruiser. The reporter advised Don he

was about to reach the scene of a big fire, and would have a live report. Burns ended the hour, Don rolled the news intro, and the newscast began. The reporter buzzed in again, ready to go live, was duly introduced and put on air.

With the authentic sounds of fire-truck chatter in the background, he delivered his on-the-scene report: "I'm on Berri Street, just south of Mont-Royal, where fire is blazing away in a three-storey triplex. More details as they become available, this is Bill Edwards in the CKGM News Cruiser."

As the newscast continued, Don buzzed Bill.

"What number on Berri?"

"Looks like 4325, 4327, and 4329."

"That's where I live."

Pause.

"Don, don't come home tonight."

DON: Luckily, Roger lived not far from the station, so I called him and spent the night on his sofa. It was the beginning of a few weeks of couch surfing. I went to the apartment the day after the fire to check out the damage. 4329 rue Berri was the top floor of a stone-fronted, three-storey walk-up, the kind of row housing that runs for blocks in Montreal's central working-poor neighbourhoods. The fire had started in the flat next to ours, where a young immigrant family from Paris lived. The damage was catastrophic for them, serious for us. We hadn't owned decent furniture, but what we had was now unusable. Upholstered pieces sat sodden and our one carpet had been tossed into the street. Water pooled on the floors and dripped down scorched walls. My cat, Ignatius, whom I'd rescued as a broken-legged stray and who was the most affectionate animal I've ever known, had vanished, no doubt fleeing for his life. I returned several days in a row, but never saw his long-haired grey coat again. I salvaged a couple of pairs of jeans, some shirts, and a jacket, all of which reeked of smoke, and I abandoned the rest.

Other than lively on-the-spot news of fires, CKGM was going through a bad patch. It was dull. Pat Burns's talk harangues were wearing thin and some of the other talk shows were extremely weak, hosted by unusual people, some with no broadcasting experience. Advertising sales were flat. It was time for a shakeup but the owner was reluctant to invest more money, and in 1969 he accepted an offer from Toronto's CHUM Limited (run by the legendary Alan Waters) to purchase the station. A few senior executives wisely chose the moment to look for work elsewhere, and before he knew it, Roger was high man on the totem pole.

ROGER: I had just turned 23 years old, I was in love with radio, and I was excited about the changes that were coming. As summer ended,

Pat Burns returned to Vancouver. The dean of Montreal newscasters, Dean Kaye, also departed, and affable morning-show host Bill Roberts quietly left the station, too. Bill was a Montreal radio legend, a wonderful man, and a mentor to me. Broadcasting was in his blood: his father, Leslie Roberts, was a distinguished political commentator in print and on air; his son Leslie, now the third generation to be a broadcaster, is the news anchor at Global Toronto.

By September, 1969, the financial bleeding was under control, and CHUM's senior vice-president, Fred Sherratt, who was visiting Montreal once a week, brought in Ted Randal Enterprises, a Los Angeles–based radio consulting firm. The principal, Ted Randal, was a former disc jockey in San Francisco and Los Angeles. His associate Mike Lundy, also a former jock, was an easygoing Californian who enjoyed the mechanics of radio formats.

For me, Ted and Mike were an excellent adventure. In four months, I learned more about radio from them than I had in the previous four years. They smoothed out our schedule, implementing an hourly format that just naturally encouraged people to listen longer, hand-picked "the perfect music mix," with reliance on current hits and recent goldens, taught the disc jockeys to be brief yet personable, then taught me how to maintain the whole sound.

Mike Lundy's main job was to keep an eye on the property, and especially its owner, Geoff Stirling, whom Alan Waters believed was capable of doing anything to screw up the property after the deal was signed, but before CRTC approval.

Waters' worries were not without foundation, for Stirling had a reputation. But fortunately he was distracted by his pet project at the time—transforming CKGM-FM from a "soothing music" format into a free-form underground rock station. It was the direction FM stations were moving in all over North America, but Geoff took it right to the edge and peeked over. Although forty-eight at the time, he had recently discovered and embraced flower power, psychedelia, and all the trappings of the summer of love, including the spring of smoke, the autumn of acid, and the winter of oh-wow. Roger stayed focused on CKGM-AM.

ROGER: One day I was chairing a programming meeting with the on-air staff, walking them through the new formats for music, commercials, talk breaks, hoping to convince them that if they could make each individual sequence of events a "perfect" sequence, then they would have an hour of perfect sequences, and the entire broadcast day would unfold perfectly. I was the youngest person in the room, but I spoke with fervour and belief. Then, unexpectedly, the boardroom door opened and Rusty Staub poked his head in. The Montreal Expos star did a weekly "Let's Talk Baseball" show on CKGM.

He went around the table shaking hands, and on his way out I asked if he had any advice as we

launched the new format. "I think radio's just like baseball," he answered. "The way to win is, just pay meticulous attention to the fundamental details."

In one sentence, he gave me the catchphrase I needed: "Pay meticulous attention to the fundamental details." It's a phrase and a motivation and an attitude that stayed with me for over forty years, and it became one of our key mantras at Air Farce, particularly in television. The big picture, the long-term success, will take care of itself if every single element is perfect. The best script, the best direction, the right lighting, the correct setting, costume, wig and makeup . . . if every detail of every scene is perfectly executed, the entire show and ultimately the entire season will be a success. Rusty Staub knew whereof he spoke: pay meticulous attention to the fundamental details.

But the one fundamental detail no one could control was the CRTC. On Thursday, December 11, 1969, the staff at CKGM received word that the CRTC had denied the sale to CHUM Limited. The new year and a new decade dawned as scheduled, and Geoff Stirling called a small meeting for Saturday morning, January 10, 1970, at Montreal's Ritz Carlton Hotel.

ROGER: I'd heard stories about famous Stirling meetings and was prepared for anything. According to legend, he once called a staff meeting at his radio station in Windsor, Ontario. There was a chart supplied for where people should sit, and an audio-cassette tape deck in the middle of the table. The manager was instructed to start the meeting by playing the tape. On it, Stirling's voice expressed his displeasure with how the station had been performing, his solutions for the problem, and then he started naming names, following the seating chart round the table, naming those who were fired and must leave immediately, and those who could stay for the remainder of the meeting.

Stirling would fit on almost anyone's "most unforgettable character" list. He was a smart entrepreneur, ruthless when required, and with some oddly endearing foibles. At a staff party once, he made a short speech and wanted to end by thanking and introducing his wife, Joyce. Unfortunately, he couldn't remember her name, and eventually had to call her Mrs. Stirling. Another time, at a staff meeting, he called me "Francine."

Within three days of the meeting (which had been surprisingly uneventful), Geoff phoned the all-night jock while he was in the middle of his show and fired him. A week later, at 3:30 a.m. as he was getting ready to leave for work, the morning jock was phoned at home and similarly fired. Geoff's erratic behaviour was wearing me down, plus I had bought so deeply into the CHUM promise that the sudden absence of my new mentors

was devastating. I still loved radio, but it was CHUM's brand of radio that I loved the most.

At the tender age of twenty-three, I decided that life was too short for it to be this tense. I knew that my bank account would carry me for about six months if I played things very carefully. I got to my office, sat down and typed a note to staff and colleagues. I don't remember what it said, but it was short, managed to quote both Bob Dylan ("for the times are a-changing") and Robert Browning ("a man's reach must exceed his grasp"), and wished everybody well. So, as of January 19, 1970, I was unemployed, but optimistic. That night, I gathered with Patrick Conlon and Gay Claitman at a favourite pub, The Annex, on Montreal's Crescent Street, for beer and emotional sustenance.

My Loyola schoolmate Patrick and I had become great friends, largely through a shared fascination with radio, advertising, media in general, and the power and wit of words, the latter being a hallmark of every Jesuit education.

PATRICK: One of the first things I admired about Roger was his astonishing ability to completely inhabit an imagined character. One day, Roger called a popular St. Catherine Street restaurant to make a lunch reservation. He was channelling a fussy travelling companion of the young Lord Kensington (my role), who was visiting Montreal for a few days. Roger aced the British accent—he and his family had come from England. He wasn't asking for exceptional attention from the restaurant, but his haughty-yet-courteous tone made it clear that was the goal.

We showed up on time, both of us looking unintentionally dowdy in badly fitting suits. Roger stepped forward to the hostess and announced our arrival. She led us to a small table. His performance as the loyal family attendant was impeccable. He solicitously removed my coat and drew a chair out so I could sit. Before settling opposite, he placed a napkin on my lap and we waited for service. I looked around the busy restaurant. Every other table was occupied.

It was then that I realized ours was the only table with a lit candle at its centre—the sole acknowledgement by the restaurant that someone apparently special was in the room. Roger and I smiled at each other. We had pulled it off.

At the end of a meal that went smoothly, we asked for a bill. After a few minutes, the hostess came to our table. "With our compliments," she said. "Bienvenue à Montréal." Roger helped me on with my coat and then produced a British half-crown which he placed discreetly on the table.

As we were leaving the restaurant, Roger started fretting about the size of the tip. "It's

One of The Jest Society's early performances, 1970.
(*Left to right*) Martin Bronstein, Roger, Patrick Conlon

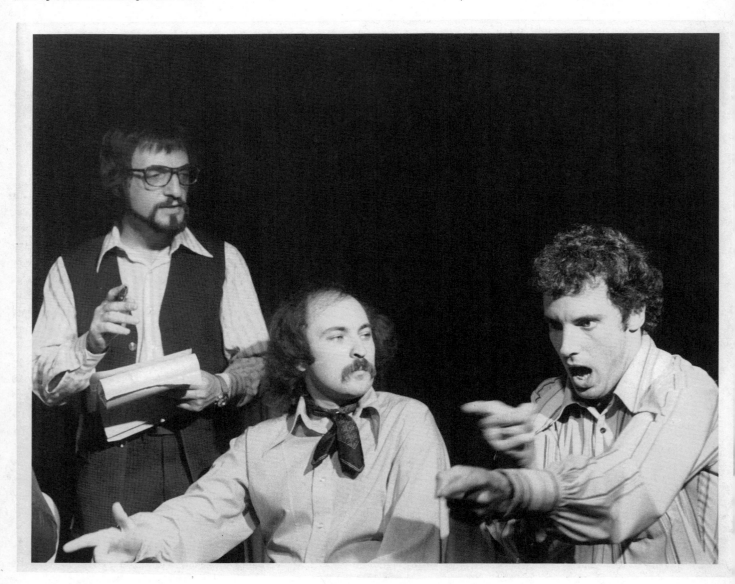

all I had, but I hope that was enough," he said. Much of his life thereafter was spent making sure that everyone was fairly treated, that everyone had enough.

ROGER: Patrick was now a freelance advertising copywriter, doing very well creatively and financially. Gay Claitman had been a copywriter at CKGM and had now moved to another radio station, the market-leading CJAD. We had become instant friends at work, and she and Patrick quickly clicked when they met. We were on the same wavelength and had fun together, and all lived within a few blocks of each other near the old Montreal Forum.

Patrick and Gay invited to me to meet with their friend Les Nirenberg, who was producing television segments for CBC in Montreal and also co-ordinating various projects such as public-service commercials (anti-smoking) and audio tracks for *Sesame Street* animations. Les was brimming with ideas and enthusiasm, and as the next month or two went by, the four of us enjoyed improvising together and recording our efforts. Les found a market for some of them, and before long I was actually joining ACTRA, the performers' union, and working legitimate gigs. Les proposed that we refer to ourselves as "The Beaver Follies Radio Theatre," which I thought was a wonderful name.

Then, without warning, along came what must have been a life-changing day for me, though I had no clue at the time. Thursday, May 21, 1970. The note in my daybook just says, "Out at 8:00 with Patrick and Gay to Martin Bronstein's re: The Jest Society." No other details. The next entry, four days later: "Out at 3:00 to Martin Bronstein's for Jest Society," and the next day, Tuesday, May 26, "Jest Society Rehearsal at John Morgan's, 8:15-11:30."

Of these three meetings, the only one I clearly remember was the third one, at John Morgan's. Somehow in the first two gatherings, the five of us—John, Martin, Patrick, Gay, and I—must have sniffed out what we liked about each other, and quickly agreed to workshop and rehearse some sketches together.

John Morgan and Martin Bronstein's written wit first went national on May 7, 1967, when, according to a CBC Radio release, "a new comedy writing team bows in on the national scene when *Funny You Should Say That!*, a fast-paced revue, is presented on CBC Showcase." The new team was a pair of Brits who met in Montreal, where they worked as journalists, magazine writers, and editors. But at heart, Morgan was still a Welsh lad with some funny ideas and a healthy disrespect for authority. Bronstein was an imaginative Londoner with a zest for journalism and a passion for satire and jazz.

"We can promise the audience one thing," Morgan was quoted at the time, "there won't be any tired Canadian jokes. Diefenbaker's

name won't be mentioned a single time. And the same goes for Judy LaMarsh." It was to be a promise he couldn't keep, of course, because then as now, politics and satire were inseparable.

Funny You Should Say That! became an immediate hit, a favourite of listeners and critics. Starring Barrie Baldaro, Joan Stuart, Ted Zeigler, and eventually Peter Cullen (and rotating guests such as Max Ferguson and Dave Broadfoot), it was a blast of fresh air—and a very different point of view.

Zeigler was a clever character comic, an American in Montreal best known as "Johnny Jellybean," host of a daily kids' show on CFCF-Television, where a lot of the dialogue was aimed above the heads of the kids (which made him an icon for university students). Cullen, a native Montrealer, was a gifted comic actor and voice artist; he'd appeared in stage reviews and worked as a DJ at CKGM Radio. Joan Stuart was a versatile and impish comic actress, who gleefully threw herself into her roles.

In a regular Morgan-written segment called *The Langlaises*, Cullen played Gilles, a frustrated French-Canadian husband to Stuart's Penelope, his cold English-Canadian wife. It was every bickering sitcom couple, but with the added zest of French/English tension, providing a funny pressure valve in those early days of separatism, reflecting both the fun and tension of the two solitudes of Montreal.

An exasperated Cullen, in his Verdun working-class francophone voice: "Making love to an English girl is like playing Russian roulette. Five times out of six, it doesn't work." The audience lapped it up.

As writers, John and Martin both loved playing with words and turning them into mind-pictures. *FYSST* had a good run on air, but, frustrated with producers who insisted on flying to Los Angeles to import U.S. guests such as Jonathan Winters and Lily Tomlin—

when the whole idea of *Funny You Should Say That!* was to bring a Canadian sensibility to the airwaves—Morgan and Bronstein eventually stepped away from it, as well as from a television version of it named *Comedy Cafe*, then *Comedy Crackers*, then *Zut*, until the network ran out of cute names. Meanwhile, John and Martin continued their journalism careers, and after a brief, unhappy fling in British television with the *David Frost Show*, plotted a new kind of comedy program that would not be ruined by uncooperative guest performers, over-rehearsal of the musical numbers and under-rehearsal of the sketches, and all the other horrors that happen when you're not in control of your own show.

CHAPTER 4

The Jest Society

THE FOUNDATIONS OF THE FARCE

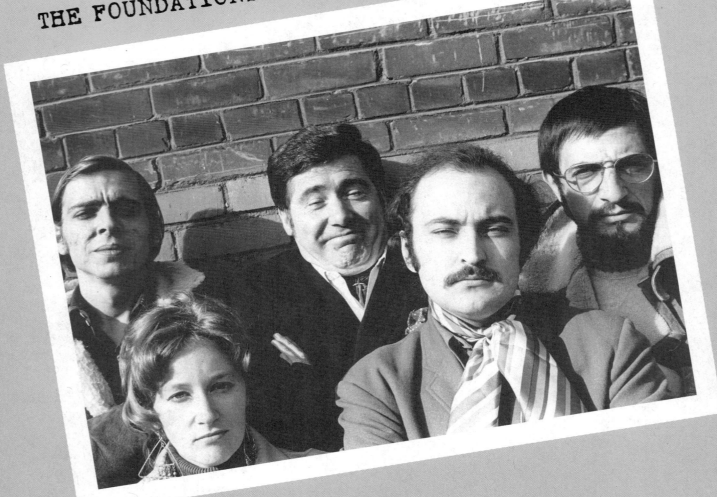

PHOTO: DON FERGUSON

The Jest Society, Fall 1970. (*Left to right*) Steve
Whistance-Smith, Gay Claitman, John, Roger, Martin.

ROGER: John Morgan and his sociable wife, Ena, had a large, comfy apartment on St. Catherine Street. I discovered Ena had owned two restaurants in the city, one of which was a café called The Limelight, not far from where I lived, and a favourite late-night spot for tea and a pastry. So, Ena had prepared a lovely table of rehearsal fuel, and John and Martin had a list of sketch ideas they wanted to play with. We set up a little stage area in the living room with a few pieces of small furniture and began improvising and entertaining each other. At one point I got carried away and leaped up onto a beautiful old Quebec pine stool, which promptly collapsed under me. I scored points for enthusiasm, but it wasn't a great way to make a first impression on John and Ena.

In a very casual way, the five of us had just agreed to have some fun together, and to take a chance with the Jest Society idea. There were no extensive auditions, or drawn-out discussions, and no mention of salaries or rights. It was tremendously easygoing, and I think the advantage was that we had nothing to lose. It would either work or it wouldn't, and life would go on, either way. I think this rather blasé attitude is what made our opening efforts so successful; when we went out on stage together, we were a bunch of people who were comfortable together--there was no anxiety, nor the dreaded whiff of flop sweats. Particularly in my case, I had absolutely nothing to lose, and everything to gain, although I didn't realize it at the time. And much as I'd enjoyed occasionally performing in front of an

audience, or being silly behind a microphone, I had never seen myself as a performer. I liked being with performers and I liked the sizzle of entertainment, but I saw myself as a programmer, a manager--my ambition was to own a radio station by the time I was forty. So The Jest Society would be a few Sunday nights of fun in a Montreal summer, and then who knows what would happen next? Certainly, at age twenty-three, I never dreamed that it would be the beginning of a lifetime career.

Martin Bronstein was thirty-five that summer in Montreal, and John Morgan was forty—so they were a decade or so older than Patrick, Gay, and me, and they had each travelled from their home country to discover new opportunities in North America. Martin had been in Montreal since 1959, worked in advertising for two years, then became a freelance journalist, writing some humour columns for the *Montreal Star*, reviewing concerts on CBC Radio, testing cars, writing plays and documentaries. He described himself as "a cockney, with a Russian father and a Polish mother." After he met up with John Morgan—quite possibly over a squash game in the mid-1960s—the pair devised *Funny You Should Say That!* and sold it to CBC Radio. Martin was bearded, had a good eye for fashion, a passion for music —especially Cleo Laine and John Dankworth—an ear for language, and a gleam for comedy and satire. He had grown up in the London borough of Hackney, in that city's north east, which Martin remembered as being pretty tough in the post-war years. He could turn on the full cockney accent with ease. He worshipped Lenny Bruce.

John Morgan was, all his life, a Welsh lad. He was born in the Rhondda Valley, South Wales, in the small industrial town of Aberdare. His father had been a bus conductor and had died when John was a young man. His mother, Cassie, a sparkling old dear, eventually became a fixture at early *Air Farce* radio tapings—not in the theatre, but happily sitting in John's car outside. (She did this in all weather, even winter, and when John bought a huge second-hand Oldsmobile convertible, she'd sit in it dressed in a coat and gloves and wrapped in scarves, with the top down.) Although John would often go back to Aberdare later in life, he was anxious to distance himself from it when he was young. He came of age in the years immediately following the Second World War (and he wasted no time starting— he lost his virginity at the age of fifteen on May 8, 1945, when wild parties erupted all over the U.K. to celebrate victory in Europe). By the time he turned twenty, he was crouched over a small motorbike, racing off to tour the continent. His adventure almost ended the day it began. Clattering downhill on a narrow English road, he pulled out to pass a large transport truck only to find his underpowered motorbike buffeted by a headwind while another large transport headed straight towards him. With no safe option, he lowered his head, opened the throttle, and at the last possible moment cut in front of the vehicle he was trying to pass. He never forgot the sound that the handle of his tennis racket made—ping!—as it clipped the huge transport's front grill. He headed south to Italy, where he took up for a while with an Italian countess who'd lost her husband in the war, and later he found himself changing spark plugs in the pits at the racetrack at Monza.

John's first career out of school was teaching, first in Wales and later in London, where he taught briefly at the Lavender Hill

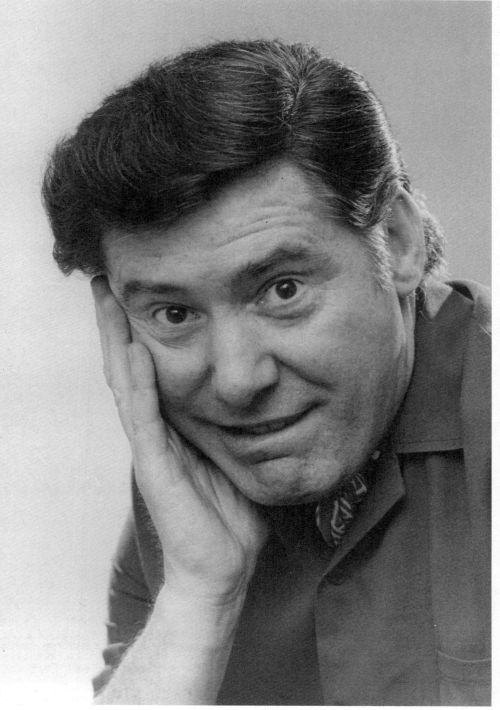

School. He bought himself a second-hand MG and drove around Europe (in better style this time), then decided to try Canada, somehow finding a job as a reporter in Timmins, Ontario, at Lord Thomson of Fleet's original newspaper, the *Timmins Daily Press*. From there he progressed to the warmer climate of Windsor, Ontario, first with the nearby small-town weekly, the *Sandwich Herald*, and then the *Windsor Star*.

He found another second-hand sports car to jet around Windsor, Detroit, and Essex County, sniffing out local stories. His entrepreneurial spirit also made its debut, and he opened an espresso café, and was active in the Windsor Press Club. Next stop, Montreal, where he became the Quebec editor for *Marketing*, the weekly advertising-industry magazine, and also edited a small monthly magazine modelled on *The New Yorker*, called *The Montrealer*.

PHOTO: NORMAN CHAMBERLIN

As editor of *The Montrealer*, John would occasionally have lunch at a smart new restaurant in the Drummond Medical Building, run by a vivacious Londoner and fine cook named Ena Pompa. One day he suggested to her that the restaurant could have a nice free ad every month in *The Montrealer*, if he could have a nice free meal every week. The deal was struck, a romance began, and thus, in the most Morganesque manner, did John meet Ena. Their son, Christopher, was born in 1967, and later, in the early Air Farce years, their daughter Sarah came along in 1975.

It was not surprising that two expatriate Brits living in Anglo Montreal, both journalists and fans of fast cars and racquet sports, would eventually meet, and Martin and John enjoyed each other's company and found a good creative spark in each other. *Funny You Should Say That!* was widely admired for its clever language, social insight, and good laughs.

However, when the radio experience turned unhappy at the hands of a producer they didn't care for, they were determined to start up a new comedy company where they would take full creative

responsibility. Martin had come up with the name "The Jest Society" as a play on Prime Minister Pierre Trudeau's 1968 federal election promise of "A Just Society." It gave the troupe a contemporary and faintly political brand, reflective of the type of material John and Martin wanted us to do—literate comedy, with an awareness of current events and politics. As the folksingers were writing protest songs, it was time for the comedians to start poking sticks in hornets' nests.

There was another rehearsal on Thursday, May 28, 1970, this time with the addition of Montreal actor Don Scanlan, who brought a touch of professional flare to our efforts. And another rehearsal the next day. A good thing too, because the first show for a paying audience was going to be that Sunday.

Martin and John had booked The Revue Theatre, a small 150-seat theatre on de Maisonneuve Boulevard in downtown Montreal. It was run by Arleigh Peterson, who was the theatre's artistic director, as well as being an actor, choreographer, and director of Montreal's Black Theatre Workshop. Arleigh made up a small poster, reading "Martin Bronstein's Jest Society Company," with what appeared to be John Lennon and Yoko Ono lookalike heads poking out of a shoe. The copy beneath it read, "Join the lace-in demons." We never quite understood that reference. Tickets were two dollars, and the schedule showed Sundays at 9:00 p.m.—May 17, May 31, June 14, and June 28. There's no record of the May 17 date, but the lace-in demons were ready to step on stage on May 31.

Martin had a clever monologue, which turned into a real audience-pleaser, giving the reaction of cops in different countries to a couple making love in the middle of the street. John had a fine piece,

Transcendental Airlines, where as the guru-pilot he encouraged the passengers to get the plane airborne through the power of meditation alone. Gay, Patrick, and Roger had a good sketch about a married couple coming to an adoption agency and unintentionally revealing their racial prejudices on the grounds of interior-decorating clashes, insisting that "white goes with everything."

ROGER: I always like it when timelines intersect. On Saturday, May 30, we six improvisers were rehearsing on stage at the Revue Theatre. On the same afternoon, it was Don Ferguson's twenty-fourth birthday, and he was graduating with the Class of 1970 at Loyola College, wrapping up what he always calls "a four-year course on the seven-year plan." As soon as classes ended, he'd moved to Toronto to take a job as an audio-visual producer and photographer, but of course was back in Montreal for his birthday and graduation weekend. We connected after the events of the day, had dinner, talked half the night, and he stayed over at my place, after I hit him up for a $100 loan.

So it would have been around 4:00 a.m. on Sunday, May 31, by the time I got to sleep. But not for long. I kept being awakened by distant but distinct explosive noises. It turned out that there had been five bombs set off in nearby Westmount before 5:00 a.m. There were no serious injuries, nor serious damage, but it was a very clear statement from the FLQ, the *Front de libération du Québec*, that the Quiet Revolution was about to get noisy.

Up at noon, Don and I had some breakfast, then he headed back to Toronto and I walked over to the Revue Theatre for a final Jest Society technical run-through. The group of us then traipsed to the Happy Wanderer on St. Catherine Street for a pre-show dinner. The Happy Wanderer was a faintly Swiss semi-basement restaurant that had a daily $1.24 special. Anything priced at $1.25 or more would be subject to Quebec Sales Tax, so their gimmick was to keep the price a penny below the taxable trigger. The dinner was usually a little bowl of cole slaw, a main course such as schnitzel, carrots, and potatoes, a choice of JELL-O or rice pudding, and coffee. John Morgan kept exclaiming what a fine meal it was for such a low price, my first clue of his abiding interest in economical eating.

Then, back to the Revue Theatre for our first performance, from 9:15 to 11:00 p.m., with about forty people in the audience.

A one-page playbill handed out to the opening-night audience told them what to expect. It was headed, "Martin Bronstein's The Jest Society, A Morgan and Bronstein Production." It briefly described the cast, and pitched the show's concept: "The Jest Society was formed when Morgan & Bronstein got tired of writing weekly scripts. Now, they get together with the other members and throw ideas at each other. When an idea hits everybody, they work on it (still throwing ideas into it) until everybody is happy (or tired). This improvised humour has to dispense with certain theatrical traditions like props, makeup and

punchlines. It also calls for more participation from the audience than is normal. So we just ask you to be abnormal tonight."

I had taken on publicity duties for the show, managing to get a cast picture in the *Montreal Star* and a good listing in the *Gazette*, and we had a mention on CJAD, plus Arleigh Peterson had pasted up some of the "lace-in demons" posters around downtown. Nevertheless, I had hoped for more than forty people in the audience.

However, just one of those forty was the only person we needed, the one who would change everything. His name was Guy Sprung. He went on to have a distinguished career in Canadian theatre and I've still never met him. But he was at the show, then went back to the *Montreal Star* and composed this rave review, which appeared in print the next day:

> "Light, smooth, enjoyable," the poster proclaims, and light the skits were in material, smooth in delivery, and enjoyable thanks to some very talented acting.
>
> Much of the humour is delightfully original. The company seems well on its way to creating its own personal style.
>
> The jesters relied on their ability to create characters to make the evening satisfying and relaxing. The cast

had a tremendous easy-going attitude on stage, never taking themselves too seriously but always delivering the goods with precision.

That review kept us sailing for the next two weeks, until our second performance, on Sunday, June 14. In between, we rehearsed together several times, and John and Ena had us all over for a celebratory dinner--the first of many feasts that Ena would create for years to come.

Sunday, June 28, was our third performance, for "another 40 or so," says my diary, "sitting on their hands." Only three shows and already I was learning theatre talk and how to blame the audience.

We had another surprise after our third show: Actors Equity Association informed Don Scanlan that he--a professional--couldn't perform on the same stage as John, Martin, Patrick, Gay, and me, who were all amateurs. The alternative was for us all to join Equity, but they wouldn't let us in because we hadn't yet established a professional reputation, and besides, Martin and John couldn't afford to pay us all, and themselves, Equity rates. They were financing this entire venture, renting the theatre, paying the stage and lighting crew, and sharing the revenue among the cast. They knew that they had achieved what they'd wanted for years--a compatible group of quick-witted

people who paid attention to current events and had a warped sense of humour, a relish for the English language, and evidently a willingness to make fools of ourselves in public, if that's what it took to get a laugh.

For the first half of the show, we'd improvise a variety of monologues and sketches, blackouts and quickies--some were just absurdist, some were about current issues (believe it or not, "women's liberation" was always a popular topic) and some were stories from the daily headlines. Then, when the audience was happy and laughing, Martin would step out and chat with them, soliciting suggestions for topics we could attack in the second half. When he had a good list, the audience would take an intermission, and the cast would start working.

Martin would have the list, one of us would be the note-taker, and we'd start exchanging rapid-fire ideas for how to deal with a topic, or even better, how to interlace a couple of the topics for even greater fun. As soon as we found a direction we liked, we'd jump to finding a conclusion, make a note, and move on.

Twenty minutes later, intermission was over, and we'd hand the lighting guy a list of topics, and key words indicating where we thought we might end up, and where he should turn out the lights, so that the audience would realize the sketch was

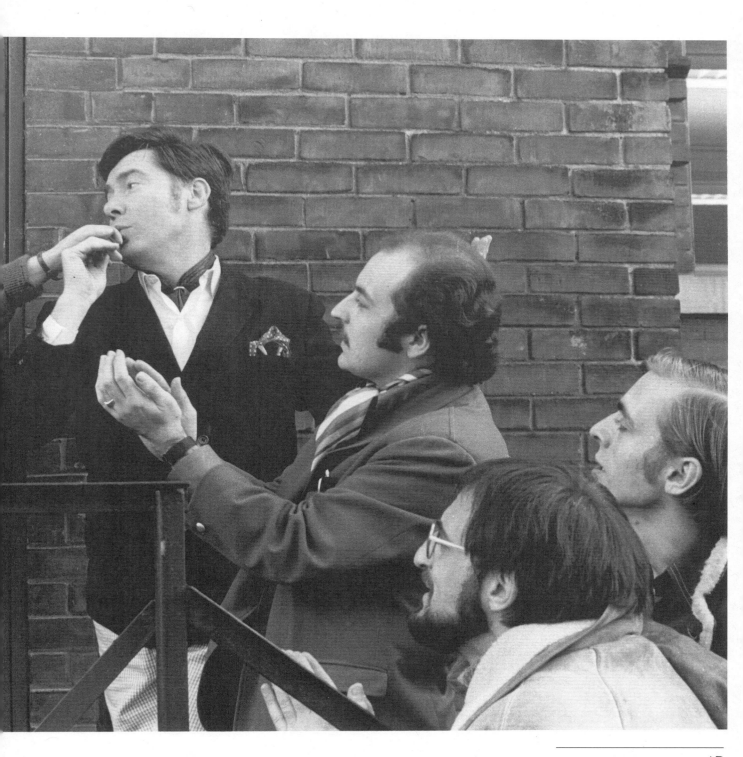

over, they'd laugh and applaud, then the lights would come up and we'd attack the next topic.

Some improvs worked better than others, of course, but the audience enjoyed seeing us being inventive on the spot and there was a great forgiveness factor. To close the evening, we'd end with a particularly good piece that we'd actually rehearsed and knew to be a good closer.

Intrigued by the *Montreal Star* revue, Patrick Conlon's parents decided to come to the second performance. His father, Ned, was a famous broadcaster in the city, having worked at most of the radio and television stations. His mother, Norah, was an elegant, warm lady and they made an attractive couple. I don't think we knew they were in the house, and when one of the audience had suggested "the monkeys at the Granby zoo," Patrick and I quickly said we could do that, both evidently thinking the same thought.

After intermission, a few sketches in, the lights came up on Patrick and me, sitting on a bench, looking out. We'd occasionally scratch ourselves, peel an imaginary banana or two, and in slow, deep, articulate voices we would discuss some of the other topics of the day, including a few more of the audience suggestions, which triggered some good laughs. Then Patrick looked to his left, and said "Uh-oh, here come a bunch of school kids. We'd better give them what they want."

At this point, Gay walked on as a schoolteacher or zookeeper, and said to the imaginary kids, "And here we have our young male monkeys." At this point Patrick and I starting vigorously grunting, thrusting our hips, and performing the universal fist-pumping gesture of masturbation, as Gay scurried off stage horrified.

The audience burst out laughing because it was (a) unexpected, (b) rude, and (c) probably accurate. Patrick later learned that not all the audience was amused. Ned and Norah warned him that he wouldn't do his reputation any favours if he stayed with the kind of group who thought this kind of filth was funny. My own parents wisely stayed away.

After our final performance on July 26, none of us was certain where this Jest Society thing was going, or whether it had just been an amusing way to keep busy for a handful of summer Sunday nights.

In the middle of August, Patrick, Gay and I were invited over to Martin Bronstein's for what I noted in my diary as another "explosive meeting" with Martin and John, discussing plans to run The Jest Society either at Montreal's Mother Martin's café or in Toronto. I can't remember what would have made the meeting explosive, but it would have been the first of many such encounters between John and Martin. As compatible and companionable as they were in so many ways, they could have

tempestuous arguments that almost led to blows, usually on matters of comedic taste or approach. A frequent tension was that Martin preferred satire while John preferred funny. To refine that further, John was never afraid to go below the belt for the laughs to be found in double-entendres and what the English quaintly call "toilet humour." Martin, admirably, felt strongly that we should be above that. I agreed with them both, but deep down knew that the masturbating monkeys would always get a good laugh.

John, being a Welshman, could rant and rave at the drop of a topic, but no matter how carried away he became, there was always a touch of humour to keep the exchange on a semi-friendly keel. Martin's humour was often more sharp-edged, and of little help in softening the anger of an argument. It would be "an explosive meeting" that would eventually change the direction of The Jest Society and Air Farce, but for now, the life of the comedy troupe was still slowly unfolding with our greatest stage successes just ahead.

By the beginning of October, Jest Society rehearsals had begun again, as John and Martin (on the strength of the Guy Sprung review) had snagged a booking for us at a small Toronto alternative theatre space called The Poor Alex, on Brunswick Avenue just south of Bloor Street West, in the University of Toronto area.

Our Toronto debut would be Thursday, October 8, but I evidently didn't make a special day of it. "Up at 7:30 a.m., rush day at Olive till 4:00 p.m.," my diary says. Then I met Gay, we took a bus to the airport, flew to Toronto, arrived at the theatre by 8:30 and stepped on stage ten minutes later. Looking back now, I can't believe the sheer over-confidence (or amateur stupidity) of that. I treated what might have been our make-it-or-break-it Toronto debut just like another day at the factory.

By 11:00 p.m. the show was done, and we were invited upstairs to a small welcome reception by John Sime, the impresario of the Poor Alex, the attached Three Schools of Art, and some bookshops on Bloor Street. He was quite a cultural force in the Annex, and was glad to have brought us in. Among the opening-night guests were Lorne Michaels, who was making a name for himself with comedy partner Hart Pomerantz in a series of hip new CBC comedy specials, and Lorne's wife Rosie, daughter of the legendary Frank Shuster of Wayne & Shuster fame.

Toronto was utterly different from Montreal. Everyone spoke English, the bars closed early, the food was boring, and you could turn right on a red light (but not in Montreal where, as the cliché still goes, a red light is merely a suggestion to slow down). But perhaps most noticeable to

Roger in one of the two Poor Alex
dressing rooms, November 1970.

visiting Montrealers was the absence of separatist political tension in the air. At home, the FLQ had begun the week by kidnapping British High Commissioner James "Jasper" Cross, spurring a massive cross-Canada manhunt. John was waiting in his car outside the Spadina subway station when his parked car caught the eye of a Toronto police officer. The cop hopped out of his cruiser and hot-footed it across the street.

JOHN: Is there something wrong, officer?

COP: You're in a no-parking zone.

JOHN: Sorry, I didn't know. I'm just visiting.

COP: Your car has Quebec plates. You from Montreal?

JOHN: Yes.

COP: You sound English.

JOHN: I'm an immigrant.

COP: Yeah. Well, I'll let you off this time with a warning. Welcome to Toronto.

The cop started walking back to his car on the opposite side of the street, but halfway across, turned and came back.

COP: You're not by any chance James Cross, are you?
JOHN: No.
COP: Damn. It's just not my day.

For John, that was a defining moment. Toronto was a different Canada. In Montreal, people lived in fear of bombs and kidnappings, and some were afraid to speak English. In Toronto, all that angst was fodder for a joke. From a cop, no less.

That Friday, we did an afternoon rehearsal, then a good evening performance. We woke up Saturday morning to discover that the *Toronto Telegram*'s theatre critic, DuBarry Campeau, was our newest fan, with a very glowing review. On the strength of her review, the Saturday night show was a packed, a full house--which included Herbert Whittaker, the influential *Globe and Mail* theatre critic.

DuBarry Campeau described us as:

. . . a quintet of excellent actors who also happen to be delightful zanies. They create a kind of non-musical revue that is based on their ability to follow almost any idea through to its absurdly logical conclusion.

Their special quality is a sort of insouciant blitheness that disguises their professional expertise. Watching them is rather like being at a party with a group of well-mannered people who are marvellously entertaining.

This is the kind of witty, civilized entertainment that glitters and sparkles...

It was quite stunning for us all to read this--praise beyond our hopes that confirmed our belief that what we were doing was different, and funny, and appreciated. Maybe we could keep it going for longer than a few months!

That Saturday night, we performed our double-header, with shows at 8:30 and 11:00 p.m., to full houses. The box office told us some people were coming to the first show and sticking around for the second. After midnight, in the early hours of Sunday, October 11, we stepped out of the theatre to see groups of university students all discussing the latest news from Montreal: the FLQ had just kidnapped Quebec provincial cabinet minister Pierre Laporte. He was held hostage for seven days, until his body was found on October 17.

This was stunning news in so many ways, but as a group of Montrealers, we each knew that it meant the beginning of the end of the Montreal

that we knew, which was rapidly changing. Little did we know that when we returned to Montreal that week, there would be armed soldiers and police dogs outside our neighbourhood subway station.

Toronto audiences were pleasantly surprised by The Jest Society, partly because it was current, topical, irreverent, and cheeky. The gold standard for Toronto revues at the time was a revue based on the songs of Noel Coward, presented in the nightclub cabaret setting of The Theatre in the Dell, with cocktails on the table and sophisticated performances by a tuxedoed Tom Kneebone and a bejewelled and gowned Dinah Christie. It was entitled *Oh Coward!* and--intriguingly--had opened on May 14, 1970, just two weeks before Jest opened in Montreal. It symbolized the difference between Toronto and Montreal tastes at the time.

Elsewhere in the city, the big touring Broadway and West-End shows came to Ed Mirvish's Royal Alexandra Theatre. The small experimental theatres, which would go on to champion Canadian-written plays featuring Canadian artists, were just being formed--Theatre Passe Muraille, Global Village, Tarragon Theatre. In time they would contribute so much to Canada's rich theatre scene. And in fairness, Toronto audiences had always supported the annual *Spring Thaw* revue, and Dora Mavor Moore's New Play Society at Hart House. But

by and large, they did like their theatre to be imported, or at least based on imported scripts.

So, against this background, the great and much-admired Herbert Whittaker shared his thoughts about The Jest Society with *Globe and Mail* readers on Friday, October 16, after mentioning a few other plays that had opened in recent weeks:

> To talk of The Jest Society in the same space as these other entertainments is to do justice to neither, for the players appearing weekends at the Poor Alex are as sophisticated in style as others are naive. Come to think of it, The Jest Society even makes The Noel Coward Revue look sweetly old-fashioned.

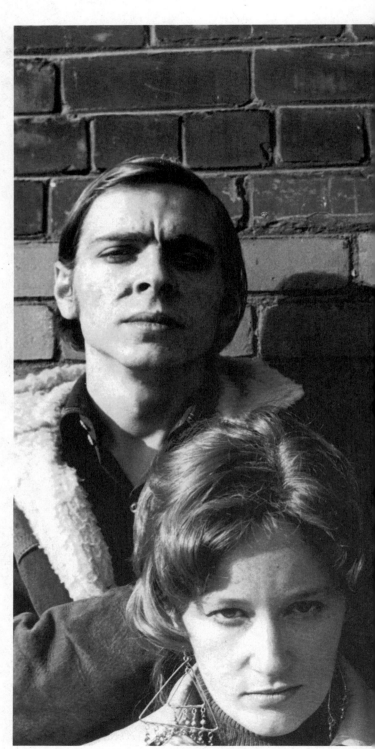

Roger looks maniacal! The Jest Society in October 1970: Steve Whistance-Smith, Gay Claitman, John, Roger, Martin Bronstein.

Their work is as clean as it is swift. Deft is the word for The Jest Society.

Another review, from the then-weekly *Toronto Citizen*, captured the Jest spirit:

It consists of a series of skits in which the cast ridicules, satirizes, puns and jokes at everything from oral sex to the FLQ.

Nothing is sacred or immune from these jesters; at times discretion and good taste are suspended. In spite of this, it is a successful and original type of theatre.

Oral sex jokes. Pretty advanced for Toronto in 1970.

For our second weekend in Toronto, we were breaking in a new performer, Steve Whistance-Smith, because Patrick had forecast that the weekly commute to Toronto was going to cause problems with his steady creative work in Montreal, which paid much better than whatever beer money we were pocketing from The Jest Society. Gay, too, was worried that she couldn't keep taking days off from her full-time job at CJAD Radio in Montreal. None of us wanted to split up the group, but frankly, it wasn't going to last that

long anyway, and we'd always be friends, so it was no big deal, right?

DON: Right, indeed. Roger, Patrick, and Gay remained friends always, and forty years later Patrick and Gay were two of the people who spoke at Roger's memorial celebration in Toronto, on April 11, 2011.

ROGER: The dean of theatre critics, Nathan Cohen, attended the third weekend, and was seen to be having a good time. His critiques, one for radio and one in that Monday's edition of the influential *Toronto Star*, would complete the Toronto trifecta for The Jest Society. Cohen wrote:

> *Impudence with a twinkle marks this show, solid proof that topical revue has not vanished from the local landscape. The Jest Society is the creation of Montreal writer-performers Martin Bronstein and John Morgan, the writers of the Sunday afternoon CBC radio program Funny You Should Say That!, in its palmier days. They bring to their stage entertainment the same sense of literacy, informed awareness, civilized relish for the ludicrous and grotesque, and the same conviction that there's nothing sacred.*

It's unthinkable that the show will be allowed to end this weekend as scheduled.

And indeed, the run was quickly extended into December. We were a certified, critic-approved hit, and the good people of Toronto kept the box office busy for weeks and weeks. With Steve about to take on Patrick's roles, we needed some new publicity photos, and for a few hours on the last Saturday in October, Don Ferguson joined us with his Nikon camera.

DON: I'd been hired before graduating from Loyola to work at an audio-visual production company in Toronto. I started on the audio side, producing sound tracks for slide films and commercials, and was trying to worm my way over to the photography side. Roger, Patrick, and Gay were friends, and Roger knew I had access to a darkroom, so he brought John to meet me and sure, I was interested in a freelance shoot. And for a comedy troupe living on a shoestring, my price was right (always a primo consideration as far as John was concerned). Instead of charging a session fee, I said, "Let me hang around backstage (I'd already seen the show) and shoot candids for my own portfolio." Agreed. I offered to eat the cost of processing and printing the

8 x 10 glossies, too, but John said "No, we've got to pay you something," so we settled at a buck a print, which didn't cover costs but I really didn't care.

We spent an afternoon shooting in front of the Poor Alex and in the alley beside it, at Queen's Park behind the Ontario Legislature building, and outside Marshall McLuhan's office on the University of Toronto campus. They were Jest Society's first publicity photos. It was all good for me. I got some neat portfolio shots, was able to continue hanging with my friends (as it was, I'd been coming by the theatre most nights for a beer after the show anyway), got to know Martin and John, and as an unintended by-product, I learned everyone's lines.

Later in the fall, Steve was offered an irresistible role in a new Canadian play and decided to leave. Martin and John had to replace him on short notice, but it wasn't easy-- there was no script for a new actor to learn, because everything had begun as an improv and there wasn't a single word of the show written down anywhere. So they offered me $65 to fill in for a week. I asked for $75, they agreed, and that's how I became an actor. By then we all knew each other, we got along well, and I was a quick learner. Probably most important, since this was a troupe created and run by writers,

I thought like a writer and had a natural talent for coming up with endings, a skill always in demand in the sketch comedy business. So one week became two and we know the rest--I never left. I began performing in all four Friday and Saturday shows, and in all shows from then on.

ROGER: It strikes me today that the Toronto media were tremendously supportive of this small theatrical event called The Jest Society. The Poor Alex had only 113 seats, hardly a major venue. And yet all three daily newspapers, several weekly papers, and a few radio stations all sent critics or reporters, and later continued the support with follow-up stories and features. In the world of 2011, the local entertainment pages, morning radio shows, and early-prime television are dominated by the revolving parade of U.S. pop culture--preferably movie stars acting badly, or the teenage sensation of the day, or the latest contrived surprise in reality programming. The media landscape has changed so much that a small, non-professional troupe arriving from another city to play in a tiny side-street theatre would be lucky to get a free listing in small type in the weekly "What's On" pages. Newspapers no longer have the staff, or the motivation, to send out critics and reporters, not once but multiple times. The

(Below) We trumpeted our great reviews in our first Toronto poster. Trivia fact: it's the same poster that's taped to the door in the photo on page 42, in which Pat Conlon appears in the cast. That photo is from an earlier publicity shoot; Steve Whistance-Smith joined after Pat decided to stay in Montreal. *(Facing)* The cast outside the Poor Alex.

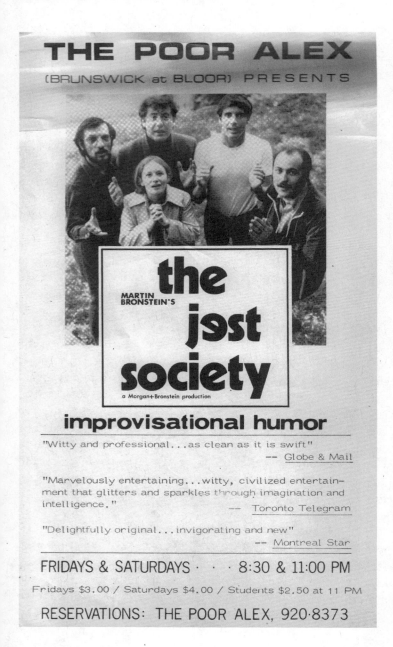

THE POOR ALEX

(BRUNSWICK at BLOOR) PRESENTS

MARTIN BRONSTEIN'S

the jest society

a Morgan+Bronstein production

improvisational humor

"Witty and professional...as clean as it is swift"
— Globe & Mail

"Marvelously entertaining...witty, civilized entertainment that glitters and sparkles through imagination and intelligence."
— Toronto Telegram

"Delightfully original...invigorating and new"
— Montreal Star

FRIDAYS & SATURDAYS · · 8:30 & 11:00 PM

Fridays $3.00 / Saturdays $4.00 / Students $2.50 at 11 PM

RESERVATIONS: THE POOR ALEX, 920·8373

media support we found as The Jest Society was totally transforming for our group: it lead to us being embraced by Toronto theatre-goers, and taken seriously as an artistic event with a promising future. I wish every small group of would-be comics could be so fortunate today.

An example of this continuing media support was a feature article the *Toronto Star* ran in November about John and Martin:

> They launched *The Jest Society* after several years as comedy writers in Montreal and in England. They did not find these years particularly hilarious and claim they still mourn the deaths of some of their best jokes at the hands of talk show and variety host David Frost.
>
> They were among a squad of writers whose job was to prepare stand-up jokes for Frost who, according to Bronstein, would go on with a clipboard containing 40,000 jokes, use eight of them and screw them up.
>
> They quickly parted with Frost and returned to Canada, disillusioned with the state of humour in Britain. "In Britain you can still get a laugh by just saying a word like knickers or constipation," Bronstein says incredulously.

Notice, this was Martin's observation about knickers and constipation, not John's. A diversity of opinion that would return in years to come. Keeping up the media attention in December, journalist Sid Adilman, who would become a lifetime supporter of our group, and of many Canadian artists, ran a feature profile in the *Toronto Telegram* that was the first to reveal John's ambivalence about being on stage. Through the rest of his career, we always called him "the reluctant celebrity":

"I never wanted to perform," Morgan says. "I never intended to perform. I've only been a performer since the end of May. Producers forced me to. They insisted. Only I knew what I wanted for a sketch."

It's worth noting that John was one of the producers.

Our final Poor Alex show was on December 12, and then we headed back to Montreal for a series of three "homecoming" performances at the Saidye Bronfman Centre, from Sunday through Tuesday. This time, my parents came to see the show, and so did my sister and her husband, and all pronounced themselves pleased with what they saw. Fortunately, no-one had suggested an improv about male monkeys in the zoo. And the *Montreal Star's* Zelda Heller had a good time, too:

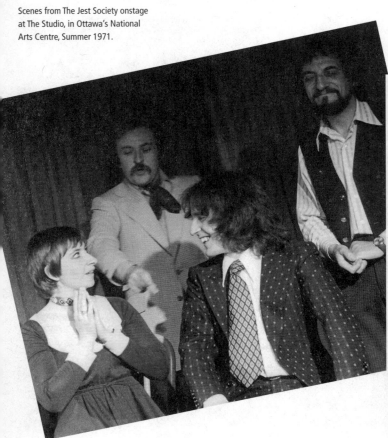

The tone of the humour is consistently mild and gentle. Nobody bites, nobody is violently attacked, lewdness, bitter satire, scalpeled incisiveness are all equally absent. In their stead The Jest Society supplies a tolerant, slightly irreverent look at local or national or human foibles, evoking a tendency to laugh with, rather than at the victims, and a persistent feeling that one is not very unlike them.

In that paragraph, Ms. Heller summed up what the audiences would like most from everything we would go on to do, as either The Jest Society or Air Farce. And yet, it would also prove to be the strongest criticism levelled at us by those who felt that our satire was never blunt enough. On the whole, and looking back forty years, we think we chose the right strength.

And so we ended 1970 back in Montreal, where it all began. But not for long. We were back on stage in Toronto on Thursday, January 7, two of the critics were back too, and the next day we had two more great reviews, pointing out that the show had so much new material in it that it was worth a second visit. We were clearly on a roll.

Steve Whistance-Smith's last night in the cast was the following Saturday, and by the next Friday--which was January 22, 1971--Don was playing all of Steve's parts. At the same time we were meeting a new performer who was trying out with us as a possible replacement for Gay. She had been recommended to Martin by Marion André, who was then artistic director of Montreal's Saidye Bronfman Theatre and would go on to found Theatre Plus in Toronto. This actress had auditioned for Marion in Montreal, but he was casting serious roles and he thought she might be best in a comical setting. She lived in Ottawa and had taken the bus to Toronto for tryouts with us. Her name was Luba Goy.

DON: We met for the first time in the lobby of the theatre and I attempted a nervous joke. "With a name like Goy, I guess you're not Jewish. Ha-ha." Her response? "No, I'm not." Absolutely flat. I knew my attempt at a friendly greeting hadn't lit up the laugh-o-meter, but I thought it merited at least a reciprocal twitch. "Uh-oh," I thought, "I've offended her." And then I realized, "She doesn't get the joke." All this in less than a second. "How can she live twenty-five years with the last name 'Goy' and not get the joke?" It was my first intimation that perhaps this sprightly young woman from Ottawa was on a slightly different wavelength than the rest of us.

ROGER: I offered to grab something to drink from a snack bar around the corner. "Coffee or tea?" I asked. "Tea for me," said John. "Me too," said Martin. "Coffee," said Don. I looked at Luba. "Earl Grey, please," she said. "Bag out. Lemon only." This wasn't an Earl Grey neighbourhood at the time, and the chance of finding anything tastier than industrial-strength Red Rose was slim, but I was intrigued about "bag out," and asked for details. "Just the boiling water in the cup, with the lid on, and the tea bag on the outside. I'll dip it myself." I did as requested and later realized it was my first hint that Luba might require higher-than-average maintenance.

LUBA: I had done a season at Stratford, five plays with them in Ottawa at the National Arts Centre, and I was auditioning for a play with Marion André who ran the Saidye Bronfman Centre in Montreal.

Now Marion knew my work through the National Theatre School. He used to go see all the third-year student productions because he used to hire people from the theatre school. They only take six girls across Canada so it was a bit like *American Idol*, you know. I was a "Susan Boyle" because they didn't know what to do with me: "Talented but, hey, [makes a face] you know?" Anyway, I wasn't a Susan Boyle--my eyebrows looked nothing like that--but I was odd.

Smooch me, smooch you. Luba and Roger in 1971.

They thought at the end of the second year that I could go out and get a job if I wanted. I said, "No, please, please, don't throw me out. Are you throwing me out? I want to finish. I want to get a degree." I barely finished high school, but now I have two honorary degrees, doctorates ... but that's another story.

So Marion André said to me, there is an improv group, a political satirical improvisational group, that are looking for a new woman in Toronto.

I lived in Ottawa with my husband at the time and he was working for the (1972) Le Dain Commission to study drugs and whatnot. Little did I know that going to Toronto and auditioning for this group would completely change my life as an actress.

I never saw myself in improv doing political satire, because my father—he was a freedom fighter, totally involved in politics. So I vowed that I would never ever, ever, ever have anything to do with politics when I grew up. I hated politics. Yes, you know, Ukraine needed to be freed, but I was going to be an *actress*.

DON: Around this time, Martin and John got a message: please call Jim Guthro of CBC Television's Variety Department. Jim was a well-known producer. Could this be a break? We knew CBC people had seen the show, read the reviews, and were aware of its success at the box office. Was Jest about to get an offer from TV? Not quite. CBC wanted our laughter. Not our show, just the laughs it produced. They wanted to send an audio crew to record the aud-ience so they could use the laughs to sweeten their own shows. It wasn't the offer Martin and John had been hoping for, but for $500 they agreed. After all, they'd been bankrolling Jest with overdrafts on their personal accounts and money was money. The result was that, from then on, many of the laughs heard on *Wayne & Shuster*, *King of Kensington*, *Flappers*, *Hangin' In*, and other CBC comedies came from two nights of Jest Society audiences at the 113-seat Poor Alex Theatre. The irony, of course, was that CBC wanted the laughs our show generated but not the show itself. Jim Guthro told us he didn't think we could succeed in television because we were "too democratic"—everyone piped up with suggestions all the time—and there was no one in charge. It took twenty-two years but we eventually proved him wrong.

ROGER: When we finally got our television series in 1993, we recorded every show in front of a live studio audience (we still do our annual New Year's specials that way), so the laughter that viewers heard was always earned by us. We're proud of that. And of the fact that, even though our TV series ran for only sixteen seasons, CBC

Television audiences have actually been hearing people laugh at us for forty years!

In mid-January, John and Martin mentioned there was a possibility that we might take the show to Ottawa in July. And meanwhile, we were going on the road to Lennoxville, in Quebec's Eastern Townships, on Friday, January 29. On stage at Centennial Theatre at Bishop's University, Martin, John, Gay, Don, and I faced our first university audience, and Jest's largest audience yet--a good, laughing crowd of over 500. As we drove back to Montreal together, we were very happy with how the night had played, and amazed that 500 people would come to see us at the same time.

The next morning we rushed to catch Via Rail to Toronto for two Saturday night shows at the Poor Alex. It was Gay's last night with us, and she was in top form and really funny. What a great way to leave the show.

From February 4th on, The Jest Society cast was Martin Bronstein, John Morgan, Roger Abbott, Don Ferguson, and Luba Goy. The five of us would be together for four more years, until Martin stepped away in the summer of 1975. The remaining four of us would be together for over thirty years, until John retired in May 2001. And for the trio of Don, Luba, and myself, the ride lasted forty years.

The summer of 1971 brought a couple of turning points. One involved Chicago's Second City. Bernie Sahlins, the owner and one of Second City's co-founders, was looking to expand. He also had a cast that was in need of a rest. Bernie was scouting Toronto with an eye to opening a spin-off Second City company here. He'd seen Jest Society and liked what he saw, and he came up with a proposition that could offer benefits all around: Jest would travel to Chicago and spend a week with the cast, then take over the show for a couple of weeks so Bernie's Chicago cast could go on vacation. We were keen to give it a shot, but Martin and John were lukewarm. Jest was going well, they had money in it and preferred to keep building their own business. And being Brits, they didn't quite understand the allure and reputation of Second City. Besides, there were already some solid potential bookings for the summer —two weeks in The Studio at the National Arts Centre in Ottawa, followed by nine days at Theatre in the Square in Gravenhurst and two weeks at the Festival Theatre cabaret in Charlottetown. So they passed. We'll never know what might have happened to us as individuals or a troupe if Martin and John had said yes. It might have meant careers in the United States, as it did for most of Second City's original Toronto cast. But one door closes, another opens. If we had gone, there certainly would never have been a Royal Canadian Air Farce.

As it was, we spent a terrific summer in Canada. We performed eight shows a week in Ottawa. Right off the bat, we got a favourable review in the *Ottawa Citizen*, but there was a problem. The reviewer spelled Luba's name Lyuba, which is close to the original Ukrainian spelling. Luba was terribly upset, so NAC management called the *Citizen* to ask for a correction notice. The paper explained their choice

A Jest Society publicity still shot in The Studio at the National Arts Centre, Summer 1972.

of spelling. The previous year Ms. Goy had been in a production that was also reviewed by the paper, on which occasion the reviewer had spelled her name "Luba," only to have Luba complain so loudly that her name was spelled "Lyuba-with-a-'Y'" that they put a note in her file to never make the mistake again. They had been very careful to follow her instructions this time. (However, they did correct it back to Luba in subsequent articles and never spelled it differently again.)

On the first Saturday of the Ottawa run (we did two shows Friday and Saturday at 7:00 and 9:30 p.m.) Luba didn't show up at call time. We phoned her at home, her husband Ed Hanna answered, we asked

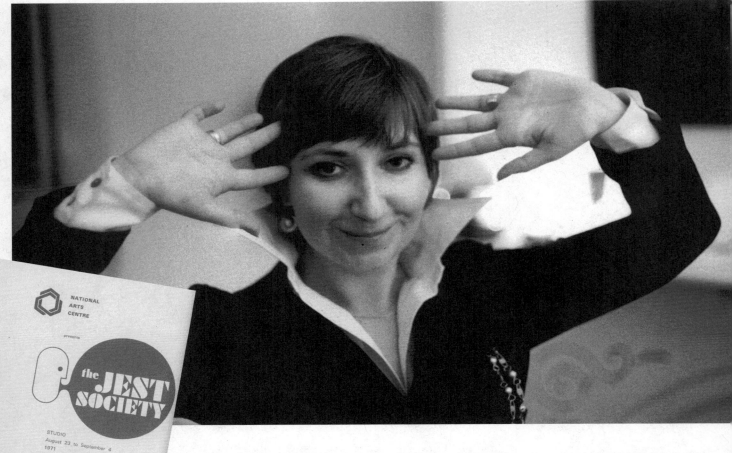

NATIONAL ARTS CENTRE

presents

the JEST SOCIETY

STUDIO
August 23 to September 4
1971
Held over by popular demand
until September 18

for Luba. He told us she couldn't come to the phone just then, as she was in the middle of making dinner. We explained the show began in forty minutes. He relayed the message, we heard a shriek, and fifteen minutes later she arrived backstage, spinning like a Tasmanian devil. The woman who for the next thirty-five years proudly pointed out to anyone who would listen that she was the only professional in the group (trained at the National Theatre School, don't you know), and insisted on being the group's Equity deputy, had forgotten there was a 7:00 p.m. show. Next week, the same thing happened. This time, when Ed answered the phone and heard Martin's voice, he immediately said, "Not again." Luba has a heart of gold and audiences love her, but in forty years, her organizational skills have not improved. How we managed to stick together all this time is a mystery; that we managed it at all speaks volumes.

DON: After two weeks in Ottawa and almost two in Gravenhurst, we had forty-eight hours before our show opened in Charlottetown. We all decided to make a vacation of it. John and Martin drove down with their families, Luba travelled with Ed, and Roger, my girlfriend Stefania, and I drove the 900 miles in my new car--an orange Mini stuffed to the gills with three suitcases crammed with stage clothes, clothes to live in, clothes to go out to dinner in, a 9-foot bell tent, two sleeping bags, a Coleman camp stove, a gas lantern, and a cooler, which left room only for one cramped individual in what passed as a back seat.

Who can't enjoy Prince Edward Island in summer? This was vacation and we enjoyed every

Memories of summer, 1971. (*Left*) Cute? Definitely! Funny? Even more definitely! (*Right*) Held over at the NAC!; program for Charlottetown's Confederation Centre; sandwiched between The Sanderlings and Plaza Suite in Gravenhurst; a mosaic of reviews for a 1972 poster.

minute. The only thing that got in the way was work--unfortunately, the experience at the Festival cabaret fell somewhere between passable and hilarious. After our successes in Ottawa and Gravenhurst, the Festival cabaret was a bit of a letdown. The venue was an experiment and we were one of the first acts to play it. Festival management wanted to increase traffic, and a licensed cabaret must have seemed a good idea, perfectly in keeping with their theatrical mandate. To the locals, however, it was a new bar, so they came to drink and chat. We perfectly fit Dave Broadfoot's definition, years later, of a comedian who works in a bar: "a paid irritant." When we asked for sketch suggestions before intermission, some patrons seemed surprised to discover that there had been a show going on. If management wanted to pack the place and sell a wagonload of booze, a country singer would have done the trick.

Backstage--wait a minute, there was no backstage, just a loading dock and two restrooms--there were no dressing rooms. By the third night, we abandoned costume changes--there was no place to change into them. The stagehand who worked our show, a terminally bored teenager, could never

quite focus on what we were trying to achieve. His primary task was to turn out the lights at the end of each sketch, thereby affording us a dignified exit from the stage in darkness, and, as it turned out at the Charlottetown cabaret, frequently in silence. He worked the show for two weeks and we doubt if he ever heard more than half of it in total. He spent every night standing in the wings with his nose buried in a book. At least once during every performance, we'd scurry into the wings with the stage still ablaze behind us and gently interrupt his reading with the words, "You can turn the lights off now."

We returned to Ottawa for another triumphant stand at the National Arts Centre. We ran for two weeks and were held over again until September 18. As the summer progressed, despite the fact that we were all relatively young, every Monday we woke up more tired than we had been a week earlier. Even though we spent only two to five hours a day on stage, we expended all our energy doing it. For the first time, we understood why opera singers took days off between performances. Live performing at a high level is hard work.

We arrived back in Toronto after almost ten weeks on the road, with only a little bit of friction surfacing now and then between Martin and John. In the next year there'd be a definitive break, but for now, with new theatre gigs booked through fall and winter in and

(*Left*) March 28, 2011. After Roger died, National Arts Centre CEO Peter Herrendorf ordered the NAC flag lowered to half mast in his honour. (*Facing*) Roger and Don recording Jest Society sketches for *The Entertainers* in CBC's Studio G on Jarvis Street, 1971.

PHOTO: TINA NESRALLAH

around Toronto, the future looked bright. And we had a new gig lined up—recording comedy for a ninety-minute CBC Radio show called *The Entertainers*. For Roger, Don, and Luba, radio would be a new experience. And after a summer spent improvising and developing new material—material that we knew worked because live audiences laughed at it—we were ready to tackle the new medium.

The Entertainers had been created by producer Ron Solloway, a dry, witty Yorkshireman who loved Broadway, appreciated comedy and was open to new ideas. Canada's most famous variety performer, Juliette, hosted the show. It had status, it had cachet, it had stars. What were we doing on it? Ron programmed the show so that each of the three half-hours contained the same elements: music, chat, comedy. He pre-recorded elements whenever he could get performers into the studio, and packaged the show together later. Nothing was performed live, and material could be held for weeks or used immediately, depending on what Ron felt benefited the particular episode he was assembling.

We recorded at CBC's Jarvis Street production building, in Studio G, a massive room where, in pre-television days, large orchestras had played live to an enthralled national radio audience. We worked at one end of it, close to the control room. We stood at microphones with our scripts on music stands; Ron, his associate producer, and a technician sat behind their high glass wall and conducted the proceedings. After a year of live theatre work,

recording in a studio felt flat. Jokes that had been met with riotous laughter less than a month ago now hung in the empty air. How do you know what works, if there's no one to laugh at it? If a comedian tells a joke in a forest, is it funny?

On the whole, while we liked and admired Ron, we never felt truly comfortable with the material we did for *The Entertainers*. We deeply missed the excitement, the instant feedback, the visceral thrill of performing for a live audience, where you had no safety net. It was the best way we knew of using our talents. But good things still happened in Studio G.

ROGER: One of our favourite characters was born there by accident. We frequently wrote with John at his house. One day one of us came up with the idea of a radio phone-in show about etiquette. The host would be an expert who would advise callers how to behave in various situations. We roughed out a script and tried it out at our next recording session. One of the parts called for a toffee-nosed English woman to relate her struggles making and serving a proper cup of tea. We can't remember who played the on-air host, but we wanted Luba to play the caller and for some reason she just couldn't get a handle on

it. Best efforts, but after several takes it was clear the character was not going to come. The three of us tried to coach her. We took turns performing in bad falsetto and immediately got the giggles. Soon we were so busy entertaining each other that we quite forgot what we'd set out to do originally. The caller morphed from a proper English lady into a pretentious dowager. We tried her as dizzy and inept, high-toned and nasty, and unaware of her own foibles. We scribbled re-writes on the spot until, eventually, we had John, speaking in a ridiculous English accent and broken falsetto, describing tea-making gone disastrously awry:

JOHN (falsetto): Now I stand in my parlour, hip-deep in tepid water, the kettle has boiled dry, the flocking is off the wall, my sugar bowl is afloat in the garden, the guests have fled, and the canary has drowned.

In that small, crazy session, one of Air Farce's favourite radio characters, the randy dowager whose airs of social superiority couldn't hide her essentially earthy nature, came to life: first name Amy, last name Pompa (after John's mother-in-law), with a "de la" tossed in because she had pretensions of grandeur. Amy de la Pompa was born.

We remained part of *The Entertainers* for two years, until spring 1973. In the summer of 1972, John and Martin had a verbal

What we looked like in the early 1970s. (*Below*) Don finds true love; (*Opposite*) Roger is The Dude.

MARTIN: That's exactly the kind of low-end rubbish we both said we didn't want to do.

JOHN: Come on, we're just trying to make 'em laugh.

MARTIN: No we're not. Any baggy pants comedian can "make 'em laugh." The Jest Society is supposed to be different.

JOHN: You don't think coming to the theatre and having a good laugh on a Saturday night makes a difference to some poor bloke who's been slaving away at a dead-end job all week?

MARTIN: Just once I'd like to do a sketch about a serious issue without you making double-entendres or mentioning bodily functions or throwing in knickers jokes!

JOHN: Didn't you hear the audience laughing?

MARTIN: It's exactly the kind of shit we swore we wouldn't do!

JOHN: It's a bloody comedy show!

MARTIN: My name is on this show and it's not what I want The Jest Society to do! I'm trying to do intelligent, meaningful comedy and you keep turning it into "Knees Up Mother Brown."

JOHN: Since when is the show yours? We're partners.

MARTIN: I don't want to work with someone who settles for second best.

JOHN: You're a self-righteous prig!

MARTIN: And you play to the lowest common denominator every chance you get!

battle royal backstage at the NAC. Tension had been building throughout the run. They were equal partners, but The Jest Society had been Martin's idea originally, and when it came to matters of taste, he believed he should have the upper hand. Between the first and second shows on a Saturday night, John remarked how much fun he'd had doing an improv during the 7:00 performance. He'd been broad and a bit vulgar, as was his natural inclination, and the audience had lapped it up. Martin accused him of playing to the pit.

A comedic Rubicon was crossed. Martin and John continued to do radio together through the 1972–73 season, but by the end of the summer of 1972, John had left their theatrical partnership.

Henceforth, Martin ran Jest Society stage productions on his own, eventually with a new cast. Jest Society would become what he had always wanted it to be: a vehicle for stinging satire that exposed society's foibles. There would be no room for poop jokes.

Later, John mused, "When you're young you think you'll have lots of chances to hit it big, that if you miss one chance, no big deal, there'll be plenty of others. But there's no guarantee. You may only get the one." We'd been doing the show for two years, hadn't run out of ideas, and liked our colleagues. Something was working. We didn't know exactly what it was but sensed there might be a future in it.

The Farce Is Born

THE CURTAIN RISES AT THE CURTAIN CLUB BETWEEN EVENTS HEROIC AND NOT-SO-HEROIC IN WALES

With no commitment from The Entertainers for a third season, we wondered: was this the end of our flirtation with radio? We were young and confident and aware that these were our salad days; we were also determined to keep them green. So we took the summer off and went to Europe.

John headed home to Wales to become co-landlord of a pub with his friend, George Rees. The pub was the social hub of the tiny seaside town of Llangennith, on the Gower Peninsula in South Wales, where the Rees family were the village entrepreneurs. They owned a farm, a campground on the beach, a herd of sheep, several stone houses, the small hotel and dining room that also housed the pub, and the only gas pump in town. Running a pub was a perfect fit for John, who was as warm and friendly a human being as you'd ever hope to meet, and had a natural affinity for the hospitality business. His wife, Ena, who'd owned restaurants in Montreal, had hospitality in her blood, too. John also possessed an entrepreneurial spirit and had grand plans for the King's Head: a North American–style patio out back with a barbecue and disco, upgraded rooms in the hotel to appeal to Londoners down for the weekend, and a new stone wall out front that followed the curve of the road. His friend and co-owner, George, was a gifted amateur pianist who, as a young man, had played a Chopin sonata for his final exam at the Royal

(*Left*) The King's Head Hotel and Pub with the new stone wall, Llangennith, Wales, 1973; (*Above*) John the publican back from a shopping trip.

Academy of Music in London—and did so "as well as anyone could play it," according to his examiner. When he'd visited Toronto the year before, John put him to work playing piano as our warm-up when Jest Society did a second run at the Poor Alex. Standing in the wings, our cue to come on stage was when George segued from whatever pop tune he was playing to a Chopin prelude.

Don went to explore Italy with his girlfriend, Stefania, who'd been born and raised in Milan. He'd only visited Europe once for a few days, and embraced the possibility of a long sojourn. By coincidence, Luba and Ed had also decided to take a European holiday and booked the same flight, so at the end of May, the four of them flew off to London together.

DON: Drinks were free on board and you could have as many as you wanted. And you could smoke. Ashtrays at every seat, no smoke detectors in the johns. Halfway across the Atlantic, the four of us lined up outside the same washroom, the first one in lit a joint, had a couple of tokes, left it for the next person, and so on until we'd each had our fun. Old World, here we come.

Roger, too, went to Europe. He began with a week in London, visiting friends and going to the theatre, then trained down to Wales to look in on John and Ena and George and the King's Head pub. The pub had been, if not exactly neglected, then at the very least left to its own devices for too many years. To John, who loved North America's positive attitude, the King's Head represented all that was wrong with pre-Thatcherite Britain. Lack of ambition. Poor work habits. Shoddy service. Not to mention indifferent food. John saw opportunity and set about breathing new life into the place. When Roger arrived in Llangennith, he decided to stay the summer and pitch in. Having for many years frequented all manner of restaurants, Roger became maître d' in the dining room. John readily found his way into village life. After all, he was a Welsh lad himself, from the south and from a small town. He understood their ways. Moreover, local lad George had brought him into his business. Roger on the other hand, was definitely a foreigner. He'd been born in England, not Wales; he wasn't a resident of the British Isles and he spoke with a funny accent. He was Canadian, which to the inhabitants of South Wales meant American, only less in your face and with less money to spend. The villagers were polite, but restrained. No point getting close. Roger was a visitor and come September would be gone. In midsummer, all of that changed.

ROGER: The King's Head hotel was small, with a dozen rooms on either side of a corridor that ran above the dining room, lounge bar, and pub. I slept in one that overlooked the road. In the middle of the night, I was awoken by what sounded like a series of loud "pops" and looked out my window. Orange filled the sky. The house across the street from the pub, adjacent to the church, was on fire. Flames leaped from the roof, sending showers of sparks skyward as the building's ancient timbers exploded. An elderly couple lived there alone. There was no one around, no emergency vehicles, no fire trucks. Obviously the fire had just started. Without thinking I ran to the house, opened the front door and stepped inside. Smoke filled the

Roger the hero shows off the front page of the South Wales *Evening Post*. He dashed into a burning building in the middle of the night to save an elderly couple's life.

hall. I saw the old man slumped at the foot of the stairs, clutching the banister, coughing. I put my arm around him and dragged him outside. "My wife," he said, "she's in the bedroom." I took a couple of deep breaths, ran back in and up the stairs to the second floor, and made my way along the corridor. It was hot, filled with smoke, and flames from the roof had begun climbing down the walls. I found the old woman in bed unconscious, somehow picked her up and carried her downstairs and outside.

A few neighbours who'd gathered took the old couple under their wing. By now the whole village was alerted, and soon firefighters arrived. When they were done we opened the pub and John, Ena, George, his brother Ed, some neighbours, and a dozen sooty firemen stood clutching pints of Double Diamond and reliving the excitement at two or three in the morning. The next day, every villager I saw said "hello." I'd saved one of their own and was now fully accepted as one of them. Two days after the fire the old man came over to the pub to thank me "for saving my wife's life." When he was done, he took my hand and pressed a ten pound note into it.

John and Roger returned to Canada at the end of the summer to bad news from CBC Radio—Ron Solloway had been promoted and his successor, Anne Hunter, didn't want any more comedy sketches from The Jest Society. As a consolation prize, because the late notice had left us with no work lined up for fall, Ron allowed us a shot at what we'd always wanted to do—record in front of a live audience, record the audience's reaction as well as our performances, and if the result was good enough, put it on the air. After that we'd see what happened. Meanwhile, Don had found an apartment in Rome. He'd send scripts, but couldn't afford to come back for a one-night show. The Royal Canadian Air Farce butterfly was about to emerge from the Jest Society cocoon.

A year earlier, Dave Broadfoot had moved back to Toronto after seven years in Montreal. He'd wanted to reestablish himself in the city and was looking for a showcase to announce his return. The Jest Society was committed to another run at the Poor Alex, so Martin and John turned over the second half of the show to Dave. It made for an odd night of comedy: the first half comprised five amateurs performing sketches

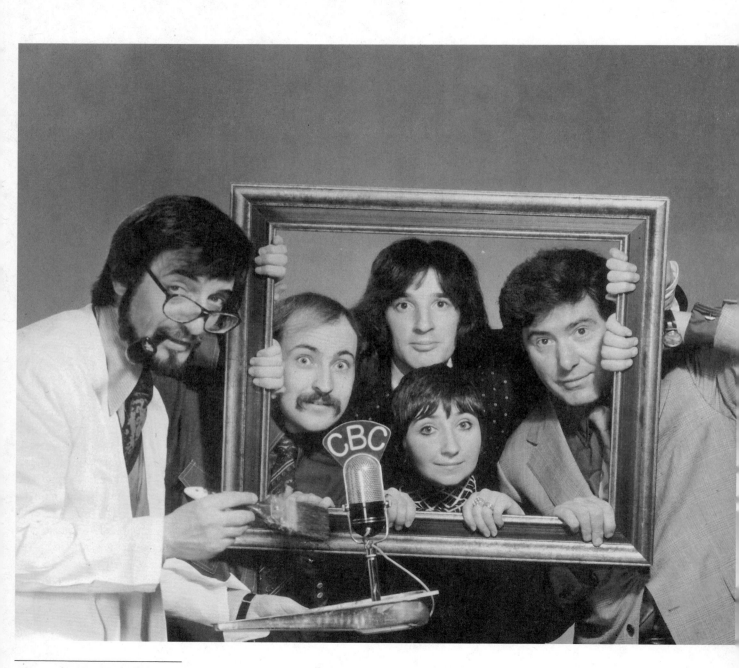

THE HIT
COMEDY REVUE
THE JEST SOCIETY
AND
DAVE BROADFOOT

'REALLY FUNNY'
'INVENTIVE & HILARIOUS'
'FRESH, LIVELY SATIRE'

POOR ALEX
BRUNSWICK & BLOOR 920-8373

OPENS March 7th
Wed, Thu, Fri. 9pm $3.
Sat. 7 & 9:30pm $4.
Previews Mar.1,2,3 $2.

(*Left to right*) Martin, Roger, Don, Luba and John in a Jest Society publicity still, 1973; The Jest Society and Dave Broadfoot poster, 1972; Dave before promotion, when Sergeant Renfrew was still a corporal.

they'd created from improvs; the second half featuring one of Canada's most experienced and talented comedians in a one-man cabaret. The first half had no music or songs and virtually no props, sets, or costumes. In his second half, Dave changed costumes several times (The Member of Parliament for Kicking Horse Pass, Sergeant Renfrew of the Mounties, Big Bobby Clobber), did one piece that was nothing but prop jokes, sat at a table ringing bells, squeezing horns and blowing whistles as a Top-40 DJ, read a newscast from the "Canadian Broadcorping Castration," performed a couple of commercial parodies, and answered audience questions. He probably sang, too. It was a revelation—so this is how a pro does it. And he was a nice guy to boot. When Ron gave us the one-shot, make-or-break, live-audience sketch-show opportunity, we immediately invited Dave to join us.

'A' is for Abbott, 'B' is for Broadfoot

DAVE BROADFOOT IN CONVERSATION WITH BILL BRIOUX

In the summer of 1969, Dave Broadfoot, a well-established player on the Canadian comedy scene, got an invitation from Sesame Street to perform a sketch about the letter 'A.' That's when he first met Roger Abbott. Broadfoot doesn't recall much about the Sesame Street sketch, but **Abbott made an instant impression.** "We got along well," he says, his memory still performance-sharp at 85. "It was right before I left for Toronto. My work in Montreal seemed to be fading out."

Where were you performing at the time?
I was always a big-banquet performer. I did countless banquets. In Montreal, it was going great for a while, but the gentiles in Montreal were not into banquets so much. It was all Jewish audiences for me, even Hadassah. Beyond that, well, I quickly discovered that atheists don't hold banquets.

Things were different at the time in Toronto?
Oh yes. Guys would take on two a night, rush over to the King Edward hotel for a second show. I could never do that—they might want a longer show, or I'd have to do an encore. If you're worrying about your watch, it's not worth it for me.

Besides Abbott, had you met any of your future Farceurs before heading to Toronto?
In Montreal I met John Morgan . . . I'll defend him to the death. He was the most prolific writer I've ever worked with. He was so imaginative—amazing.

Would you say he brought a kind of Monty Python vibe to the troupe?
He said something to me a long time ago: "You can't always afford to be linear. You've got to think laterally—think sideways." And he was right.
Another time I came over to pick him up and give him a ride. "Can we stop by the library?" he asked. John was an avid reader. He ran back upstairs and came down with his arms full of books. I said to him, "John, where do you find time to read all that?" And he said, and I'll never forget this, "There can be no output without input."

How did you come to be a part of the Jest Society?
They were performing at the Poor Alex, a small stage that was just south of Bloor Street.
Roger or John—one of them—asked me if I'd like to be a guest in that stage show and I said absolutely. I did my character, the Member for Kicking Horse Pass. In another sketch Roger was the translator and I was [former Leader of the Opposition] Robert Stanfield. I was working in bad French he was translating for me. It was hysterical.

How did that first Poor Alex performance go over?
They did a thing there for the opening night I would never do, it was a big mistake. They invited all kinds of performers to see the show. That's the worst thing you can do. Get bus drivers, cab drivers, nurses—never show people, they're the worst. They feel this competitive sense all the time. I was amazed that they had done that for opening night, but it was too late, what can you do. We got through it, and from then on, it was only a fun experience.

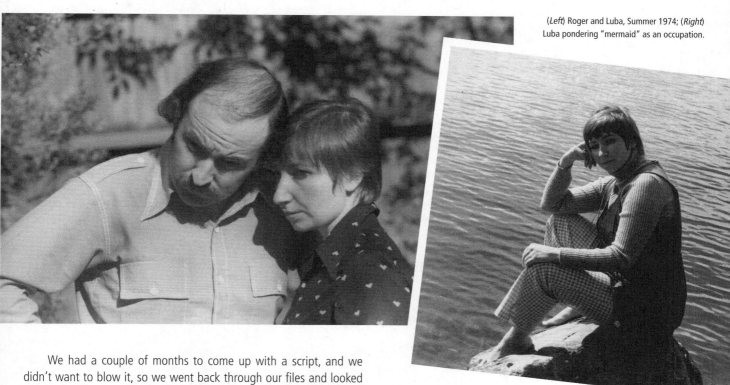

(*Left*) Roger and Luba, Summer 1974; (*Right*) Luba pondering "mermaid" as an occupation.

We had a couple of months to come up with a script, and we didn't want to blow it, so we went back through our files and looked at everything we'd done in the past three years that was any good, and began rewriting and polishing. Our comedy apples wouldn't just shine, they'd dazzle. Theatre audiences had kept us current in the past, but we hadn't performed in months, so we wrote new material, too. John wrote and performed one of the best new pieces, "Coffee Shop," which we also called "Just a Coffee." In December 1988, at our fifteenth anniversary radio taping at Roy Thomson Hall, we sneaked it into the script and John performed it again, a small, private anniversary gift to ourselves.

We had a naming dilemma. What would we call the show? Couldn't be The Jest Society for two reasons: one, it wasn't; two, Martin wanted to keep Jest Society separate (understandable, since it was an established hit and this was something untested and new), so he could continue with its success. So we had to come up with a new name. First choice: Les Nirenberg's 1970 suggestion, The Beaver Follies. Nice try, but CBC wasn't about to be fooled. They asked us to think again. In October, Roger and John were chatting, tossing suggestions back and forth. At the time, Ottawa had been on a naming kick of its own and various departments and crown corporations recently had been given spanking new monikers: Parks Canada, Information Canada, Revenue Canada, Air Canada. Anything at all, as long as it ended in "Canada."

Someone said it was too bad Air Canada was taken because it would have been a good rename for CBC (since radio and TV shows were "aired"). Maybe CBC could take Air Canada's name and Air Canada could be renamed something that describes it better, like Air Farce. Much laughter. No, CBC should be called Air Farce. Even more laughter. Hey, whadaya think . . . Air Farce. Maybe a name for the show? Kinda short, though. How about Royal Canadian Air Farce? Sounds like a name that might fly. More laughter. CBC buys it.

And we did our bit for bilingualism, too, adding a three-word tag after announcer Alan McFee boomed out, "Royal Canadian Air Farce." Originally Roger voiced it in a light, delicate falsetto, but a year or so later Luba got a bee in her bonnet about it and made a bit of a fuss. Why should a guy do something in falsetto when there was a woman in the group? Although Roger had originated the tag and loved voicing it himself—it was a proprietary thing, his tiny secret signature on the opening title—he stepped aside to keep her happy. And so for almost 22 years it was Luba who chirped, "Ici Farce Canada!" A bright soprano rather than a moment of whimsy, but it worked nevertheless.

Luba and "The Boys"

LUBA GOY IN CONVERSATION WITH BILL BRIOUX

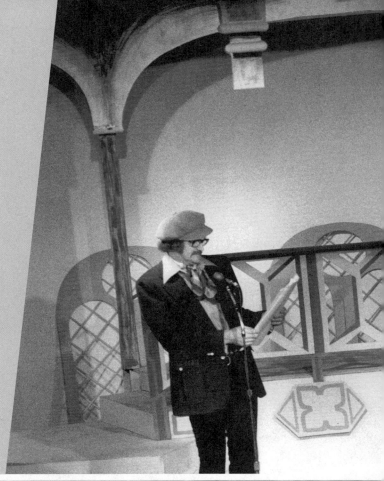

I just got along well with the guys. You had to accept them the way they were. And I remember Roger was so marvellous because he was the peacemaker. He hated confrontation. I've never seen him angry in my life. Disappointed yes, but never angry . . . It just wasn't in his nature . . . Everybody would come and complain to him and whine, and he would listen and he'd be so sympathetic but he wouldn't take sides. You wanted him to, but he had that ability. That's why he was such a good producer.

John would have his raves. He'd come in from Bala by car and he'd go, "Beautiful day and wouldn't you know it we have to work." He'd be complaining about working. And he'd go, "Bloody sodding Don Valley! Sodding Don Valley!" And then he would have his rave and then we would get on to rehearsal.

Dave Broadfoot would be apoplectic, especially in our radio days. Dave was very busy and Dave would do these one-man shows all over Canada. He'd be like, "Can we get on with the rehearsal? I've got a plane to catch. I'm off to Alberta. I've got a show to do!" We'd be like, "Oh, have another cup of tea, dear."

And all John would talk about was, "We need a theatre with a place in the back to make tea." And John would be, "Come on lads, we've got to stoke the furnace," which meant we had to go eat. At 5:30 John had to eat. He'd always be on our backs about it . . . And then nobody would ever sit across a table from John because he never ever talked when his mouth was empty. He liked fish sandwiches, so a tuna sandwich with lots of mayonnaise, and he'd take a huge bite, and he had caps on his teeth, which he was quite unaware of. He'd take a huge bite and go [mimics John talking with his mouth full], "Mmmm . . . you know, I think in the scene where . . . " and if you sat across from him you'd be like, "Oh, God, I can't look," because he'd be like, eating, chewing, his mouth full of fish sandwich or egg salad. It would be like, "Who wants to sit across from John today?"

But John was so funny . . . such a character. You could not train him.

1974. (*Top*) The magic of radio: Luba is taller than Dave; (*Bottom*) the long and the short of it: in reality, Dave is 6'2", Luba is 5'0"

We needed a place to record our bold little experiment, and Ron Solloway had a connection at The Curtain Club in Richmond Hill, Ontario, about twenty-five kilometres north of Toronto—just far enough away that we wouldn't be tempted to do "Toronto jokes" for a national audience. We knew within the first half-hour that this was what we'd always wanted to do—stand on stage, scripts in hand, a sound-effects guy with kettles and coconuts set up next to us, and a live, laughing audience in front.

The Curtain Club was both a building and an amateur theatrical troupe. When the show began to attract audiences, listeners whose fancies had taken flight at the words "Curtain Club" wrote to inquire about tickets. Ah, radio. They imagined a nightclub where patrons lounged at little round tables, their cocktails glimmering in the soft light of tiny lamps topped with red shades, while the elegantly outfitted cast quipped and cavorted on a glittering stage. Actually, the Curtain Club was a Quonset hut on a service road in a suburb struggling messily to shed its rural past. The audience sat in rows of reclaimed movie theatre seats, and we performed in whatever stage set the theatre company had built for its current production, anything from *Billy Budd* to *Separate Tables* to *Murder in the Cathedral*. We never knew until we arrived for our technical rehearsal how much stage we'd have to work with, or what it would look like. Sometimes half of us stood in front of a porch while the others stood in a garden. Other times we paced the deck of a tall ship between the mainmast and the captain's cabin. Some of the sets made for fun entrances at the start of the show.

There were five of us in the cast, but never room on stage for that many microphones, so we shared. Not as easy as you might think. At one end of the height spectrum stood Dave, six-foot-two in stocking feet. At the other end, Luba, five-foot-two in heels. Sharing was out of the question without some brilliant technological innovation, and our crew rose to the occasion, creating a device so effective that we carted it around with us to radio tapings for years to come: a box. It was painted pine, twenty inches square by six inches tall, and it did the trick. We didn't drape it in fabric or disguise it with lights or in any way try to hide what it was. In fact we announced to the world exactly what it was with words boldly stencilled on it that everyone in the audience could see: "Luba's Box." "I love radio," Luba would proclaim, "because on radio I'm slim, willowy, and five-nine."

On December 9, 1973, CBC broadcast the first half-hour. It wasn't an overnight success; in fact, it was somewhat ignored. There were a few complaints from listeners who'd been expecting a concert from the Air Force band. Some newspapers, spotting an obvious typo, changed the "a" in Farce to an "o," so it looked like we were a team of Second World War flyboys. This kind of helpful correction followed us around for several years, until eventually the typo began to be corrected the other way. So did campaigns against the name, usually mounted by people who accused us of besmirching a noble fighting force.

These campaigns seemed to bear out the misgivings that Dave Broadfoot, a merchant navy veteran, had voiced from the start. "I liked 'Canadian,'" he recalls, "but 'Royal Canadian Air Farce'—I had a kind of ambivalence about it, it was so close to the real thing. One letter

difference. I felt, why are we looking for trouble?"

The protesters would have had a point, except that the "Royal" designation for the Canadian air force had disappeared five years earlier, when Defence Minister Paul Hellyer had unified Canada's Armed Forces. As far as we were concerned, we weren't using their name, we were using ours. "Hey," we said, "don't get mad at us, save it for Hellyer."

CBC aired the next two shows in subsequent weeks and liked them enough to order three more. Then another three. And again. From the start, the CBC programmers knew they had stumbled across something special. By May, we'd done a season of eighteen shows, and were invited back for twenty-six more starting in September. Word went to Rome: Don, come home—we've got a full-time job (at least for a year). Word came back from Rome: *Bene*—see you in Wales at the end of August.

The summer of 1974, John and Roger returned to the pub in Wales. We never quite believed our success would last, and in John's case this meant the need for a Welsh bolt-hole. The King's Head was going to be it, so at the end of May he eagerly decamped to Wales to continue building up the business with his friend George Rees. The King's Head and its denizens continued to delight. George's mother had had a mastectomy and the site of her former left breast now served as the main branch of the Rees family bank. She kept hundreds, if not thousands, of pounds in her vacated bra cup. A man from Inland Revenue came that summer to perform an audit, and after three days trying to decipher how the businesses functioned, he gave up, accepted a complementary Cornish pasty and a pint, and returned to London.

Roger—now a bona-fide village local—spent another fun summer as the dining room sommelier and maître d', good experience for what would become one of his favourite radio characters, Henri, maître d' of the House of Commons Cafeteria. At the end of August, Don arrived at the pub on a busy Saturday night, after a seventeen-hour journey via plane, two trains and two buses that had begun at 3:00 a.m. in Rome. John, who hadn't seen him in over a year, said, "Hiya Donny! Grab a tea-towel, would you? We need help with the washing up." Don spent the next three hours standing in what was basically a closet with a sink, washing pint glasses and plates. It was good to be back with friends.

DON: Over the next couple of weeks, the three of us, between washing dishes, serving dinner, and pulling pints, talked about plans for the Air Farce radio show, and drank our way through the pub's wine cellar. The cellar was a recent discovery.

Sometime in the late 1950s, a wine merchant must have sweet-talked the Rees family into buying burgundy for the pub. Problem: nobody in Llangennith drank wine, and 99 per cent of the population drank only one brand of beer, Double Diamond. We'd eat dinner in the hotel dining room after the pub had closed for the night. By then, Roger would have fetched the evening's bottles, cradling them like newborns on their journey up from the cellar. He'd remove the foil and pull the cork with elaborate ceremony, solemnly pour the first glass, and take the first exquisite sip. "Elixir!" he'd pronounce it, and pour for John and me. John, although he enjoyed a drop of red as much as the next fellow, was by no means a connoisseur, and when the glasses were getting low, instead of asking Roger to pour again, he'd grab the bottle and gesture with it vigorously, his raised eyebrows inquiring, "who's for seconds?" Roger would cringe in horror as the sediment he'd been so careful not to disturb leaped from the bottom of the bottle and clouded the remaining nectar.

I had to return to Canada ahead of John and Roger. I'd been away from Canada for sixteen months and needed to re-establish a base in Toronto before the radio season began. Roger was happy to take a break from the pub, so he decided to accompany me to London, a city he knew

and loved, whereas I had been there only once for a couple of nights on the way to Italy the previous year.

ROGER: Because we were leaving early the next day, John asked if we'd do him a favour and cook breakfast for a hotel guest who had an early morning departure to attend his mother's funeral. We agreed. Because it was our last night at the pub, Don and I decided to have a glass or two of the good burgundy before tottering off to bed. One glass became another, and then the cognac came out. We got the giggles. We had more to drink and the next thing we knew it was four in the morning. We were very tired, also quite drunk, but not so drunk that we didn't realize that if we went to bed now, there wasn't an alarm clock in creation capable of waking us in time to serve breakfast to the departing hotel guest and his wife. How ever were we going to stay awake? We decided to keep drinking.

The guests were leaving at 6:30. By 6:00, Don and I were in the kitchen devising the menu. Orange juice, fried eggs, bacon, toast, and tea. That should do it. I'm not a kitchen person, so Don cooked. I set a table for two in the dining room, close to the kitchen serving hatch. When the guests arrived, I did my best imitation of a sober person and took their orders. Two eggs over

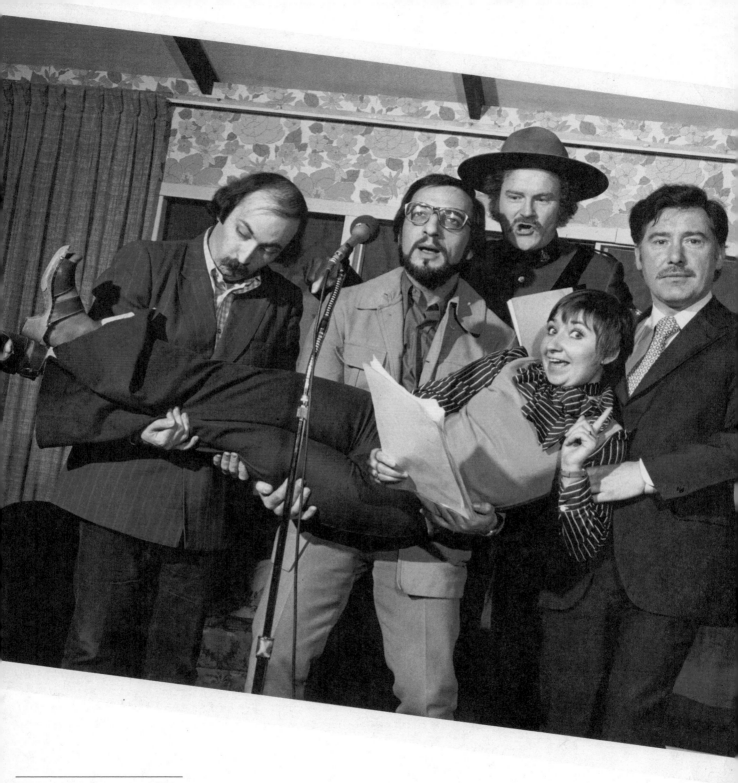

easy, two eggs sunny side up, both with bacon and white toast.

Back in the kitchen, tiredness, too much to drink, and the realization that I was about to serve breakfast while barely capable of coordinated movement struck me as incredibly funny. We closed the kitchen hatch so the guests couldn't hear us laughing. Somehow, Don timed the cooking properly and the eggs, bacon, and toast were all ready within a few seconds of each other. He'd warmed the plates in the oven. I brought the plates over, he laid the breakfasts on them, and I immediately dropped both plates on the kitchen floor. This struck us both as even funnier. I pulled myself together, and with as straight a face as I could manage, went into the dining room to explain there'd been an accident, however breakfast would be ready soon. More tea?

Don began cooking breakfast all over again. Aware that the guests were only ten feet away on the other side of the closed kitchen hatch, and were no doubt exchanging confounded looks as they heard the continuing ruckus in the kitchen, I redoubled my efforts to control myself, which made control even

harder to attain. We were ready to serve again. "Don't worry," I assured Don, "I won't drop them this time." As he put the food on the plates, I gestured to demonstrate my self-control and watched, snorting and choking in paroxysms of suppressed laughter, as both breakfasts slid off their plates onto the floor. We were never going to get this done.

But the third time proved the charm, and a mere fifteen minutes later than scheduled, the guests drove away from the hotel, having finally downed their hearty King's Head breakfasts to fortify them for mother's funeral. A couple of hours later Don and I boarded a train in Swansea bound for London.

Don had the last laugh. We arrived at the Air Canada office to find there were no economy-class flights to Toronto available for an entire week. Don had no money but I had a credit card, so he flew home first class.

CHAPTER 6

Finding our Groove

THE SECOND SEASON AND BEYOND

Is it 1975, or what! On the left is Ron Solloway, the man who put The Jest Society on radio and produced the first season of *Royal Canadian Air Farce*; beside him is Keith Duncan, one of our favourite producers, who succeeded Ron in Season Two.

By mid-September, everyone was back in Toronto, gearing up for *Royal Canadian Air Farce's* second season. With Don back in the cast, Don and Roger began writing as a team. John and Martin continued to write independently of each other. They also made the decision to perform in alternate shows in order to reduce the number of British accents in any one episode. Dave, who still pursued his strong solo career, focused increasingly on writing for his Bobby Clobber and Sergeant Renfrew characters. The CBC production team--Ron Solloway, Keith Duncan, Bryan Hill, Alex Sheridan, Ray Sora, and Anne Hunter--were back too, with minor changes. Ron was now running the Variety Department, so Keith became our full-time producer. And Bryan Hill became our full-time recording engineer, something he did for another nineteen years, before becoming producer for our final four seasons. And both Luba and Ena had news--they were pregnant, and by coincidence both due at the end of January. We did the math and remembered that we'd had a pretty good end-of-season wrap party in April.

In these early days, we bulk-recorded. That is, every three weeks we'd drive up to Richmond Hill with a stack of scripts, and over the course of an evening, record the sketches in a running order designed for simplicity of production and the enjoyment of the theatre audience. We didn't give much thought to what a half-hour broadcast would sound like, and left it entirely up to the producer to figure out, as he edited the material into acceptable-for-broadcast shape. Sketches that didn't work were easy—he'd just dump them. Sketches that worked well were also easy, a nip and a tuck and they were ready to go. But sketches that partly—or even mostly—worked had to be refined, and since there was no possibility of post-production, the only way to improve them was by editing the bad bits. And there were plenty of those, because although we were usually disciplined enough not to mess up a sketch that was working (occasionally alcohol got the better of us), if we realized mid-performance that a sketch wasn't working at all, we might try to salvage it by improvising. This succeeded often enough that it became an acceptable tactic, but inevitably large swaths

The Curtain Club control booth in 1974. Bryan Hill began as our recording engineer that year and eventually became our producer. He remained with us right through to the end, 23 years later; Keith is wondering what page of the script we're on.

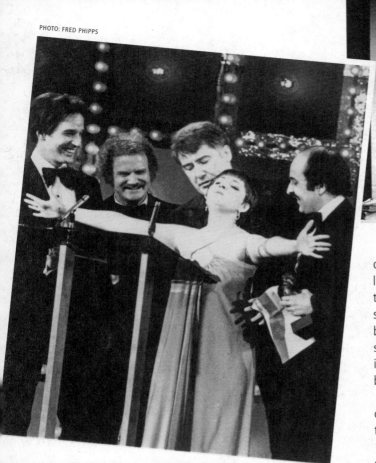

of off-script improvisation ended up on the cutting room floor—quite literally, as this was before computers and digitization. We recorded the show on quarter-inch audiotape that travelled at fifteen inches per second, seventy-five feet a minute. The producer edited using a razor blade and sticky tape. At the end of a session, his office floor would scarcely be visible beneath hundreds of feet of discarded audiotape; it looked like the aftermath of a gift-wrapping blitz that used only brown ribbon.

Because the weekly broadcasts ran twenty-five minutes without commercials and we recorded once every three weeks, we needed to come away from a taping with seventy-five minutes of show, roughly 100 minutes of raw material. Some nights, we brought so many sketches to record that we had to provide the audience with two intermissions. A large reel held only an hour's worth of tape, so if a show ran long, the producer had to stop so the recording engineer could load a new tape onto his deck. We consistently aimed to be laugh-out-loud funny, never merely amusing. Why? Because amused audiences smile and you can't hear smiles on radio. Rule #1: our comedy had to make people laugh.

That's a discipline we adopted at the start, and never forgot. It's another reason to cherish live audiences—they keep you honest. People don't decide whether or not to laugh; laughter erupts spontaneously and instantaneously, or not at all.

We drove to Richmond Hill and back in all sorts of weather. In winter, the usual thirty-minute trip could sometimes take twice as long. Normally we did our own form of car pooling, with the cast dividing between two cars. One cool, rainy day Roger was driving, with John in the front passenger seat and Don and Luba in the back. Dave and Martin were travelling in a separate car. As we drove up the single-

Alex Sheridan

MAN OF A THOUSAND NOISES

Alex Sheridan was our first sound-effects technician, and although he was much more of an artist than a technician, CBC didn't have a category for "wizard," so despite his imagination, impeccable comedic timing, and sparkling show-biz flair, in CBC's books Alex was always listed as a technician, never the artist that he was.

He knew all of the classic sound-effects tricks. Walk through snow? Crunch cotton bags of cornstarch. Horses' hooves? Coconut shells on a wood block. And at what pace would you like your mount to travel? Walk, trot, canter, gallop? Say the word and Alex made it happen. Even people who had grown up in the golden age of radio listening to *Jake and the Kid* or *The Lone Ranger* had never seen anything like it. For most of those years, sound-effects technicians were heard, not seen. But at an *Air Farce* taping, Alex stood on stage alongside the actors and was a feature attraction of the show.

He fascinated our live audiences. Onstage, he worked surrounded by an elaborate array of equipment, old and new, that bristled with microphones and occupied about twenty-five square feet of space, right at the front of the stage. He had a specially built wooden door adorned with various doorbells, chimes, buzzers, door knobs that rattled, bolts that shot, and bells that tinkled, which, depending on what the script called for, would fly open, slam shut, discreetly signal the arrival of a customer in a shop, or close smoothly behind a departing character with a dignified, quiet click. The hinges of doors large and small creaked with rust or groaned ominously, thanks to a violin bow. And a wood-framed window slid open stealthily to admit burglars, slammed down on its sill to keep them out, and rattled noisily during thunderstorms. The thunder, of course, was produced by Alex flexing a metal sheet.

Alex had electronic equipment, too; several tape-cartridge machines that were loaded with pre-recorded sounds and could be fired anytime. But his favourite piece of equipment was his table. It was Alex's unique performance space, his own mini-stage. It stood between him and the audience, and whenever possible, Alex performed his cues there. He took great delight in making his sound effects as visual as possible. So pouring a cup of tea involved a teacup, a teapot, a teabag, a basin, a napkin and occasionally, the ability to burp. He'd pour the tea past the teacup and into the basin, and the tea would pour and pour and pour until a ridiculous amount had flowed into what was supposed to be a simple cup, and then he'd finish his pouring with a series of well-spaced dribbles that couldn't help but call to mind an older gentleman concluding his urination. By this time, the audience, and frequently the cast, would be in stitches. Alex would then delicately pat his lips with the napkin and sigh contentedly. He used the same equipment and technique when the script called for someone to have a pee, only this time he'd end the effect by taking a sip from the teacup. He was a master.

Live sound effects were one of the things that not only made *Air Farce* distinct, but also so much fun to see. We were the only show of any kind in North America that used them, and after every performance, people crowded around Alex to get a closer look at how sound-effects wizardry was done.

lane road north of Toronto, another car tried to pass and sideswiped us. We spun out of control and came to an eye-poppingly abrupt stop in a ditch. Seatbelts were new and compliance was low, particularly from John, who hated being told what to do, and normally didn't buckle up just on principle. For some reason on this day—probably the rain—we insisted he wear his seat belt, and it definitely saved him from a severe head injury, possibly worse. It's impossible to imagine what might have become of Air Farce if any one of us, in those early days, had to be replaced. As diverse as we were in age, background, education, and interests, we had a magic chemistry that, for reasons we never figured out, just worked. Lucky us, that we were able to stay together for as long as we did.

A few years later in Vancouver, three of us, Roger, Don, and Dave, taped a CBC comedy special hosted by David Steinberg. During a break, David told us we were fortunate to be doing *Air Farce* in Canada, because in the United States we wouldn't have survived. The constellations of agents, managers, producers, and dealmakers that circle talent in Los Angeles would have inexorably pulled the group apart as first one, and then another of us would have been offered other, individual work. A writing gig here, a film role there, a comedy pilot somewhere else, and the group would have broken into pieces, flung apart by the centripetal energy of its own success.

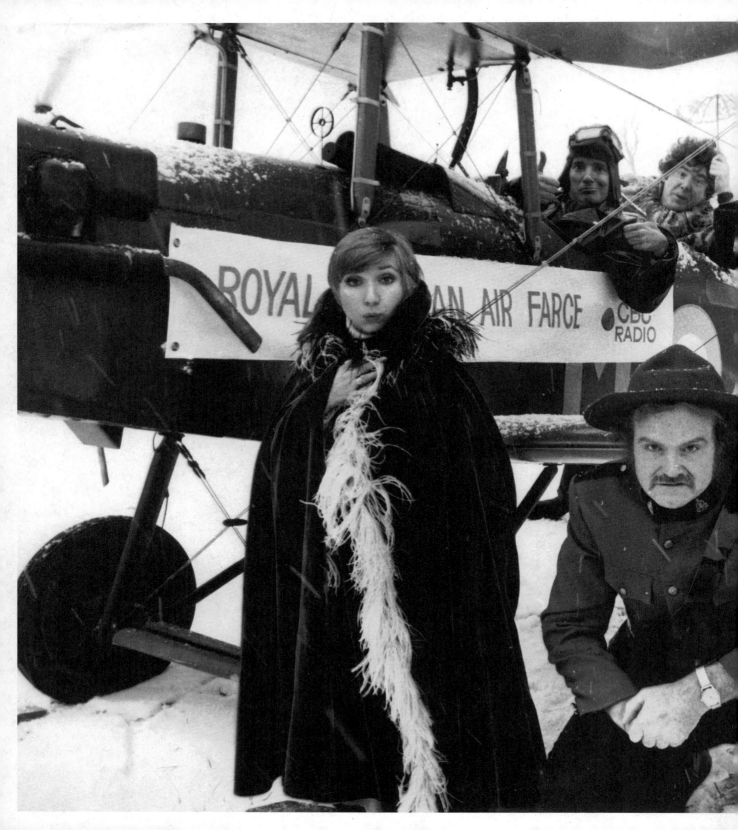

The full cast in November 1974. (*Clockwise from left*) Luba, Don, John, Martin, Roger and Dave as a very serious Corporal Renfrew.

We taped at the Curtain Club every third Thursday. In the morning, the crew loaded in and set up; in the afternoon, we rehearsed with sound effects and music; in the evening, we recorded; after the show, the crew tore down and loaded out. Long days. Our producer spent the next week breaking down the recorded material into three rough shows, and then fine cut the first of them for the next broadcast. Frequently, the highlight of the taping day was the dinner break, when we'd drive to a diner at a nearby mall, order "whatever was fast" and a bottle of wine, and begin wrestling with endings for unfinished scripts. John never seemed to worry about it. He'd lay his script on the table and begin writing with a Pentel black marker on a lined pad. We never did completely convince him that the script needed to be ready more than ten minutes before we stepped on stage. Sometimes the only people who knew how a piece ended were John and whoever was on stage with him. In those cases, the producer learned that, just as in The Jest Society, if we weren't sure where we were going and got a huge laugh along the way, we were quite happy to stop there, take our bows, and step away from the microphones. Cue music and applause.

After the Thursday taping, we'd take a couple of days off and then begin worrying about the next session. We had roughly two weeks to come up with 90–100 minutes of script before gathering, usually at Roger's house on Hazelton Avenue in Yorkville, to read and begin rehearsing. The first read was always fairly relaxed and social, especially in the early years. Roger had discovered the pleasures of Twining's teas and we took a break every couple of hours for a cuppa. Roger insisted on playing mother and pouring the tea. He made a point of solicitously inquiring of each of us in turn whether we were "m.f."—milk first—which Roger believed was the only proper way to do it; you introduced

Late 1970s. Roger and Don during a writing session. The photo was probably taken by John.

tea to milk, never the other way around. There were usually cookies, too, and again they had to be proper English biscuits, preferably made by Peek Freans or Cadbury.

The rehearsals were fruitful, and looking back, are a striking reminder that, although we were professionals getting paid for our efforts, there was a strong sense of the amateur about what we were doing. Amateur in the original sense of the word—we did it because we loved it. We had no office, no proper rehearsal space; in fact we had very little that was formal. We were unwittingly building one of Canada's most successful comedy shows, and even after five years, were still meeting to rehearse in someone's living room. At least once every couple of months, Dave, who used to put his teacup on the floor beside the sofa where he sat, would leap to his feet to perform a role and send the teacup flying; it became a mini-feature of *Air Farce* rehearsals.

Roger and Don lived four blocks apart. When Don left Italy to come back to Canada, he and Stefania split up and she stayed in their apartment in Rome. Don and Roger, both single, spent most of their time with each other, working and also playing.

DON: We watched a lot of TV, mostly comedy. One of the ways you know that you're doing the right work is when you can't tell whether you're working or playing. We were into comedy. It was fun making it, it was fun watching it. How many people can say when they're watching comedy on television that they're working? We honestly could.

We were twenty-eight and had already known each other for more than half our lives. We constantly lent each other money, and never

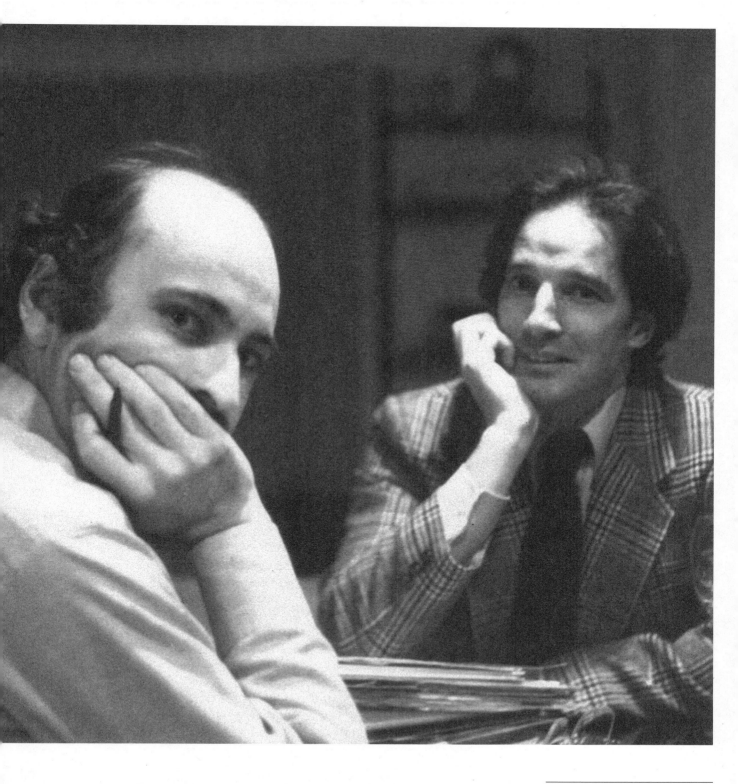

kept track. "I need fifty bucks until tomorrow." "Man, that's a great radio, can you lend me $200?" "Have you got ten? I need some smokes." This went on for years. Every so often one of us would ask if the other had any idea how much may have been owing or was owed. Neither of us had a clue. We guessed it was probably even, but cheerfully acknowledged that one might owe the other thousands. We simply didn't care.

One day, Roger announced to me out of the blue that he'd woken up that morning and realized he was "a bachelor." He said it with pride, and with the certainty that he was right. He fancied himself a bachelor in the great tradition of English bachelors, as he imagined they might live in London. He liked going out to dinner parties or movies or the theatre, or working late, and he liked coming home to his own space. He could pour himself a glass of wine, open a mystery novel and curl up in his favourite chair. It was a good life.

As might be expected of a young bachelor, he hated doing laundry. The laundromat was less than a block away, but you had to cross Avenue Road with a bag of soiled clothes to get to it, and who wanted to do that? Fortunately, the variety store where he bought his cigarettes also sold socks and underwear, so every so often when he'd buy a pack of cigarettes, he'd buy socks

or underpants, too. At one point, he owned over 100 pairs of socks and underwear. He admitted it was excessive, but boasted he only had to do laundry once every three months.

Roger had this thing about clocks. They had to be accurate. I once came to fetch him at his apartment; he lived on the ground floor of a house on Hazelton Avenue in Yorkville and had left the door open because he was expecting me. I arrived seconds before 6:00 p.m., and I know the time precisely because as I entered his apartment, he was sitting on his living room sofa, intent on his wristwatch and wearing a triumphant smile on his face, as all through the apartment, every timekeeping device he owned confirmed the hour. The clock radio in his bedroom sounded the long CBC beep, his stereo receiver, set to CKFM, went boop-boop, his television, tuned to the alphanumeric time and weather channel that cable companies used to provide, sounded its characteristic tone as the digital display flipped from 5:59:59 to 6:00:00, the clock on his mantelpiece chimed the hour, the door of the cuckoo clock on his kitchen wall flew open and the wooden bird went nuts, and the second hand on his wristwatch swept past the top of its dial. All in perfect synch. He'd spent the better part of an afternoon adjusting every timepiece he owned for this one triumphant

moment. It was the most satisfying experience an anal-retentive control freak could have.

Yet this same man, as fanatical as he was about clocks being accurate, and as much as he loved food, was never on time for dinner in his life. His tardiness was legendary.

We understood that it wasn't enough for listeners to like the show, they had to be engaged. So we started running silly contests. We had nothing to give away as prizes; in fact, CBC policy expressly forbade it—it was considered "buying listeners" and beneath the dignity of the corporation—so our prize was minimal: we announced the winner's name on the air. We tried Canadian trivia—it would be a cakewalk now with Google, but in the mid-1970s people had to go to libraries to do research—too difficult. We recorded a comedy album and were able to offer it as a come-on (it was considered a promotional device, not a vulgar prize) for a limerick-writing contest, but discovered that Canada was not a nation of limerick writers. With one exception. By far the best limericks came from an anonymous contributor in British Columbia, who mailed them on postcards from different parts of the province (we checked the postmarks, hoping to track the author down) and signed them with preposterous fake names—J.W. Foxhead, P.J. McFry, L.X. Hoople. We pleaded on air for whoever it was to identify him or her self so we could send the album, but no dice; they never rose to the bait, and we never discovered who possessed that delightful, playful mind. The free album, although won several times, was never claimed.

Our most popular contest came to us courtesy of Canada Post. Postal codes introduced in the early 1970s prompted a brief, impromptu national pastime—inventing semi-silly phrases to help remember them. CBC Toronto's postal code was (still is, but who writes anymore?) M5W 1E6. The *As It Happens* show jumped on the bandwagon and came up with "Make Five Wieners I'll Eat Six." We invited our listeners to send their suggestions, and unlike the limerick contest, entries flooded in. But dozens of listeners submitted entries solely for their own—and presumably, our—amusement, knowing it was highly unlikely we'd announce "My Fifth Wish Is Easy Sex" or "Mona Fondles Wallace In Eastern Saskatchewan" as the winner.

Half of acting is showing up and the other half is simply listening intently to the other actors. As a troupe, we listened to our audience. We wanted to connect with them, have a dialogue. The point was to entertain. However, we wanted to do more than just get cheap laughs, and we didn't want laughs at any price. How to achieve this remained an underlying creative tension from the beginning. It's what Martin and John continued to disagree about. Roger, Don, and Dave wrestled with it, too. It's a dilemma because there's no pat answer that meets every test. Creating comedy is an existential pursuit; each joke must be judged on its own merit; and what may be the right thing to say here today, might be the wrong thing to say somewhere else tomorrow. A joke that kills in a comedy club can die in a church basement.

Dave liked comedy with a social purpose. If you could inform, provoke, or educate while making people laugh, that's what you should aim for. He was the son of fundamentalist Christians, and while he utterly rejected organized religion's inherent intolerance and their urge to proselytize, he retained a sense of purpose, call it duty even, to do good. There were successful Jewish and Italian comedians, and in some sense Dave was a Protestant comedian; his desire to

Don and Roger Go Nose to Nose

THE BATTLE OVER BROADFOOT

ROGER: In the spring of 1975, we helped produce a half-hour television pilot for Dave Broadfoot.

DON: We called it, with our usual flair, *The Dave Broadfoot Comedy Show*.

ROGER: It was a fine title.

DON: Great title.

ROGER: A title can only be so long, and this one told viewers everything they needed to know: who the star was, that it was comedy, and that it was a show.

DON: Great title.

ROGER: We thought that if CBC picked up the pilot, we could come up with something splashier.

DON: But probably wouldn't.

ROGER: We'd worked with Dave for a few years by now and believed he belonged on national television in a show of his own. As it turned out, that wouldn't happen for twenty-one years.

DON: That's when we produced a network special for him in 1996. It's ironic that a guy who was one of CBC's brightest lights when TV started in 1952 had to wait so long for his own show that, by the time it arrived forty-four years later, it was called, *Old Enough To Say What I Want*.

ROGER: We built *The Dave Broadfoot Comedy Show* pilot entirely around Dave and shot it at one of CBC's Toronto studios. The production began well, with the usual optimism that everyone would get along fine and the show would be a big hit. But it ended really badly between Don and me.

DON: The worst. It was the lowest point ever in our personal or professional relationship. Roger always liked to be in charge and he got so into producing that he just took over. It was partly my fault—neither of us can remember the exact circumstances anymore. I may have had something else on the go. Roger stepped up. He had clear ideas.

ROGER: I'm a fanatic for details and as usual I became obsessed with all the minutiae of everything that had to be done. I wanted everything to be perfect: the sets, the lights, the audience seating, you name it.

DON: He wanted perfection; I was satisfied with excellence.

ROGER: At least once a year Don reminds me that perfection is unattainable.

DON: Anyway, the Broadfoot show. It began fine, each of us making suggestions, discussing everything together, but as the production evolved, Roger began to take over. Every time a choice was made, it was Roger's choice; every time a decision was made, it was Roger's decision.

ROGER: I didn't have a clue I was doing this. In my mind, the show had to be done right and I knew what should be done and I knew the right way to do it. It never occurred to me that Don didn't agree and it never occurred to me to check with him.

DON: By the time we shot the show, I didn't even care about it anymore, at least not in a positive way. I'd been seething, and at the end of the night a bunch of us, colleagues and friends, went to a bar for a congratulatory, wrap-party–type drink. Roger was satisfied the production had gone as well as it could and for some reason, right there in the bar, I totally lost it. I launched into a tirade and swore I'd never work with him again. It was embarrassing—no one had any idea anything had been wrong, no one knew where to look, and I didn't care who heard me. And when I finished I stormed out of the place.

ROGER: I was in complete shock. I was speechless, which as anyone who knows me could tell you, is something that never happens. I had no idea. I'd made all the decisions as if I was working alone because I didn't want anyone messing things up.

DON: We're different. Roger still can't admit that someone else can do something as well as he can. And of course, he's right, which is why I'm happy most of the time to let him go for it.

ROGER: We didn't speak for days, maybe a week, and when we did we didn't mention what had happened. But it crystallized us as a team. We were better together than either of us on our own. I think we both decided independently that this was going to be as bad as it was ever going to get, so let's move on.

DON: After the blowout, we got back to doing *Air Farce* and we knew that we had each other's back.

ROGER: CBC didn't pick up *The Dave Broadfoot Comedy Show* pilot, by the way, so we never had to come up with a different name.

educate and inform constituted comedy, in Roger's words, "in the missionary position."

Broadly, our goal was to have fun and make people laugh. We paid attention to what our live audiences liked and gave them more of it, and we heard loud and clear what they didn't like and tried not to do it again—there's nothing louder than the silence that greets a failed joke. Listen and react appropriately. It's not brain surgery, but it's amazing how many people who say they want to work in comedy just don't get it. Until you've been on the receiving end of an audience's laughter, you have no idea how pleasurable—and addictive—it can be. Is there a happier sound than unbridled laughter? No wonder we loved going to work.

Every so often we'd hear that Air Farce had crossed "the line" —particularly when we made fun of the royal family or the pope. Usually the whereabouts of "the line" was known only to the people who didn't like what we'd said, but it's a fact of comedy life that "the line" keeps moving and the only way to discover its location is to step over it. The development of e-mail debased the currency of disapproval because it made it too easy. Impulsive idiots suddenly found it a snap to communicate, and being both idiots and impulsive, didn't hesitate to do so. Before that, disgruntled listeners thought about what they were going to say before putting pen to paper, and perhaps rewrote their letter if they felt its meaning wasn't clear. Those who took the trouble to do this deserved our attention and got it. Mind you, there were some who clearly drank vitriol for breakfast, and to these Don would occasionally write a polite, formal reply on Royal Canadian Air Farce letterhead:

Dear Sir,

We don't wish to alarm you, but a person who is clearly deranged has written a crank letter to us and signed your name to it. You may wish to notify your local police.

Sincerely,
Don Ferguson, Royal Canadian Air Farce

It was definitely a two-way street, this dialogue with the audience and the listeners. We kept our relationship fluid. They changed, we changed with them. Their interests and ours were entwined. Our comedy characters changed, too. Renfrew, Clobber, Amy de la Pompa, Hector Bagley, and Henri the House of Commons maître d' remained audience favourites for years, but whenever response declined we gave them a rest. Sometimes writers couldn't find inspiration; for long stretches neither Amy nor Hector would, as John put it, "talk to me." Don, Roger, and Luba played most of the public figures and those figures changed at the public's whim. Because we weren't a sitcom, we didn't have a fixed cast of characters that listeners would eventually tire of and lose interest in. Our characters came straight from the news headlines, and they refreshed or replaced themselves constantly. When politicians were voted from office, sports heroes retired, or celebrities fell from grace, we dropped them from our roster and turned our attention to the new arrivals. None of us can take credit for this recipe for longevity; it was just blind dumb luck. We began by listening to what our audience wanted, and we never stopped asking them about what they were interested in.

Rick and Gord

THE WRITING DEPARTMENT GETS A BOOST AND WE TAKE TO THE BOARDS IN CABBAGETOWN

PHOTO: JEFF SPEED

Writers Rick Olsen and Gord Holtam during rehearsal, 1990.

While touring and live shows capped an eventful decade in radio, one of the most significant events had taken place at the halfway mark. In early summer, 1976, we got a call from Ron Solloway, who'd been our original producer in 1971 when The Jest Society began taping segments for his weekly variety show, The Entertainers. Ron was now Head of Radio Variety, the department responsible for Air Farce, and he asked if we'd do him a favour.

Two inexperienced youngsters who aspired to write comedy had met with a colleague of Ron's, television producer Leonard Starmer, the charming, classy, white-haired eminence who had long executive-produced the top-rated *Wayne & Shuster* specials for CBC Television. Len had nothing to offer the two young men—who had never written comedy before—but something about them piqued his interest, so he suggested they talk to Ron, who might help them get started in radio. Ron didn't know what to do with them either, so he offered us fifty dollars to meet them and "at least talk to them." The two young men were Gord Holtam and Rick Olsen, and they ended up writing for *Air Farce* for thirty-two years.

Rick and Gord grew up in East York, a middle-class neighbourhood without pretensions that, a few years earlier, had surrendered its municipal independence to become one of the five boroughs that comprised the growing city of Toronto. East York had largely managed to avoid the developers' excitement. It was nothing special, a modest array of quiet streets dotted with small bungalows, with mom-and-pop variety stores at the busier corners, 1960s high-rises lining the wider thoroughfares, and a scattering of playgrounds and parks. It was a good place from which to view the world and absorb middle-class values.

The four of us met at Don's apartment. Rick had brown hair, Gord was almost blond; they were average height, weight, and build, and like us, they had been friends since high school. They were the antithesis of showbiz flash. With them, they brought a couple of sample scripts—comedy sketches they'd been working on—and asked for feedback, which we gave. They thanked us and said goodbye. And that was that. We phoned Ron to tell him we'd earned his fifty dollars.

"If I come across other young writers, would you be willing to meet with them, too?" he asked.

"Sure," we said.

A week later, Rick and Gord phoned. They'd had another go at the scripts, would we be willing to look at the rewrites? They'd already had their fifty bucks worth, so this meeting would be on the house, but what the heck, they were keen, that had to be worth something. The scripts had been changed, but not really improved very much in our eyes.

A week later, they called again with more rewrites. Again, we went through the changes, making suggestions about structure, character, pacing. A week later, they called a fourth time. This was getting to be annoying. But they were getting better and their desire to learn and willingness to work were impressive, so in September, as much to get them off our backs as to offer encouragement, we proposed a formal arrangement: they'd join the Writers' Guild, we'd give them a contract to write one minute of script per episode, and we'd continue to comment on and edit their work. If it worked out, good. If it didn't, it wouldn't have been for lack of trying.

For the next two years, Rick and Gord continued to submit and we continued to rewrite every script they wrote. Improvement stalled. It always took longer to rewrite their material than it did to write original material of our own, so what was the point? And besides being time consuming, it also cost us money out of our own pockets. We'd clearly arrived at a creative impasse, and the sensible solution was to end our arrangement. Rick and Gord must have felt the way we did and proposed we change the way we worked. "We're not learning anything anymore. Let us submit our scripts directly to the cast, sit in on the cast read, listen to their comments, and do our own rewrites." We decided to give it a shot. It marked the beginning of their ascendancy to becoming one of the best comedy sketch-writing partnerships in history. Every week, their confidence grew and their material improved—tighter, sharper, faster, funnier. With this step—

taking control of their own material by becoming responsible for their own rewrites—they launched themselves to professional heights from which they would never look back.

We now had the best writing team of any comedy show on radio—or television—in Canada. John Morgan was a joyful eccentric, his writing populated with outrageous characters and improbable situations. He was a voracious reader, highly opinionated, a natural clown, and extremely clever. Unlike John, who considered that his job as a writer was to throw the clay onto the potter's wheel and let the cast help him shape the final product, Rick and Gord always arrived with polished scripts. Their material wasn't simply written, it was rewritten. John brought first drafts to the table. He wanted to hear them performed and he counted on cast input to improve and reshape them. He'd sit at the table and urge us on, black marker in hand, ready to take dictation, "Okay, give it to me, what happens next?" He'd look to everyone to suggest jokes, dialogue, plot twists, and of course, the eternally elusive endings.

LUBA: He would come in with 23-page scripts, radio scripts, and they'd always be, "End to Come." And a lot of it was written out by hand, you know, burning the midnight oil. And it was always Dr. Punchline, which is normally Don Ferguson, who would think of a fantastic ending. We would call him Dr. Punchline. There'd be three old farts who couldn't remember things, and of course they all had nicknames: Bungey, Fudger, and Woppo. Dave Broadfoot also had a character but he wasn't in all the shows. John Morgan to the very end used

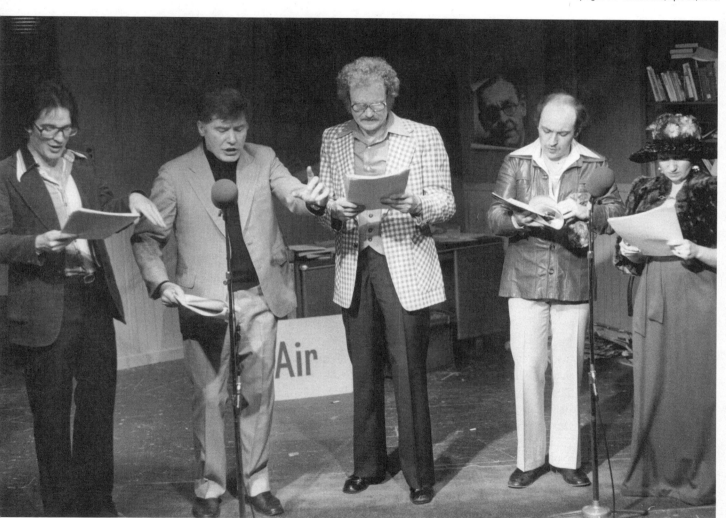

The five of us taping at the Curtain Club, April 18, 1976.

to call Roger Bungey--or Bunge. "Oh Bunge, I've got this idea ... " So Bungey and then Fudger was Don and Woppo was John. But these three--Bungey, Fudger and Woppo--they will always be that to me. And, if I really wanted to be super affectionate to Roger, I'd call him Bungey, because that's who he was, that was his little nickname. We loved calling him Bunge.

John always remained an independent thinker. Occasionally he'd say, "No, it's just not working. Leave it with me. I've got an idea," and come in the next day with a script that went off in a completely different direction, or was brand new.

If John's scripts were baroque, Rick's and Gord's were Palladian. The shape, the structure, the lines—all had been carefully considered. They intended every script they brought to the table to be a finished, polished product, ready to go on air. Of course that never—or hardly ever—happened, for a host of reasons. Sometimes they and John had written on similar topics, sometimes the casting had to be changed—we were always concerned about "cast balance," the notion that roles be evenly distributed among the cast—and sometimes a concept simply didn't work. But usually it was because the instant a script was read aloud by the actors, changes that no amount of preparation could have accounted for suddenly suggested themselves. This happens to all writers, but over their careers Rick and Gord consistently brought in material that was much closer to a finished product than was John's.

Personality played a role in this, but so did artistic ambition. John had a natural bent for outlandish invented characters, a Techni-color imagination, and no qualms about attempting the impossible. Rick's and Gord's goals were more modest. Their characters inhabited the "real" worlds of politics, television, advertising, and the media's versions of reality in general. They became masters of media parody and wrote mostly short and medium-length sketches. John would occasionally let fly with an entire half-hour adventure: Newfoundlanders floating their house to Toronto because it was the only way they could afford to own one in the Big Smoke; Russia sabotaging the United States water supply by dumping billions of litres of vodka into the Arctic Ocean (entirely and happily consumed by Canadians before a drop reaches the border); a murder mystery featuring The Demon Barber of Barrington Street.

The great strength of Rick's and Gord's writing was that it shared the ethos of the majority of Canadians. They were in pitch-perfect tune with 99 per cent of our listeners (and would continue to be later with our viewers). What was on listeners' minds was what was on Rick's and Gord's. For years, they had the unfailing ability to know what vast swaths of Canada cared about and how they felt about it. It was a gift. They were the right people in the right place at the right time.

Dave Broadfoot brought a slate of established characters: Sergeant Renfrew of the Royal Canadian Mounted Police, who embarked on absurd policing misadventures; dim-witted hockey player Big Bobby Clobber; and the bombastic Member of Parliament for Kicking Horse Pass, who sounded off about politics and social issues. He liked these characters to appear regularly, so every week at least one of them was featured in the show. The task of devising a comedy monologue for every show would daunt even a team of writers. For Dave, the task must have seemed Herculean, and the rest of us were

quick to help, with the exception of Luba, who didn't write. Soon, the Renfrew and KHP monologues and Clobber's interviews with Big Jim Harrison (played by Roger) became group efforts. Dave would bring in a script, read it aloud at the rehearsal table, and we'd all pitch in with everything from "this is a better joke if you change this word" to (in the case of Renfrew) "the plot needs to be crazier, why not have him jump out of the airplane?" A classic and oft-argued issue in the case of Bobby Clobber was, "how dumb is too dumb?" The group could grow quite hysterical suggesting misunderstandings and turns of phrases that invariably rendered Bobby's already flickering bulb even dimmer, until Dave would draw us all up short with the sharp reminder, "Hold on, he's stupid, but he's not a moron."

Dave always relied on John, who had a terrific understanding of how to set up a joke, but he began to rely more and more on Rick and Gord, too. They worked well together. All three were diligent and devoted to their craft, and as Rick and Gord began to prove themselves week after week with the quality of the material they were writing, Dave felt comfortable turning to them for help.

Eventually, the one stumbling block became Clobber. Dave had spent the bulk of his career as a one-man operation. He performed as a stand-up in clubs and at banquets and conventions, and he'd headlined his own comedy revues, which he also wrote, produced, and directed. He'd carved his own path and profited by following it. It wasn't always easy for such a self-reliant star to take suggestions, because he knew what he wanted and what had worked in the past. Clobber was a case in point. Dave would come in with a script. He and Roger would perform it. We'd pile in with assistance. Dave would ask Rick and Gord to incorporate the suggestions and do a rewrite. They'd present it at the next rehearsal, Dave and Roger would perform it again, Dave would take it home

with him, and at the next rehearsal 50 per cent of Rick's and Gord's rewrites would be gone, replaced by Dave's original dialogue. At the next rehearsal, a little more of Dave's original was back in the script. As time passed, Rick and Gord began declining to assist. In any case, as Dave got older he became less interested in performing the character, and eventually Big Bobby skated off to the NHL retirement home.

In the spring of 1980, CBC technicians went on strike, ending our season early. And then—tragedy. Driving home after work, our sound-effects genius Alex Sheridan was killed in a head-on collision with a drunk driver whose licence had been revoked and insurance suspended.

Our whole team was crushed. This was the real world shattering our comedy world. Out of the blue, no warning, undeserved, totally unexpected, he wasn't even sick and suddenly he was gone. The force of the other car's impact was so great that Alex went to his grave with his seat belt buried in his chest. Talk about unfair, and a reminder that the end can come anytime. We loved Alex and hugely admired his skill and incredible showbiz flair. But at the Catholic funeral service, none of us could help but smile when the little altar bells rang for the Eucharist—we all visualized a script with a sound effect cue, "Alex: Ting of Bell."

We'd originally shared the writing duties with John and his now-departed creative partner, Martin Bronstein, but we began to write less and less as Rick and Gord proved that they were more than up to the job. Eventually our contributions diminished to a trickle, which turned out to be a good thing, because with our time freed up, we could focus on the future of *Air Farce*, developing the show's profile, seeking opportunities, and plotting what to do next.

"Next" came soon enough. We'd moved our performing base from the Curtain Club in Richmond Hill to CBC's Parliament Street

The master at work. (*Left to right*) Alex Sheridan bemused and bewildered at Cabbagetown, 1979; onstage with John and Dave for television in 1980; showing that even if you have a dry sense of humour, sound effects can be wet work.

studio at the edge of Toronto's Cabbagetown, a tiny enclave of classic nineteenth-century red brick houses and workers' cottages undergoing rapid gentrification. The "studio," with its two resident cats and a cast of over-refreshed street people occasionally wandering in, was actually a former movie theatre that had been converted to serve as the local CBC radio station's news and production hub. The morning and afternoon drive shows, as well as the noon-hour show and phone-in, broadcast from there. It also housed offices for administration and work spaces for news.

A seminal moment in the evolution of Air Farce occurred in January, 1982, when CBC launched *The Journal*, one of the most important and influential news and current affairs programs ever produced by CBC (created by Mark Starowicz, another Loyola boy). The program had unprecedented production values and stuck rigorously to a highly formatted presentation style. The hosts sat at an anchor desk in *The Journal*'s home base main studio, with correspondents and interviewees speaking to them in a style known as a "double-ender": the host and their subjects looked directly into different cameras and directly at the home viewer. *The Journal* had a memorable and dramatic music package, too, one that was also used in a tightly orchestrated format. The show played its distinctive musical signature relentlessly, in intros, extros, and bridges. The stings created pace and emphasized the newness of the on-air product, but were used so often that they sometimes seemed to be punctuating themselves. In

general, the camera and music formatting were so rigid and so striking that we couldn't help but find them hilarious. They were ripe for parody.

The Journal launched in mid-January 1982 and we were scheduled to tape radio shows on Friday, January 29. Game on. Roger, with his background in radio and deep understanding of broadcast formatting, immediately saw the possibiliites for satire. Rick and Gord were media babies and couldn't resist either. Every one of us watched The Journal every night, each time finding more ways to have fun at the program's expense. A script rapidly took shape, Roger practically cackling with glee with each rewrite. On Friday night, the Cabbagetown audience received the piece so enthusiastically that we couldn't bear to wait a week for it to air. "A week from now," we told producer Johnny Dalton,

"the moment will have passed. It won't be fresh. The press will have had a shot at it. We've got to be first." So for the first time in its nine-year history, the show was edited overnight. Immediately following the show, Johnny left the crew to tear down while he and Bryan Hill took a cab to CBC and cut the show together over the next several hours. Then he took the tape to network master control, pulled the episode already scheduled and substituted the new one. The impact of that "Journal" show was instantaneous and enormous. Listeners called in to say it was one of the best we'd ever done, and the critics noticed, too. It began a new policy of immediacy for Air Farce, making us more topical than ever with "day-after" broadcasts, lifting the tempo of the show, and motivating us to hit new creative heights.

We continued to tape every two weeks, but from then on loaded the first half with topical material that we broadcast the next day. The show that followed a week later benefited too, because if Rick and Gord knew there was a newsworthy event coming up, they'd create material that dealt with it. The result: even the week-delayed show began to feel topical. This pattern opened up new paths of creative freedom for John. His ability to originate script on his own was nothing short of mind-boggling, but now he could give his imagination more range. And because, unlike Rick and Gord, he didn't gravitate as naturally to current events for inspiration, he could write long sketches and even began to write entire half-hour stories weeks in advance, counting on the rest of us to insert topical references and tidbits when we rehearsed, and to fine-tune the scripts prior to the taping.

This working method became so successful that we never deviated from it. In future years, even when we travelled extensively and recorded in locations such as Whitehorse, San Francisco, Inuvik, Goose Bay, and Baden-Soellingen, Germany, we always found a way to broadcast across the network within twenty-four hours.

Meanwhile, the CBC bureaucracy was busy finding new ways to make our Cabbagetown home less habitable. Every October, we returned to the studio to begin our new season of live-audience tapings, and every October we discovered the number of audience seats had shrunk over the summer. Originally, the theatre had a balcony and a large ground floor, with two aisles dividing a centre and two side sections. The transformation began with the balcony being drywalled and turned into administrators' offices. Then, news offices and mini-studios began gobbling up the side seating until a series of half-walled, half-glassed booths had replaced the seats entirely, leaving just the centre section for an audience. The final straw landed on the camel's

back in October 1983, when we returned for our first taping of the new season and found a huge broadcast pod, thirty feet in diameter and fifteen feet high, occupying the centre of the stage, as if something from *Close Encounters of the Third Kind* had magically materialized indoors. Work stations and desks for a newsroom (now relocated from the side aisles to make way for—you guessed it—more management offices) covered the rest of the stage. There was literally no place for us to perform.

To say we were upset would be an understatement. We were furious. And flabbergasted. *Air Farce* was the second-highest-rated show on the network and we hadn't even been told this was coming. It was yet another cold-water-in-the-face reminder that CBC was in the news and information business, not entertainment. It hadn't occurred to any of the brainiacs in management responsible for this renovation that an audience of CBC Radio listeners—CBC's customers, not that anyone at CBC ever thought that way—would be arriving within a few hours expecting to see and hear a show. Our crew scrambled. They moved desks to create room for our sound-effects setup and found a curtain to mask the broadcast pod and work stations. Because the actors had only two feet of lip at the edge of the stage where they could work, the crew placed microphone stands on the front cross aisle of the theatre floor. And to top off the debacle, the stage lighting had disappeared. On the bright side, however, electricity was no problem: the stage was pockmarked to its edge with duplex outlets and telephone connection boxes screwed to the floor. All afternoon, we kept tripping over them, none more spectacularly than Dave Broadfoot.

"I was tripping everywhere," he recalls, "my six-foot-two frame sprawling all over the place. We like to do quick entrances and exits. One day, walking on, as I got to the curtain, my foot caught on one of

those upright electrical outlets. I grabbed the curtain, yanked it down, hit someone else—it would have been funny if it wasn't such a damn mess. We were taping this live . . . Roger and I were talking and I said we can't go on like this."

Cabbagetown had been a great place to perform. It was friendly and convenient, within walking distance for many people, and on a streetcar line for those who used transit. The Opera Café, a charming restaurant with a mittel-European feel a couple of doors south of the studio, loved the surge in business every second or third Friday, even though when we'd first started taping, they had no idea what hit them. Out of the blue, they'd be deluged with customers on seemingly random Fridays, and then for weeks the crowds would fail to reappear. They caught on though, and always kept a table for us. We'd grab a bite between rehearsal and show time, chatting and laughing with our fellow diners, who would soon be members of our audience. It was all very informal and fun.

Cabbagetown was a neighbourhood in transition and had a full complement of down-and-outers. For them, the liquor and beer stores across the street were the main draws. One day, on the way to lunch, our crew gave a couple of bucks to one of the "Got-any-spare-change?" guys asking for food money outside the theatre. An hour or so later we came across him in the diner across the street, sitting at a booth feeding the money into a jukebox, happily listening to country and western tunes. "Don't you want anything to eat?" we asked. "It's my money," he replied, "and I'll do what I want with it." Everyone has to feed the soul.

It was clear that, without a stage, we were going to have to find new digs. CBC had nothing that could accommodate an audience, and to be honest, didn't seem to care. Fate intervened. Don was sitting in his office a couple of weeks later when the phone rang. At the other end was a woman named Penny who ran Big Brothers in Vancouver. The conversation went roughly like this:

PENNY: Hello, I'm trying to organize a fundraiser for Big Brothers, and *Air Farce* would be perfect! I know you don't always tape your shows in Toronto. Why not come to Vancouver and do a show here? It'd be perfect at the Queen Elizabeth Theatre or the Orpheum.

DON: Sorry, that's not possible, we can't afford to travel.

PENNY: Doesn't CBC pay for it?

DON: Right now they can't even afford to give us a stage curtain.

PENNY: Oh dear, I just assumed.

DON: How many tickets do you think you could sell?

PENNY: Oh, all of them. Your show is really popular here. Besides, we're an organization with lots of volunteers.

We talked a little more, and over the next few weeks a plan emerged. Big Brothers would rent the theatre and pay travel and accommodation for actors and crew. Those and all other production costs, including advertising, would be recovered by ticket sales. (This was something new. Until now, our tapings had always been free.) What remained after expenses would go to Big Brothers. Penny was up for it, we were definitely on, a new era of *Air Farce* was about to begin. Road tapings. In the next few years, we abandoned Toronto except for one occasion a year, an annual pre-Christmas show at Massey Hall.

(*Below*) Rick and Gord keep track of script changes, 1993; (*Facing*) Roger thanks the Academy while Rick, Don and Gord look on during an ACTRA Awards ceremony, early 1980s.

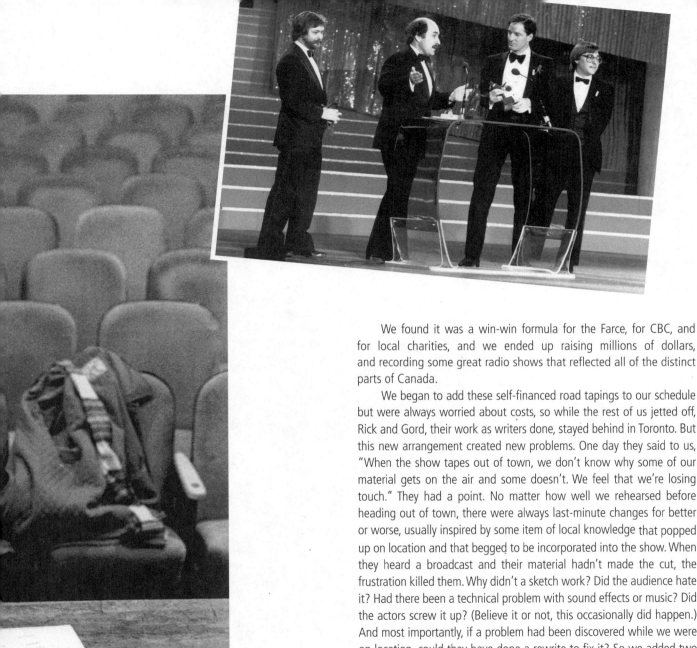

We found it was a win-win formula for the Farce, for CBC, and for local charities, and we ended up raising millions of dollars, and recording some great radio shows that reflected all of the distinct parts of Canada.

We began to add these self-financed road tapings to our schedule but were always worried about costs, so while the rest of us jetted off, Rick and Gord, their work as writers done, stayed behind in Toronto. But this new arrangement created new problems. One day they said to us, "When the show tapes out of town, we don't know why some of our material gets on the air and some doesn't. We feel that we're losing touch." They had a point. No matter how well we rehearsed before heading out of town, there were always last-minute changes for better or worse, usually inspired by some item of local knowledge that popped up on location and that begged to be incorporated into the show. When they heard a broadcast and their material hadn't made the cut, the frustration killed them. Why didn't a sketch work? Did the audience hate it? Had there been a technical problem with sound effects or music? Did the actors screw it up? (Believe it or not, this occasionally did happen.) And most importantly, if a problem had been discovered while we were on location, could they have done a rewrite to fix it? So we added two more flights, two more hotel rooms, and two more per diems to the budget, and Rick and Gord's material got even better.

We had long since passed the time when it was "Rick's material and Gord's material." It was now "Rick and Gord's material." They were so good together that we thought of them as a unit.

Written by Rick Olsen and Gord Holtam

GORD IN CONVERSATION WITH BILL BRIOUX

At what point did you formally become writers on the show?
Season five [of the radio show], I think. Season four we had the sketches that I mentioned and a few more, 'cause it happened midway through the season. Season five we worked uncredited for the entire season. I'm not sure if we were included in the rehearsals for season five ...

Why did you work uncredited?
It was a political thing with one of the originals. Martin Bronstein was still involved in the show, but very much at arm's length, so it was a matter of severing ties with him before Rick and I could be brought on. It was a little tricky, so we just went with it. We were happy to have our work performed and to get paid for it.

And you knew once the deal was done at the end of the year ...
We were hoping. It was very vague when it was going to happen. We would ask a number of times and Roger would say, "Well, we're working on it." I think there were legalities that had to be sorted. What we found over time with Air Farce was, why make something simple when it can be complicated?

Season six, it was formalized; we were contractors and we were included in the rehearsals right from the very beginning. The deal was that we would write the original pieces and be responsible for all the rewrites.

So we were quite happy to do the rewrites—as many as were necessary—because that way we would have control over our own material and that way we could maintain the integrity of the sketch. And that's something Rick and I continue to do to this day.

Dave Broadfoot says he wrote most of his monologues, but always wanted to bring them to the group and bat them around to get them as polished as possible. Was he different from the rest of the group in that way?
Yeah, Dave and John were pretty much opposite ends of the spectrum. John was very loose, "We'll get it right on the night ... " He'd be working right up until show time. Dave is very methodical, he likes to have everything ready to go before show time. Also, very, very professional. If the rehearsal time is at one o'clock, Dave is there at one o'clock. John was a little more relaxed about it.

The first time we met Dave he was very gracious. After the show—this was back in Richmond Hill again—we went backstage and we were introduced to everybody, and Rick and I are standing there going, "This is Dave Broadfoot!" And he said, "Which ones did you write again? Oh yeah, 'Three Stars,' that was very funny ... " He was very gracious and just made us all feel so at ease, because even at that time, Dave was an icon. After we established ourselves with Air Farce, Dave—and this is after he left the show, and then came back and left again—he would say, "There's a couple of things I'm working on, just want to run them by you, do you mind if I come over?" Dave would come over and he had his act, which he would be performing at nightclubs or on the corporate circuit, and he would do a Renfrew he was working on, or a Kicking Horse Pass, and he would say, "I just want to get your feedback on this," and we would think, this is Dave Broadfoot, performing his act for us—how great is that?

John Morgan, I understand, would hand off a five-minute sketch and then head up to his cottage.
He was the opposite of how Rick and I would work. We liked to come in with our first draft, in our own minds being the final draft. We had it polished, it was ready to go, the ending was there, the characters were clear, the premise was there, it was nicely typed—everything was perfect. Of course, with Air Farce, it would go through

a number of rewrites anyway, as everyone had their say and input. But we always aimed to make it a final draft. John was just the opposite. He would do a first draft, he'd type it up, he would bring it in and say, "Alright, tell me what you think?"

Now when you started writing for Air Farce, did you feel you had to find their voice and write to it or find your voice and bring it to them?

We were in our twenties then, so there's sort of, I don't know if it's an innocence or a naïveté or arrogance—probably all of those things, but we felt we had something to bring to the show. We were always looking for new characters and characters they could do.

Rick and I, when we decided this was what we wanted to do, we pretty much immersed ourselves in the area of comedy. We watched all of the Marx Brothers' movies. Rick's influence was Woody Allen; we watched all the Woody Allen movies, we read his books and his plays, and listened to the records of other stand-ups. It just snowballed. We started researching comedy right from its roots. Not just what was going on currently at the time, but going back into the forties, fifties and sixties, into vaudeville, silent movies, the British movies, the Goons, and Monty Python. We felt that the performers at Air Farce didn't have that same kind of scope. They knew what worked for them. We felt we could bring a wider range of perspective to them . . . what Rick and I wanted to do when we joined Air Farce officially, was to play to the strengths of the performers on the show.

Where did you see those strengths?

Dave had done a character called Bobby Clobber once on radio, and we were big hockey fans—Rick especially—so we wrote a Bobby Clobber sketch and gave it to Dave, and he liked it and performed it and it worked well. And we did another and another, and gradually practically every other taping there'd be Bobby Clobber, because it became a fan favourite. That was the kind of strength we were working towards.

And then Dave had done many Sergeant Renfrew's already and Rick and I thought, let's take a crack at these.

We also tried some of the Kicking Horse Passes. They were harder to do. They were hard, politically insightful gags.

In rehearsal quite often the cast would drop into a character just for fun. One that comes to mind, Roger likes to talk like a Norwegian, for some reason. So Rick and I kind of go, "Why don't we come up with a Norwegian character for him?" I think we called him Heikki Flergen Pootz or something. If the performer has an acceptance of the character, you're halfway there already, because they enjoy doing it.

I've heard Don described as the chameleon of the group.

Yeah. That would be a fair assessment. He does a lot of really good impressions. A lot of the characters, he would just drop into the character and you'd forget it was Don. Roger could, too, but his range of characters was a little narrower. It was tricky finding one for him, but when you did, like, say, Gilbert Smythe Bite-Me, the critic, it was a killer.

That wasn't so much an impression as a character, although it was based on [former Globe and Mail TV critic] John Haslett Cuff . . . Rick and I would start a writing day scanning the Globe and Mail, and Haslett Cuff was always in there. We would just laugh, because there was always a negative, hateful article. And the more bitter it was, the funnier we found it.

The unusual thing was, when he reviewed our show in 1993, he liked it! I was prepared for the worst. He said something to the effect of, "They make fun of everything." I was like, that's very astute coming from someone who makes his living hating everything. That pretty much was the show—we make fun of everything.

Did you find it a challenge writing for Luba?

Our first meeting with her back at the Curtain Club when we were introduced to Luba—"Oh yes, what sketches did you write?" It was like that, very challenging. We identified the sketches. "Hmm—no strong parts there for women." That kind of defined Luba for us, right from the beginning. You have to get the right character for her to do. But when she gets into that character—boy! She did a great Sheila Copps. We thought since Sheila Copps is very outspoken, let's exaggerate it and have her scream a lot. So her catch phrase was, "This is what I'm saying, we have to have change. DO YOU HEAR ME, WE HAVE TO HAVE CHANGE!!" Luba went for it, no holds barred. Not everyone can come out and scream at an audience and get laughs, but she was able to do that.

This is true of all of them: once they went on stage, they would throw themselves into a character. Even if they had reservations about a character, when it was show time, they went out and gave it 100 per cent. Never once, in all of the years I worked with the original cast, did they ever walk through a piece.

Air Farce on Its Own Two Feet

...AND ALMOST CALLING IT QUITS!

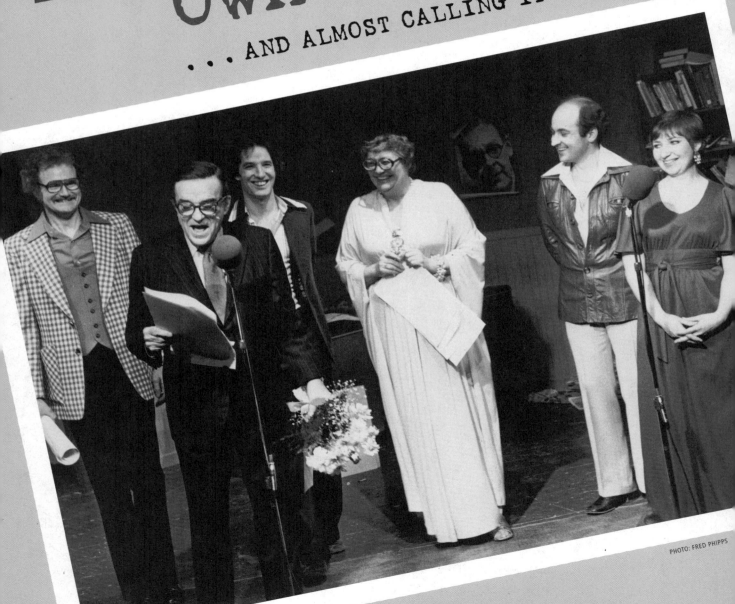

PHOTO: FRED PHIPPS

In October 1975, CBC knocked the training wheels off. We were given our own listing and our own time slot. And later that season, with CBC's encouragement, we took our first baby steps out of Toronto: at the end of April we taped two shows at the Calgary Festival. We also played host at the Curtain Club to our first-ever guest stars—Alan McFee, Earl Cameron, and Judy LaMarsh.

Alan McFee, a CBC announcer legendary for his sense of mischief and dark humour, had entertained radio audiences for many years as second banana on *The Max Ferguson Show* (no relation to Don) and as host of *Eclectic Circus*. He became our show's announcer. Earl Cameron had recently retired as reader of CBC Television's national news. John Morgan said the look in Earl's eyes when his lines got huge laughs from the audience was unforgettable: "You could see the light bulb come on as he realized that instead of sitting in an empty studio reading news all those years, he could have been doing this." Judy LaMarsh had been a federal cabinet minister and later hosted a national CBC radio show. We didn't realize it at the time, but the three of them pretty much embodied the qualifications we looked for in guests we invited on our shows for the next thirty-five years: you had to be Canadian, it helped if you worked in radio or TV, and we had a natural affinity for politicians. Judy was all three.

The following season, we taped two episodes at Niagara College in Welland, Ontario, and the year after, we embarked on our first multiple-destination tour: we opened with a taping in Hamilton; midway through the season we swung through western Canada, visiting Winnipeg, Edmonton, Victoria and Regina in that order; and in May we did our first and only prison gig. We also had a new producer. Ron Solloway had moved to a more exalted management position and Keith Duncan had been promoted to executive producer. The new head of Variety assigned a new producer, Bill Howell, on a trial basis. Don, who was already working with Bill on *Johnny Chase*, a science-fantasy series that Don had created with his friend Henry Sobotka, was skeptical of Bill's suitability, but the new head brushed aside his concerns and told us not to worry; if Bill wasn't a good fit, she'd replace him with someone who was.

Don was right about Bill. He was a published poet and a bundle of energy, but not a good match—chalk to Air Farce's cheese. We could never comprehend what rationale he used when assembling

Left) April 18, 1976. A radio taping at the Curtain Club in ichmond Hill, with special guests Alan McFee (our announcer, naking his only live appearance) and broadcaster and former abinet minister, Judy LaMarsh. Dave, Don, Roger and Luba watch.

shows for broadcast. He assembled one on the basis that every sketch in it had something to do with "conservative"—one sketch had a conservative politician in it, another mentioned the word "blue" (conservative colour), another sketch title began with the letter "C." No consideration of pace, cast balance, sketch style, or mood. He also had a favourite expression when it was time to start rehearsal or a taping. Where another producer might say, "Let's roll" or "Let's do it", Bill said, "Let's stomp this toad!" He later produced a show hosted by playwright Erika Ritter, who said he "spoke Venusian." At Christmas we trooped into the Variety head's office.

AIR FARCE: Well, we kept our end of the bargain and gave the guy a shot, but it's hopeless.

HEAD: He's an energetic guy.

AIR FARCE: He's just not on our wavelength, so let's bite the bullet and make the change.

HEAD: Sorry, I can't do it.

AIR FARCE: If he didn't work out, you said you'd find someone else.

HEAD: I don't have another producer, and even if I did I don't have another show where I can assign Bill.

AIR FARCE: So where does that leave us?

HEAD: You'll have to live with him.

Ahhhh, the respect artists get at CBC.

Our western swing would be our first attempt at recording in several locations in quick succession and we didn't want to bite off more than we could chew. So we limited our ambition to obtaining just four broadcasts, one from each city we'd visit. We'd also spend as much time as possible promoting Royal Canadian Air Farce through meetings with local entertainment writers and interviews on local CBC radio stations. The schedule made it clear this wasn't a pleasure trip:

Nov 24-26 – rehearse in Toronto
Nov 27 – fly to Winnipeg
Nov 28 – tape shows 9 & 10 in Winnipeg
Nov 29 – fly to Edmonton and re-tape shows 9 & 10
Nov 30 – promotion in Edmonton
Dec 1 – fly to Victoria and rehearse
Dec 2 – tape shows 11 & 12 in Victoria
Dec 3 – promotion in Victoria, re-writes for Regina
Dec 4 – fly to Regina, rehearse and promote
Dec 5 – re-tape shows 11 & 12 in Regina
Dec 6 – home

The shows would be edited for broadcast after we returned to Toronto.

We arrived in Winnipeg around 8:00 p.m. and checked into the hotel. It wasn't in the centre of town and nothing you'd recommend to a friend—CBC wasn't about to blow a hole in its budget in order to travel five actors and five crew for a mere radio show—but we had no illusions about our status and were happy for the opportunity to visit the west.

The hotel was undistinguished but it did provide the only excitement we had in Winnipeg—when Dave checked into his room, it was already occupied.

In Edmonton, we performed at the university. In a news sketch, John proudly announced the name of the chief newscaster, Rhomboid Muckfuster. He got the "Rhomboid" right but transposed crucial

consonants in "Muckfuster." As he heard his mispronunciation escape his lips, he stopped immediately and turned beet red. This was almost thirty-five years ago and some words were never, ever, under any circumstances uttered in public. Not on stage, not in theatres, not by comedians. There was a moment of shocked silence. The audience had no way of knowing that John's slip of the tongue was a mistake. They couldn't believe their ears. Then John broke up. Then we broke up. Then the audience broke up. Don lay on the stage laughing hysterically. Luba, wiping tears, pretended to be shocked. Roger made mock apologies. Dave told the audience, "I'm leaving now. I want to get a good seat in the police car," and walked offstage into the wings.

The weather in Winnipeg and Edmonton had been wintry. Cold winds, snow on the ground. As our plane approached the runway in Victoria, we saw the cement strip laid against a carpet of green grass. Red and yellow flowers flourished along its borders. Are you serious? Are we in the same country? Welcome to British California. That afternoon, we strolled around Victoria with John—without having to wear winter coats!—absorbing the sights past the Empress Hotel and along Government Street. Roger and John, who had never been to Victoria before, couldn't believe the fast-food outlets.

JOHN: Look at this—Kentucky Fried Chicken, McDonald's. How can the city let this happen!

ROGER: They shouldn't allow franchises. They make the place look tacky.

JOHN: It's a crying shame. These streets should be one-off shops, authentic tea rooms, not this American crap, for God's sake.

ROGER: A disgrace.

JOHN: Hey look, Rogers Chocolates.

ROGER: I've read about this place. We've got to buy some.

DON: Careful, guys, I hear it might be a chain.

Government Street was a fine place for a stroll. Across from Rogers Chocolates, Murchie's dispensed teas of the world and was happy to brew a pot (which made John happy), and further along, in a majestic older building, Munro's, a legendary bookshop, displayed its wares on polished wood shelves and tables.

Next stop: Regina. Welcome back to winter. Real winter. Fierce winds, blowing snow, temperature dropping to -40 (same in Celsius and Fahrenheit, we discovered). On the television set in the hotel room, hourly bulletins warned that exposed skin freezes in minutes. After dinner, we met with John in Roger's room to discuss the show script and plot tomorrow's rehearsal schedule. Standing at the hotel room's triple-glazed picture window, we noticed frost collecting between the layers. "My God," John wondered, "why do people live here? Don't they know Victoria is a two-hour plane ride away?" Next night, after the taping, our rented car wouldn't start without a boost. We'd plugged in the block heater, but parked the car pointing head into the wind. The local crew gave our battery a boost and coaxed the engine back to life. Whew, that was close—wouldn't want to spend the night stuck out here! Don drove, dropped Roger, Dave, John, and Luba at a restaurant around the corner from the hotel and walked back to the restaurant after parking the car underground.

DON: I came out of the hotel but must have turned left instead of right, or vice versa. After a couple of blocks I realized I was in big trouble. I'd gone in the wrong direction. Nothing looked familiar. I was lost, and suddenly very, very cold. My head felt as if it was being squeezed by a metal band. It was late, the streets were utterly deserted--not a soul around, not a light on in any building, not a single car had driven past--and suddenly I was scared. I twigged that if I didn't find shelter right away, I could die out here. It was that cold. If I collapsed no one would find me. I turned and retraced my steps, stumbled to the hotel, and considered myself lucky to make it back safely. At the front desk, I asked directions to the restaurant. It was only one block away. I warmed up in the lobby for several minutes and then joined the others for dinner. I'd never been so scared of winter.

At the end of our western tour, the others flew home, while we flew to Los Angeles to spend a few weeks with producer Norman Sedawie. Norman had been one of many CBC Television directors who moved to California in the late fifties and early sixties, CBC demo reels under their arms, to look for work in Hollywood. Norman had done well and he and his wife Gayle settled there permanently, living the southern California dream in a sprawling San Fernando Valley ranch house complete with pool, tennis court, and enough parking for the small fleet of cars required by two independent adults and three teenage sons. Norman had returned to Toronto the previous summer to produce two series for Global Television: *Mixed Doubles* and *Caught in the Act*.

ROGER: The word went out that Norman Sedawie was looking for writers, so Don and I drove up to Global to meet him. He explained the two projects he was doing and we decided we'd like to get involved. The concept of *Mixed Doubles* was two-handed comedy sketches; the concept of *Caught in the Act* was variety performance. Don and I soon found ourselves working as script editors on *Mixed Doubles*, reading submissions, asking for rewrites. Because Norman still had active business in Los Angeles and had to be there for extended periods, he also asked if we could help with post-production on *Caught in the Act*. Before we knew it, we had full-time jobs script editing one series and supervising post-production on another. Because Norman spent so much time in L.A., we were constantly couriering copies of the shows back and forth, and with the titles *Mixed Doubles* and *Caught in the Act*, U.S. customs invariably held them up, thinking they were porn. Must have been very disappointing for them to watch Canadian comedians and cabaret performers keeping their clothes on.

Our second-last gig of the season took us to Maplehurst Correctional Institute, in Milton, Ontario, west of Toronto. We didn't

want to do the prison gig, but Bill Howell booked it anyway. It was the only time we played to what was literally a captive audience and it was hard to know who suffered most, the audience, or us. Several hundred young men incarcerated for up to two years in a cinder-block fortress create an atmosphere so charged with testosterone that you can practically set fire to it. They neither knew nor cared about current events, but boy did they appreciate a female when they saw one. Luba had covered herself from head to toe in an outfit that Omar the Tent Maker would have been proud of, but every turn of her head provoked whistles, catcalls, and shouts of "Marry me!"

A month later, we again trooped into the head of Variety's office. She'd said, "Carry on until the end of the season" and we had. Once again, we asked for a replacement producer. We had sworn that we'd only do *Air Farce* for as long as it was fun, and it had begun not to be. Comedy needs to be created in an atmosphere of openness, happiness, and joy, and Bill, no matter what his other talents might have been, was simply not a good match for us. The show was suffering and we knew it, even if CBC management and the public hadn't yet caught on. We pleaded for a change. But even though the next season wouldn't begin for four months, we were told a change was not possible—not enough time to process the paperwork. For the first time, we clearly understood our situation vis-à-vis CBC: employees, no matter how inappropriate for the task they were assigned, took precedence over freelancers. Staff producers were more important than actors and writers who worked on contract because, at CBC, programs came and went but employees stuck around forever. Besides, what could Air Farce do? They couldn't take their show someplace else—there was no someplace else. The head of Variety saw no point in assuaging us.

We had a group meeting soon after and decided we had no choice—our only option was to quit. But John had a problem. His work prospects were better in the U.K. than in Canada, but with a wife and two young children he needed time to relocate. Could we do one more season? We agreed. We'd all use the year to start preparing for life after Air Farce.

John made the rounds of his contacts in England. He'd done a summer radio series for the BBC a year or two earlier called *It's All in the Mind of Johnson Morgan* (there was already another actor in the British Isles named John Morgan), in which he'd re-used some *Air Farce* radio scripts. It had been recorded in front of a live audience at the Paris Theatre in London, and John hoped he could revive it. Roger and Don went to Los Angeles. Dave refocused on his solo career. Luba began auditioning for roles in television series. Artistically, the next season was the least satisfying we ever had. We began to wean ourselves off taping at the Curtain Club but didn't find another venue that we liked as much. They were too large or too small, or too formal or too rough. We tried the Adelaide Court Theatre in downtown Toronto, a tiny venue that in the nineteenth century had been a courthouse and jail (not another jail!!!) but it was cramped and the acoustics didn't suit our needs. We'd decided not to breathe a word about our decision until the season was over and John had established himself in England, so we struggled through the year grinning and bearing it.

It was a pity to have to call it quits because, by the end of the season, we'd settled into CBC's Cabbagetown Studio on Parliament Street. And then two weeks before the final taping of the season, a miracle happened. Based partly on the success of *Johnny Chase*, which had wrapped that year after fifty episodes, Radio Drama asked Bill to

produce and direct a new series. One catch: he had to start immediately. Bill longed to work in drama, so even though it meant jumping ship with just one taping to go, he snapped it up. Stuck for a producer—for what only we knew was going to be our last taping ever—the head of Variety asked Keith Duncan to return to his old job. At Friday afternoon's rehearsal the atmosphere was relaxed and easy, as Keith, with his laid-back manner, bantered with the crew. The mood was completely different from what it had been for the past eighteen months. The good feeling continued through the dinner break and the first half of the taping. At intermission the five of us—Roger, Dave, Don, Luba, and John—held an impromptu meeting backstage. For the first time in almost two years we were enjoying ourselves. If Keith was going to produce next season, we wanted to keep doing it. The fun was back! We decided backstage at intermission that we'd return next fall and Air Farce would continue. We had drafted a note explaining the decision to quit and were going to deliver it to CBC on Monday. Instead, we tore it up.

ROGER: The lesson we learned was that no matter how strong a show is, no matter how focused, dedicated, talented, or hard-working the creators are, the tone is set at the top. The top job in any hierarchical organization, no matter how large or small, is critical. The right person has to be in it. The job definition itself determines the influence the individual who holds it wields. The fact that one person in the wrong job had brought us to within a hair's breadth of ending it . . . well, it was just serendipity that it didn't happen.

By now, John had relocated his family in England. With his children enrolled in school there, he became a commuter. For the next thirteen years he travelled between England and Canada several times a year. "I don't commute often, but when I do it's a hell of a trip," he'd say. Because he wanted to spend as much time as possible with his family and the minimum time away, he always arrived in Canada the day before he had to start work and left the day it finished. He tried everything imaginable to overcome jetlag. Sleeping pills on the flight, before the flight, after the flight. Prescriptions ending in "-ine" to keep him awake or wake him up. Staying awake for thirty-six hours then crashing. Herbal remedies. Brandy. Ultimately he devised a "natural" solution: a week before leaving England he'd begin going to bed an hour later every night to put himself on Toronto time. Being a night owl, this came easily. For the return journey, he'd wake an hour earlier every day, which meant that on the evening that he departed for England he'd have arisen at one or two in the morning and worked all day, hopefully to pass out on the flight home. Only John would consider this a sensible solution.

We headed back to Los Angeles again, still unsure about the future of Air Farce. Having dodged one bullet didn't mean another couldn't be fired at any time. Who knew what management whims lay ahead?

DON: My wife was American; she worked in Toronto as a talent agent and was very supportive of a move south. It was tempting. I'd have no trouble getting a green card, and we'd already begun the process by meeting with an immigration officer at the American consulate in Toronto. On one particular trip, Roger and I made what turned out to be a

life-altering decision. We took a meeting with one of American television's movers and shakers, Stan Daniels, a Canadian who'd won several Emmys for writing and producing one of the most successful sitcoms of the era, *The Mary Tyler Moore Show*. He was currently co-creator and one of the producers of *Taxi*, a new sitcom that was just staffing up, and he offered us a chance to write. Roger and I floated out of that meeting. We couldn't believe our luck. We drove back to the long-term rental place we were staying in--one of those classic, two-storey motels built around a pool that dotted Los Angeles at the time--and the sun had never shone as brightly as it did that afternoon. We sat on our balcony overlooking palm trees and the pool, cracked open a bottle of California bubbly and toasted our big break.

But then we started thinking more deeply about what this might mean, not just in the immediate future but beyond, and within an hour we'd decided to take a pass and return to Canada instead.

ROGER: We realized that even if *Taxi* was to become a big hit, it would still be just another sitcom in the vast American television firmament, whereas *Air Farce*, even though it was a radio show, occupied a special place in the hearts and minds of its listeners. *Air Farce*'s raw material was Canada. The subjects of its best jokes were Canadian. Its characters were Canadian. We believed that we connected with our listeners on a deeper and more meaningful level than we could ever connect with anyone on an American sitcom. If *Air Farce* had been one of several shows that did what we did, we may have happily decamped. But there was no other show like it or that had appeared ready to replace it. Besides, it was our baby. It was an ongoing experiment, like the country itself, and we weren't prepared to abandon it.

DON: Fifteen years later when *Air Farce* became a TV series, the local CBC-Television station in Toronto was carrying *Taxi* reruns at 11:30 p.m. It had won fourteen Emmys and lasted five years on ABC. *Air Farce* on TV was just getting started.

Committing to Canada

RECORDING ON THE ROAD REFINED

Having decided once and for all that our future lay north of the 49th parallel, we took steps to organize Air Farce as a business. Martin Bronstein had left Air Farce to focus on The Jest Society and on his journalism career (which would eventually take him back to Britain in 1982, to become editor of Squash Player International magazine). We bought his share of the company and set up a proper office in Toronto. No more rehearsals at Roger's house or all-night writing sessions at Don's. The corner of Gerrard and Church wasn't the most savoury of locations, but the offices at 66 Gerrard St. East were affordable and close (but not too close) to CBC.

Sixty-six Gerrard St. East was a heritage building across the street from Ryerson University. Its covered front entrance was a handy trysting place for the hookers who patrolled Gerrard Street overnight; on winter mornings, the first to arrive at the office had to watch carefully to avoid stepping on discarded condoms that lay flat, like pale, two-dimensional protozoa, on the front steps. Inside, Air Farce shared ground-floor offices with television legend Ross McLean on one side and a gay sex-novelty business on the other. Occasionally, unexpected large shipments of double-dong-dildos, leather harnesses, and other sex paraphernalia found temporary storage in the Air Farce boardroom. One year when the provincial government orchestrated its customary pre-election demonstration of moral watchdoggery by ordering a police crackdown on all things gay in Toronto, the sex-novelty business was raided and padlocked in the wee hours of the morning. But the police overlooked the company's stockroom; by the time detectives arrived the next morning to begin pawing through the owners' business records, the

stockroom had unofficially become Air Farce premises, with a prominent Royal Canadian Air Farce sign fastened to the door. The neighbours were able to carry on their mail-order business unimpeded while their lawyers pursued their case through the courts.

There never appeared to be a coherent plan behind our trips out of town to tape radio shows. If anything, remote recordings seemed to be nothing more than sporadic outbursts of flag waving or promotional zeal that depended upon managerial whim. One year we'd visit several places, the next, none. But whenever CBC decided we should make a foray or two into "the regions," we didn't need any encouragement. We were always happy to go.

Every time we went on the road we upped the ante a little. On our western swing, which was the first time we visited four cities on the trot, we sensibly limited our goal to coming home with four good broadcasts. On our next outing, which was to be a four-city tour through eastern Canada, we opted to try for eight broadcasts. We'd refined our Toronto taping schedule and were now taping episodes every

(*Left*) An early 1980's CBC publicity shot. (*Above*) Rehearsing a radio taping at West Hill High School in Montreal, Dec. 8, 1979. (*Extreme right*) Roger confers with our sound effects wizard, Alex Sheridan.

We had an inspiration: since we were going to be in Ottawa, why not build an entire show around our new prime minister, Joe Clark, the youngest PM Canada had ever had and who'd only been elected at the beginning of the summer? We'd do a "this-is-your-life-Joe-Clark" script. It would be current and feel very topical, and best of all, we could write it in advance.

* * *

two weeks. After our producer edited out chit-chat with the audience, fluffs, false starts, miscues, technical glitches, the occasional naughty word, and sketches that just plain didn't work, what was left became two very funny half-hours. We were used to that two-episodes-every-two-weeks rhythm, but taking the show to Montreal, Halifax, Fredericton, and Ottawa meant having to record eight episodes in eleven days, a considerably more ambitious undertaking.

Even though we weren't nearly as topical as we became years later, coming up with enough different material to record eight different 25-minute shows in less than two weeks proved daunting.

As we were to re-discover years later when "on the road" became the only way we recorded the show, local CBC stations could be a goldmine of goodwill and help. They provided technicians to help us set up and tear down, offered emergency repairs or loans of equipment, and usually opened their local airwaves to provide publicity

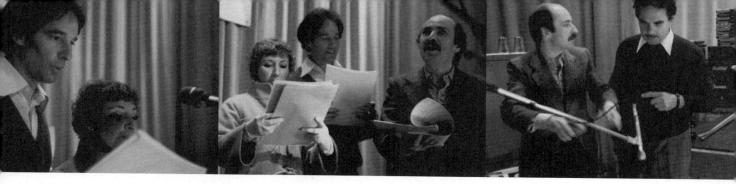

for the event. And the local morning and afternoon drive producers were always good sources of local dirt that we could weave into our scripts.

Montreal and Halifax went well. The cast was fresh, the crew full of piss and vinegar, the scripts the latest to be rewritten, and the shows themselves had the benefit of being the most recently rehearsed before leaving Toronto. In Montreal, we did a long multi-scene piece involving a mix-up between the YMCA and the RCMP, and in Halifax we recorded two long sketches, the "History of Sport" featuring Big Bobby Clobber and "The Demon Barber of Barrington Street," one of John's classic pastiches that blended crime detection and Victorian England with abundant topical references to present-day Halifax. Five days out and we'd recorded four shows. Our mini-tour was half over.

It was snowing when we arrived in Fredericton, and cold. But rehearsing in The Playhouse Theatre, we were able to ignore what was going on outside and soon we were heading back to the hotel to change for the show, and continue with rewrites. Ah yes, rewrites. The curse of the comedy scribbler.

It's a truism that any script can always be made better, but when you're up against a deadline that's going to imbed your words forever onto magnetic recording tape in front of a paying live audience, a writer-performer's mind focuses in a way that only fear can make possible. For twenty-four years on radio and another sixteen on television, the pre-show dinner break was consistently used for last-minute rewrites. And in radio, what usually needed the most attention were endings. Punchlines. A typical dinner-break discussion, an hour before taping, would go like this:

ROGER: Okay, we're in pretty good shape, but the "Burglar in the Canadian Mint" sketch doesn't have an ending.

DON: How about he stuffs $50-dollar bills in his pockets and claims he's a Quebec cabinet minister on a tour?

ROGER: Too predictable.

JOHN: Besides, I used it last week.

DAVE: One thing I learned from Mavor Moore was that if you can't end a sketch with a laugh, end it logically.

DON: So what's the logical next step here?

JOHN: Anyone want more wine?

ROGER: John, it's your sketch, what do you think?

JOHN: If I knew, I wouldn't have ended it, "ETC."

(In the real world "etc." means "et cetera," but not at the end of an *Air Farce* sketch written by John Morgan, where it was John's shorthand for "end to come." Virtually every taping had at least one sketch that, until the dinner break, stopped abruptly with the letters ETC. Sometimes, when creativity at the keyboard failed us, we'd go on stage with an "ETC". ending and just wing it. Somehow, we nearly always managed to pull it off—and the many occasions when we didn't never made it to air.)

DON: How about, the burglar is American and when he realizes he's in the Canadian Mint, decides to make a donation?

JOHN: Leave it to me and Donnie, we'll ad lib something.

ROGER: Dave, what do you think?

DAVE: I think I'll have more wine.

The Fredericton taping went well. The audience laughed in all the right places and we left the theatre feeling terrific. We were pleased that we'd pulled it off and relieved that our third stop would yield two great broadcasts. We were also completely drained of energy. The next day, Saturday, we had to fly to Ottawa, where we could take the evening off before rehearsing and recording the remaining two shows. Don, who played Joe Clark, was looking forward to the half-hour special, *Joe Clark, This Is Your Life*. But our publicist had news that was utterly unexpected: Joe Clark's government had fallen. In the next forty-eight hours, we'd have to completely rewrite the show. The wind dumped out of our sails. God knows how Joe Clark felt.

Saturday morning, we flew to Ottawa.

DON: I had a minor epiphany on that flight. I was seated next to one of our technical crew. Can't remember who. I had my seat tray pulled down with the Clark script on it, making notes for the rewrite, what could stay in, what had to go, what some of the changes might have to be. We were forty-five minutes into the flight and my seat mate was enjoying his second beer.

CREW GUY: I love this; it's the best kind of work you can get.

DON: Yeah. It's fun, isn't it? Making people laugh.

CREW GUY: (*Raising his plastic glass and gulping a quarter of his favourite breakfast drink in one go*) Nope, WODO's.

DON: WODOs?

CREW GUY: Work On Day Off.

DON: We're not working, we're travelling.

CREW GUY: I'm scheduled to travel on a day off; that's eight hours, double-time-and-a-half.

DON: (*Trying not to sound totally incredulous and utterly idiotic*) You're getting paid?

CREW GUY: Double-time-and-a-half. Sure you don't want a beer? Don't have to drive.

This was an early lesson in Canadian show-biz economics. It wasn't unusual for the technical crew, members of the all-powerful National Association of Broadcast Employees and Technicians union (NABET), to earn more money than we did. They were on the clock, but talent wasn't. We got paid the same whether the show was recorded in a studio in Toronto or 2,000 kilometres away in Yellowknife. And script fees bore no relation to how long it took to write them. One day, we vowed, we'd make more money than the technicians!

We recorded on Sunday night at Queen Elizabeth High School in Ottawa's West End. The auditorium was packed and somehow we got through both halves of the show. The first half comprised sketches and a lengthy "Air Farce History Book" (a feature we used occasionally) piece on Radisson and Des Grosseilliers. We began the second half with a few more sketches and then launched into the rewritten Joe Clark special. The audience laughed in all the right places but we hadn't managed to provide enough "right places." So, instead of getting eight broadcasts out of our mini-tour, we got seven. But the Joe Clark piece wasn't entirely lost. We salvaged as much of the good writing as we could and took another crack at it back in Toronto. At the beginning of April we aired "Joe—Lost in Time," twenty minutes long, almost an entire show on its own.

(*Left*) Taping at CBC's Cabbagetown Studio on Parliament Street in Toronto, October, 1981. The two of you who aren't in this sketch, please read along. (*Below*) Roger in full flight.

DON: I loved imitating Joe Clark because audiences enjoyed it so much. The fact that he'd almost stumbled into office--Canadians were fed up with Pierre Trudeau and his perceived arrogance--and then had fumbled away the prize by failing to seek the help of other parties, tarred him as a bit of a political accident, someone whose reach had exceeded his grasp and who had consequently been destined to cough up his achievement. But the basis of the audience's pleasure was a genuine affection for the man. He came across--and my caricature exaggerated these characteristics--as puffed up and self-important, a bumbler who tried to mask his shortcomings with inflated speech, but beneath that surface the public saw and admired a sincere and dedicated man. How much of Joe's public speaking style was a result of natural inclination I'll never know, but I saw it as affectation. He'd been catapulted from relative obscurity to become the youngest prime minister that Canada had ever had, and I think he felt the need to sound wiser than his experience and older than his years.

(*Left to right*) Recording engineer Bryan Hill, producer John Dalton and maintenance technician Keith Vanderkley with the CBC mobile in Waterloo, Ontario, April 19, 1982; Dave performs in St. John's, Newfoundland, September 26, 1982; earlier the same day, Don, Bill Robinson and John Dalton chat during rehearsal. John Dalton, a proud St. John's native, made it a priority for us to tape in his home province; (*Opposite*) The day after taping in Whitehorse, we rented a Chevy suburban and put over 1,600 km on it in 24 hours, May 5, 1983. Every Canadian should visit the north.

Joe Clark and Air Farce crossed paths several times over the years. One such time followed the disastrous rout at the polls in 1992, when Brian Mulroney's successor, Kim Campbell, led the Conservatives onto the endangered species list. The party turned to Joe to lead them back from the brink of extinction and Joe responded. We were now doing television and invited Joe to do a guest shot on the show. Like most politicians, his schedule was full, and although we taped our show twice (once at 6:30 p.m. and a second time at 9:00 p.m., in front of a different audience), Joe could only make himself available for the first one. So we agreed that if necessary we'd shoot his sketch twice. As anticipated, our director wanted a second take, so Roger, who was in the sketch with Joe, asked the audience if they'd bear with us. They indicated their willingness by applauding loudly, to which Joe responded, "Thanks, it's nice to get a second chance," which got a huge laugh. It was charmingly typical of the man: quick-witted, self-deprecatory and very aware of how the Canadian public saw him.

A year or two later, we got a call from a Progressive Conservative organizer in Ottawa. The party, now even more diminished and marginalized, would be holding a fundraiser at the National Arts Centre, and was looking for a main attraction. Would Roger and Don perform? Normally the two of us charged whichever political organization called us the same fee: at the time it was $10,000, plus expenses. But in this case we made an exception. We told the organizer, we'd do it for free, "as a personal favour for the leader." The event raised tens of thousands of dollars but didn't prevent the inevitable. Within a couple of years, the old Progressive Conservative Party was gone, having slipped beneath new waves of political change.

Over the years we'd developed a clear policy when it came to political parties: mistreat them all equally. We cheerfully described ourselves as "equal-opportunity offenders," which meant spreading the pain around evenly, bashing and ridiculing all comers and, to the extent that we were aware of our own biases and were honourable enough not to indulge them, not playing favourites.

We walked this tightrope as much for the good of our comedy as out of a sense of fairness. What makes a joke funny is that it's both logical and unexpected at the same time. If a show becomes a soapbox for a particular point of view, it becomes to a certain extent predictable and dulls one of the best weapons a comedian has: surprise. So treating all political viewpoints with equal skepticism—even cynicism—was also in our own self-interest. It enabled us to produce the best political comedy we could.

Because we were on the public broadcaster, paid for by taxpayers, we were also very aware that we had a responsibility not to get our host in trouble. (Even when CBC is doing its job superbly, there are those who hate the Mother Corp in principle.)

Occasionally during elections, respecting CBC's fairness guidelines meant counting how many minutes of airtime we devoted to each political party. It seemed quite a funny thing to do, counting the insults, but it reminded us how fortunate we were to be living in Canada. In most other countries on this planet we'd either be subject to censorship or quaking in our boots lest we offend political masters who have no sense of humour and employ hired goons. But in Canada we have to make sure that the political party with the most seats in the House of Commons—i.e., the government of the day—is the target of the most satirical comments, otherwise they're not getting their fair share of airtime!

DAVE: Do you know what they call comedians like us in South America?

ONE OF US: No. What?

DAVE: Political prisoners.

Vive le Canada!

Of course, no matter how hard you try to be fair, you're going to offend some people. In the fall of 1985, we were guests on the local Toronto CBC Radio station's phone-in show. The subject was political comedy and satire. Most people who called were complimentary (a belated "thank you" to you all) but one person, a caller from London, Ontario, was very unhappy.

CALLER: I've got a bone to pick with Air Farce.

DON: Sure, go ahead.

CALLER: Yes with Air Farce and CBC. You guys are biased. You're so obviously liberals and hate conservatives, you shouldn't be on the air. It's a waste of taxpayer's money.

ROGER: Can you be specific?

CALLER: Yes, the way you treat Brian Mulroney. He won the biggest majority in history, he's been in office for over a year and you never give him any credit, you never treat him fairly.

ROGER: You really think so?

CALLER: Your liberal bias shows all the time. He never does anything good. And you know how you show your bias? You don't attack his policies, you attack him. Personally. You never did that with Trudeau.

DON: Sir, I did Trudeau and now I do Mulroney, and I don't see how you can say we didn't make fun of Trudeau personally. We portrayed him as arrogant, whining, aloof, walking on water, giving people the finger, wearing stupid capes and floppy hats, we made fun of his marriage, we had him insult reporters, tell voters to attempt reproduction with themselves,

he was a comedy goldmine. We always made fun of him personally.

CALLER: Yeah, but in his case you were right.

Another occasion for us to test our biases occurred the year after Stephen Harper was elected. We did the New Year's special as usual, and in January Don received a personal letter from a man in Alberta, a Reform Party stalwart, who attacked us for being strongly biased against Mr. Harper and his government. The letter was heartfelt, to say the least, if you count personal insults, threats to end our careers, and unfounded accusations as heartfelt. The author also wrote that he was circulating the letter and its accusations to as many Reform supporters as he could in Alberta.

The letter accused us of using our special to subvert the new government by making twenty-four attacks, putdowns, and jokes—he'd counted them—against the new Harper government, versus taking many fewer shots at the Liberals, NDP, and Bloc Québécois. We were curious: we had one of our staff check the previous two New Year's specials, when Paul Martin was prime minister, to tally how many times we went after the various political parties in those years. The result? In both previous New Year's Eve specials, we'd gone after the ruling Liberals even more than we had the new government, and as we'd done in the most recent special, we had spread the rest of our insults proportionately among the opposition parties. In other words, we were harsher on the Liberals when they'd been in power than we were on the new Conservatives. It turned out our accuser was guilty of exactly what he'd accused us of—unfounded bias. He was partisan and hadn't bothered to check his facts. We can only guess what the people who work at *The National* must go through.

Okay, Don has the edge when it comes to impersonating Brian Mulroney.

The governing party always gets more attention than the others, not just on our show but everywhere else—newspapers, magazines, newscasts, blogs, water-cooler conversations, you name it—and for the same reason: they're the government, and as the government their policies are the ones that Canadians care about most. The attention we paid to the new guys was really a sign that Stephen Harper and his party had arrived politically, and they ought to have been encouraged by it. Instead, it seemed to make both the government and its supporters more paranoid than ever. These guys were the opposite of poor losers, they were unhappy winners. Maybe now after six years in power and a majority government, they'll learn to enjoy it!

Air Farce on Tour
OR HOW WE CAME TO SEE CANADA

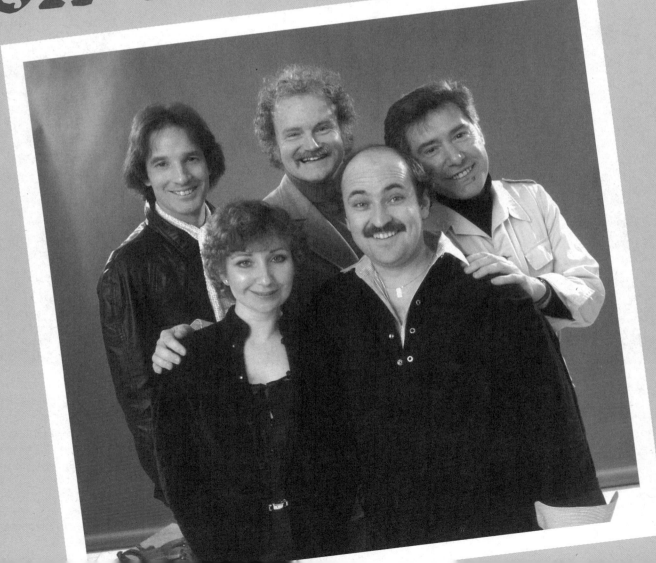

PHOTO: FRED PHIPPS

As our confidence in radio grew through the latter half of the seventies, we were always looking for opportunities to hit the boards and, by 1980, we realized they wouldn't simply come to us--we had to create them. Our first taste of performing outside of Toronto taught us there was a market out in small and mid-size communities where people were eager to see entertaining shows and as eager to pay for it. But not much of a market, because the typical venue--a smallish theatre--meant a smallish return. The trick was going to be finding a way to make a tour economically viable.

We hooked up with Peter Sever, who was the founder, president, and chief cook and bottle washer of General Artists Management Inc., a small company that worked out of offices on Queen Street East, not far from CBC's five-storey design facility on Sackville Street. Peter had once managed a dance company in Toronto, and GAMI now managed individual artists—singers, musicians, and dancers—and booked their concerts and tours. This would be a change for both GAMI and Air Farce, as Peter was accustomed to dealing with a more high-falutin' level of artist than comedians, and we'd never worked with a tour promoter at all.

If we had a picture in our minds of what to expect before we met Peter, it would have been straight out of a *New Yorker* cartoon: someone exuding elegance, sophistication, and refinement, with impeccable manners, gesticulating with a cigarette holder and perhaps sporting a monocle. Peter was none of that. Passionate about the arts, he was meat-and-potatoes all the way, kind of rough around

the edges, with the commercial instincts of a rug salesman in a souk. It was a good introduction to the economics of touring in Canada, especially for a troupe, because despite any aura of glamour that might hover over the enterprise, ultimately success comes down to squeezing every last drop of blood out of the touring stone; to have even a faint chance of making a profit, you've got to keep expenses low, low, low. If you're lucky and good, an unsubsidized troupe may even eke out a tiny profit.

Peter worked for a fee plus a percentage after expenses, so he had a keen interest in keeping costs low in order to increase profit. There was a downside to this as far as we were concerned because it meant minimal rehearsal time and maximum time on the road, "economy" accommodation and travel, and starvation-level per diems. ("What? No wine with dinner?!") We understood the wisdom of Peter's method, but we were hiring ourselves and didn't want to sleep in motels and eat at lunch counters, so after some meaningful negotiations, we arrived at a compromise: his margin wouldn't be

(*Below*) The Member of Parliament for Kicking Horse Pass entertains for the United Way.
(*Right*) Summer, 1977: Dave celebrates 25 years in show business at Old Angelo's in Toronto.

as plump as he'd have liked (note the word "plump"; no one dreamed of margins being "fat"), and we'd be more comfortable than the casts of most travelling shows.

There were five of us in the cast, plus our stage manager, Ron Ward. That's six salaries, six per diems, six hotel rooms, and—the real killer when you're flying—six plane tickets every time you move from one venue to the next. By the time the tour was over, travel and accommodation would be our biggest expense. The only people sure to make a profit were the airlines.

The stress was as much mental as physical. Daily, you experienced a new environment filled with unfamiliar faces.

New theatre, new stage crew, new airport, new hotel room, new restaurant, new local hosts who always arranged a post-show gathering at someone's house that you felt required to attend. That's why, after a week or so of a tour, there begins an unconscious, at first almost imperceptible, circling of the mental wagons. If you're not one of us, stay outside the boundary. Physical fatigue is easily recognizable. Your legs hurt or your arms are tired. But your brain never feels tired the way your body does, and it takes time for the realization to sink in that what's sloshing between your ears may once have been brain but is now cerebral mush. Mental fatigue manifests itself in ways that you do eventually notice. The primary signal is that you become incapable of absorbing new information. Your short-term memory disintegrates. You can't remember the name of your hotel, the name of the sponsor, what you just ate for lunch. You can't learn new lines, either. You become short-tempered and cranky. You can't sleep, but all you want to do is sleep. We had a day off in Calgary and no one got out of their bed. John managed a walk and was accosted by a hooker. The exchange went like this:

HOOKER: Hey mister, interested in a lady?
JOHN: Sure, do you know one?

We paid ourselves more than a normal cast-for-hire would probably earn because it was our show—we didn't believe another cast could perform it. The public wanted to see Roger, Don, John, Dave, and Luba, not people they didn't know. Dave was the highest paid, not merely because he was worth it. When we'd first broached the notion, Dave didn't want to go.

DON: It was after a rehearsal, I think. Dave and I were standing on the sidewalk on Mutual Street behind the old CBC Radio building, one of us was going to give the other a lift home, and I brought up the subject of the tour. Dave said he didn't want to do it. I was kind of shocked, surprised for sure. And disappointed. Dave was our big star. He'd been a stellar cast member of *Spring Thaw*, performed for the Queen, and entertained our peacekeeping troops in Asia and the Middle East. He wasn't just famous, he was a legend. He'd taught us so much about performing and about Canada, how could we tour without him?

Dave had been touring his entire life and knew exactly what to expect. He used two words repeatedly: "exhausting" and "brutal." At this point in his career he was doing a lot of banquets and conventions, earning several thousand dollars a pop. It was going to cost a lot of lost income to take a couple of months off and tour as part of Air Farce.

So I asked him how much he needed to earn in order to make seven or eight weeks of touring worthwhile, and he told me and that's what we paid him. We understood his situation. He was in a tricky spot. The radio show was great for his visibility and kept him in demand, so he definitely didn't want to jeopardize radio. At the same time, non-radio touring was going to eat

Fall 1979, rehearsing at CBC's Cabbagetown Studio on Parliament Street in Toronto. Note Alex Sheridan's car door in the background.

into the time he could use to earn lucrative solo money. It was awkward. He didn't want to rock the boat, but the fact was he needed more dough and he was worth it and we were happy to pay him.

There were generally two kinds of tours being booked in Canada in the early 1980s: 1) difficult, and 2) how-the-hell-do-I-get-off-this-tour. If you were a single or duo and wanted to play Ottawa, Toronto, Winnipeg, Regina, Calgary, Edmonton, and Vancouver, you could fly to those cities, do your gigs and come home. (If you were internationally famous, you'd skip Ottawa, Winnipeg, Regina, Calgary, and Edmonton and just play Toronto and Vancouver.) You had to be a big enough draw to sell out large venues and small enough in number so that travel costs weren't too high. That gave you a chance of making a buck. If you weren't a big enough draw to sell out large venues and the cast and crew added up to more than three people, you had to drive. Small venues and driveable distances meant you played Ottawa, Kingston, Belleville, Oshawa, Toronto, Orillia, Gravenhurst, Sudbury, Sault Ste. Marie, Thunder Bay, Dryden, Winnipeg, Brandon, Regina, Medicine Hat, Lethbridge, Calgary, Red Deer, Edmonton, and then looped back to Saskatoon before flying home to Toronto, leaving B.C. for another time when you weren't so exhausted and maybe, just maybe, the cast had forgotten how awful touring was and was willing to speak to each other again.

Being on CBC Radio every weekend and doing well in the ratings meant that everywhere CBC Radio was heard there was an audience champing at the bit to see us and hence a local promoter willing to book our show. This didn't mean there was a Phineas Taylor Barnum bursting with show ideas and spectacular promotion stunts in every town across

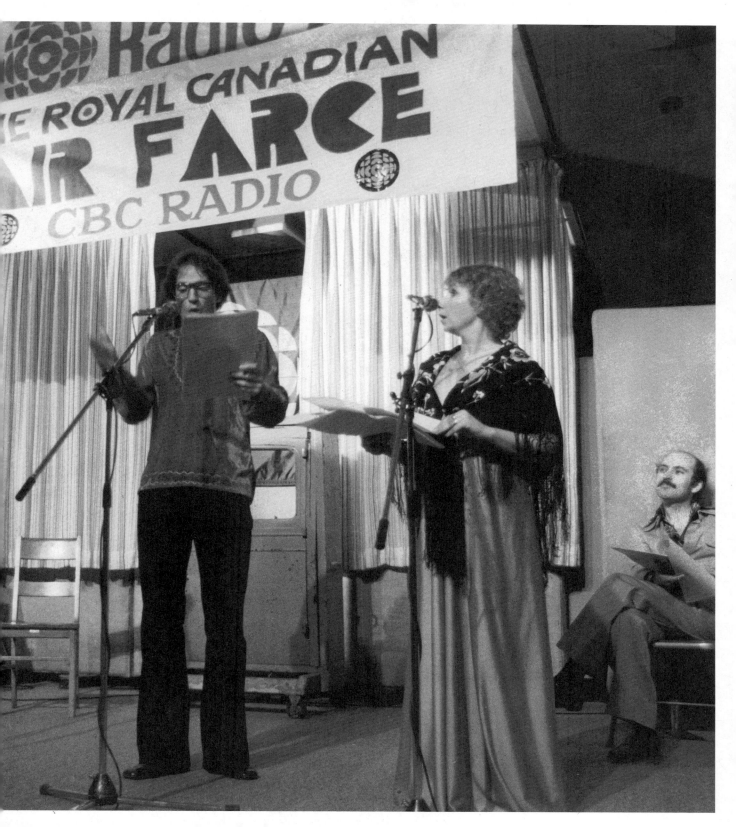

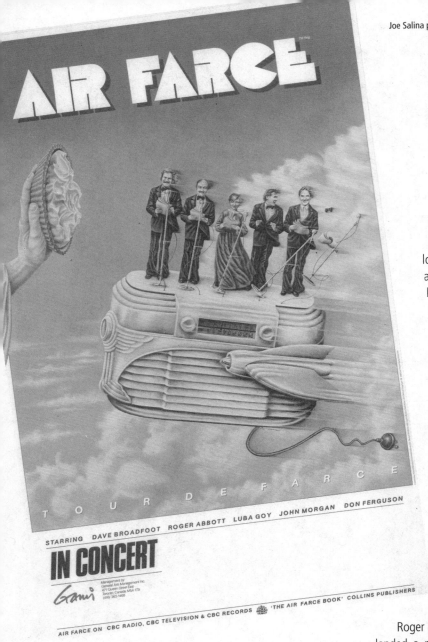

AIR FARCE

TOUR DE FARCE

STARRING DAVE BROADFOOT ROGER ABBOTT LUBA GOY JOHN MORGAN DON FERGUSON

IN CONCERT

Management by
General Arts Management Inc.
471 Queen Street East
Toronto, Canada M5A 1T9
(416) 363-1488

AIR FARCE ON CBC RADIO, CBC TELEVISION & CBC RECORDS 'THE AIR FARCE BOOK' COLLINS PUBLISHERS

local theatre company performing *Billy Budd*; on Sunday afternoon Sharon, Lois, and Bram would warble for the kids; Wednesday night it was Flutes of the Andes; and on Saturday, Royal Canadian Air Farce.

Our tour would be a bit of a hybrid. We'd play Ottawa and Kingston, but not Belleville or Oshawa; Sudbury and Thunder Bay but not Orillia or North Bay. We'd fly where distances warranted the expense, but otherwise drive. We'd do the tour in two swings—east in the fall, west in the spring—because we had to work around our radio schedule. Each swing would last three or four weeks. Peter Sever went to work booking the dates; we started organizing the show.

As Royal Canadian Air Farce, we'd never worked with a director. Part of this was our natural mistrust as writers (Why hire a director to screw up the show when you can do it yourself for free?), and part was creative ferment (Why hire a director when we've already got five in the cast?). Air Farce rehearsals were organized chaos, with everyone freely throwing out suggestions, but the free-for-all atmosphere worked and we saw no reason to discontinue it.

Roger and Don's agent (also Don's wife at the time) had recently landed a new client, the American actor John Marley. John was an established stage and film actor who'd appeared in a number of John Cassevetes' films and was best known for his appearance in Francis Ford Coppolla's *The Godfather*, where he played the craggy-faced Hollywood studio executive who awoke with a horse's head in his bed. He'd also directed theatre in New York and had grown up in the golden age of

Canada. However, practically every town did have a theatre with a "season" of some kind, and employed someone local to act as manager-impresario and keep the place humming. The usual result was a mix of performances by local and visiting theatre companies, and one-nighters by people like us. On Friday night, you'd get the

Late 1970's. Roger at his IBM Selectric.
The fastest four fingers in the group.

radio in the United States, acting in many of the era's live radio shows. He was a director, but not with a capital "D," and he understood radio performers. Perfect. We hired him.

We rehearsed in a church basement near Parliament and King, reading material aloud for John, who made notes and offered feedback. He was smart enough to realize that the material had passed muster in front of audiences. What we needed was to be moved around the stage, since at radio tapings we simply stood at microphones holding scripts.

As the CBC had its own publicists, we were never much involved with decisions they made (although we unfailingly reserved the right to criticize them afterwards). Now we were in charge and had our first big promotional challenge: devise a poster to advertise the show.

We thought about what we wanted the poster to communicate and narrowed it down to three things: Air Farce was a radio show, it was comedy, it featured the "real" original cast. We came up with our concept: the five cast members at stand-up microphones, holding scripts and mugging for an audience as they stand atop a vintage radio flying through the sky, unaware they are about to smack into a huge cream pie held by a large, divine hand. Joe Salina, an artist who worked in a variety of media, executed it as an oil painting, entirely in black, white and grey. More than thirty years later, it's still one of the best promotional images we've ever had.

* * *

(*Below*) Fall 1980. Sightseeing in the Fortress of Louisbourg, Nova Scotia. (*Left to right*) Stage manager Ron Ward, Roger, Don, Luba, an untalkative local, John and Dave.

The rigours of touring quickly became apparent. It was difficult enough if all you had to do was perform on stage, but we were ultimately responsible for all the logistics: where the troupe stayed, where they ate, how they travelled from location to location, as well as jollying local hosts and sponsors and being obliging to local media. We also had to coordinate script rewrites and cajole hotel staff to let us use their IBM Selectrics and photocopiers. A wizard of a four-finger typist, Roger could rattle off new pages faster than anyone, and used his considerable ability at schmoozing to persuade even the most reluctant small-town desk clerk to let us commandeer the hotel's printing equipment.

Touring was a great voyage of discovery, as we got to visit parts of Canada that we'd only ever seen in a high-school atlas and never

dreamed we'd have occasion to visit (with the exception, as usual, of Dave, who'd been practically everywhere, usually more than once). Knowing we might not come back motivated us to grab every chance for a side trip. Playing in Glace Bay, Nova Scotia, meant the opportunity to visit the fortress of Louisbourg. It was closed for the season, but someone made a phone call and before you could say "King Louis of France built a fort in a dumb place," a moonlighting Parks Canada employee was guiding us around. When he explained that the fort had been designed entirely in France with no consideration for local conditions, and that the fort had begun crumbling almost as soon as it was built because the local sand used to make mortar contained salt, John just couldn't accept this information. "But surely the French king must have known!" he said and repeated the phrase over and over again, making it part of Air Farce lore ever after. Unpredicted earthquake in Mexico? "Surely the French king must have known." Poor design makes metal teapots too hot to handle? "Surely the French king must have known."

In a fortress scullery, the guide drew our attention to the *pièce-de-résistance* during his summer guided tours, a pewter enema syringe. With an absolutely straight face, Roger immediately inquired: Was this a standard size? Did you need a licence to operate it? Did fortress inhabitants have enema parties? And so on. We pretended to be vitally interested while the guide struggled with his answers. And so it went for the rest of the tour. Whenever the guide least expected it, Roger would raise the subject. In the kitchen garden:

"Without herbicides, how did they keep weeds out of the vegetable patches. Did they weed by hand? Or perhaps they would use a pewter enema syringe . . . "

Local knowledge made for a better show. A huge part of our fun was uncovering facts of local life in the morning and weaving them into our scripts for the evening performance. Everywhere, we dug for local dirt the way hogs snuffle out truffles. We ferreted out scandals, oddities, history, customs, things people were proud of, issues they were angry about, and stories they preferred to hide. As a result, the trip from airport to town, whatever the town we were in, was always a hilarious ride.

The unsuspecting taxi driver or local friend of the theatre who'd volunteered to pick us up—more than once we were ferried into town in the air-conditioned comfort of a funeral home limousine—would be bombarded with questions even before we were seated and the doors closed. It always began with John (who had a couple of opening jokes that required very specific local knowledge) posing his particularly unique inquiries: What's the name of the biggest funeral parlour? And where do the hookers hang out? We'll never know how many people suspected we were necrophiliacs. Who was the local Big Tomato? How's the community's hockey team doing? Who's the local television star? (There were still local television stations then that produced shows besides news.) Where do teenagers hang out? Taxi drivers were always the best source of information. They had at least as good an idea of what was going on in town as the police did, and unlike the police, they were usually happy to chat.

* * *

Early in the fall swing of our first tour, John was robbed. He didn't like credit cards because he didn't like the idea of any institution or person being privy to his spending habits. There was a bit of fear of Big Brother in John. He referred to paranoids as "people who have all of the information." This was before automatic bank machines sprouted every few blocks, replacing phone booths as urban fixtures, and cash was hard to come by on the road, so John carried large amounts with him. We arrived at our hotel in London, Ontario, late in the evening and when we checked in, John, without a credit card, was required to pay for his room up front, in cash. He whipped a fat roll of bills out of his pocket, peeled off the required amount and stuffed the remaining several hundreds of dollars back into his pants. When he awoke in the morning, his room door was ajar, his pants were on the floor, and his money was gone. A couple of good lessons for a paranoid: one, use the chain on your hotel room door; two, don't wave fistfuls of fifties in public. John always guarded his privacy, which made appearing on stage in front of hundreds of people, let alone on television in front of millions, a strange career choice. But John was full of contradictions, one of the reasons he was always so much fun to be around.

Ron Ward was an excellent stage manager, exactly the kind of person we needed. He understood the backstage world, knew what needed to get done and extracted the best work out of the local crews—which often included part-timers and volunteers—who automatically looked to him for direction. He was a workhorse, too, usually the first up in the morning and often the last to bed, as he had the ultimate responsibility for our props, costumes, and equipment, ensuring they made it out of the theatre at night, properly packed and ready to be transported to the airport first thing in the morning. He was opinionated, and wasn't shy about sharing his views. He and John hit it off right away and by the time we began the western half of the tour the following spring, they'd become buddies.

We always ate together in the evening, during the one- or two-hour lull between rehearsing with the local crew and "call time" at the theatre, usually a half-hour before curtain. We'd set out armed with a copy of *Dining Out in Canada*, a terrific little paperback guide to the best restaurants in every mid- and small-size community in the country, naively anticipating that the road trip would be half stage tour, half gastronomical road trip. We had no idea how much work touring would be and how we'd be lucky some days to even find time to eat.

We ate many meals in hotel coffee shops, and they always began the same way. The waitress (it was inevitably a waitress, never a waiter) would appear beside our table and ask, "What would you like?" Dave would say, "Separate cheques" (we looked after our own expenses on the first tour). The waitress would look back in disbelief, the rest of us would laugh, Dave would repeat, "Seriously, separate cheques," and at the end of the meal we'd inevitably get one cheque for the entire table. It became a running joke that provoked more laughter each time Dave made the request.

We hit the road only thirteen years after centennial year, 1967, when a huge—and surprising, because largely unexpected—swelling of patriotic fervour had swept the nation in a year-long explosion of festivals, projects, and celebrations to mark Canada's 100th birthday. In preparation for, and all during 1967, citizens were encouraged to create their own centennial projects. Ottawa was generous with financial support, the provinces climbed on board, and for many communities the centennial project of choice became the building, renovating, or sprucing up of a local performing arts centre. For us, in 1980–81, it meant we had high-quality venues where we could mount our show. Provincial governments and local communities didn't want their venues turning into white elephants in the 1970s, so arts funding became a normal part of expenditures at all levels of government. Communities could afford to import travelling shows and citizens had come to expect them. On more than one occasion we gave heartfelt thanks to Canada's 100th birthday as we played in the various Centennial Halls, Centennial Community Centres, and Centennial Arenas, the enduring infrastructure heritage of 1967. The west, especially, had a host of new buildings, and in 1981 Alberta also happened to be flush with oil money. As a result we'd been able to book a slew of performances there.

Pierre Trudeau was also once again Canada's top dog, having regained power after Joe Clark let it slip through his fingers, and since political satire was one of our stocks-in-trade, we had Trudeau zingers aplenty in the show. One thing we noticed as we travelled east to west was that, in the east, audiences loved to hate Trudeau, whereas in the west they just plain hated him. Don, who played Trudeau, consequently loved the west—the jokes worked best there.

We'd begun the "spring" leg of our tour in wintry London, Ontario, on February 13, 1981, which was followed by Waterloo (February 14),

Sudbury (February 15 and 16), Timmins (February 17), and Kapuskasing (February 18), before flying to B.C. for a night in Victoria (February 20) and two dates in Vancouver (February 22 and 24). The Vancouver shows proved to be stressful. The unionized theatre crew (Canadian Union of Public Employees—CUPE) at the Queen Elizabeth Theatre went on strike and so our promoter scrambled to find an alternate venue. We performed both nights on a stage erected in a hotel ballroom. Hotel ballrooms, because they are large and lack intimacy, are never good places to play, but the show had sold well and we were glad not to have to refund the tickets. Two nights with expenses but no revenue would have been enough to put the entire tour in the red. As it was, we were relieved to do the show; it meant we could actually enjoy the day off that followed before flying out of the province.

Our mini-provincial tour of Alberta began on February 27 in Grande Prairie, an agricultural and resource town about 400 kilometres northwest of Edmonton. We'd flown from Vancouver to Edmonton, then from Edmonton's downtown municipal airport to Grande Prairie, arriving around 9:00 p.m. It was dark, windy, and cold, with snow still piled outside the airport and lining the roads. With help from a local crew, we collected our luggage, tossed it into a pair of vans, and drove to our hotel. When we arrived, we were missing a piece—Luba's stage clothes. We called the airport but the errant bag wasn't there. The airline assured us it had arrived. But after that? No one knew. It had vanished into thin air.

In every town we played, we mined local knowledge, not just to uncover local gossip or learn the name of the local funeral home. Luba also needed a place to have her hair done, and sometimes her nails, and the local presenter

was always happy to line up appointments and scare up a volunteer to chauffeur Luba around. But on the morning of February 27, we definitely needed something more: a glamorous show gown (at least one, but preferably two or more because we were at the beginning of a multi-performance swing and wouldn't get to a big city—Calgary—for more than a week). "Your mission impossible, Ms. Local Volunteer, should you choose to accept it, is to locate a fa-a-abulous gown, have it fitted, and make sure alterations are completed in time for tonight's performance." Needless to say, in Grande Prairie where country music was king and line dancing at a local watering hole was about as Hollywood as it got, there was zero demand for the sort of hey-look-at-me frock that Air Farce's Canadian-Ukrainian national treasure desperately needed.

Everywhere we played we did media interviews for local TV and radio on the day of the show, fighting down to the wire to sell the last few tickets to every performance. Usually, we managed to spread the load evenly through the cast—with the exception of John, who pooh-poohed "show biz bullshit," although occasionally he could be convinced to jaw with a local (male) newspaper reporter, whom John tended to regard as a fellow comrade-in-arms from the ink-stained-wretch tribe. Being the only female, Luba was always in demand and Grande Prairie had been no exception. But that all went out the window, as would her participation in the tech rehearsal if necessary, as we scrambled to adjust and reschedule our promotional obligations. If there was a bright light in this situation, it was that this being Grande Prairie, there weren't more than two or three stores even worth looking in, and by 10:00 a.m., Luba, accompanied by a suitably excited local committeewoman who'd been apprised of the urgency of the situation, disappeared in a cloud of car exhaust and snowflakes in pursuit of suitable diva raiment.

She returned in mid-afternoon, flushed and successful, with two new dresses safely in the nimble hands of a seamstress who'd been pressed into emergency service. Luba's factotum would deliver them to the hotel in a couple of hours. Around the same time, we got a call from the airline—the missing bag had been found! In the confusion of the arrivals area the night before, an overzealous father had snatched it off the luggage carousel, believing it to be his daughter's, and flung it into the back of his pickup for the drive home to their farm 200 miles north.

He kindly returned it the next day in time for our departure, but we could only imagine what the expressions on his family's faces had been the night before if they'd opened the purloined bag; they'd have beheld, among other items, a floor-length blue ball gown, a red sequined jacket, and the *pièce-de-résistance*—a three-quarter-length sparkler, completely covered in black, silver, and copper sequins, in the shape of a fish.

We'd been scheduled to fly from gig to gig on tiny airlines in even tinier airplanes, but after Grande Prairie the weather turned unseasonably mild and promised to remain that way. So, with bright sunshine and blue skies in the offing, we immediately changed our travel plans, cancelled the airline tickets, rented a couple of vehicles, tossed our bags into the back and set out to drive everywhere we could. Finally, this road trip was going to live up to its name—it was going to be a road trip! For the next week, we drove the length and breadth of southern Alberta, eschewing direct routes, staying off the main highways, taking side trips and dirt roads, and generally seeing as much of the province as we could. We loved Alberta. The badlands, hoodoos, cattle ranches, wheat fields, oil rigs, railway towns, prairie, rolling countryside, and the foothills of the Rockies. It was all glorious. The big skies, the openness, the wondrous spaciousness, the land all

around just waiting to burst into spring. We revelled in it. Alberta was the highlight of our tour.

Appreciative audiences helped, too. We were well received everywhere and also learned first-hand that western hospitality was no myth. People were clearly proud of their province and took great pains to welcome us. Always after the show, there'd be a small reception that someone on the theatre board had arranged. In Red Deer, a professor at the local community college invited us, the local sponsor and a few friends over to his house. We were driven to the outskirts of town and ushered into a spacious modern showpiece, all wood and glass and with a huge indoor swimming pool. How did a community college prof manage to afford this? He explained that a bunch of locals "in the oil patch" met every morning for coffee and gossip at a downtown Red Deer restaurant and he'd taken to joining them. A tip here, a word there, and in the course of a few years he'd amassed enough personal wealth to throw up these spectacular digs. Hmm, we easterners thought, there might be something to this oil-patch business, after all.

"Welcome to L.A.," said our host when we arrived at our fourth-to-last stop.

"L.A.?"

"Lethbridge, Alberta!" A well-worn local joke. We saw our first Hutterites, women covered head to toe in black nineteenth-century bustled dresses and bonnets, men in black suits and hats and brilliant bright-red or blue shirts, driving into town in huge trucks, the kind we were used to seeing haul earth and gravel at eastern construction sites.

Our Vancouver labour problems were repeated in Lethbridge. Our venue, the Yates Centre, had also been struck, and on March 2 the Lethbridge Civic Workers, who were members of CUPE Local 70, announced they'd keep us—and any patrons—from entering the theatre.

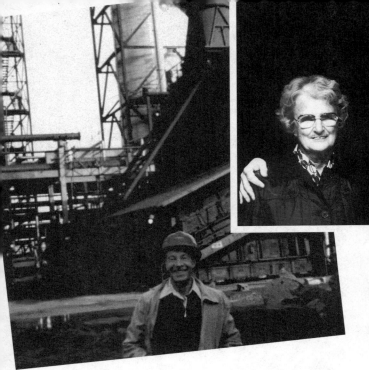

whom Don was especially anxious to see—his parents, Neil and Cecilia, who'd moved to Fort McMurray a year earlier, like practically everyone else who turned up there, looking for work, adventure, money, or all three. Neil was a retired mechanical engineer whose job was to monitor various equipment in use at Syncrude, one of two large oil companies mining the tar sands.

Luckily, the next day a court ordered that they couldn't picket on Centre property, only on the sidewalk outside it, so our March 4 show proceeded as scheduled. To say we felt uncomfortable put it mildly. But the next day the skies were clear again, the sun shone again, and the angst of the previous evening had faded. Standing at the deep gorge that used to mark the west end of town, where the Old Man River snakes under the longest trestle bridge in Canada, we lingered until a CPR freight rumbled across heading to Vancouver, and felt we'd experienced a truly Canadian moment.

Our penultimate stop was Edmonton and then on to Fort McMurray, practically the end of the world as far as non-native Albertans are concerned, and the end of our journey on this particular road trip. Sticking to our decision not to fly unless we had to, we opted for the Red Arrow bus, a 450-kilometre, five-hour-long ride straight north from Edmonton into the heart of the tar sands. Fort Mac is big now; more than 80,000 people work there, scraping the bitumen-soaked muck into gargantuan trucks and "cracking"—steam processing—it on its way to becoming fuel that we burn in our factories, homes, and cars. In 1981, it was home to only 18,000 people but already a boom town, the population having doubled in the previous five years. Among those thousands of recent arrivals were two senior citizens from Montreal

DON: My dad took me around the operation, and at one point he said, "Wait here a minute, I have to check a meter." Next thing I know, he's scrambling up the metal rungs bolted to the outside of a huge exhaust stack. I couldn't believe my eyes. He's sixty-eight years old and he's climbing smokestacks? There are thirty-year-olds who'd quit rather than do that. When he came down a few minutes later he said, "Don't tell your mom; she'd be really upset." My mother thought Dad sat in an office and sometimes drove around in a truck to inspect equipment. She had no idea he was also a smokestack monkey. Father-son bond, I never let on to her how physically demanding Dad's work could be. But she found out soon enough. A year later he had a heart attack and had to 'fess up. He retired then and they returned to Montreal where they lived another decade together, no climbing allowed.

One-third of Fort McMurray's population were Newfoundlanders, so everywhere you went you heard the distinctive lilt and accent of

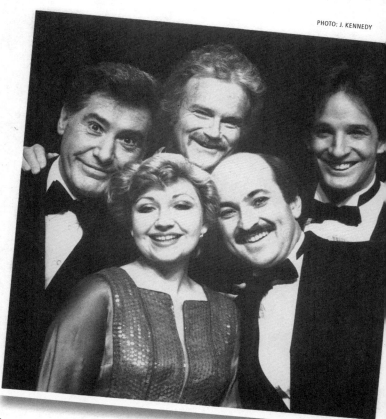

PHOTO: J. KENNEDY

island speech. At the time, Fort Mac held the single largest population of Newfoundlanders off the Rock. Because the labour force in Fort McMurray was almost entirely imported, the audience for our performance was as diverse as Canada itself. Skilled workers, many of them very well educated, thirsted for a taste of life "outside," and so cultural events were always well attended. We were a hot ticket and our show easily sold out. In fact, in this town where there was always plenty of spending money but seldom enough to spend it on, some people made a profit by scalping their tickets. When we finished that final performance, a local photographer clambered on stage and got the five of us to crowd together for a picture for the local newspaper. As a favour, he also grabbed a shot of Don with his parents who had attended the show and were as proud as peacocks —an unexpected souvenir of their two-and-a-half years in Fort Mac.

For the group shot, we bumped shoulders and grinned into the camera as we'd done for many cameras many times before, but the result was hardly commonplace. Partly because we'd just wrapped our final performance, partly because the audience had loved the show, partly because the tour as a whole had done very well, it turned out to be one of the happiest pictures of the five of us—Roger, Don, Luba, John, and Dave—ever taken. Even today it radiates the pleasure and satisfaction of making people laugh and captures the joy of performing better than any of the thousands of frames shot during dozens of studio photo sessions over the years. We all look so happy. And relieved! We'd finished the hard work and now could go home.

A Box Office Education

A STEAMY EPISODE, ENDING WITH DON AT SEA

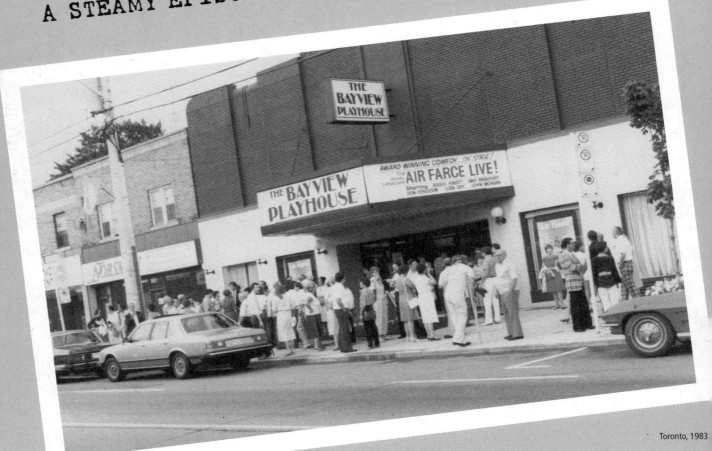

Toronto, 1983

We managed to fit the tour into our schedule by pinching time out of either end of our radio season. When you've got a radio series (or years later, a TV series), one of the Catch-22s for touring is that there's **no market for it in summer,** when you actually have time to do it. It's all about weather. Audiences attend concerts or go to theatre in fall, winter and spring, not when the days stretch out long and evenings revolve around the barbecue, assuming people are in town at all.

Any occupation where you take summer off sounds like a dream. For us, summer lay fallow because the radio season on CBC ran from October until May. Four months to relax and recharge! The big break sounds wonderful but in practice it's a big problem. No work equals no pay. You have to adapt to this early if you're going to survive.

DON: There are no salaried actors or writers. Theatre, radio, or TV, everyone works under union contracts that specify minimum payments for the type of work done. Of course, if you're a star, you don't work for minimums. But starting out, we all do. It's a fact of life. And when the work's done, the pay's done. Actors and writers are independent contractors. You do a gig, you collect your cheque, you go to a bar, restaurant, whatever, and you have a good time. Money is for

spending. The only thing you have to make sure of is that at the end of the month you have enough left to pay the rent. It's not a big responsibility and it's not complicated, but you'd be amazed how many creative types--artists, actors, writers, musicians--have trouble grasping the concept.

ROGER: Don and I were prudent. We budgeted. John always knew where every single one of his pennies was, and Dave was not only a sensible person, he also had a manager who was a whiz at keeping track of income and expenses. At the other end of the scale was Luba. She could never focus on her finances. Eventually, she got help from Paul Simmons, who was also Dave's manager. He was a godsend. Kept track of her income, paid her bills, did her income taxes. Basically, he put her on a

money diet. Luba could never say no to an impulse buy or a person in need, so there was plenty of frustration over the years on both sides, but it worked for a long time and certainly saved her a lot of grief.

DON: Roger was a born manager, and between the two of us had the lion's share of financial acumen. So he'd project what our annual income would be, and then we'd divide it by twelve to make sure we took home a paycheque every month. Even with that discipline, though, I remember year after year just barely being able to make the rent at the beginning of October, and then counting the days 'til the first pay cheque of the new radio season arrived. And I didn't wait for it to drop into my mailbox, I'd go to the CBC pay office and pick it up.

We decided to keep ourselves employed during the summer of 1983 by mounting a theatre run in Toronto. We were nervous about this for all the usual reasons. Will we write a good enough show? Will the critics hate it? Can we afford to take the chance?

The first order of business was to locate a venue. In a city frequently criticized for having too many theatres, there weren't many. The big commercial houses were too big; we'd never fill them. The government-subsidized houses didn't rent their spaces when they weren't using them because they didn't have to. That left few possibilities, but the best was the Bayview Playhouse, a property on a commercial street in the heart of a residential neighbourhood of comparatively well-heeled

professionals, precisely the kind of people we imagined would enjoy a leisurely evening stroll to their local Bijou for a fun summer evening of live-theatre laughs.

There was only one problem—the owner. Whenever we mentioned his name, eyebrows shot skyward and fingers wagged in warning. We spoke to producers who'd done business with him. Many were still angry. Clearly, the man had an unfortunate reputation.

But we were nothing if not optimistic, and besides, we dearly wanted to work that summer. So we met the owner, toured his establishment with him, checked out the acoustics, made sure there were enough large letters to spell "Royal Canadian Air Farce" on both sides of the marquee out front, fussed over a couple of broken seats, inspected the dressing rooms, discussed box office operations and financial arrangements, held our noses, crossed our fingers, and struck a deal. We'd take the theatre for six weeks, pay half the rent up front, and maintain a sharp-eyed vigilance.

The die was cast. We hired Bill Layton to design a set, his task made somewhat challenging by the fact that we hadn't written the show yet. It was going to be a series of unconnected comedy sketches, so the most important things were to keep the setting neutral, lay out a couple of distinct playing areas, and provide enough entrances and exits so the cast could get on and off stage quickly during blackouts without colliding with each other in the dark.

We hired a director we liked whom we'd known in Montreal, Joel Greenberg. In 1983, he was directing musicals and his skills were exactly what we needed. Just as John Marley had done three years earlier, Joel's job was to move us around the stage and suggest stage business that would either sharpen the comedy or provide moments of laughter that we hadn't conceived.

The week before opening, we took possession of the theatre, brought in the sets and began rehearsing in earnest. The summer had started warm and by opening night in early July had become a typical Toronto steam bath: stinking, sweltering, sweat-pouring-down-the-middle-of-your-back hot. Luckily, the theatre was air-conditioned. At least it said so in the contract. Problem was it didn't work. We complained to the owner.

ROGER & DON: You've got to fix the air conditioning. It's an oven inside the theatre, the audiences are melting.

THEATRE OWNER: (*sweat pouring down his face*) There's nothing wrong with the air conditioning.

ROGER & DON: And it's twice as hot on stage under the lights.

THEATRE OWNER: (*sweat still pouring down his face*) I've never had a complaint.

We legged it to the nearest Canadian Tire and bought a couple of gizmos to measure temperature and humidity and placed them in the audience seats. The temperature hit 82 degrees Fahrenheit (28 Celsius) by 6:00 p.m. and the humidity clocked in at 80 per cent.

ROGER & DON: Now will you admit the system isn't working?

THEATRE OWNER: It's record-breaking heat outside.

ROGER & DON: No it's not; it's in the high seventies.

THEATRE OWNER: It's just temporary; the A/C wasn't built to handle extremes.

ROGER & DON: Show us the system. We'll call a repair company and fix it ourselves.

Down into the bowels of the theatre we descended to examine the overwhelmed system. The "air conditioning" turned out to be pipes that ran through the basement under the theatre seats. No fans, no dehumidification, no cooling. Just City of Toronto tap water sitting in sweaty cast-iron pipes.

ROGER & DON: You lied, there's no air conditioning!

THEATRE OWNER: It's water cooling. Same thing.

ROGER & DON: It doesn't work!

THEATRE OWNER: You have to leave it on long enough.

It was obvious that the Bayview Playhouse's cooling system would never work and never had. We bought blocks of ice and laid them on the pipes, hoping for at least some cooling effect. No dice. We bought fans to blow the air around. Nothing worked. Audiences came to the show, sweated profusely, complained fruitlessly, and left at the end of the night looking like victims of an attempted drowning. And backstage wasn't any better. For most of the run the backstage temperature was never less than 26 degrees Celsius (79 degrees Fahrenheit), and even hotter on stage under the lights. We thought the owner would have been a fine subject for psychological study—if we hadn't wanted to throttle him. His ability to carry on as if nothing was amiss was stupefying.

He had us over a barrel. We'd paid half the rent up front, built and installed a set that was custom-made for this theatre stage, and spent thousands of dollars advertising our presence. We couldn't afford to quit and we couldn't afford to leave for another theatre, even if one had been available. We were just going to have

On stage at the Bayview Playhouse, summer 1983. For the show's finale, John would start a soulful rendition of "Send in the Clowns" alone on stage, then the rest of us would show up and prevent him from continuing. (A public service, we'd heard him sing before.) (*Right*) Don in Louis XVI garb playing Prime Minister Pierre Trudeau. (*Bottom*) *Air Farce Live!* became an album and a special for Global Television.

to tough it out and pray that audiences kept coming despite the sweltering heat.

Fortunately, the reviews were good—in the *Globe and Mail*, Ray Conlogue wonderfully described Luba as "that distillation of girlishness"—and we were selling out. At the end of the first week, after the Saturday night show had wrapped and the last of the sweat-soaked crowd had trickled out of the lobby, Roger went to the box office, as pre-arranged with the owner, to do the weekly reconciliation with the manager and collect the receipts for deposit at the bank across the street.

> **ROGER:** Everything ready? I'm dying to get out of here.
>
> **BOX OFFICE MANAGER:** Not quite.
>
> **ROGER:** Well, let's do it, I want to hit the night deposit box before I go to the bar, and boy could I use a drink.
>
> **BOX OFFICE MANAGER:** It's not ready.
>
> **ROGER:** Give me the rest of the week up to today to check, while you finish reconciling tonight.

> **BOX OFFICE MANAGER:** I can't.
>
> **ROGER:** It should be easy; we were sold out tonight.
>
> **BOX OFFICE MANAGER:** There isn't anything.
>
> **ROGER:** What?!

The cash, the credit card receipts, everything was gone. The owner had come by after the show began, scooped the entire week's receipts and departed. We were stunned. There was nothing to do but wait until Monday and confront him then.

Monday came and we had another surprise. The owner had apparently winged off to Paris on vacation and wouldn't be back for a couple of weeks.

For the next two weeks—and for the remainder of the run—we collected the box office receipts every night at intermission and deposited them in the bank right after the show. When the owner returned from Paris, he acknowledged no malfeasance, only that there'd been some confusion in the way box office protocol had been managed. It was just an issue of timing, a matter of how and when the box office receipts were to have been disbursed, that's all. Nothing untoward about it. His inability to admit wrongdoing was a marvel. He calmly suggested that we simply not pay rent until this naturally

occurring fiscal imbalance had been repaired. His tone was all "This is business as usual."

Two things saved us from financial shipwreck. The show was a hit, so every week there was a small profit, and most importantly, we'd committed to a six-week run. If the run had been shorter we'd never have been able to recoup the money he'd taken at the end of our opening week, because there wouldn't have been enough weeks left to withhold rent payments. Less-savvy producers mounting a shorter run of a show with less box office appeal would have been ruined. It was an experience we would never forget. The theatre was actually a good one (if you didn't need air conditioning), well maintained, and in a fine location. But dealing with the owner was a disaster, and we joined the chorus of bamboozled producers in Toronto who'd run afoul of him. Never before or since did we encounter a situation so difficult.

But we liked working during the summer. It kept us sharp, visible, and employed. The careers of self-employed people, especially performers, tend to veer wildly between too much work and none at all. And a steady gig versus

THE ROYAL CANADIAN
AIR FARCE

ROGER ABBOTT · DAVE BROADFOOT · DON FERGUSON · LUBA GOY · JOHN MORGAN

four or five months of unemployment appealed to what practically every freelancer wants deep down—security. There was also the danger, even for a group enjoying the success we were, that offers of individual employment might come along, especially during a lengthy fallow period, and the group could, almost by accident, drift apart. So we immediately began thinking about the summer of 1984. If we were going to mount a show in Toronto, where would we do it?

While researching venues for the 1983 show, a successful independent producer, Marlene Smith, suggested we look at Young People's Theatre, a 468-seat house downtown near St. Lawrence Market. We'd visited it in March. After almost $700,000 of renovations, it had first-rate seating, lighting and sound systems, and by coincidence the theatre company's publicist was Julia Drake, who'd worked at GAMI during our national tour.

We'd chosen The Bayview Playhouse over YPT because it had more of a showbiz feel: a big marquee over the sidewalk and a bar on the second floor balcony. And it was in the middle of a residential neighbourhood; patrons could stroll over after dinner. Even though YPT specialized in theatre for children and teens, it felt a bit earnest and lacked curb appeal. After our Bayview experience, however, it looked better than ever. And it had air conditioning!

But not all of the drama that next year happened on the YPT stage.

DON: Just before Christmas, 1983, my father spoke to me of his childhood. I'd told him I planned to sail across the Atlantic with a friend in the spring, and he said, "You love sailing, just like your grandfather." My father had never talked about his childhood and I knew there was a secret buried in his past. My grandfather was a sailor? The story emerged. His mother had fallen for a sailor and had become pregnant. The sailor, a Brazilian national serving as an officer in the British navy, had died during a sea battle before they could marry, and my father had grown up in Edwardian England under the moral stigma of illegitimacy. I felt as if a gong had been struck in the distant past and I was one of the resonances vibrating in the present. Like his father, I loved sailing, and all my adult life had been fascinated by Brazil; I had never suspected a family connection.

After taping radio shows in Windsor on March 15, 1984, we took a nine-and-a-half-week break. Next taping: May 22 in Yellowknife. A friend, Brian

(*Left*) Poster of our 1984 show at YPT; (*Right*) April 1984. Arr, matey! Pirate Don aboard Nordvag, dockside at Horta in the Azores.

Otter, had bought a 64-foot wooden boat in Stockholm and needed help sailing it back to Canada. So on March 16, I flew to Stockholm to join him and a couple of other hardy souls who had signed on for the mission. The vessel, *Nordvag* (North Wave), had begun life as a fishing boat in the North Sea, and was later converted to a sailing ketch, albeit one with a 200-horsepower Volvo diesel marine engine. When I arrived, *Nordvag* was hauled out so we could prepare her for her long journey. Daytime temperatures seldom went above freezing. We lived onboard, thanks to an oil furnace that fired away night and day. We cleaned, scraped, painted, checked systems, built food storage for the lengthy sea journey ahead, bent on *Nordvag*'s heavy Dacron sails with cracked, bleeding fingers, and finally, after weeks of prep, we provisioned and set off on a bright afternoon into the cold Nordic air.

The sea ice hadn't broken up and we needed 24 hours to navigate the 25-nautical-mile archipelago between Stockholm and the Baltic Sea. In the Baltic, the decks froze and we tugged ourselves across it on a rope, crawling on hands and knees. Off of Kalmar, we ran aground on a sandbar after misreading a channel marker in the dark and had to be towed off by a tug in the morning. We motored through the Kiel Canal and out into open water, guided by beautifully decorated navigation buoys, each hand-painted to look like chocolate soldiers from some nineteenth-century operetta. Using German Admiralty charts (shades of World War Two!) we sailed across the North Sea to England at night, through clusters of offshore drilling platforms lit up like Christmas trees.

Then we turned south for the Azores, where we arrived a week later, the breeze blowing warm on our faces. We spent Easter week moored along the quay in Horta, on the island of Faial. It's a transit point for people crossing between Europe and North America, and apart from an undercover cop who followed our group everywhere, volunteering to either sell drugs or buy them from us, the islanders were warm, friendly, and helpful. One of the highlights for a crew grown accustomed to paying three American dollars for one tasteless, weak beer in Stockholm, was Pete's Bar, where you

slapped down two bucks and got three Heinekens in return. Sailor's paradise. We departed Easter Sunday morning after a local butcher drove to the quay with his son and delivered a half-dozen frozen chickens. We had no refrigeration, so they'd be cooked and eaten in a day or two, the last "fresh" food we'd have for three weeks.

I love being on the open ocean. There's nothing like coming up on deck for the first time each day, looking round, and seeing nothing but the flat 360-degree sweep of horizon that surrounds you, water below, sky above. It was a tonic. The routine at sea settled my mind and prepared me for the changes I'd face when I returned home.

By the time we made landfall in Bermuda, I'd run out of sailing time. I flew to Toronto, began rehearsals on May 18, and flew with the *Air Farce* cast and crew to Yellowknife two days later. Yellowknife was the perfect place to re-enter Canada after months away and weeks at sea. The sun didn't set at that time of year; at 2:00 a.m., the sky would dip to dark blue and then brighten again by 5:00 a.m. A high-school friend lived there and I spent time visiting him and his family. School was done and the neighbourhood kids ran freely, sleeping on stair landings and couches at whoever's house they happened to be visiting when exhaustion kicked in. In the backyard, we strolled down to Great Slave Lake and listened to the candle ice

in the bay crackle and snap in the warming sun. Overhead, geese and ducks flew in from the south, squawking in the crystal air. It was magical.

We premiered our YPT show at the beginning of July and on July 7 my daughter was born. The event changed my life forever and I can never thank her enough for being born, or her mother enough for making it possible.

Yellowknife marked the end of the 1983–84 radio season. The YPT show garnered solid reviews and we settled in for the summer. For the first time, we incorporated video, using two large screens at either side of the stage. We realized that we were responding to one of the challenges of having done well in the past—you can't rest on your laurels, you have to keep doing well. As we discovered on television years later, getting to the top of the heap is only half the battle. You have to fight every day to stay there.

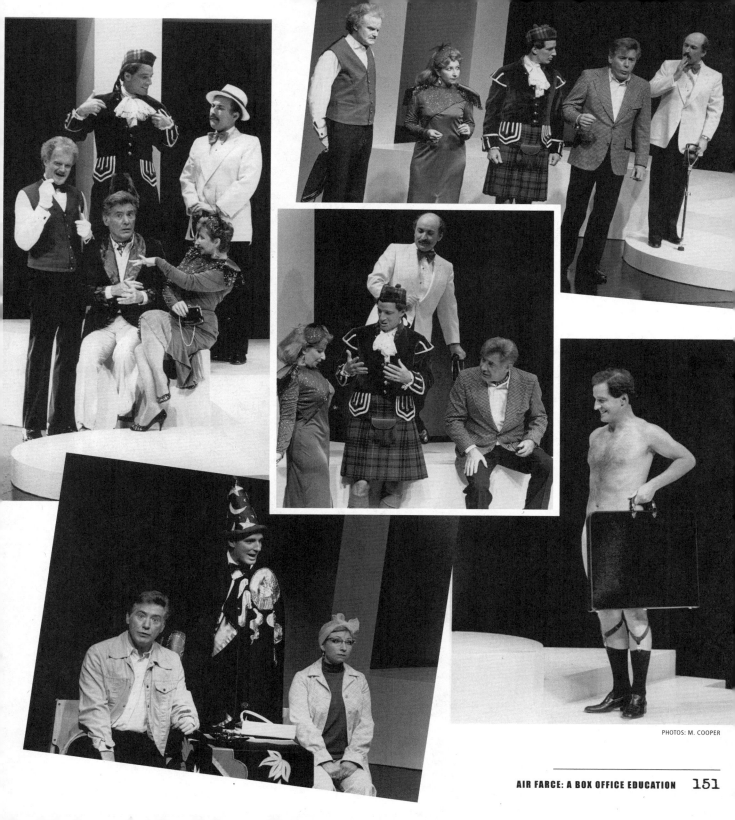

The Golden Era

TOURING AND TAPING IN THE 1980s

PHOTO: MARTIN (PHARLOW?)

1980. A break during the shooting of our first TV special. (*Left to right*) Rick, Gord, Roger, Luba, director Trevor Evans, Don and John. A running gag throughout the show was "don't miss the big finale, our famous Chinese restaurant sketch." The punch line was that as soon as we started it, we ran out of time and so the audience never saw it.

In 1980, CBC Television took a chance on us--could these radio guys make the move to TV? Our first effort rocketed to near the top of the weekly ratings, placing third behind *Hockey Night in Canada* and an Anne Murray special. Could a series be far behind? CBC offered us ten half-hours. We were reluctant to accept because the proposed format wasn't really us, but it was a take-it-or-leave-it proposition. We blended radio performances--glammed up to a fare-thee-well on a glossy stage decorated with lacquer, neon, and two gorgeous female models--with traditional-style television sketch comedy. The result was mixed, but good enough to be offered a second season, which we wrote but never got a chance to shoot because of a CBC technicians strike. Instead, CBC proposed another special, to be shot in Vancouver.

Why would a Toronto comedy troupe shoot a TV special in Vancouver? We wondered the same thing. CBC's Toronto studios ran at capacity and Toronto desperately needed a new facility, but this is Canada and tax-payer dollars have to be spread around, so a spanking-new studio was built in Vancouver where there were no productions to go into it. Toronto technicians worked overtime while Vancouver technicians were being paid to sit on their hands. Not good. Solution? Dispatch a Toronto production to Vancouver. Air Farce, come on down!

We thought going to Vancouver was dumb but happily accepted the gig. However, we couldn't stop thinking how expensive this was going to make the show.

We wanted to do topical comedy, but once again that was impossible. We had to deliver the script in September so that sets could be designed and built in November, ready for us to shoot the show in December, which would be edited—in Vancouver, more hotels and per diems—in January and February and broadcast in May. Nine

1980. CBC's Studio 7 in Toronto. Stage manager Shane Strachan and King Louis XV (Dave) take a break.

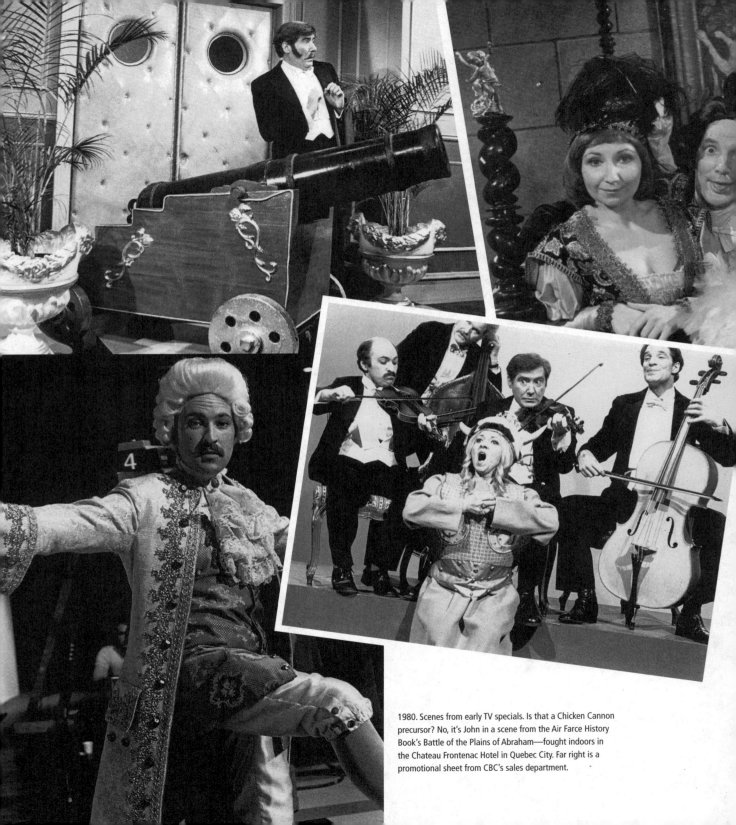

1980. Scenes from early TV specials. Is that a Chicken Cannon precursor? No, it's John in a scene from the Air Farce History Book's Battle of the Plains of Abraham—fought indoors in the Chateau Frontenac Hotel in Quebec City. Far right is a promotional sheet from CBC's sales department.

PHOTO: MARTIN FRANKLIN

28:50 minutes
Videotape

LIGHT ENTERTAINMENT

The Air Farce

Canada's best defence? Its Air Farce!

Now a series after a highly successful initial special, the Air Farce lets loose its wild humour through the talented persons of Dave Broadfoot, Luba Goy, Don Ferguson, Roger Abbott and John Morgan. And of course the stage is peopled by far more than five talented comedians. There's the wonderfully prissy Amy de la Pompa, stunned

hockey player Bobby Clobber, Luba Goy's unintelligible cleaning lady, the unctuous undertaker Hector Baggley and bumbling Sergeant Renfrew of the Royal Canadian Mounted Police.

The Air Farce pokes fun at every imaginable situation, appearing in every possible guise and disguise. From Caesar's court to a Shakespearean hamburger joint, the "farceurs" create havoc and laughter, craziness and fun.

months from start to finish. Not much chance of us playing to our strength, then. When we began rehearsing on the sets we discovered that one of our sketches—a scene set in a booth in a restaurant—just wasn't as strong as we thought. It didn't seem funny and we couldn't make it work. Besides, we had another, much better idea that we liked a lot more and were dying to do. Our director, Trevor Evans, said, "You can do whatever sketch you want, as long as it takes place in this restaurant." Then he added, "Face it, TV specials get written by the carpenters."

Looking back at our earliest attempts at television, Dave observes that Trevor's achievements as director for the wildly succesful Wayne & Shuster specials weren't the best preparation for work with Air Farce: "Air Farce I think is more cerebral. Frank and Johnny were wonderful performers and wonderful to work with. I loved them both. Very, very bright men, well educated. When they were kids at the University of Toronto they were doing Gilbert & Sullivan. Very erudite, yet they had a child-like thing about them. Trevor was just not on our wavelength."

For the TV shoot, the full cast flew to Vancouver on the same flight. We met at the gate but Luba, as usual, was late. The rest of us boarded together when our rows were called. No sign of Luba. We sat on the plane, eyes glued to the entrance door, wondering how close she'd cut it this time. We imagined her chatting merrily to the airline employees at the gate, oblivious to the time, while they tried to steer her aboard. We sighed. 'Twas ever thus. She wouldn't appear until the last second.

Then the door closed, we were told to buckle up, and the plane pushed back from the gate. No Luba. We shook our heads. The plane taxied to the runway and waited in line on the apron next to it. Then the engines changed their pitch and we changed direction. The pilot came on the P.A: "Sorry ladies and gentlemen, but we have an equipment problem. Our radar isn't working and we have to return to the gate." We taxied back to the gate and after a minute or so the door swung open to admit a very sheepish, very tiny-looking Luba. She was clearly an emotional wreck. (We could only imagine the condition of the gate agents after telling her she'd missed the flight.) She stepped

(*Clockwise from top left*) Vancouver, December 1981. Luba backstage in a favourite costume; Queen Elizabeth II arrives in Burrard Inlet; Luciano Pavarotti (Roger) gets pied; Luba, Roger, Dave and Don; John enjoys a glass of wine and a smoke outside his dressing room—would Amy de la Pompa have looked like this?

gingerly onto the plane. Her eyes were puffy and red, her makeup smudged: she looked like a raccoon that had been soaked by a garden sprinkler.

LUBA: I had a boyfriend at the time, and he rented a car. Then, in the rain the windshield wiper flew off so we couldn't see the highway. He took a shortcut and got lost. We couldn't see--we were blinded. And I knew I was going to miss the plane to Vancouver. We were like totally lost, trying to get to Pearson airport. Finally we got there and I said I know I missed the plane, when is the next one?

Oh, they said. The plane has been delayed. It's on the tarmac. I think we can probably get you on board. It's highly unusual for us to open the gate, but I think we might make an exception because you're Air Farce. Then they have me in this vehicle-- I'm zooming through the airport, it is pissing rain, it's been delayed--a huge 747 with two hundred million people on board . . .

They open the door . . . and I slink on. "Hello gentlemen . . ."

To this day a couple of us are convinced that, when Luba arrived at the gate and found the flight had departed without her, she emitted such an ear-splitting howl that it knocked out the airplane's radar.

Punctuality was never Luba's strong suit. Usually the fault lay with the cab company or the weather, but not always.

LUBA: It's the way of the world. Something always happened. For example. It was Thanksgiving and we had a rehearsal. We had to rehearse until three o'clock and then we have turkey with our families.

Well, I wake up in the morning and my cat has eaten my parrot and all that is left is the head.

And I was so upset. I had to clean up the feathers and the little head.

I arrived late for rehearsal and it was like, what's your excuse this time?

The cat ate the bird.

And it's Thanksgiving. I was so upset.

They used to sit on each other's laps.

The parrot used to swoop down and one day the cat got it. It's all my fault. He did not want

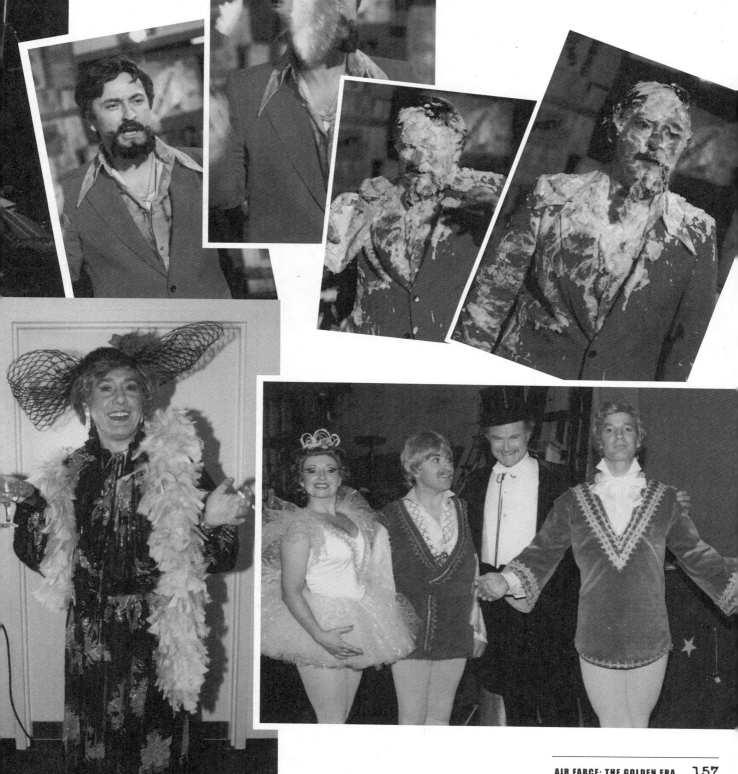

PHOTO: V. NOGUCHI

to stay in his cage. The
cage was very high.

I kept the head for
a year in the barbeque.
I didn't know what to do
with it and then I had
to bury it in the garden.

His name was Gonzo and I could do anything
with him. He used to play dead bird. I would say to
him (in Ukrainian), "dead canary."

He was actually my son's bird.

Dead and feathers everywhere and every feather
had claw marks and there was no body. She ate Gonzo.
Oh yeah. "How could you eat the bird, I feed you!"

Through the 1980s, Air Farce enjoyed what we recognized and
appreciated at the time as a golden era. We'd begun airing our radio
shows almost as soon as we taped them. Topicality made us better. It
provided focus for our writing and an incredibly strong connection to our
audience. Their world was ours, ours was theirs. We laughed together at
events as they unfolded. Losing our stage at the Cabbagetown Studio
and successfully charging admission for the Vancouver Big Brothers
taping had been a blessing in disguise; it opened a whole new way of
producing our radio shows, one we hadn't even known was possible.
At CBC, we never considered charging admission; in fact, CBC policy
prohibited it. But this was a new beast. Air Farce partnered with a local
charity to rent a venue and cover all production, promotion, advertising
and travel costs. The local charity was responsible for ticket sales, with
lots of help from us.

It was literally a win-win-
win situation. Winner #1—
the charity. The charity raised
money. Equally important it
also raised awareness for its
cause, because beginning
several weeks before the
taping we supplied local CBC radio with personalized, entertaining,
custom-made promos five days a week for both their morning and
afternoon shows to promote the big event. Winner #2—CBC. The
local CBC station scored major brownie points for being a caring
community member, and the CBC network broadcast a show that
filled the corporation's mandate to a "T" by giving cities and towns
from every corner of Canada high-profile national exposure. Moreover,
people who never listened to CBC in their lives now listened to *Air
Farce*. Winner #3—Royal Canadian Air Farce. We made our best
shows ever. We were no longer dependent on CBC to provide a
suitable venue. Even when we came back to Toronto to do our one
taping there a year, we rented Massey Hall. The new business model
served us for the rest of our time on radio. Having to get out of Toronto
proved to be the best thing that could have ever happened to us.

We favoured local charities. They were frequently bootstrap
operations that lacked the resources to raise large sums of money
on their own, and because they weren't branches of large national
organizations, the people involved usually felt a very strong
connection to their cause. It was a personal passion, not a job.
Without planning it, the charitable causes we connected with
evolved into two broad categories, arts and health. Arts ran the
gamut from theatre companies to performing arts centres; health

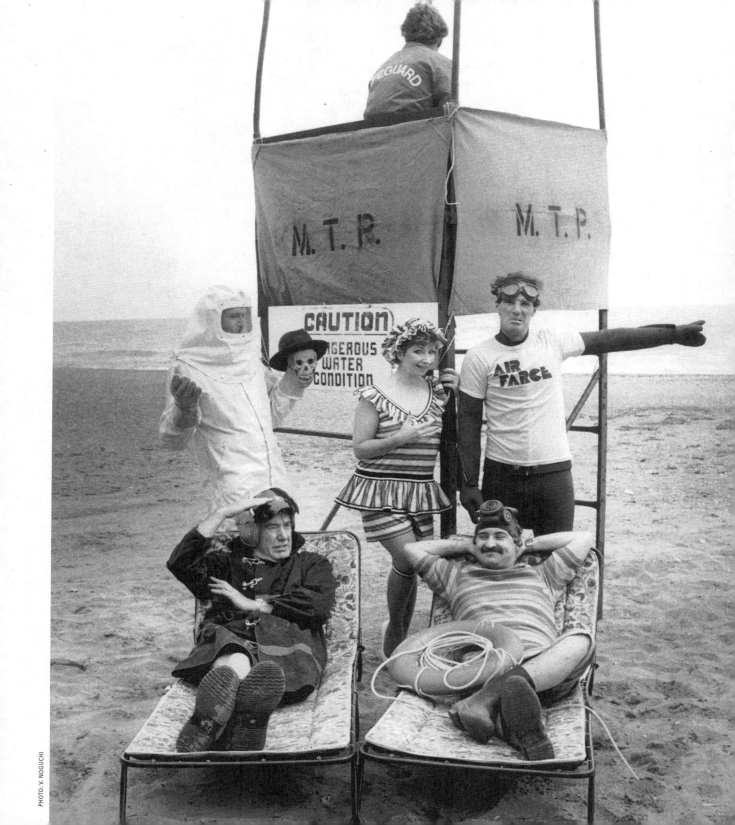

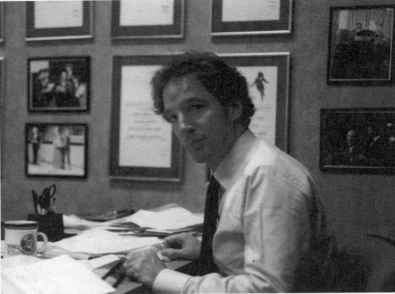

included children's hospitals, hospices, and women's shelters. We worked closely with them all to ensure the success of the events. Our own experience in theatres and on tour proved invaluable, and Roger, ever the brilliant organizer, created *The Air Farce Radio Taping Handbook*, a how-to guide we sent to organizations who wanted to work with us.

We'd often be in town for less than forty-eight hours, arriving the evening before the taping and flying out the morning after. In that time, we did as much publicity as we could, with one or two of us appearing live on the local CBC radio morning show, while others might do phone-ins to private stations or do a quick hit with a local television news hour. Usually we made time for at least one newspaper interview, too. While the cast promoted and writers did rewrites, the crew set up. A typical taping day schedule in the theatre looked like this:

9:00 a.m. – 1:00 p.m. — Load-in and set-up
1:00 p.m. – 2:00 p.m. — Break
2:00 p.m. – 6:00 p.m. — Technical rehearsal
6:00 p.m. – 7:30 p.m. — Rewrites and break
7:30 p.m. – 8:00 p.m. — Audience seating
8:00 p.m. – 8:15 p.m. — Warm-up

8:15 p.m. – 9:00 p.m. — Tape first show
9:00 p.m. – 9:20 p.m. — Intermission
9:20 p.m. – 10:05 p.m. — Tape second show
10:05 p.m. – 11:30 p.m. — Tear-down, load-out

Johnny Dalton, a charming Newfoundlander whose enjoyment of life was infectious, produced *Air Farce* for most of these golden years. One of Johnny's great gifts was to make work fun. He was smart, focused, organized, patient and a great manager of people. When he joined us in 1982, he brought no agenda with him. He said later that he was so intimidated coming from St. John's to *Air Farce* in Toronto that he decided to keep his mouth shut and do nothing but observe for the entire first season. But he was on our wavelength from the get-go, and like many good leaders in creative fields, he saw his role as creating the best conditions for others—writers, actors, technicians— to do their work. He produced the radio show until 1987 and we were sorry to lose him. Always one to choose quality of life over work, he moved to CBC Halifax because the pace was slower and more relaxed and it would be the best place to bring up his children.

Luba once commented how lucky we were to be doing comedy because the show was "angst-free." She was right. The audience

Mid-1980's. In our offices at 66 Gerrard Street East. Long-time assistant Caroline Harrison's official job title was "merry andrew," an archaic term for a clown. But Caroline especially liked it because a merry andrew is also "a mountebank's assistant."

arrived at the theatre in a joyful mood, knowing they were going to have a good time. And no matter how tired, cranky, jet-lagged, tense, or stressed the cast and crew may have been getting everything ready for 8:00 p.m., all that was forgotten the moment the show began.

When the theatre's house lights dimmed and the cast stepped out on stage, we entered into an unspoken conspiracy with the audience. They were now part of the show. They had a job to do. And they knew it. There was no laugh track for the evening's performance (and hence for tomorrow's and next week's broadcasts) unless they supplied it. They knew we counted on them to respond as much as they counted on us to give them reason to. It was that two-way street again. And they did more than meet us halfway. To help a joke along, we might add a physical gesture that only they could see. Or we'd make an exit with an exaggerated walk that the home audience would never be party to—except, perhaps, to wonder what it was that caused the theatre audience to laugh.

Because we were four people standing at microphones on large stages in big theatres, we employed a lot of physical gesture, whether reacting to what others were saying or to emphasize our own performances. To patrons in the balcony we appeared not much larger than dots, and we wanted to make sure they got all the jokes, too. Big stages, such as the Jubilee Auditoriums in Calgary and Edmonton, are sixty feet across and forty feet deep. You can drop a curtain to reduce the depth, but with the actors' microphones thirty feet from either wing, there's a lot of ground to cover when making an entrance. Usually we segued as seamlessly as possible from one sketch to the next, so there was never a lull in the proceedings—unless we wanted a character to make a solo entrance. Imagine a sketch involving Roger and Luba has just ended. They exit to applause and for a moment

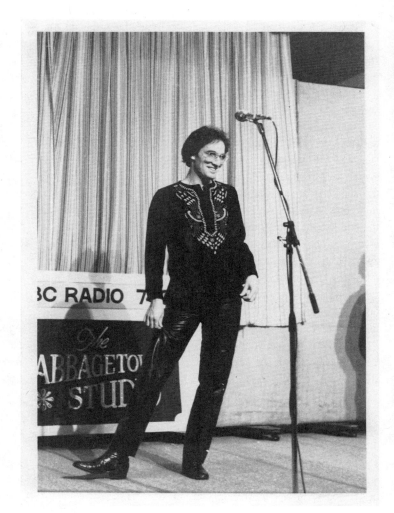

A cow died for these pants.

the stage is bare. Then the "Sergeant Renfrew" theme begins and Dave marches from the wings, resplendent in his scarlet tunic, back straight and arms swinging, and he perfectly times his arrival at his microphone so that, as the applause ends and his theme fades away, he can begin to relate his hapless Mountie's latest adventure: "I'm Sergeant Renfrew . . . "

And it wasn't just monologue characters that merited long entrances. Don did a side-splitting version of Brian Mulroney's walk. Our favourite way of bringing the Mulroney character into a scene was to do it unannounced. The writing challenge was to disguise who the character about to enter was until Don-as-Mulroney appeared. John, one of whose mantras was "the bigger the buildup the better the knockdown," was a master of this set-up. Typically, characters in a scene might be discussing some problem that only one (unnamed) person could possibly solve, and with a "here he is now," Don would enter from the wings, chin pointing north, bum pointing south, arms swinging like twin pendulums and smiling a smarmy grin that positively oozed unctuousness. He'd pause and point to imaginary friends in the balcony and wave to imaginary supporters in the house. The audience laughed and cheered. Occasionally they carried on for so long that Don had to walk all the way across the stage and back and then stand at his microphone gesticulating in character until they quieted sufficiently for him to speak. Those moments were never broadcast but one "Mulroney walk" lasted almost forty seconds, so producer Tom Shipton—who succeeded Johnny Dalton as another of our great radio producers—saved it and used it as the background track for several *Air Farce* radio promos.

When we started taping at Richmond Hill, we just walked on stage at the beginning of the evening, said "Hi folks, thanks for coming,"

maybe did a little chit-chat with the audience, then began taping. When we started touring, we played bigger venues and developed a more polished and professional start. The stage would be bare except for a soft glow that illuminated the sound-effects area and our microphones. The house opened and a thirty-five-minute music track began playing as the audience entered and took their seats. The music built steadily in pace, intensity, and volume, so the audience had to speak louder and louder to have a conversation in their seats. When the house was full and the audience volume had built to an animated roar and we were ready to start the show, Bryan Hill would segue to our theme. It built to its climax, the house lights dimmed, the stage lights exploded into full brightness and Roger would bounce out on stage. The crowd would whoop, whistle, and holler, welcoming him with wildly enthusiastic applause. Houston, we have lift-off.

After chatting with the audience, jollying them along and getting several good laughs, Roger remained on stage and introduced the rest of the cast one at a time. Originally, we had no set pattern other than to save Dave to the end, but soon we settled on alphabetical order; Abbott first, then Broadfoot, Ferguson, Goy, and Morgan. After John's hellos, Roger introduced the sound effects technician—originally Alex Sheridan, then Ernie Zammit and Matt Wilcott, for a few years Bill Robinson, then Jean Sarrazin and Cathy Perry, and Anton Szabo for the six-year home stretch—and we'd start the taping.

We more or less organized what each person was going to say, never an easy task when dealing with five distinct egos. A snappy comment about something that was so local in nature it would never make the national broadcast was always good. And so was a dependable warm-up joke that didn't take long to tell and always got a laugh. There were a couple of favourites that got recycled every few years:

JOHN: A man riding the London underground during morning rush hour is standing directly in front of a well-dressed gentleman who is seated, wearing a bowler hat and reading *The Times*. The car is packed and the first man can't help but lean over the seated man, and can't help but notice a strong, unpleasant odour, which one usually associates with toilets, emanating from him. He says to the seated man, "I say, have you, you know, done something?" The seated gentleman says, "Why yes, as a matter of fact I have." Standing man: "Well, what are you going to do about it?" Seated man: "I don't know, I haven't finished yet."

DON: Three old men are sitting in a café, and the subject of humanity's greatest invention comes up. First man: "It's the wheel. With the wheel, humans move enormous weights over long distances. We built cities and extended our reach across continents. It made great civilizations possible. The wheel is the greatest invention of all time!" Second man: "Fire. Before fire we lived by the light of the sun and the moon. We were cold in winter. We ate raw food. But with fire, we kept warm, we extended the length of our days, we ate better. Fire is the greatest invention of all time!" Third man: "The greatest invention of all time is the thermos bottle." The other two look at him incredulously. He continues, "When it's cold, it keeps things hot. When it's hot, it keeps things cold. How does it know?"

Luba didn't feel comfortable telling a joke. She was primarily an actor and a lot of actors only really feel comfortable in character. But since the purpose of warm-up was to let the audience see us as ourselves (they'd spend the rest of the evening seeing us as characters), she'd often talk about whatever was on her mind. Audiences were sometimes bewildered because they had no clue where she was headed with her story, but they weren't alone. Often, neither did Luba. When necessary, Roger would step forward and with a witty remark deftly bail her out. Audiences loved Luba so it didn't really matter what she said or did.

In the early days Dave bore the responsibility of being lead dog and sometimes did an extensive warm-up of his own, thereby killing two birds with one stone, as he'd also be testing new material for his stand-up act (a stand-up never stops writing). Eventually Dave decided that short was best and at times would snap off just one or two one-liners and step aside.

Roger relished the role of host, was quick on his feet and undeniably welcoming, but he frequently got so caught up in enjoying the audience that he'd lose track of the time. He'd ramble on while the rest of the cast, fidgeting like thoroughbreds in the starting gate at the Queen's Plate, chafed at the bit in the wings. He also liked to give the audience a heads-up about subjects we'd be covering in the show and unwittingly—but frequently—used jokes from the script to do so. If Dave had a Sergeant Renfrew monologue, almost invariably Roger told a bit about the premise "just to set it up," but then, caught up in the moment, he would frequently forget where

his funny thoughts were coming from and roll out some of the monologue's better moments, often blurting out the punchline for the best laugh of all. Dave would practically go apoplectic standing in the wings. Fortunately, the Renfrew character usually appeared late in the show, and by the time Dave came to his punchline, the audience had either forgotten it or were so pleased to hear it again that they laughed anyway.

In November 1985, we recorded at the National Arts Centre in Ottawa, in what was then known as the Opera and is now called Southam Hall. It's a capacious, side-aisle venue, with almost 2,300 seats and three balconies. We felt some local star power would add sparkle to our cast, so we recruited Mike Duffy who, as CBC Television's chief Ottawa correspondent, was Mr. Ottawa. He seemed to know everyone in the capital and was affectionately referred to as "the senator," a role he took on for real some twenty years later when Stephen Harper appointed him to the Red Chamber. We arrived as usual, the evening before the taping, and Mike took us on his personal tour of Ottawa. Having discovered a common love of early rock'n'roll, we wheeled around the capital region with his car's audio system cranked up, listening to "Rockin' Robin," "Rock Around the Clock," "Be-Bop-a-Lula," "Blue Suede Shoes," and other classics in his collection of cassettes. We tooled around Rockcliffe and up to the U.S. Embassy gates just so we could watch an armed Marine appear out of nowhere and shoo us away. We ate dinner late at an Italian joint in the west end where Mike ordered veal scaloppini and mesmerized us with his ability to wrap a piece of veal the size of a child's fist around his fork and then, scarcely pausing for breath, make it disappear with one quick bite. He was a great host, full of goodwill and even better anecdotes, and a terrific guy to hang with.

The next evening, the Opera was filled to its capacity of 2,300. Luba looked gorgeous, the men elegant, and the show couldn't have gone better. Mike hosted an "Ottawa Quiz" that put the audience in stitches. When the show ended we were swarmed by well-wishers and friends, one of whom was the executive vice-president of CBC, Bill Armstrong, a long-time supporter.

DON: The look on his face was unalloyed joy. He beamed a smile so big it could have been carved on a pumpkin. His voice bubbled with excitement. He grabbed me by the shoulders and shouted, "It's fantastic! The Opera! Sold out! For a *radio* show!"

Bill hit the nail on the head. With the possible exception of the country music series, *The Tommy Hunter Show*, CBC Television didn't have a single show that could give away 2,300 tickets let alone sell them. And unlike the Hunter show, we didn't showcase big-name American guests. Our star attraction had been a CBC reporter.

Bouncing around the country recording radio shows was the very definition of "earn as you learn." We got paid to find out about places, visit them, and make people laugh about what we'd discovered. Having grown up, like many Canadians, feeling that CBC was Toronto-centric— we remember Wayne and Shuster making jokes about Bathurst and St. Clair and not being able to relate—we took special delight in visiting places like Inuvik and Goose Bay, making local jokes in front of the local audience, and then broadcasting them in our show. Take that, Toronto! We'll show you how to put local jokes on the network! The major difference between us and our predecessors was that having experienced what it was like to feel left out, we always made a point to

May 21, 1984. Yellowknife. (*Top*) Dave checks out our hotel (just kidding). (*Bottom*) Producer John Dalton, Don, production assistant Debra Toffan, Roger, guest actor Margaret Pacsu.

provide enough context so that even if a joke about, for instance, utilidors (in northern communities permafrost prevents the burying of utility services like electricity, water, and sewage, so these services are carried in large-diameter, above-ground conduits called utilidors), didn't hit someone listening in Sheet Harbour with the same impact as it did someone in Inuvik, they'd still be able to get the joke. John once wondered, "Is it worth all the effort?" His neighbour had commented that the previous weekend's Yellowknife broadcast had been, "really good, really convincing. It sounded like you were actually there!"

After a decade of travelling, you could drop us into any large or medium-size city in Canada (and many small ones), and we felt at home in each and every one. We could go for a walk in Saskatoon, or Halifax, or Vancouver and not get lost. We could spend an afternoon strolling around Calgary or St. John's without having to ask for directions. We knew where to find a good restaurant, a hotel, a bank machine, and a liquor store. What more do you need to know than that? The radio show truly made us citizens of all of Canada.

Branching Out

SYMPHONIES AND SALES CONFERENCES, DAVE DEPARTS, AND THE END OF RADIO

You can tell it's summer—we're relaxed

When Don's marriage went bust in the early 1980s, he found himself thousands of dollars in debt and in need of extra work. **Dave encouraged him to try stand-up.** As a solo performer, Dave had worked the banquet and convention circuit for years. It meant a lot of travel, but it could be quite lucrative. If you were good at it, you could earn more money in one night than you would working at a comedy club for a week or taping radio shows for CBC. Best of all, unlike radio, stand-up didn't require a new show every week. You wrote a half-hour comedy routine, you developed it, re-worked it, refined it--and you could re-use it. Do the same routine at every gig, gradually evolve and reinvent it over months--necessary because you become stale and routines don't last forever--and a year later you have a new routine that you can work the circuit with all over again.

DON: My first couple of gigs, I was terrified. I'd been performing comedy for more than a decade but never on my own. The first thing I realized was that absolutely no sketch material that I'd improvised, written, or otherwise developed in the previous ten years could possibly be adapted to stand-up. It was a totally different beast. So I set about writing. The most I could come up with was twenty minutes, some of it pretty lame, but I had an offer to do a small lunch gig in Saint John, New Brunswick, so I took it. I had two huge fears: one, that no one in that small hotel function room would find anything I said or did funny; two, that I'd go blank and forget my routine, and unlike in sketch comedy, there'd be no one alongside to toss me a line if I needed help. And there'd be no escape. So I flew to Saint John with notes on three-by-five-inch file cards in every pocket of my pants and the entire routine handwritten on sheets of notepaper folded in an inside pocket of my suit jacket. I went blank twice but recovered well enough that the fear in my eyes couldn't have been visible for more than a few seconds, and managed to hang in for twenty-four minutes before running out of material. For all twenty-four minutes a river of icy cold perspiration--the "flop sweats"--poured down my back. I wished I was anywhere else doing anything else but this.

A short time later I did a second gig, an annual banquet for customs brokers in Niagara Falls. I made the two-hour trip by bus so I could work at memorizing my material on the way. When I arrived at the small motor hotel, it was not quite four in the afternoon and the corridor outside my room was

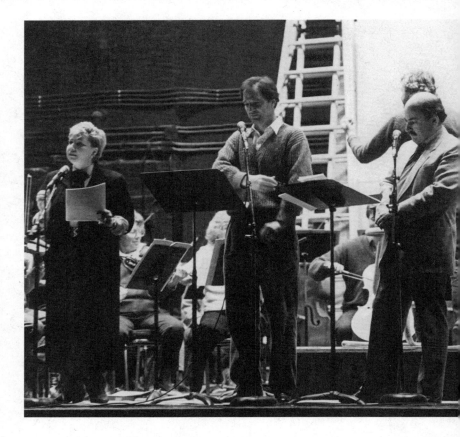

Brian Jackson conducts a rehearsal with the Kingston Symphony in 1987; Post-Dave, Luba, Don and Roger perform a Toronto Symphony pops concert in 1990.

chock-a-block with well-oiled customs brokers who had spilled out of their own rooms to socialize in the hall. They clutched highball glasses and beer bottles, laughed heartily and slapped each other on the back. At six o'clock, the head table guests (I was one) assembled in a small room next to the room where dinner would be served. It was hospitality time. Drinks were poured. Many drinks. I was too afraid to do more than sip at a light beer. At seven, when a bagpiper led us into the dining room, several tables of tipsy customs brokers were throwing dinner rolls at each other. I took this to be not a good sign. When my turn came to entertain after dinner, I stood at a rostrum at the head table feeling relatively safe, because by now the buns had been cleared away. I read from notes and so was able to put all of my energy into performing. The routine didn't totally suck and some of it actually worked better than I'd hoped.

On the bus home the next morning I realized, "I can actually do this. It's different, it's scary, it's walking a tightrope without a net, but I can do it." I'd taken up the challenge because I needed money; I was a family man, in a new relationship and with an infant daughter. But now I wanted to do it for another reason: to prove to myself that I could.

I learned to adjust to different and unusual situations, and to make people laugh who'd never heard of me or Air Farce. Performing with friends for the huge audiences who came to see Air Farce soon felt like being on holiday.

In addition to stage and radio, Air Farce picked up extra work doing corporate gigs and whatever else came along that was interesting. Dave, Roger, and Don played a comedy concert in Philadelphia in 1987 celebrating the 200th anniversary of the American Constitution. It was a once-in-a-lifetime lineup of satirists and political comedians: Andy Rooney, Mark Russell, Dick Gregory, Art Buchwald, the Capitol Steps, Dave Broadfoot, and Roger and Don. Two sold-out nights in a gorgeous old theatre downtown. After the first night, Dick Gregory said it was such a great show, we should take it on the road, we'd sell out in every major city in America. But everyone had commitments and it never happened. Should have. It was a great idea.

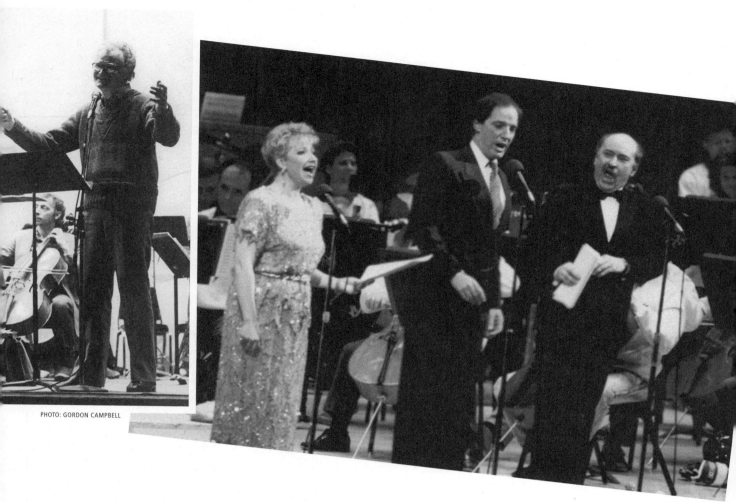

We were hanging in the hotel hospitality suite, when a room-service waiter pushed a trolley of alcohol into the room. He'd come to restock the bar but needed a signature. "Is Mary here? I need Mary to sign for this." Sprawled in chairs were Roger and Don, Dave Broadfoot, Dick Gregory, and Art Buchwald. We looked at each other. Clearly, there was no Mary here; there wasn't a female in sight. "I can't leave the liquor unless Mary signs for it." Art Buchwald waved a hand, "I'm Mary." The waiter shoved the receipt at him, Art scrawled "Mary," and the waiter restocked the bar. Lesson: when life gets complicated, just get a signature.

We also began performing with symphony orchestras. Brian Jackson, music director and resident conductor at Orchestra London,

was looking for an innovative program idea and mentioned Air Farce to a mutual friend. Brian was in Toronto frequently and for a few months one summer, whenever he was in town, he and Don tossed ideas back and forth and Brian teased out musical possibilities on a piano. Roger got involved too, and the three of us grappled with the same creative dilemma: what's the concept? It was easy to check off what we didn't want it to be: not a musical comedy, not a comedy musical, and definitely not comedy music. What, within our limitations, do we want to do, and what, within its expectations, does an audience want to hear? Once we asked the question, "Wouldn't people enjoy going to a symphony concert where they could laugh out loud?" we began to

zero in on our music-and-comedy marriage. Within a year, Dave, Luba, Roger, and Don took to the stage with Orchestra London and performed "Air Farce Opus One," a concert of light classics, Air Farce comedy, and several occasions where the orchestra and Air Farce combined their talents. The show was a pleasure to do because for a change Air Farce didn't have to carry the whole evening. We'd do a couple of numbers then rest·in the wings while the orchestra performed excerpts from The Moldau or some other pops concert staple—we actually got several orchestras to play CBC's *Hockey Night in Canada* theme as one of their selections—then we'd saunter back out and conduct an audience-participation music quiz. Creating "Opus One" was largely a labour of creative enjoyment for its own sake, as were the "Opus Two" and "Opus Three" that followed, because there weren't (still aren't) enough symphony orchestras in Canada to make the creative effort financially worthwhile. Initially, we played with orchestras in London, Calgary, Edmonton, Regina, Winnipeg, and Kitchener-Waterloo. Later we added Toronto, Hamilton, Vancouver, Kingston, Thunder Bay, Sudbury, and Victoria.

We played with the Sudbury Symphony one spring. It was a community orchestra composed largely of music teachers and students, dedicated amateurs, and less-talented volunteers who could read music and follow a conductor without setting neighbourhood dogs howling. The orchestra didn't lack ambition. It had chosen to perform George Gershwin's "Rhapsody in Blue," a selection that no other orchestra we'd played with had had the courage to attempt. We sat through rehearsal, biting our hands and trying to keep straight faces as the band sawed through some unrecognizable piece of atonal modernity, waiting for "Rhapsody in Blue" to begin. During a break we asked when they'd be attempting it, and were told they'd just played it.

The Sudbury concertmaster moonlighted as conductor of the Timmins Symphony and asked if we'd play with his orchestra next year. We had several gigs of various kinds booked in the time period he requested, so when we returned to Toronto and checked our schedule we said, "What the hell. Why not?" We'd tack it on as an extra date. How bad could it be? Not bad at all, as it turned out, but there was one surprise: when we arrived at the airport, we were greeted not by the Sudbury concertmaster/Timmins conductor who'd hired us, but by the Timmins first violin. Why would he be guiding the orchestra through its paces this weekend? Because the conductor had landed an even better gig—he was playing at a wedding. Oh yes, and Don got food poisoning at dinner, so when he wasn't on stage Roger or Luba would hold his costume out of the way so he could barf freely into a wastebasket in the dressing room. A memorable gig.

The radio show continued to provide memorable moments, too. Season Fourteen in 1986–87 typified travel in the second half of the 1980s: Waterloo, Edmonton, Fredericton, Corner Brook, Sydney, Ottawa, Markham, Montreal, Winnipeg, Barrie, and Halifax. In the fall of 1986, we taped episodes in Germany at the Canadian Forces base in Lahr. The Berlin Wall hadn't come down yet, so Lahr was in what was still called West Germany. We flew over on a Boeing 707 Canadian Forces military transport from a base at Trenton, Ontario. First impression of military life: bureaucracy with guns. Hierarchy rules, rank trumps everything, paperwork coming out the whoo-ha. With a station stop in England the trip took almost twelve hours. Not an uncomfortable flight, but it reminded us of VIA Rail—it was basic transportation and would never be mistaken for the hospitality business. At the base we met the driver assigned to us by the army, Sergeant Jim, a cheerful fellow who chauffeured us to the base supermarket (actually run by the American

forces) so we could buy German wine at discount prices. And cheap American booze. The American forces, unlike the Canadians, who made a point to shop in the local economy, could afford to take America with them wherever they went, and so they did. An American serviceman could spend months in West Germany and never eat, drink, see, watch, read, or listen to anything that he couldn't back home.

We saw how tough Canadian military life was, especially for the wives of enlisted men. Basically you bumped along the bottom in a state of permanent near-poverty. Never any extra money. Lousy housing. Lots of babies. Men called away at a moment's notice to go on exercises, manoeuvres, what have you. Didn't matter what your plans were, ladies, best not to have any. Women were an afterthought, appendages in this man's world of military preparedness.

The cheap booze was bound to be a problem. Bill, our sound-effects guy, was enjoying Lahr so much that he started belting back the hard stuff in the middle of the afternoon. During the show he entered his own comedy world, making private sound-effects jokes: in a scene where Luba played a brisk, dainty woman entering a shop, he clomp-clomp-clomped her across the room with hobnailed boots. Very funny to Bill, not so much to us. That was his last taping with Air Farce.

Next stop, Fredericton, where we had a hilarious time with New Brunswick premier Richard Hatfield. He'd made headlines during Queen Elizabeth's Royal Visit earlier in the year. During a pre-flight security check, the RCMP had found a bag of marijuana in an outside pocket of his briefcase. Premier Busted! He beat the charge when his lawyer successfully argued that because it was an outside pocket, any number of people could have had access to it. Whatever. We're sure every flying pot smoker in the country made note of the "Richard Hatfield Defence."

ROGER: Don and I remembered an evening in Ottawa a couple of years earlier. We performed at a newspaper awards dinner in the Chateau Laurier hotel. Dozens of politicians attended, including Richard Hatfield. He had a reputation for living the high life and during this period flew to New York City every weekend to party, away from the eyes of New Brunswick voters. When we finished our performance, we noticed him slip out of the room. The next morning as we waited for an airport cab, he emerged from the hotel behind us. "Should we share?" he asked. Why not? We piled in and the cab slipped along the Rideau Canal on its way out of town. Mr. Hatfield looked as if he hadn't slept. His suit was rumpled, his eyes bleary, a thin film of sweat covered his face. His hands trembled slightly and he seemed to have trouble keeping himself together. When we got out of the cab and headed to our separate flights, Don turned to me and said, "You know, that's the first time I've been with anyone and the word 'debauched' came to mind."

For Fredericton, Rick and Gord had written a terrific script that made sure the political guest (Hatfield) got lots of laughs, scored a few light-hearted political points at the expense of rivals, and generally looked good. At the afternoon tech rehearsal in the Fredericton Playhouse, a couple of the premier's assistants came across the street from the Legislature to discuss suggested changes for the script. As usual, we were completely obliging. Our guidelines when we sent advance scripts

to guests were always the same: "We want you to have fun with us. Here's the script. We think it's a good one and will work well in front of the live theatre audience as well as on radio. If there's anything you'd like to change, feel free. If there's anything you'd like dropped, please mention that too. We're also happy to accept improvements. The only proviso is that if you feel it necessary to make so many changes that we feel the script is no longer funny, we may choose not to do it."

The assistants suggested some modest changes and we were good to go. They took the revised script back to the premier's office for final approval. Fifteen minutes before the show began, we met Mr. Hatfield backstage for a quick run-through. He was in top form, ready and raring to go. We teased his entrance a couple of times and then brought him out midway through the first half. He entered to sustained applause. In his fourth consecutive term, he was clearly still enormously popular with New Brunswick voters.

The script was a two-hander, with Roger interviewing the premier, and it began with an innocuous greeting:

ROGER: Mr. Premier, good to see you! Hello!
HATFIELD: Hi!

But Roger ad-libbed a small change:

ROGER: Mr. Premier, Hello! How are you feeling?
HATFIELD: Hi!

The response brought down the house.

* * *

In 1988, we taped in Calgary during the Olympics. The big event that weekend was the men's gold-medal final in figure skating: our Brian Orser vs. the United States's Brian Boitano. It was a nail-biting competition, but Boitano got the nod from the judges and won gold. Brain Orser settled for silver. We watched on television in our hotel rooms, along with millions of Canadians and practically every living soul in Calgary. Up early for breakfast the next morning, we passed a Calgary Sun newspaper box. The headline read: "Orser Loses." To shout the next morning that, as a result of a panel of dubiously honest judges, Brian Orser had lost seemed unnecessarily cruel.

A week before the skate, Brian had agreed to be a guest at the taping and we had a Big Bobby Clobber sketch for him to appear in. All day, we wondered if he would show up. He must have been crushed and we were afraid he'd bow out, not ready to face a crowd. But he didn't. People of his calibre, we've learned, don't. Athletes who train for years for a shot at Olympic Gold are mentally tough. He arrived backstage shortly before 8:00 p.m., looking exhausted. Had he slept? Possibly not. Less than twenty-four hours earlier, he'd skated on the biggest stage in the sporting world in the biggest competition of his life and narrowly missed top spot. He was clearly still dealing with the disappointment. He waited in the wings while Roger and Dave launched into the Bobby Clobber piece. At one point, Big Bobby (Dave) told Big Jim (Roger) that he was going to become a better player because he hired a new skating coach. "Can I meet him?" asked Big Jim. "Sure," replied Bobby, and shouted into the wings, "come on out, Brian!" Brian Orser walked onstage and the audience erupted. They let loose a huge roar and leaped to their feet. They stood applauding for a full minute. We were so glad Brian had joined us. This was the real response to his skate the previous night. He was a hero.

Part of our self-proclaimed mandate has always been to say the unsayable. In September 1988, at the Seoul Olympic Games, Ben Johnson ran the Olympic 100-metre final in a world record time of 9.79 seconds and carried the pride of Canada to the gold-medal podium. Three days later, on September 27, his urine test revealed banned steroids and he was stripped of his medal. Canadians went from the heights of glory to the depths of humiliation.

ROGER: The following Sunday, we (Don, Luba, Roger) had agreed to appear in a gala fundraising concert for the Stratford Shakespearean Festival at Toronto's Roy Thomson Hall. Tickets were seriously high-priced and the crème de la crème of Toronto society, business, and philanthropy were in attendance. Britain's David Frost flew in by Concorde to be the high-profile master of ceremonies.

When we arrived at Roy Thomson Hall, the producer of the event, Brian Robertson, who at the time was a new acquaintance, was waiting for us with a very sober instruction: "This is a festive event and so I'm asking everyone, and everyone is agreeing, not to make any mention of the Ben Johnson affair. It's still just too raw and we want our audience to be able to forget about it."

Don and I looked at each other. "Well," said Don, "people expect it from us. We can't exactly not mention it."

"I'm begging you," said Brian. "Please don't use the word Olympics, scandal, or Johnson. The country is practically in mourning and we want this to be a joyous afternoon."

After a moment's hesitation, we agreed. Luba looked surprised. We promised Brian that we would definitely not use the words "Olympics, scandal, or Johnson."

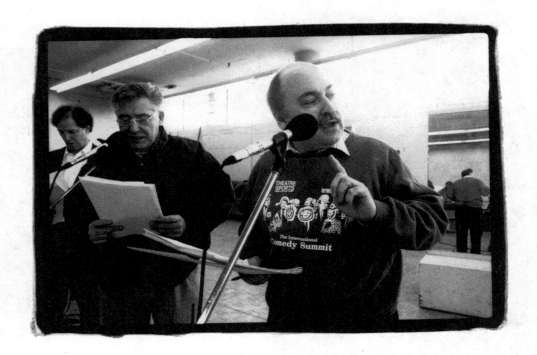

When our turn came mid-way through the show,
David Frost introduced us as warmly as if he
listened to *Air Farce* every week. We ad-libbed a
few words of greeting then launched into one of
our standard bits, a comedy newscast.

"From the Air Farce news centre, here what's
happening across Canada and around the world,"
I began.

Then Don added, "The news is brought to you by
Uncle Ben's Steroid Rice. Cooks itself in 9.79 seconds!"

There was the slightest beat of silence in the
hall, the slightest intake of surprise, followed
by the sound of 2,500 people letting out the
hugest laugh we'd heard all year. We'd spoken the
unspeakable, and we'd honoured Brian Robertson's
request: the only words we'd needed were "Ben,"
"steroids," and "9.79 seconds," and none were on
the prohibited list. Thank you, Jesuits.

When the show ended, Barbara Frum--the most
respected television journalist in the country--
came to our dressing room with her husband,
Murray, who was chair of the Stratford Board.
Were we in trouble? Barbara broke into the
biggest smile and said, "You've done it. All week
on *The Journal*, we've been agonizing over this
story, and in one line this afternoon, you guys
have proven we can laugh about it. You have your
finger on the pulse of the country better than
anyone else."

"We've always been good at taking rectal
temperatures," I said modestly.

Saying the unsayable. That's always been our
job, and we love doing it.

We did plenty of corporate gigs through the 1980s and into the
1990s. They paid well and kept us sharp between tapings. They could
be hard to find time for, because we each pursued individual careers,
but when we were all available at the same time and the money made
it worthwhile, then the four of us enjoyed doing them. (John never
participated; when radio took a break he skedaddled back to England.)
It was a neat niche market. This time we'd been hired by one of Canada's
largest accounting firms to perform at a three-day national convention
in Ottawa. With corporate gigs, the time of performance depends
entirely on when they want you. Usually it's in the evening, but some-
times it's at lunch and, more often than you'd believe, in the morning. In
this case the performance would last exactly an hour, on a stage built
inside the Ottawa Convention Centre, and begin at 11:00 on a Thursday
morning. The only possible time for tech rehearsal with the staging
company's crew was four hours earlier, at 7:00 a.m. (never an hour
favoured by entertainers; for many of us, 7:00 a.m. is closer to bedtime
than work time).

Two days prior, the four of us—Roger, Dave, Luba, and Don—met
in our Gerrard Street office, went through the script, collected our travel
schedules and airline tickets from our assistant, Libby Sellwood, and bid
our adieus until we'd meet in the Ottawa Convention Centre at 7:00 a.m
on Thursday. Luba's mother lived in Ottawa, and because Luba didn't get
to see her often, she'd opted to travel to Ottawa early Wednesday and
stay with her mother Wednesday night.

Thursday morning at 7:00, we met in the cavernous room in the Convention Centre where our stage had been built. Roger was cheerfully rubbing sleep out of his eyes, Don was beat, and Dave was anxious to start so we could grab some breakfast. The crew needed another twenty or thirty minutes to hang the last few lights, which was fine with us. We needed coffee. Luba was late, but that was to be expected. However, by 7:30 the crew was almost done and she still hadn't turned up, so—here we go again—time to track her down.

DON: I found a house phone and called Luba in her room. But there was no Luba Goy registered at the hotel. That's right, I remembered, she'd stayed at her mother's, I'd have to call her there. Problem was, we didn't know Luba's mother's phone number; she'd remarried years earlier, and none of us knew her last name. Only chance of getting the number was to call Luba's son in Toronto and ask him for it before he went to school. So I phoned Toronto. After a half-dozen rings, I was sure I'd missed him when the receiver lifted and a sleepy voice croaked, "Hello?" Not quite trusting my ears, I said, "Luba?" I was speechless for a couple of seconds, then took a deep breath and told her I was calling from Ottawa where we were due on stage in three-and-a-half hours. "Fuck," she said, and hung up.

This was a disaster. Without Luba we were missing 25 per cent of the cast and all of the female roles. Dave, Roger and I set ourselves up beside the stage and started revising the script. We recast where we could, wrote in changes where possible, and tossed out sketches that we couldn't do without her. By 9:30 we'd made the changes and begun going through them with the stage manager. We were finishing up at quarter to eleven, fifteen minutes before show time, when, unannounced and unexpected, Luba turned up. "I'm here!" she said, "where's my script?!" She was pumped so full of adrenaline that she was high as a kite. We'd wanted to kill her for the past three hours; now that she was here in the flesh we wanted to do it even more. We bit our lips, cursed her under our breaths, and went over the script a second time with the crew, changing everything back to what it had been originally. We got through the performance but hated every moment. That day marked a turning point. Luba had been late before, so often in fact that everyone had come to expect it and made adjustments; radio rehearsals frequently began without her. She'd lost airplane tickets, scripts, and schedules. She'd missed flights. But she'd never put us through anything like this.

We got a blow-by-blow re-enactment of Luba's morning later that day. After Don's call she'd leaped out of bed and raced to the airport. She didn't have any money to pay the cab driver; he insisted she give him some kind of surety or he wouldn't let her out of the cab, so she handed over a ring (which she later bought back by contacting the driver and paying her fare). She didn't have her plane ticket so she had to buy one. She didn't have her credit card, either, but luckily she found in her purse

October 11, 1990. Rehearsing on stage in Saskatoon.

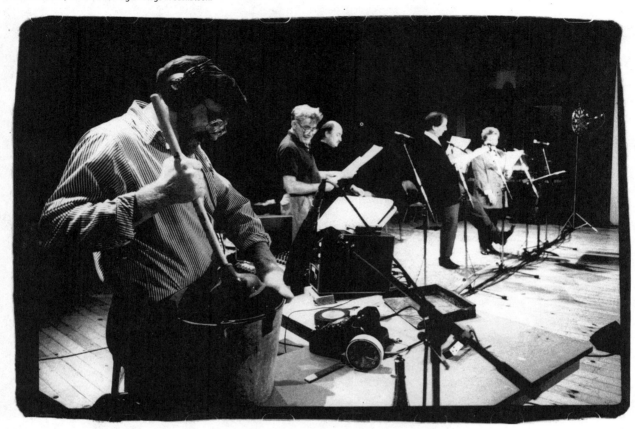

the credit card receipt for a ticket she'd had to buy the week before when she'd missed another flight. Aboard the airplane, she commandeered one of the forward washrooms and spent the entire flight applying makeup. Upon landing in Ottawa, the cabin crew hustled her through the airport and into a cab. She arrived at the Westin with no money to pay for it and assured the driver there was no worry—she'd get cash from the front desk; they could charge it to her room. But no, the front desk couldn't help; there was no Luba Goy registered and therefore no room to charge the cab to. Step forward a distinguished gentleman who had observed the commotion and Luba's distress: "How can I help?" he asked. And that's how Luba met our show's sponsor.

We returned to Toronto that afternoon. The next day Luba phoned our office and bawled out Libby for not having phoned her at home to remind her of the gig. Luba's calamities were never her fault.

For Dave it was the last straw. He quit Air Farce—radio tapings, symphony concerts, corporate gigs, the whole shooting match— shortly after. Dave dominated the show in the early years. He was the established star. We admired his talent, appreciated his hard work, and liked him personally. He was and remains a very funny, decent, kind-hearted, and likeable man. And a delightful dinner companion. He had brought talent and experience to the show, but the demands of his thriving solo career required that his professional life be run with maximum discipline and efficiency. The forbearance that the rest of us could maintain over incidents such as Vancouver and Ottawa were a luxury he couldn't afford. Moreover, those incidents ran against the high personal and professional standards he'd built his career on. "I can't live like that," he says today. "That's not my life . . . I like to err on the side of being somewhere too soon."

Big finish at Massey Hall. Dave acknowledges the cheers after a performance as the Member of Parliament for Kicking Horse Pass. Jeff Speed took this photo at our annual pre-Christmas radio taping in Toronto, December 1990.

Life after Dave meant a big adjustment, but it also presented an opportunity. Without weekly contributions from Big Bobby Clobber or Sergeant Renfrew or the Member for Kicking Horse Pass, Air Farce subtly altered the content of the broadcasts, added more politics, broadened the mix. Roger, Don, and Luba carried on with symphony concerts and heaved a collective sigh of relief after the first two performances without Dave in the cast. Half expecting—and fearing—that reviewers would find the show wanting without Dave, it was a relief that his absence wasn't mentioned. One door closes, another opens. Touring is gruelling, but it gets you out, understanding the country, meeting the fans, earning an income, and we didn't want to give it up. So for another half-dozen years the three of us carried on adding stage dates to radio-taping dates, typically spending exhausting long weekends in Halifax, then Liverpool, then Yarmouth, and on to Fredericton, ending up back in our hotel raiding the mini-bar for snack food at midnight because we hadn't eaten all day.

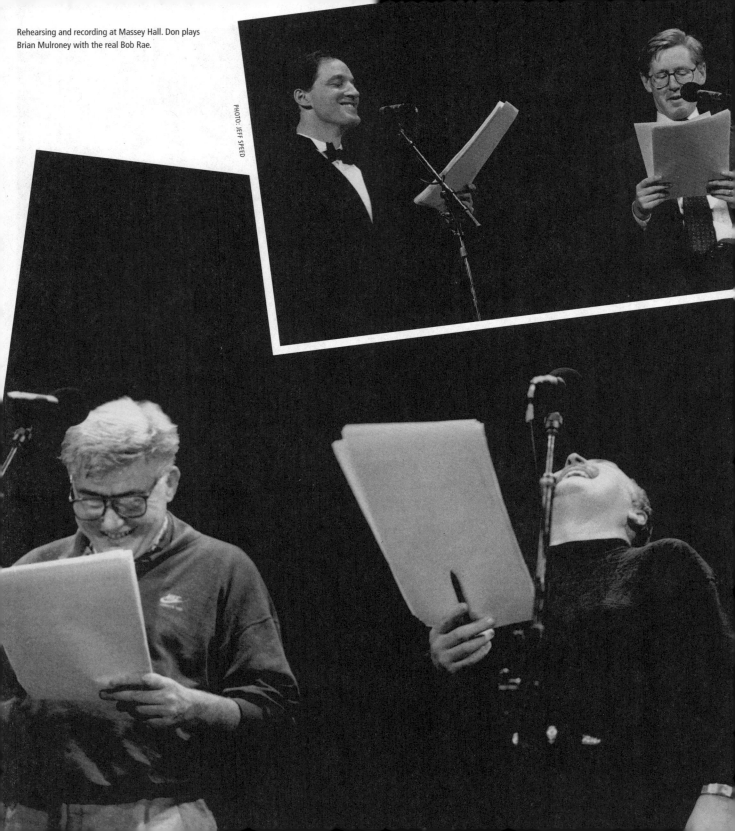

Rehearsing and recording at Massey Hall. Don plays
Brian Mulroney with the real Bob Rae.

PHOTO: JEFF SPEED

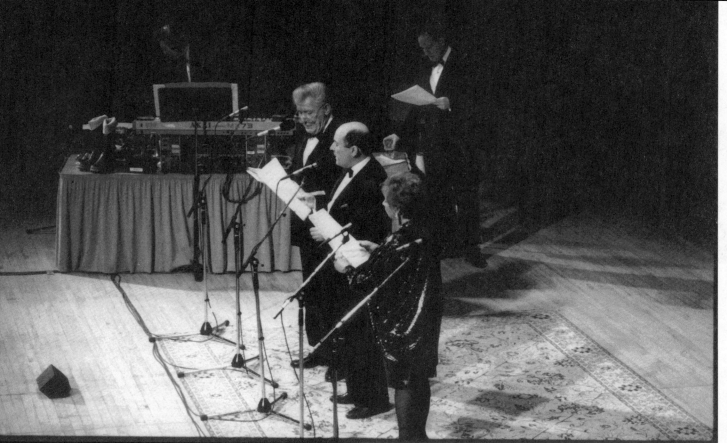

For as long as we did the radio show, Massey Hall was our favourite venue. Because we taped in December, usually at the end of the second or third week, the show always had a festive air. Christmas was coming and we looked forward to a long break. After Dave left the group, the Massey Hall tapings were even more special because they became our annual reunion. Dave returned every year and brought his favourite characters with him.

Radio touring continued right up until we began television. We recorded memorably in San Francisco (at Bimbo's 365, a legendary jazz and comedy club), where the crowd was mostly Canadian expats, grateful for a taste of home and happy to explain the Canadian jokes to the Americans. It was a rare occasion and an odd sensation: to be Canadians in the United States and to be, at least temporarily, in the majority.

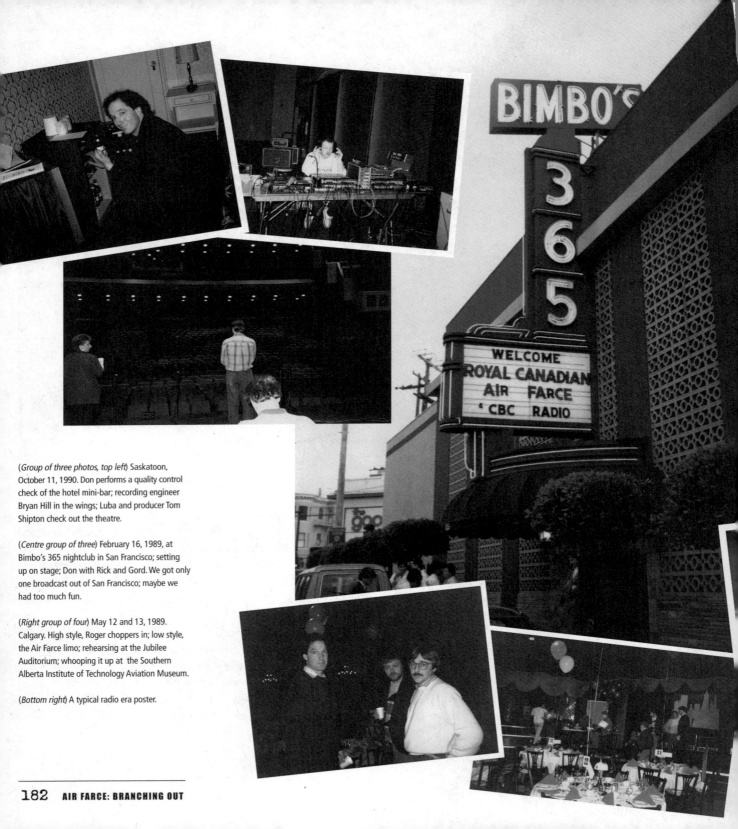

(*Group of three photos, top left*) Saskatoon, October 11, 1990. Don performs a quality control check of the hotel mini-bar; recording engineer Bryan Hill in the wings; Luba and producer Tom Shipton check out the theatre.

(*Centre group of three*) February 16, 1989, at Bimbo's 365 nightclub in San Francisco; setting up on stage; Don with Rick and Gord. We got only one broadcast out of San Francisco; maybe we had too much fun.

(*Right group of four*) May 12 and 13, 1989. Calgary. High style, Roger choppers in; low style, the Air Farce limo; rehearsing at the Jubilee Auditorium; whooping it up at the Southern Alberta Institute of Technology Aviation Museum.

(*Bottom right*) A typical radio era poster.

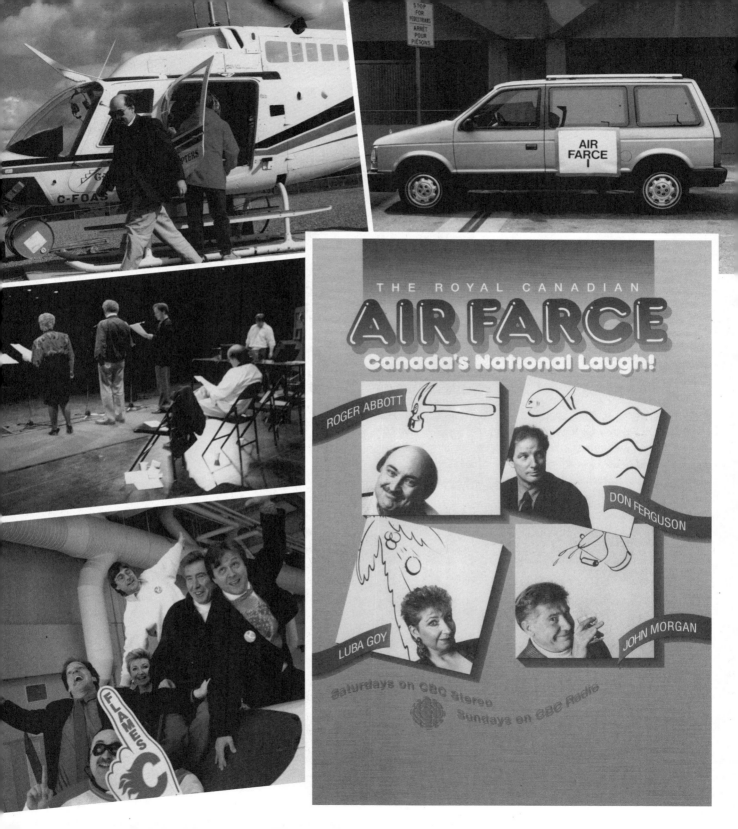

We visited Quebec City in the early 1990s, where at the post-show reception, dozens of audience members recognized each other with something approaching shock: "You? You're Anglophone? I had no idea!" Anglos didn't advertise their ethnicity in Quebec City, it was bad for business and very bad for advancement if you worked in government. The reception turned into a "secret Anglophone" reunion.

There were sad moments, too. In April 1991, Don's father, who had been very ill for more than a year (Don had been flying to Montreal to visit him every week or two for months), died the night before we taped in Halifax. At his father's request, Don carried on. None of us would forget Don coming off stage between sketches, bawling his eyes out in the wings all night long.

And sweet moments. One Sunday evening, cooling our heels in Edmonton airport while waiting for the flight home to Toronto, Don asked if anyone wanted something to drink.

"A coffee," said Roger.

"Me too," said Luba. "A coffee. With milk."

Don raised an eyebrow and looked at her skeptically. "Not tea, bag out?"

Luba batted her eyes, "I'm being low maintenance today."

How can you not love her?

* * *

Life seemed unimaginable without Air Farce on radio, even after the success of the television series, so we continued touring and taping for as long as we could. We hit the road in August and September and again in April and May, when the television season ended; between October and the end of March, we recorded at the Glenn Gould Studio in the CBC Broadcast Centre in Toronto. We had to give up our annual Massey Hall celebration, and with the exception of a 20th anniversary gala at Roy Thompson Hall, we never did a major Toronto taping again. When the pressure of television increased, we began broadcasting from the Glenn Gould Studio to the stereo network live at 9:30 on Saturday morning. Some of the audience came after shopping at St. Lawrence Market; the atmosphere was relaxed and casual.

We still managed to visit a lot of Canada in those last four years, taping in Winnipeg, Ottawa, Saint John, Halifax, Cold Lake, Victoria, Vancouver, St. John's, Regina, Calgary, Port Hope, Lennoxville, Wolfville, Kelowna, Whitehorse, Windsor and Edmonton, some of them more than once. John, Rick, and Gord didn't want to stop doing radio, but it was time. We asked, "If you had a successful television series, would you start a radio series?" Because we were in that very position now, only we'd come at it in typical Air Farce fashion—backwards. John, Rick, and Gord were finding it harder to maintain the quality we'd always striven for. John, in particular, was raiding his files and recycling

August 1990. Tech rehearsal on Sackville Street: Tom
Shipton, Bryan Hill, technician Joram Kalfa. Rehearsals
weren't all work and no play.

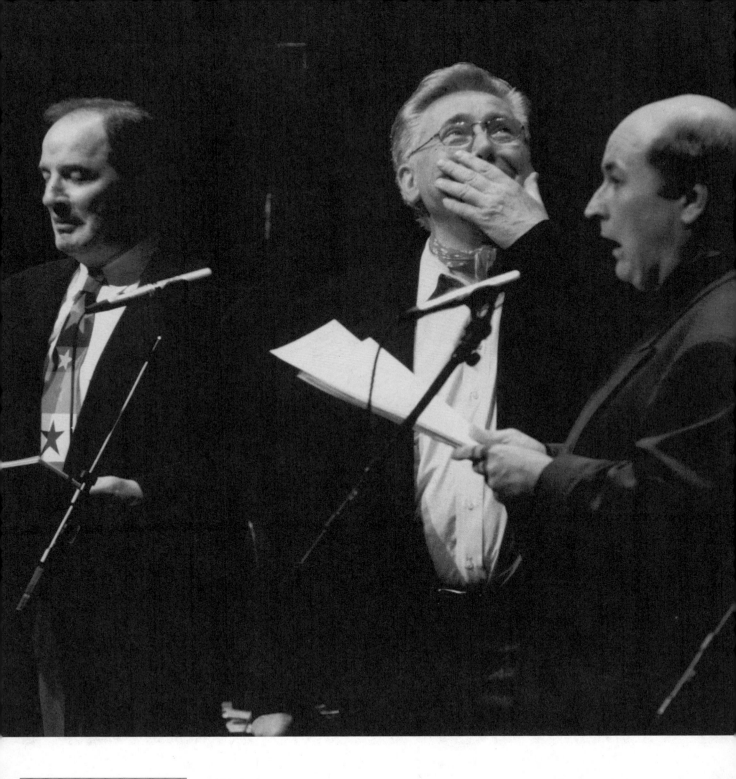

AIR FARCE RADIO-EDMONTON 9/5/97
REQUIAT IN PACEM

(*Clockwise from far left*) Taping radio in Whitehorse, May 23, 1996; backstage at Theatre St. Denis in Montreal. In 1992 we became the first Canadians to become inducted into the International Humour Hall of Fame; May 1997. Don, Wayne Testori, Bryan Hill, John, Gord, Ray Folcik, Rick, Anton Szabo, and Roger on the morning after our last radio taping. John wrote the epitaph on this, his copy of the photo.

material from years ago. This was not a good sign. There were only so many slots on television and radio, and were we not being selfish, keeping two of them for ourselves? The only way for someone else to get a crack at a radio series was if we gave up our spot. It was partly fear that was keeping us doing radio. We knew and understood radio; it had been our bread and butter for a long time. And we knew that television viewers and network brass could be very fickle.

On May 9, 1997, we taped our final radio show in Edmonton. As we stood outside the hotel on the morning after, waiting for our rides to the airport, only a couple of us could say with certainty that this would be it, but everyone kind of knew that Air Farce's radio days had at long last come to an end. What had sneaked on the air on December 9, 1973, after a one-shot, make-or-break, live-audience taping at the Curtain Club in Richmond Hill, had lasted longer than anyone could have dreamed. What we'd miss most was working together, the camaraderie of the road. Bryan Hill, now our producer, had begun as our recording engineer twenty-three years earlier. It was bittersweet. We had a lifetime of memories and now our paths would cross much less often. As a radio troupe, we'd enjoyed a long, long day in the sun. We'd had a golden age that lasted more than a decade. We'd miss performing live for our fabulous audiences that we loved and respected. But nostalgia would have to wait. The television series was really taking off.

The Magic Ting

ROGER RECOUNTS AIR FARCE'S INDIRECT JOURNEY TO
THE SMALL SCREEN, WHILE DON ENJOYS A VERY DIRECT
ENCOUNTER WITH SOON-TO-BE VICEROYALTY

Roger and Don with music director
Glenn Morley and Marv Dolgay.

ROGER: Every Christmas season, revered CBC Television journalist and former National News anchor Knowlton Nash and his wife, Lorraine Thomson, traditionally held three "festive celebrations" on three consecutive Sundays at their Toronto condo. **Kir Royales were the drink of choice, paella was the buffet lunch.** The first of the three parties was for the hard-core journalists--people Knowlton worked with who were now reporting the news for CBC, CTV, Global, Canadian Press, the *Globe and Mail*, ABC, CBS, and NBC.

The second of the three was for Knowlton's CBC News "family"--the field producers, the lineup editors, the people who every day kept *The National* as Canada's leader in broadcast journalism. Again, serious news talk.

The third party was a bit different: it was for Knowlton and Lorraine's friends in the entertainment world, as well as being a rain date for those who couldn't make the first two parties. So you might find the legendary comic Frank Shuster standing in a corner with a plate of paella, chatting with veteran foreign correspondent Joe Schlesinger, who was nursing a Kir Royale. This was the party I was often invited to, because Lorraine and I worked together on the ACTRA Awards.

So, it's a week or two before Christmas of 1989, an early Sunday afternoon at Knowlton and Lorraine's.

Around 1:30, Carol Reynolds--the just-appointed head of CBC Television's Entertainment division--arrives with her husband. She's lovely and positive, and tells me, "We were just listening to Air Farce on the car radio, and I'm still laughing. What a hysterical show today. You guys are fabulous!" This is good to hear, and I thank her. Always a good sign when a television executive thinks you're funny, even if she didn't add, "we must have coffee some time and talk about bringing you to television."

Brian Robertson and his wife Jo were standing nearby. Brian at the time was chief exec of CARAS, the Canadian Academy of Recording Arts & Sciences--a fancy name for the music industry association, and to some extent Brian was its chief lobbyist and the diplomat who tried to keep all the very competitive record companies focused on a common goal. He'd also

worked in advertising, was an occasional theatrical entrepreneur, and knew his way around the entertainment business, as well as being a decent and classy guy.

Brian watched Carol and her husband move into the party, and laughingly asked me, "Did she offer you a series?" He added that, if no one else, he thought that Air Farce belonged on television and if there was anything he could ever do to help, we need just ask.

Four or five months later, Don and I were in Windsor, promoting a show we were doing that night at Chrysler Cleary Auditorium, the city's 1,200-seat waterfront theatre. There were still about sixty unsold tickets and we were never satisfied unless the show was sold out. We were on our way to a radio interview, hoping to drum up enough interest to sell the remaining seats. One of us said, "I bet if we were on television, the place would have been sold out already." (This is where the little sound effect of a magical "ting!" is inserted, marking the sound of a small idea that's going to turn into something big.) "Let's talk to Brian Robertson," I suggested, "maybe he has some ideas."

So we did. Brian offered to talk to Carol Reynolds, hoping to get some sense as to whether CBC Television was interested in bringing our kind of topical comedy to TV. At the time, CBC's schedule was a mix of American sitcoms and dramas, a British

series or two, Sunday night Canadian music or skating specials featuring Anne Murray or Toller Cranston, the Friday night tradition of *The Tommy Hunter Show* for country music fans, and made-in-Canada adventure series such as Bruno Gerussi's *The Beachcombers*. Four times a year, there was a *Wayne & Shuster* comedy special.

Long story short (but it's one which can be made much longer), CBC said they would be glad to receive some "paper" outlining our proposal. Brian cleverly talked them into a $10,000 development fee so that we could put some serious effort into the proposal.

Time passed. Carol Reynolds was promoted, and George Anthony stepped in as head of Arts, Science, Music, and Variety programming (which presumably included comedy, which we've always felt is both an Art and a Science). And then CBC "passed," as they say in the business--in television, no one ever says "no." They say, "We'll pass" or "We'll have to take a pass this time."

The unspoken opinion was that Air Farce was a radio show and would never fly on television, and that Canadian TV viewers had failed to demonstrate any interest in topical comedy or political satire. Of course, they'd never been offered any, either. Radio did that.

So Brian looked for interest at other networks, and there was a flicker from a company called WIC--Western International Communications. It owned the

A stellar array of Canadian comedians tape a TV special, Vancouver 1977. Among them: David Steinberg, Jayne Eastwood, Derek McGrath, Rosemary Radcliffe, Mike McDonald, Ben Gordon, Chas Lawther, Suzette Couture, Ralph Benmergui, Jackson Davies. Roger and Don are sitting at front left, Dave is standing at right. Front and centre is director Perry Rosemond. The next time we'd work with him would be December 1992, on our first New Year's special.

most powerful TV stations in Western Canada. While we were in Edmonton for a radio taping, Brian flew out to join us and we met with WIC executives, toured their huge studio where we could shoot the show, and shook hands and had a jolly time. At another radio taping in Vancouver, we marched over to WIC headquarters and met with more executives, all looking forward to a wonderful opportunity together.

And so began the dreaded development hell. Scripts were written. Notes and suggestions came back. Production dates were discussed. Nothing much happened.

Meanwhile, Brian and Ralph Mellanby (who produced *Hockey Night in Canada* and a few Olympic spectaculars) had formed a production company that became associated with an organization called Canada 125, celebrating the century-and-a-quarter anniversary of Confederation, whose festivities would take place throughout 1992. They brought some of the Canada 125 people to our annual radio taping

at Massey Hall in December of 1991, and a few days later Brian reported that Canada 125 would invest as much as $200,000 into producing an Air Farce TV show, as long as it aired sometime in 1992. You'd think the networks would jump at it.

The days, weeks and months of 1992 ticked away. WIC eventually passed because of creative differences (code for "they didn't think our show would succeed").

Next, Toronto's Baton Broadcasting, which owned CFTO, the CTV affiliate in Canada's largest television market, as well as other stations, had a look.

Baton was keen. Script was discussed. We thought it should be a look back at the year 1992, a comedy year-ender. But Baton couldn't convince enough of their CTV affiliated partners to carry the show-- because Air Farce was an unproven television commodity, and besides it was Canadian and who watches Canadian comedy, anyway?

By now, it was November of 1992, less than two months till the end of 1992, when that $200,000 from

Canada 125 would turn into a pumpkin if we couldn't get a TV show on the air by New Year's Eve. Baton's Alan Chapman had an idea: Baton would produce the show at its studios and sell it to CBC, who could broadcast it.

Now, a little sidestep to the story. In October 1992, CBC launched a late-night talk-variety show called *Friday Night with Ralph Benmergui*, and it was the first production to come from the new state-of-the-art CBC Broadcasting Centre on Front Street in Toronto, opposite the CN Tower. An acquaintance from New York was coming to Toronto and asked if I could arrange for him to visit the new studios. I reserved a pair of seats in the Benmergui audience and took him to the show. Also visiting the VIP room that night was Vancouver broadcaster Vicki Gabereau, who was a great friend of a great friend. We always had a good time together, so after the show Vicki and I decided to go for a drink. We were out on the street looking for a cab, when Ivan Fecan and his wife, Sandra Faire, came out of the CBC building. Ivan, always described at the time as the boy wonder of Canadian television, was CBC's vice-president for English Television. Broadcasting was in his blood; his instincts were amazing; he was successful, admired, and feared. I knew Ivan, and Vicki had worked with Sandra, so we all started chatting, and the four of us went to a bar in Cabbagetown—where, in fact, Sandra and Ivan lived, just down Amelia

Street from me. We had a great night together. I knew that Alan Chapman was planning to offer our show to Ivan, but it just didn't seem the right time or place to talk business. It was late Friday night, we'd all been to Ralph Benmergui's show, we were all relaxing and I didn't want to spoil the mood by turning it into a pitch session. Besides, it was Friday the 13th of November and I didn't want to jinx anything.

A couple of days later—Tuesday, November 17—Alan Chapman phoned Ivan Fecan at CBC. Fecan liked the idea—actually what he really liked was a show that already had $200,000 in funding ($150,000 after Brian and Ralph's company took their share)—but he suggested to Chapman that since CBC was just opening its new studios, it would make sense to produce it at CBC if CBC was going to broadcast it. Chapman "gave" us to CBC with his best wishes.

Ivan called the Air Farce office to say that he was buying the show. We were rehearsing radio when he called, because we were taping that week in Winnipeg, so our assistant Caroline Harrison took a message. Ivan said it would be a New Year's Eve special, and we should "make it a great show and take no prisoners." It would air 8:00 to 9:00 p.m.—exactly three hours before the deadline when the Canada 125 money would disappear.

We had the week of December 14–18 clear in our schedule, so that's when we'd shoot the special.

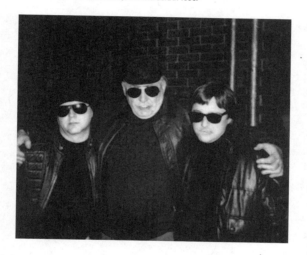

Don't mess with the writers. Rick, John and Gord in 1996.

That left less than a month to write the script and organize the show, while fitting in that week's radio show in Winnipeg, then writing and rehearsing our annual Massey Hall radio reunion and taping it in Toronto on December 3, plus Luba, Don, and I had a gig in--appropriately--Windsor (where the whole TV idea had been born with that magic sound effect: "ting!"), the night after Winnipeg.

We had a hurried meeting with Brian Robertson just before we left for Winnipeg; Brian would try to line up an all-important director for the TV special--someone who could make our script visually interesting (assuming John, Gord, and Rick would find time to write one), and who would also pass the CBC approval process, as well as be compatible with our group. Plus it had to be someone whose opinions John could respect, since John did not love all directors.

By the time Don and I came back from Winnipeg and Windsor, Brian had lined up meetings with the legendary director Perry Rosemond. Originally from Winnipeg, Perry had done everything in television, from documentaries to children's shows to running Molstar's *Hockey Night in Canada* division and creating *King of Kensington*, the seminal Canadian sitcom starring Al Waxman. Perry had spent years in Los Angeles, too, directing comedies and variety shows for ABC, CBS, and NBC. Best of all, he and John had worked together on the *King of Kensington* pilot script and liked each other. Plus, Perry had directed a show that Don and Roger had appeared in, and another one for CTV that Luba had been in, so even though we didn't know each other well, at least we knew each other.

Brian and Don and I met with Perry on Tuesday morning, November 24, and we agreed to work together. A good thing, too, since we'd have to start rehearsals in less than two weeks. That afternoon, Brian organized a meeting with Marv Dolgay and Glenn Morley, whose Tambre Productions could provide the music tracks for the special. The next day, we went to CBC and looked at Studio 41, "the Ralph Benmergui studio," where we'd shoot the show.

By coincidence, our first rehearsal for the show that would start our 16-year run on television, was on Sunday, December 13--which meant that neither Brian nor I could attend the 1992 edition of the annual Festive Brunch (#3) at Knowlton Nash and Lorraine Thomson's . . . three years after Brian had first said, "If you ever need some help getting a TV show going, just ask."

Not many shows walked through the doors of CBC with enough cash to fully finance their production, but that didn't stop CBC's in-house financial people from trying to extract more. When their bosses asked them to develop a budget for our one-hour special, the tab touched $400,000. We told CBC we didn't have $400,000. In fact, with less than three weeks to go before we began shooting, even if we had $400,000 there wasn't enough time to spend it. Eventually the budget discussion was settled like this:

CBC: How much money do you have?
AIR FARCE: $150,000.
CBC: That's fine, we'll take it.

We're convinced CBC made money on the deal. With fully staffed design and technical departments already on the corporation's tab, this was a cash windfall dropped into their laps. In and out the door in less than a month? Merry Christmas to CBC.

We had long been admirers of Radio-Canada's year-end Bye-Bye shows, an annual live New Year's Eve television comedy special that bid adieu to the year just passed with a strong cast of Quebec comedy stars and special guests. We wanted our show to cover similar territory (with a fraction of the budget) and decided to call it *Year of the Farce: 1992*. John and Gord and Rick turned their attention to the script and continued to plug away at it while writing the Massey Hall radio taping. Early in December, we met at our Gerrard Street offices to talk about script and budget. We laid out the production costs and fees for directing, performing, writing, and producing. Divided among all of us, no one was going to get rich. John asked for a break so he, Rick, and Gord could have a meeting at a coffee shop around the corner from our office. There was $25,000 for writing and producing and when they came back they said they wanted it all. We explained that left nothing for us as producers, but they refused to budge. John had a strong anti-producer bias and now that TV loomed, he was going to make sure the writers weren't going to get screwed by the producers, even if they happened to be us. We were dumbfounded. But we said fine. After working this hard to get a shot, we weren't going to let it slip away.

CBC was still moving into its spanking-new production centre in downtown Toronto, right across the street from the Convention Centre, CN Tower, and SkyDome. It was an exciting place to come to work.

Technicians were installing radio and television facilities as fast as the new equipment arrived. Permanent sets for *Street Legal* filled rehearsal halls and blocked corridors, and *Friday Night with Ralph Benmergui* went live to the network out of the only production-ready facility on the tenth floor, Studio 41. That's where we'd record our show; not only was it the only one available, it had seating for a live studio audience. The *Friday Night* set had not been designed to be moved; we'd have to perform around, over, and in front of it. And we couldn't show it either. "But since you're doing a New Year's special," we were told, "you'll be surprised how much of it you can hide with balloons."

We met director Perry Rosemond for our first script read in a sixth-floor rehearsal hall. He began by telling us that we had "good physiques for television," which prompted John to snort, "Oh, sure." Perry explained that he didn't mean we were athletes or models, just that we were of average height and build and no one had bad skin; we wouldn't cause major headaches for wardrobe, hair and makeup, a.k.a. the beauty department. An early TV lesson learned: "good physique" doesn't mean "presence of good," it means "absence of bad." The fact that Perry wasn't trying to flatter us and that his manner was matter-of-fact had a calming effect on whatever jitters we were feeling. "Right," we thought. "Let's get to work."

We started putting the script on its feet. It had been a decade since we last had a crack at television and the conditions this time were probably as good as they were ever going to get. We had ten years of experience under our belts making Canadians laugh with our kind of comedy. We knew what audiences laughed at and how to make radio shows. Could Air Farce make the transition to television? In less than a month, we'd find out.

The sixth-floor rehearsal hall was around the corner from the swank offices of CBC's most formidable arts presenter, Adrienne Clarkson, later the Right Honourable Adrienne Clarkson, twenty-sixth Governor General of Canada. She had a reputation for being very smart and very opinionated and not suffering fools, and on the second day of rehearsal, Don met her for the first time.

DON: I was standing by the elevators on a coffee run when Adrienne Clarkson sailed around the corner. "Oh, hi Roger," she said, "I heard Air Farce was in the building. You must be very excited." I was somewhat taken aback that Air Farce had even registered on her radar. I agreed that we were indeed excited and was bold enough to add, "But I'm not Roger, I'm Don." She blinked, shot me a look and said, "No, you're not. You're Roger." For half a second I believed her. After all, she was Adrienne Clarkson.

CHAPTER 15

Television

ROLLING IN ON A LUCKY BOUNCE...
AND LANDING ON OUR FEET

Summer 1993. CBC's official publicity photo for
the first year of our TV series.

Perry Rosemond proved to be the ideal director for the New Year's special. He was efficient, well-organized, jovial, and modest. Trevor Evans, the talented director who had handled our first forays into television more than ten years earlier, had sharpened his skills working with Johnny Wayne and Frank Shuster. He directed their specials and, along with CBC, saw *Air Farce* as *Wayne & Shuster junior*. With Trevor's hand on the tiller we had capacious Wayne & Shuster-style sets and glamorous showgirls--very Hollywood and proven to be successful with audiences--but it wasn't who we were. At first Perry probably didn't quite get our sensibility either. He'd worked years in Los Angeles and was a pro at showbiz glitz and glam, but because of time constraints and our limited budget, there was no opportunity to turn us into something else. What Perry did very well as a director was to serve the comedy, something we appreciated very much in these first days together. He never imposed himself. During what became a sixteen-year relationship, "serving the comedy" was the foundation upon which his directorial decision-making rested. His first question when reading a script was always: What is the writer's intent?

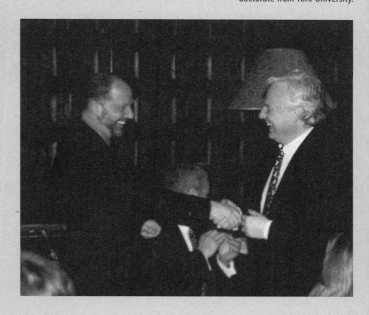

Mid-1990's. Don congratulates Ivan Fecan on receiving his honorary doctorate from York University.

He says he enjoyed working with us as performers, because of the confidence our years in radio had given us, that we "were able to perform comedy on television without showing fear in (our) eyes." That's not to say we didn't experience a few jitters come the big day. "At one point," Perry recalls, "I went down to the studio—I believe it was between dress and show—and Don looked a little upset. And I said, 'What's wrong?' And he said, 'I'm nervous.' The way he said it, it was like the first time he'd ever been nervous about anything! It almost came to him as an interesting revelation."

We taped the show in as close to "real time" as we could, keeping items short, sometimes with our characters speaking just a line or two while wearing costume pieces rather than undergoing full wardrobe changes, the live audience of radio faithful who'd phoned for tickets lapped it up, sets were minimal and balloons floated everywhere.

We felt we'd pulled it off—an hour-long comedy special with three weeks prep. John flew back to England; Perry, Roger, and Don tucked into the editing.

Spring 1983. Roger working for his favourite cause, Easter Seals Ontario.

To his great credit, after seeing the rough edit of the show between Christmas and New Year's, Ivan Fecan phoned Roger at home and said, "Let's do more." This kind of thing didn't happen often in television. (Television executive joke: Executive #1, "Did you like the show last night?" Executive #2, "I don't know, I haven't seen the ratings yet.") Television executives have long been mocked as fence-sitting bet-hedgers. And you can't blame them. Because of the high stakes, practically every prime-time programming decision is high risk. There's a saying in the business: "No one knows anything." Executives and producers do their utmost to stack the odds in their favour. Would anyone starting from scratch cast a new comedy show with a less likely assortment of characters: three performers in the second half of their forties; one a Ukrainian-Canadian graduate of the National Theatre School and the only one of the group to have ever taken an acting lesson; one an English-born and another a Canadian-born producer/actor; and the fourth a Welshman in his early sixties who was primarily a writer? Never. But somehow it worked and Ivan recognized that it did. When the ratings appeared, they confirmed his judgment. They were better than expected. And hearing *Year of the Farce: 1992* discussed —positively!—on Peter Gzowski's radio show sent us over the moon.

Roger's and Don's commitment to Easter Seals included attending the annual American Easter Seals host-producer conference as part of a five- or six-person delegation from Toronto. Every year we learned something new about raising funds and building awareness for Easter Seals; it was also when we held the first production meetings for the annual spring Easter Seals telethon. The conference had been held in interesting places (New Orleans), inappropriate places (Las Vegas), and in January 1993 the site was Los Angeles. At the Air Canada lounge in Toronto, we ran into Ivan Fecan, who happened to be on the same flight (he was up front on CBC's dime, we were in the back on Easter Seals' nickel) and we agreed to meet for breakfast the next morning at the Four Seasons Hotel, "the television hotel," in Beverly Hills. We got together at 8:00 a.m. and for a couple of hours discussed the pros and cons of specials versus series. The advantage of specials was in the very name —they'd be "special"; moreover, we'd be able to continue the radio series.

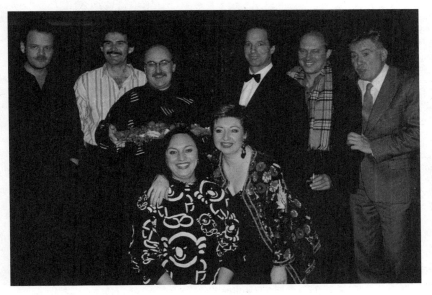

Producer Bryan Hill, sound effects technician Anton Szabo, Roger, guest star Barbara Budd, Luba, Don, recording engineer Ray Folcik and John.

The advantage of a series was that we were familiar with the format and, if it worked, we might be able to create the same weekly audience habit that we had on radio. Ivan professed no preference and left the decision entirely up to us: what did Air Farce want to do? We finished our breakfasts, shook hands and that was it—we'd made our deal to do TV. Details to be worked out later. Of particular delight to Roger was that none of the meetings leading to this moment had been held inside CBC.

By the time we boarded the plane to come home, we had decided in favour of a series. An unexpected outcome: because the show became a runaway hit, we were in studio every January for the next fifteen years and could never attend another Easter Seals conference, although we kept working the annual telethon until the year Roger died.

Sad news awaited when we returned to Toronto. John's wife, Ena, had become ill between Christmas and New Year's, and in January had been diagnosed with terminal cancer. She was a lively, warm, generous person, quick to laugh and fun to be with; it was inconceivable that she now had only a couple of months to live. We'd last seen her in Montreal in

August, when Air Farce had been inducted into the Just For Laughs International Humour Hall of Fame, and we were all—Roger, Don, Luba, Rick, Gord, Dave, our radio crews, and everyone who knew Ena—shaken by the news and deeply saddened. John cancelled his participation in radio tapings indefinitely in order to be by her side. We didn't know when—or even if—he'd return from the U.K.

A couple of times in the past, we'd hired Barbara Budd, who co-hosted *As It Happens* on CBC Radio, to work with us. Barbara was quick-witted, smart, had an earthy sense of humour, and had trained as an actor. Once again we turned to her: would she help out in John's absence? She agreed. Dave Broadfoot returned too, five years after leaving the troupe, to help fill in for John through most of the spring of 1993. (John repaid the favour ten years later. When Dave was awarded the Governor General's Performing Arts Award in 2003, John came out of retirement to perform with us on gala night. It was the one and only time he did.)

Ena died in February, sooner than expected, and John returned to Canada briefly in March and again in May. At an age when many people considered retiring—John was almost 63—he was about to embark on a

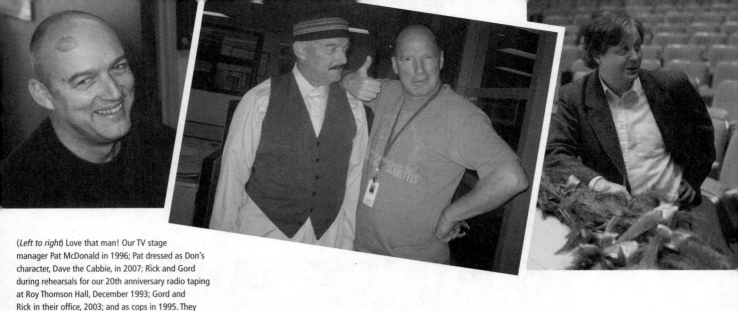

(*Left to right*) Love that man! Our TV stage manager Pat McDonald in 1996; Pat dressed as Don's character, Dave the Cabbie, in 2007; Rick and Gord during rehearsals for our 20th anniversary radio taping at Roy Thomson Hall, December 1993; Gord and Rick in their office, 2003; and as cops in 1995. They occasionally appeared in the show in silent roles.

new career: television star. Canadians who'd never heard of a Welshman named John Morgan were soon going to meet a Scotsman they'd never forget—Jock McBile.

We continued to negotiate contract details with CBC and began our initiation into the arcane world of CBC television budgeting, in which there were two kinds of currency: real dollars that were used when a producer had to rent, buy, or hire outside of CBC; and CBC dollars, also known as "rubles," that were drawn against the corporation's albatross-like commitment of union obligations.

In addition to owning a vast array of plant and equipment, CBC employed a large unionized staff of creative and technical personnel. This system worked well when CBC produced most of its programming in-house, but when CBC's budget began to shrink and the corporation could afford to produce fewer programs, the unionized payroll requirement continued to drain cash from the corporation, even when employees had less and less to do.

A result of lower demand was that there had become available a permanent pool of technical and design employees that no experienced CBC producers would touch with a barge pole; schedulers routinely solved the resulting personnel assignment dilemma by stuffing rookie shows like ours with these less desirable people. Luckily, CBC threw us a couple of lifelines in the form of network executive Kay Soares and our first line producer, Bev Dale. They knew the good from the mediocre and

the mediocre from the unacceptable. We worked with them during the course of the summer and managed to assemble a decent, if not perfect, crew. Sometimes we just got lucky.

ROGER: We were sitting in Don's office interviewing candidates for stage manager positions. We needed two: the "number one" or "first" would be the director's eyes and ears on the set, working with the actors in front of the audience. The "second" worked backstage, where hair, makeup and wardrobe would transform actors from one character into the next as the live taping progressed. One of the people we interviewed was a bald man a couple of years older than us, who had spent the previous two seasons stage-managing *The Kids in the Hall* series. He was soft-spoken, modest, and self-effacing, the very antithesis of the take-charge field-general type we were looking for. His name was Pat McDonald. He'd moved to Toronto from Windsor when CBC shut down production there, and discovered to his surprise and delight that Toronto was not the big, bad place he feared it would be; instead

PHOTO: JEFF SPEED

he found his new CBC colleagues to be friendly, helpful and accomplished. This sounded very positive to our ears. He knew *Royal Canadian Air Farce* on radio and liked it. Even better. He closed by saying that he didn't particularly care if he got the job of "first" or "second" stage manager; he'd just like to work on the show. As soon as he left the office, Don turned to me and said, "That's our number one." And he was. We hired him and he stayed with us for as long as we did the show. People who attended our live tapings loved him; they frequently urged us to put him on the air.

We worried that the double load of radio and television would overwhelm our three-person writing staff of John, Rick, and Gord. All around us, people said we needed to add writers, that the show couldn't survive with so few. On radio, the argument went, we might be able to get by with just three, but a network television comedy required five or six minimum. *Saturday Night Live*, which produced about forty-five minutes of sketch comedy (equal to our weekly combined radio and TV requirement), employed more than fifteen *pairs* of writers. We were spooked. The time to address this was now, before production started.

Rick and Gord were spooked, too, and called an emergency meeting on a Sunday morning to make their case. The discussion unfolded along these lines:

RICK and GORD: We've been writing the radio show with John, we can do the TV show, too.

ROGER and DON: Double the material? Plus a new medium?

RICK and GORD: We'll do it with John.

ROGER and DON: But how?

RICK and GORD: We can.

ROGER and DON: Okay. Let's start again from the beginning. You and John want to write all of the radio show and all of the TV. How are you going to do it? What's your plan?

RICK and GORD: We've been writing the show, we don't think there should be any other writers.

ROGER and DON: What if one of you gets sick?

RICK and GORD: We don't think there should be any new writers.

ROGER and DON: What if by week three you need help, what do we do then?

RICK and GORD: There shouldn't be other writers.

As an exchange of ideas, it lacked details. As a discussion, the meeting was devoid of give and take. As a conversation, it desperately cried out for some sparkle and wit. But it did contain one very clear piece of information: Rick and Gord (and John) wanted to write radio and TV alone, without help. Their reasons, not that they gave any, seemed to be threefold: 1) they were proud of what they'd accomplished in radio and were confident they could continue their artistic success in television; 2) having proved themselves in the lesser-regarded medium, they'd earned the right to have a crack at the more high-profile one on their own terms; 3) now that fatter paycheques loomed, they weren't keen to share the lucre with newcomers after they'd laid all the groundwork. So against the advice of everyone (except Rick, Gord, and John) we deferred to their wishes—you're supposed to dance with the one that brung ya, ain'tcha?—and prepared to launch *Royal Canadian Air Farce* with the smallest writing staff in scripted television.

We debated whether to bring our radio characters along for the ride and decided, ultimately, not to. We left them in vacuum land because radio listeners had created their own mental pictures and we didn't want to mess with the magic. Two people sitting in the same car, listening to the same sketch, each imagined it differently, as did every member of a family sitting around the kitchen table after Sunday lunch. We knew that if we brought our characters to television, more than 500,000 individually imagined Amys or Bernards or Henris would

disappear and be replaced by the one that we put on screen. In the end, one radio character did make the transition, Mike from Canmore.

By the end of summer, we were ready to go. We opened with radio tapings in September—on the road in Winnipeg and Ottawa—and then jumped off the deep end into TV. Actually, not quite the deep end. Kay Soares strongly urged us to do a dry run. She realized that going to air with the results of our first-ever taping would be the equivalent of inviting an extended family to Thanksgiving dinner without ever having turned on a stove before. The dry run would be the equivalent of shooting a pilot episode, and was especially necessary in our case, because we weren't just testing our comedy—which, all things being equal, we were pretty confident would work—we were test-driving the machine that we'd built over the summer for turning words into television for the next seven months. If the writers delivered scripts first thing Monday morning, could our new machine design and build everything we needed by Thursday? Could we record all the sketches that we'd need for a show in one evening? Could we assemble the results quickly enough to put them on the air less than twenty-four hours later?

At this point, no matter how good or bad a job the producers have done, the director takes on the responsibility of delivering the pictures. When shooting wraps, whether on a mega-budget Hollywood superhero spectacular or a weekly sketch comedy show in Toronto,

(*Left*) Norm with his famous owner, Mike from Canmore, in 1999; John dressed as Jock McBile got his own float in a Canmore, Alberta, parade in 1996. (*Right*) 1995. The Friday morning edit gang: (*Left to right*) director Perry Rosemond, sound effects technician Tom Wood, associate director Linda Bain, production editor Grant Ducsharm; Perry backstage with former CBC news anchor Knowlton Nash in 1997.

a production is in deep doo-doo if it doesn't have all the pictures it needs. Perry Rosemond realized that the only way to get Air Farce on air as quickly as we needed was to record each sketch as if it were being broadcast live. This meant not only planning every camera shot in advance (as all directors do), it also meant cutting between cameras as the sketch played in front of the live audience so that we'd end up with a "line-cut" that, in theory, we could broadcast "as is" if we had to. Perry also knew that retakes would be needed in practically every sketch. Actors flub lines, drop props or stand in the wrong place in the set. Camera shots accidentally make it look as if a plant is growing out of an actor's head. A special effect might fail, or a light could blow out during a take. The more complicated the sketch the more there is to go awry. Perry recommended that rather than stop a sketch and re-shoot in front of the audience—who wouldn't laugh at a joke a second time—it would be better to re-shoot the entire show in front of a different audience and use the time in between tapings to rewrite the jokes that didn't work.

So every Thursday we shot the show twice, once at 6:30 p.m. and again at 9:00 p.m. Considering that dress rehearsal began at noon and we didn't finish discussing edits until after midnight, it made for a long day. Especially when, every second Friday for the entire season, we'd also be taping two radio shows with completely different scripts in front of yet another live audience at the ground-floor Glenn Gould

Studio in the same Broadcasting Centre. Were we crazy? Definitely. Was the learning curve steep? Straight up. Did people get tired? You bet. Did we have fun? We had a ball.

As anticipated, the dry run didn't produce enough material for a broadcast and neither did the first real taping, but between them we had more than we needed. Putting together that first show with editor Grant Ducsharm we learned another lesson from Perry: "Put the shiniest apples on top". We knew that principle to be true—we'd practised it for twenty years on radio—but television was so much harder and so much more demanding that we kept suggesting that we hold something good in reserve in case next week's effort needed help. Perry was firm: "Put the shiniest apples on top." But what about next week? Perry had a quote for this, too (New York Yankees manager Casey Stengel's instructions to Whitey Ford pitching on one day's rest during a World Series game): "Throw as hard as you can for as long as you can."

Television is extremely competitive, a voracious maw that relentlessly devours anything and everything that's new: new seasons, new formats, new shows, new technologies, new ideas, new people. Viewers,

compelled by a seemingly bottomless appetite for novelty, never stop clicking around. If the price of freedom is eternal vigilance, then the price of success in television is eternal diligence; you have to do your best every day with no let-up. Everyone rose to Perry's challenge and threw as hard as they could for as long as they could—it was a decade-and-a-half of unrelenting hard work, week after week after week. Looking back, the early days of the series also required a huge leap of faith—from CBC as well as from everyone at Air Farce. We believed and we worked hard, but any one of us who was there would have to honestly say, "We didn't know we could do it until we did."

Watching Perry during a taping or in the edit suite the next day, you might think he'd never seen the show before, let alone rehearsed it with the actors during the week. He laughed and cackled along with the audience at every twist and turn in the script. He'd also hurl pencils at the control-room monitors if an actor screwed up repeatedly, but the actors weren't supposed to know that side of him. He was also merrily ruthless in his editing. If something didn't work—a line, a joke, a turn of the head—he cut it out. He was cheerfully shameless about what the result sometimes looked like; on those occasions when an actor who had faced east one moment suddenly faced west the next, he laughingly boasted that he was "the king of the neck brace edit."

The show premiered on Friday, October 8, 1993, and the ratings arrived the following Monday. CBC's sales department had guaranteed advertisers 400,000 viewers. That first week we had 987,000, the next week we went over a million and didn't drop below it for seven years. The fact that we debuted in the middle of a federal election helped launch us. Kim Campbell had followed Brian Mulroney as prime minister and was performing dismally in the campaign. Our kind of comedy and satire was new to television. Viewers turned to us in big numbers and, when the election was over, they kept tuning in for more. By week four we were a bona fide hit and network executives began dropping by backstage during the Thursday tapings to introduce themselves and offer congratulations; clearly none had anticipated this kind of return from our bargain-basement budget. Our bosses were pleased as punch and we were proud as peacocks.

It's almost a rule in television that production leads, paperwork follows. It's not uncommon for a show to hire staff, writers, actors, and even to begin shooting without all the proper, legally binding contracts having been signed, sealed, and delivered. Air Farce proved no exception. While network brass paid backstage visits, we were getting desperate for dough. The business affairs department explained we could not be paid because cheques could not be written because our contract with the network had not yet been finalized.

Grant, Perry and Linda in the edit suite.

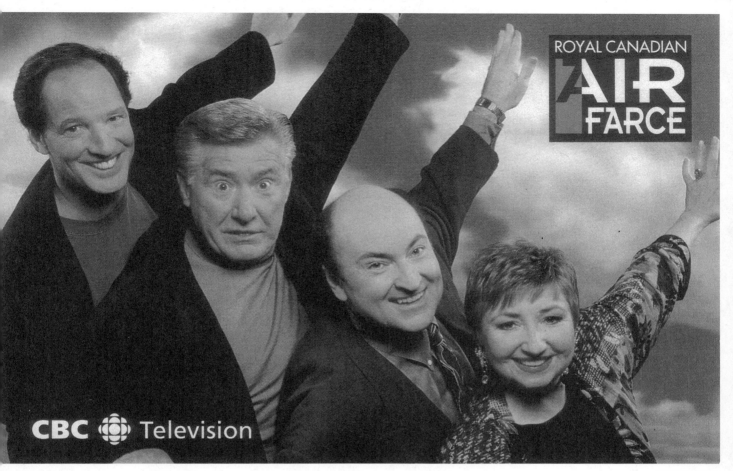

ROYAL CANADIAN AIR FARCE

CBC ⬤ Television

1993. A publicity handout for the first TV season.

PHOTO: RODNEY DAW

DON: We were frustrated. Roger was particularly upset. Someone in Business Affairs explained they had to be careful in case there was a problem with the production company not delivering. Roger, I, and Brian Robertson (whom we'd named executive producer because the network wanted someone to be in charge while Roger and I were on set) were standing outside our dressing rooms between tapings, and Roger couldn't believe it. He said loud enough for anyone standing within twenty feet to hear, "The show's already been on the air for three weeks. What better indication of our good faith could they want?!" Early the next week, we got our first CBC cheque, large enough that actors, writers, and producers could start getting paid.

ROGER: To many people at CBC Television, our success came as a bolt out of the blue. They were astounded that we'd attracted a millon viewers so quickly, and assumed that we were gob-smacked, too. But we had a ready explanation for them: "During ten years of touring," we said, "we met every one of those viewers personally."

With success came creative freedom; the fear that we'd have network executives leaning over our shoulders every week offering "helpful" suggestions melted away. We thanked our lucky stars. Countless shows are "helped" out of existence by well-meaning overseers. We had rolled into TV on a lucky bounce and landed on our feet, and CBC management wisely left us alone. *Royal Canadian Air Farce* came as close to the definition of a dream production as any broadcaster could hope for. It was hugely popular, the production team was talented, hardworking, and responsible, the show came in at the very bottom of the cost scale, viewers didn't complain incessantly (or even "cessantly") to their MPs, and nobody in the cast caused the network any embarrassment or grief. Why rock that boat?

While the television series took off, Bryan Hill continued producing our radio series. Rick, Gord, and John sent him scripts beginning on Monday and Tuesday, after the bulk of the week's TV writing was done, and continued feeding him material through the week. On Thursday morning, cast and writers read, discussed and rehearsed the radio script, then spent the rest of the day doing television. Friday morning we rehearsed radio for a couple of hours. Then the writers tweaked the scripts while Roger and Don joined Perry in the edit suite to check how that night's TV show was progressing. Around two in the afternoon, we rehearsed with the radio crew in the Glenn Gould Studio and recorded two shows Friday evening, one of which would air Saturday morning on CBC Radio 2. All in all, quite a relaxing day.

December 1993 marked our twentieth anniversary on radio so we couldn't let that occasion slip by. We'd hoped to celebrate at our old favourite, Massey Hall, but because we were now tied to television we needed a venue closer to our new offices in the Broadcasting Centre. We opted for Roy Thomson Hall, which was just across the street. On our

fifteenth anniversary, we'd re-recorded a sketch from our very first taping, "Coffee Shop" (which we also called "Just a Coffee"), and slipped it into the show. We performed it again for the live audience at Roy Thompson Hall but didn't want to repeat the piece on air, so we recorded an alternate, "Literary Hold-Up Note," also from the very first *Air Farce* taping, and dropped it into the broadcast. A little birthday present to ourselves.

On our second television episode, we hosted our first special guest —Corky and the Juice Pigs, a three-man music and comedy group, one of whom was Sean Cullen. In the winter we invited the cast of *Street Legal*—Eric Peterson, Albert Schultz, Cynthia Dale, Julie Khaner, Anthony Sherwood, and C. David Johnson—to join us for one of our largest sketch casts ever—ten people crammed into one set. Dave Broadfoot was a frequent guest. And Maple Leaf hockey star Doug Gilmour— "good ol' Kingston boy!"—joined us once, too.

We finished off the first year of television with high ratings and a firm place in CBC's schedule. And then went on to finish the radio season with tapings in Saint John and Halifax. It had been an altogether satisfying season, but looking back at the end, there was a palpable sense of "Whew! We're glad that's over."

PHOTO: RODNEY DAW

O CHRISTMAS TREACLE Had your fill of TV's holiday turkeys? Fear not. The week ahead offers tastier fare — including a cheeky New Year's Eve special from the Royal Canadian Air Farce

Broadcast Week

THE GLOBE AND MAIL • DECEMBER 25 TO DECEMBER 31, 1993

A Week in the Life of Air Farce

... A LEAN (BUT NOT MEAN) TV MACHINE

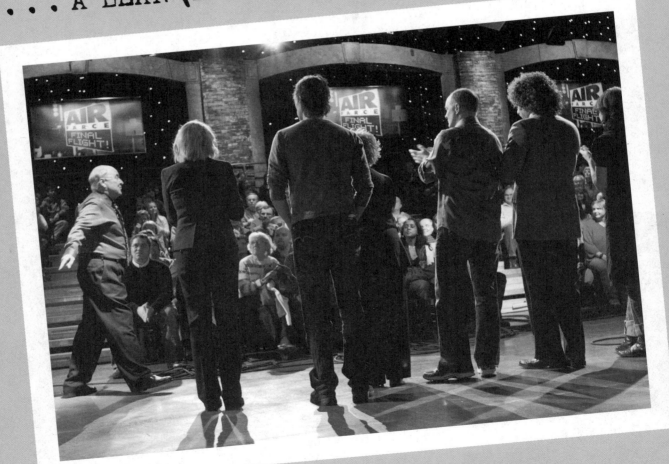

FarceFilms editor Nicolas Kleiman took this shot of Roger working the crowd during our final taping, December 2008. The backs belong to Jessica, Alan, Luba, Don, Craig and Penelope.

When Air Farce recorded radio, we developed a performance style that we adapted to television. Normally actors in sketches ignore the audience and play to each other; the opposite is true for monologists who look audiences straight in the eye in order to engage them directly. We ignored theatrical convention. Sketch or monologue, we played directly to the audience, standing at our microphones, facing outward. The result was a cross between a scene played in a theatre and a stand-up routine performed in a nightclub, a hybrid of sketch and monologue adapted to suit our performing situation.

When we made the move to television we wanted to keep facing the audience. Perry made it a point to keep the line of our eyes as close to the camera lens as possible, and the writers created scripts in which doing that seemed natural. Mimicking *The Journal*'s "double-ender" interviews was a favourite technique. So were telephone conversations, in which Perry would divide the screen in half, placing President Clinton on one side and Jean Chrétien on the other, so they conversed without looking at each other (who could before Skype?). They looked forward, just off the camera lens, almost into the eyes of the viewer at home. It was a sketch performed not as a sketch and not as a monologue either. A sketchologue, maybe.

ROGER: We ran into Frank Shuster in the Broadcasting Centre one day. In 1983, he and Johnny Wayne had barged into the Sumach Street studio where we were rehearsing our tenth anniversary show. Johnny and Frank, who were in their fourth successful decade on CBC, happened to be rehearsing their latest TV special on another floor of the building. We'd never met. They marched straight to where our group was standing, gave us a top-to-toe look-over, and Frank asked, "Ten years?" "Yes," we said. "Hmph," snorted Johnny, "Whippersnappers!" And they turned and marched out as quickly as they'd burst in. We'd been friendly since. In their television heyday, Johnny and Frank had created classic sketches like "Rinse the Blood Off My Toga" and the "Shakespearean Baseball Game." On this particular day Frank, who was a shrewd observer of all things comedic, said he liked our show but couldn't help notice that we "didn't really do sketches." I think he was secretly pleased that his and Johnny's pre-eminence in the field would not be threatened by us.

With early success also came the freedom to relax about everything except what was important—making the best show we could. As weeks

turned into months, cast, writers, technical crews, design personnel, and office staff began to believe that Air Farce would be no flash in the pan, and in fact might hang around for a few seasons. We tried to make the work environment as enjoyable as possible, and began to hear comments from management such as "What do you do to your crews? They love working with you." We asked managers, "What does CBC do to its employees, beat them?" The laugh this got didn't hide the fact that CBC had poor relations with its unionized employees. Many felt shabbily treated. Crews had little option but to accept overtime, frequently being required to return after twelve-plus-hour days on very short turnarounds. Little concern was expressed for their well-being or for that of their families, and some managers regarded lighting, staging, and other technical crews as necessary evils rather than assets. Crews responded as might be expected, with resentment and the occasional bit of sabotage. Radio hadn't prepared us for this. We also hadn't experienced daily life inside CBC before, because we'd never had an office in a CBC building until television started. Life inside the television tent opened our eyes, but it didn't change our ways.

DON: It took three years to assemble a complete crew that, top to bottom, met our standards. When someone incompetent or disruptive was assigned to a show, it wasn't easy to get rid of them because no other show wanted trouble either. Even after suffering through an entire season, we couldn't just say to a manager, "Please assign us someone better next year." Managers required us to put our reasons in writing. Only in very rare circumstances would a CBC staff producer do this, because after such

a letter was written, the manager called in the employee, showed it to him (or her), discussed the contents and then put the letter in the employee's personnel file where it stayed forever. But it didn't mean that employee wouldn't be assigned to that same producer--or even that same show--again. And if you thought the employee was a trouble-maker before, just wait till next time.

We felt we had nothing to lose. So we'd have private chats with individuals and if that didn't work we wrote letters to their files, and in a couple of cases we wrote "last chance" letters that they signed in our presence. Since we couldn't pay people more, the least we could do was improve people's work environment by ensuring that talented, hard-working crew didn't have to suffer the failings and shenanigans of incompetent, lazy, or uncooperative co-workers. It took a while, but we got the job done and after that our set had to be one of the happiest in CBC.

ROGER: CBC had begun a long struggle to make sense of their unionized bargaining units by amalgamating as many as possible. Thirteen years earlier, a camera operator dared not touch anything in a set that came under the jurisdiction of the design department--for example, moving an ashtray sideways one inch because it was in his shot--because it could threaten a work stoppage.

PRODUCTION SCHEDULE Season 16

June 28, 2011 12:24

Office: 416.205.3800 Studio 42 : 416.205.2142

Monday:

*10:30am – 1:00pm	Script Read, Cast Read through, Running Order TBD, notes to Barb.
*1:00pm – 2:00pm	Design / Special Effects Meetings (9B300)
*1:00pm – 6:00pm	Possible Farce Films Shoot (Selected Cast, TBA)
*2:00pm	Preliminary Graphics Meeting (9B300)

Tuesday:

10:30 – 11:30am	Full Production Meeting (9B300)
12:00 – 2:00pm	Rehearse – All Cast/Writers, etc. (M10F101)
2:30pm	Possible Farce Films Shoot (Selected Cast, TBA)
3:30 – 4:00pm	Wardrobe Fittings (Selected Cast TBA)

Wednesday:

10:00am	Luba to Wardrobe (9A100)	
10:20am	Don to Wardrobe (9A100)	Luba to Hair/Mu (10A114)
10:40am	Roger to Wardrobe (9A100)	Don to Hair/Mu (10A114)
11:00am	Craig to Wardrobe (9A100)	Roger to Hair/Mu (10A114/)
11:20am	Penelope to Wardrobe (9A100)	Craig to Hair/Mu (10A114)
11:40am	Alan to Wardrobe (9A100)	Penelope to Hair/Mu (10A114)
12:00pm		Alan to Hair/Mu (10A114)
11:15am		
11:30 – 12:00pm	Footage Screening (9B300)	
12:00 – 12:30pm	Graphics / Electronic Graphics Meeting (9B300)	
12:30 – 3:00pm	Rehearsal Lunch (M10F101)	
2:30 – 4:00pm	Rehearsal (M10F101)	
4:00 – 4:30pm	Possible Farce Films Shoot (Selected Cast, TBA)	
4:30 – 7:30pm	Record V/O's (Studio 42 Control Room)	
7:30 – 8:30pm	Technical Rehearsal (Studio 42)	
	Post Rehearsal Notes Meeting (9B300)	

Thursday:

*11:00am	Cast to Read New Pages (10A117)
11:30am	Cast to HMUWA
12:00 – 2:00pm	Dress Rehearsal – Part One (Studio 42)
2:00 – 2:30pm	Crew Meal Break
2:00 – 2:30pm	Script and Cast Notes Meeting (10A117)
2:30 – 4:00pm	Dress Rehearsal – Part Two (Studio 42)
*4:15 – 5:15pm	Crew Meal Break
4:00 – 4:30pm	Script and Cast Notes Meeting (10A117)
*4:30 – 5:30pm	Cast Meal Break
5:30pm	Cast to HMUWA
5:45pm	All facilities ready
6:00pm	Show, First Audience
6:45pm	Script and Cast Notes Meeting (10A117)
7:30pm	Cast to HMUWA
7:45pm	All facilities ready
8:00pm	Show, Second Audience, Preview Farce Films
9:00pm	Wrap
9:00pm	Post Show Meeting (10A117)

Friday:

9:00am	
10:00am	Edit, SFX, Mix
4:30pm	Possible Farce Films Shoot (Selected Cast, TBA)
7:00pm	Delivery to N.C.C. for Closed Captioning
8:00pm	Air to Atlantic Time Zone
	Air to Eastern Time Zone

But now if a vase of flowers had to be moved or a piece of fluff removed from a performer's jacket, whoever was handiest did it, no questions asked. But the downside was that, although fewer but larger bargaining units meant fewer strikes, it also meant that when there was one it would be a doozy. Several times we lost parts of our seasons because of this.

As we settled into television, everyone associated with the show found their sea legs and the creative team developed a steady rhythm. The work week settled into a predictable pattern.

Every Monday morning, the cast, writers, and director assembled in our boardroom for the first read of that week's script. We read it aloud twice before anyone was allowed to comment. Then we went through the script, page by page, discussing everything. Did a particular graphic contain enough information? Was the special effect requested possible to achieve with our limited resources?

Rick and Gord's sketches arrived in the production secretary's inbox on Monday morning, ready to shoot. The sketches improved during the week, after the actors started rehearsing them and Rick and Gord gave them a rewrite that was actually more like a buffing—nip a line or two here, change a word there, and the job was done. John's, on the other hand, were sometimes little more than notions expanded with dialogue. The concept made you smile but the script meandered about looking for a reason to exist. He invited suggestions, just as he had in radio, and Perry, the cast, and, in the early days, Rick and Gord, contributed ideas and jokes. Unlike Rick and Gord's material, you could never have put a John first draft in front of the cameras.

The tension between John's material versus Rick and Gord's went beyond the artistic. John was supposed to write one half of the show, Rick and Gord the other. John understood this to mean that since a typical broadcast needed eight to ten sketches, he'd write five and at least four of them would make it to air. But Rick and Gord consistently delivered more sketches than their share; six for them was a light week and more often than not they'd deliver nine or ten. Later on, when the writing share was changed to one-third John, two-thirds Rick and Gord, they still submitted more than required. And unfortunately for John, their material often won out; in a normal week, John might get two pieces in the show, representing

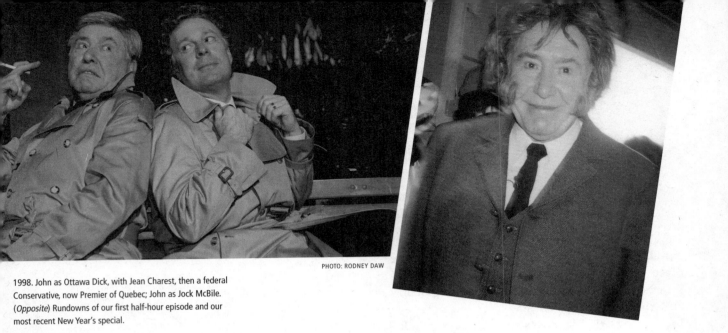

1998. John as Ottawa Dick, with Jean Charest, then a federal Conservative, now Premier of Quebec; John as Jock McBile. (*Opposite*) Rundowns of our first half-hour episode and our most recent New Year's special.

20 to 25 per cent of the total, Rick and Gord seven or eight, accounting for 75 to 80 per cent. Their material addressed the core mandate of the show—political and social satire—and did so with roles more or less equally distributed among the cast. John chafed at this but never could shake them off his tail. His material, for all its inventiveness, tended to be less in tune with the rest of the unit's boomer generation zeitgeist; his comedy roots were firmly planted in the tradition of English music hall.

Having explored and exploited pretty much every aspect of radio writing, John, Rick, and Gord dove into the creative possibilities of what was for us the new medium of television. They made especially good use of chromakey, a bit of electronic trickery where one background is substituted for another. John created "Ottawa Dick," where he played a classic 1930s hard-boiled detective who uncovered foolishness in parliament, politics, and the civil service. His secret informants, snitches, and MPs appeared larger than life on a chromakey screen beside him, their Big Brother-like heads twice as tall as he was. (Ottawa Dick always signed off by saying, "It's tough being a dick in Ottawa; the town is so damn full of them.") Rick and Gord used chromakey even more freely. They created germs who explained diseases from their Petri dish homes, talking codfish who lamented the collapse of the Atlantic fishery, singing amoebae, and other flights of fancy; sometimes *Air Farce* had the feel of a kids' show for adults. Perry had extensive experience directing children's television and had worked on *Fraggle Rock* when it came to Canada; his skills and Rick, Gord, and John's writing were a match made in television heaven.

The result was wildly original TV—as imaginatively liberated as anything we'd done on radio.

John was our natural clown. He wrote primarily for himself and favoured fictitious characters: sad-sacks, vaudeville-inspired newscasters, broadly drawn pre-feminist husbands, blue-collar working stiffs ("down-market guys" in John's words), and opinionated ranters, of whom Jock McBile was the foremost manifestation. Jock McBile vented his spleen on the news items of the week, or on larger issues, such as the rise and fall of the economy. In a blunt Scots accent (loosely based on the late Jack Webster, a crusty B.C. commentator), Jock would tell it like it is, and end his rant with "Ach, get stuffed!" Jock's opinions were never very far from John's own—he was a firm believer in work camps for young offenders and the gallows for most politicians—but he felt more comfortable sounding off in a kilt and muttonchops than as himself. He also enjoyed the irony of turning himself, a raving Welshman, into a ranting Scot.

Even though Jock seemed such a natural expression of the man, Perry remembers that John struggled with the character at the beginning. "He agonized through Jock McBile. I just left him alone when he did it the first time. I went back to his office and on the door was a sign: 'Jock McBile RIP.' He'd buried the character! I went in and said, 'No John, this guy is what we need. That kind of bile, that kind of *amicus populorum*—popular point of view—is always going to have a place in television.' I urged him to stick with it and he did. Part of John's frustration was that nobody marked

John tougher than John. He was his own sternest critic."

Other actors in John's sketches usually played supporting roles. He frequently had Luba play "the wife." He loved working with her, and with these two naturally funny people in the same sketch, it was hard not to laugh at whatever happened, although sometimes rehearsal could be funnier than anything that got on the air.

Rick and Gord wrote for Roger, Luba and Don, as well as for John, ensuring that on-camera time was spread evenly among the four performers, something that John seldom, if ever, considered. Live tapings made this necessary, because one or two actors could be changing wardrobe and getting into makeup backstage while the other actors performed a sketch for the audience. A "four-hander" brought everything to a halt as soon as it finished because, with only four actors, no one was ready to go on after it. That's why a sketch like "Donut Shop" usually closed out the evening.

AIR FARCE SEASON 1, 1993/1994
FORMAT 28:35 (BREAKS: 1x2:45, 1x2:45)

#1-01 – FRIDAY, OCTOBER 8, 1993

C.C. MASTER
D-31079

				RA	DF	LG	JM	*	writer
			time						
			0:21						R&G
			0:38	X	x	x			R&G
			1:59	X		X			JM
			1:58		X				R&G

Script	Time code	Sketch
	00:00	Nudity Disclaimer
	00:21	Opening Titles
	00:59	Hello's
	02:58	Doug Hennin...
	04:56	Long John...
	05:31	National A...
	07:07	Bumper
	07:14	Commer...
	09:59	Bumper
	10:06	Ice Be...
	12:11	Long...
	12:38	Lead...
	14:21	Str...
	15:10	Ne...
	15:46	Y...
	17:30	
	17:37	
	20:22	
	20:29	
	27:55	
	28:35	

SHOW LOG AFTV NYE 2010
RUNNING ORDER – AS BROADCAST
FORMAT 60:00 (CONTENT: 45:02, BREAKS: 2 x 3:47, 2 x 3:42)

CBC Television

AIR FARCE NEW YEAR'S EVE 2010

HD AF Master Edit Not CC: F – 000318
HD CC Master: F – 004282
SD AF CC Master: D – 154929

Script	Time In	Sketch	Time	ra	df	lg	cl	ap	pc	x	Writers	
	08:00:00	Opening Titles	0:20				X	X	X		RL/WT/KW	
A	08:00:20	Parliamentary Sinkhole- Pt. 1	2:50	X	X	X	X	X	X	JH	JH/RL/WT/K	
U	08:03:10	FF- Celine Dion Twins	1:34	X				X			RL/WT/KW	
M	08:04:44	Vince's Bed Bugs	1:52		P/T				X		RL/WT/KW	
L	08:06:36	Double Double Palin	2:35	X	x			X			RL/WT/KW	
X	08:09:11	FF-Vuvuzela-Vision	0:56				X	X			RL/WT/KW	
B	08:10:07	Parliamentary Sinkhole- Pt. 2	2:21	X	X		X	X				
	08:12:28	Commercial Break #1	3:47								RL/WT/KW	
	08:16:05	Bumper	0:03				X		X		PR/RL/W	
K	08:16:08	Obama Spice	2:10	X			X	X		X	RL/WT/KW	
S	08:18:18	FF- Airport Security	1:35				X	X	X			
E	08:19:53	Parliamentary Sinkhole- Pt. 3	1:47	X	P/T		X	X	X			
	08:21:00	Commercial Break #2	3:42								RL/WT/	
	08:24:42	Bumper	0:03				X				RL/WT/	
G	08:24:45	MyTube	2:06					X	V/O	X	RL/WT/	
Y	08:26:51	FF- Resignation HST	1:28				X	X	X			
H	08:28:09	Lightfoot/Baird/Oda	2:14									
	08:30:23	Commercial Break #3	3:47								RL/WT	
	08:34:10	Bumper	0:03					X	X	X	JH	JH/RL/
F	08:34:13	Strombo/Bieber/Gaga	3:26					V/O			RL/WT	
V	08:37:39	FF- Yoga Guru	1:39				X	X	X			
J	08:39:08	Royal Wedding	1:41									
	08:40:19	Commercial Break #4	3:42								DF/RL	
	08:44:01	Bumper	0:03		X		X			LR	RL/W	
N	08:44:04	News Timeline + Fudd	5:33	x	x	x	x	x	x	x	DF/RL	
T	08:49:37	FF- Robertson Tribute	2:52	X	X	x	x	x	X			
R	08:54:09	F-Bomb	5:27									
	08:59:36	Credits	0:15									
	08:59:51	CBC Co-Pro Logo	0:04									
	08:59:55	AF Productions Logo	0:05									
	09:00:00	Out										

Rick and Gord drew their characters from people in the news—politicians, celebrities, sports heroes, media figures, and so on—each of whom required impersonations by the actors. By no means did any of the cast specialize in impersonations—we considered our characterizations to be the television equivalent of a newspaper Editorial cartoonist's caricatures—but they did a credible enough job that audiences happily went along for the ride. Part of the fun for viewers was seeing square pegs pounded into round holes: Don as Toronto mayor Mel Lastman, Roger as Prime Minister Jean Chrétien, Luba as Wendy Mesley, John as journalist Ann Medina (John didn't exactly embrace being in drag but agreed to play Ann Medina as long as we let him smoke a cigar while doing it). Perry believed the comedy was served better if our real selves were visible inside whomever we were impersonating. And time was always a factor; limited by the constraints of live-audience tapings, we never had enough of it to do the extensive makeup required for *Saturday Night Live*–style impersonations.

ROGER: Every week, Wayne Testori, our associate producer, assembled video clips of the characters we had to imitate; each of us had our own "character reel" that he added to over the years. Don's had to be the longest. He played Bob Dylan, Preston Manning, Bill Clinton, Lucien Bouchard, Neil Young, Brian Mulroney, Prince Charles, Joe Clark, Keith Richards, Pierre Trudeau, Larry King, Lloyd Robertson, you name it. He even played Michael Jackson once in Season One or Two. He'd slip into a character and inhabit it completely. But it didn't always come easy. Sometimes he'd struggle through the week and only finally nail the character at the 9:00 p.m. taping. But he always came through. He was the workhorse of the group. If John or Luba or I were in four sketches, Don would be in six.

It created a bit of a problem when we put together our annual "Best Of" videos. The creative team would nominate their favourite sketches and there would always be too many featuring Don. So we'd go fishing for other sketches in order to balance the cast. In any given season, John might do half a dozen Jock McBile rants and appear several times as Mike From Canmore, but we could only put one of each on a "Best Of" tape, so John was always light. It was a problem balancing the writing, too, for the same reason. Every "Best Of" compilation should have an asterisk beside the title to indicate that it contained the best sketches--after we balanced casting and writing.

Current events and news were our bread and butter, but we'd learned in our radio days that anytime a victim came to mind, you couldn't make a situation funny. How could you laugh at the Balkans war in 1995 or the World Trade Center attack on Sept 11, 2001, or the Iraq invasion in 2003? Viewers expected you to do something, but what? Our solution was not to put a camera on the events themselves—let television news departments do that—but to focus on how the news media covered them. An embedded gung-ho American television journalist during the Iraq invasion made a

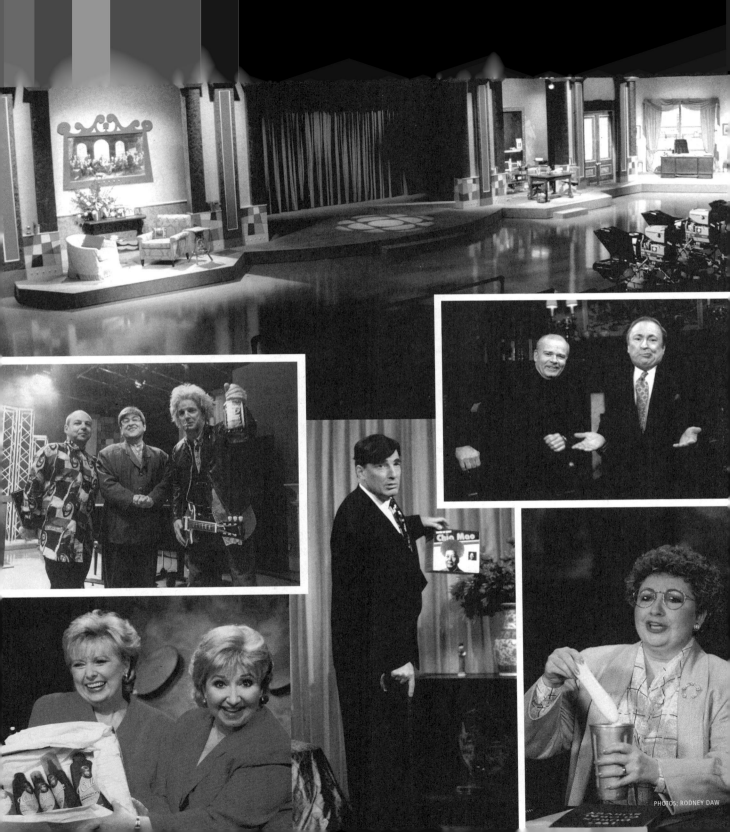

PHOTOS: RODNEY DAW

good satirical target, as did CNN star reporter Christiane Amanpour. In fact almost any foreign correspondent tricked out in trench coat, artfully arranged pashmina scarf, or Anderson Cooper "tighty-whitey" t-shirt could be sent up quite successfully.

In the 1980s we began describing ourselves as "equal opportunity offenders," because we picked on everyone, but we "offended" gently because we wanted people to see the world our way and laugh with us at its foibles. We preferred to "send up" rather than "put down" our targets. Putting down our targets might have suggested that we considered ourselves superior to them and, sadly, there's never been enough evidence to support that.

When the Monday script read finished, Rick, Gord, and John began rewrites while Perry, Roger, and Don met with the various departments, starting with the production designer, originally Paul Chiasson and later Barbara Farquharson, to discuss sets. How big? How many walls? If we wanted to do these eight sketches would the sets fit into the studio? If not, how do we move them in and out during the taping? The production designer worked late into the evening to complete working drawings for the sets; the carpenters would begin building them first thing Tuesday morning.

Next came the graphic designers. In our first season, we had one who worked at a drafting board with coloured paper stock, paints, and Letraset. By year four, we had two at computers and a third was added soon after, with a fourth occasionally hired as electronic graphics became more complex. News and sports pushed technological development and we hopped aboard every advancement like tickbirds on a rhino. Our newscasts

contained two kinds of graphic images: one for information, e.g., a picture of Prime Minister Harper would appear over the newsreader's shoulder while the newsreader delivered the verbal joke; the other kind of image was the joke itself. The newscaster set it up, the picture got the laugh. Thank heavens for Photoshop.

Graphics, of course, are not just electronic. Anytime we needed a sign—"Men" or "Exit" on a door, or "Cheese Balls $1.49, Rubber Balls $1.79" in a shop window—it came from our graphic designers. Sometimes these so-called "hard graphics" could be quite elaborate. A complex, three-dimensional, origami-like creation that had been made to decorate the wall of a religious cult's headquarters was so handsome that Rick and Gord kept it hanging for years in the office they shared.

After graphics, we met quickly with our special effects person. "Special Effects" encompass everything that isn't normally covered by any other department. A cozy fire burning in a fireplace? Special effect. Pants bulging as a person eats too much popcorn? Special effect. Rain? Snow? A hand growing out of a head? A cactus getting an erection? They're all special effects and they all had to happen in front of a live audience. What became *Air Farce*'s most famous special effect (although viewers probably didn't think of it as one) was first broadcast on March 4, 1994, towards the end of our first season: the Chicken Cannon.

The special effects shop was located in the basement of the Broadcast Centre and housed an impressive array of jars, tins, metal, wood, feathers, rubber novelties, construction materials, tools, machines, plastic foam, lam-

inates, you name it. In a casual moment, Rick and Gord asked our special effects expert at the time, Ralph Brown, what he and the other special effects people did during a week when we didn't need them. "Oh, we're always behind in our work and there's always something to do," replied Ralph, "Every so often, just for fun, we put a rubber chicken in the air cannon and fire it across the shop." Rick and Gord's ears perked up: "Really? Can we see it?"

DON: The first Chicken Cannon firing almost never happened. We were supposed to hang the targets--we had chosen three--on a wall in the set, which was a military office. Ralph Brown brought the air cannon and a couple of rubber chickens up from the special effects shop. Because he was going to be in the scene (for reasons of safety, an accredited special effects person is the only person entrusted with the actual firing of the cannon), we put him in a uniform to look like he was military, too. We revived a character I had performed in a monologue about six weeks earlier to be in charge of the cannon: Colonel Stacy. The name came from a real Air Force colonel, Mike Stacey, whom we'd met while taping radio at the Baden-Soellingen air base in Germany in 1992, and if he reads this it'll be the first time

he learns that Colonel Stacy was named after him. John played an enlisted man under my command.

Rehearsal was running late. The walls of the set were thin and the stage hands and set decorators couldn't hang the targets on them. We were edging into the crew meal break, which triggered substantial overtime penalties, so Perry, after wondering aloud how many trained professionals it took to hang a picture, said, "Forget it, put the targets on a damned easel," then stormed off the set. That was it for rehearsal. Ralph hadn't had a chance to test-fire the cannon and none of us knew what was going to happen. We'd use the 6:30 taping as our trial run.

Number one with a pullet. March 3, 1994, was
our first attempt at the Chicken Cannon. Luckily,
it didn't go as planned—it went better.

Come show time, John, Ralph, and I marched into
the set and began the scene. The premise of the
sketch was that recent spending cuts had compelled
the military to reduce its personnel to just the
three of us, but the Armed Forces were still capable
of defending Canada because we had a brilliant
new weapon, the Chicken Cannon. We had three
targets stacked one behind the other on the easel,
to illustrate how effective the cannon could be.
The first target was Bosnia (this was during the
Balkan wars of the early 1990s). We revealed a map
of the country, John stuffed one of Ralph's rubber
chickens into the cannon, I gave the order to fire
and Ralph pulled the trigger.

Ralph hadn't been able to establish a proper
level of air pressure for the cannon, so when I
gave the order to fire, air exploded out of it with a
huge "bang!" and the rubber chicken flashed across
the set, not only reaching the target, but blowing

it off the easel, taking the other two targets with
it, and knocking the easel arse-over-teakettle onto
the floor. There was a moment of shocked silence.
Then the audience erupted. I looked at John. His
face was red, his shoulders were shaking, he was
biting his lip and a tear was beginning to trace
its way down each cheek. He was on the verge of
losing it. I turned to Ralph. The look on his face
said, "Well, boss, at least I didn't miss." I started
to break up. John's eyes were jumping out of their
sockets. Struggling to stay in character, I picked
up the easel, reset the remaining two targets and
continued with the sketch.

The next target was a picture of a "foreign
fishing trawler"--European boats were hoovering
up cod from the Grand Banks while the Canadian
fishery had entered its death throes--and the
ammunition this time was a stuffed Barney-the-
Dinosaur doll. John was practically peeing himself

(*Below*) A 1998 publicity shot; (*Right*) Tim McElcheran, Luba, *Hockey Night in Canada*'s Ron MacLean and Don salute after the last Chicken Cannon ever fired, December 2008; Tim, Alan and Don, New Year's Eve, 2007

PHOTO: CYLLA VON TIEDEMANN

with anticipation as he stuffed Barney down the barrel of the cannon. I yelled "fire!" and again there was an otherworldly explosion, which propelled a purple plush toy at what seemed like 100 kilometres an hour towards the picture of the fishing trawler. Again, everything went flying. I looked at John. Seldom had I seen him so happy. He was wiping his eyes, about to self-combust. The audience was in hysterics--at the noise, at the impact of the Barney doll, at the targets and easel on the floor, at my confusion, at John's giggling.

The final target represented a potential terrorist threat: what if Canada were to be invaded by Robert Goulet (the late singer)? I reset the easel and centred his Hollywood studio portrait on it. The ammunition: coleslaw. I yelled, "fire!" and half a litre of cabbage, carrot, and mayonnaise smashed into Bob Goulet's smiling face before sending it-- and of course, the easel, too--sailing across the set. John and I saluted. John helped the rubber chicken to salute. Mission accomplished. The sketch ran nine minutes. Perry edited it down to just under five but you could still see the manic looks on John and my faces as we desperately tried not to break up.

If we'd had time to rehearse, the targets would have been fastened to a wall, the air cannon would have been less pressurized, and none of the chaos would have happened. The sketch would have been funny, but not hilarious. From then on, it was always in the back of my mind that we should leave room for something to go wrong. But not too wrong. During a rehearsal two or three seasons later, we mounted a picture of the royal family on the wall of a set and the chicken cannon fired an apple at it. The apple smashed the picture and sailed right through the 1/4-inch plywood wall behind.

Rick and Gord created another signature sketch in our first season that also stood the test of time. Officially called "A Canadian Moment," it was almost universally referred to as "The Donut Shop." It debuted without fanfare in December, 1993, with Roger and Don introducing the signature phrase, "You got that right," then resurfaced with John in March, 1994. In April the trio morphed into a gossiping foursome when Luba was added to the mix and the sketch became a regular *Air Farce* feature.

ROGER: The Donut Shop perfectly captured Canada. Donut shops have become the new village greens and general stores for Canadians from coast to coast. Sure there are Starbucks galore in big cities,

PHOTO: *OTTAWA CITIZEN*

but the basic Tim Hortons-style shop is what most Canadians gravitate to. When you pull off the Trans-Canada to stretch your legs, hike through a suburban mall or duck into an underground food court in a big city, what do you see? A donut shop with groups of people clustered around tables chatting over coffee and crullers. For me the Donut Shop felt most comfortable that one time that just John, Don, and I did it. It really felt like three ordinary people having a chinwag. When we added Luba, the dynamic changed, but probably for the better. The Donut Shop became a viewer favourite, maybe the most recognized feature of our show. It was a great way to present the week's news without doing a newscast. There was one small downside. None of us could go into a real donut shop again without being recognized.

"A Canadian Moment" changed slightly every few years. The set got spiffed up, the side walls were pushed farther apart or set at an angle, the lighting became softer. One item changed constantly: the sugar in Sam's dispenser needed to be replaced after every taping. (Typical of Roger's inventiveness, he transformed an ordinary prop into a scene-stealing wizard's wand by turning the simple act of pouring sugar into a cup into comedy magic; his sugar pours—in the cup, beside the cup, overflowing

the cup—drew all eyes as his Sam character sweetened his coffee his own unique way, blithely unaware that anyone might be watching.) Another item hardly changed at all: the donuts. The set decorators wanted something that they wouldn't have to replace every week and went to great lengths to find plastic fakes that looked good on camera. They bought several different types, but nothing looked real. When the search for the perfect fake proved fruitless, we bit the biscuit (or rather, the donut) and shelled out for twenty dozen of Canada's freshest. A week later, the real donuts still looked good and showed no signs of decay, so they were re-used. And re-used and re-used. Sitting in their Donut Shop racks in the tenth floor storage area, they air-dried to perfection. Hard as rocks, utterly inedible, perfectly camera-worthy. Set dec replaced them once a year solely to avoid the bother of having to dust them.

"A Canadian Moment" appeared for the last time on New Year's Eve, 2008, when Al, Sam, and Vera (Don, Roger, and Luba) were joined by their younger selves (Alan, Craig, and Jessica), and served by a cheerful waitress (Penelope) who toiled under the baleful eye of the irascible donut shop owner—surprise!—Dave Broadfoot.

The Donut Shop was one of several vehicles that we used to cover news stories that didn't merit an entire sketch or had broken too late in the week to be treated

(*Left to right*) Getting the Donut Shop ready for business, December 2008; onstage at the National Arts Centre in Ottawa, MPs Svend Robinson and Herb Gray, broadcaster Mike Duffy, and MP Sheila Copps play Don, John, Roger and Luba on the occasion of our receiving the Governor General's Performing Arts Award in 1998; we couldn't show a real company name so at one point made our own "Mister Bag-O-Donuts" mugs.

PHOTO: RODNEY DAW

(*Clockwise from bottom left*) John delivers the news, "Sermon on the Mount" style; "No VISA or I kill you!" Dave the Cabbie (Don) shares his opinions with a skeptical passenger (Roger) in 1999; Brenda the Bingo Lady (Luba) shows husband Sid (Roger) a winning number; Jimmy and Seamus O'Toole diligently scour all available sources for "News From Away," in 1997; also 1997, Heikki Flergen Pootz (Roger) and Svetlana (Luba) deliver "English as a Second Language News"; Mike from Canmore (John) chills backstage. Assistant set designer Diana Richter took a lot of these pictures.

more comprehensively. John's vehicles were solo spots that featured him playing strong characters. Some succeeded brilliantly: Jock McBile was one, The Prophet on the Mount another. Others were abandoned after just one attempt, like the music hall gent who wore a checked jacket straight out of Don Cherry's closet and squeezed a horn, blew a whistle, and banged a cymbal after each news item. Another of his efforts, "News for the Fast of Hearing," turned into a "tour-de-farce" for Luba. John wanted to mock the trend of having signers who translated for the deaf appear in the corner of official government broadcasts. His newsreader character would speak very quickly and the comedy would result from his reaction to the signer's gesticulations. But Luba took lessons in signing, and when she tried faithfully to keep up with John's dialogue, you couldn't take your eyes off her. Her lips quivered, her hands flew, her eyes bulged, her eyes crossed, her nostrils flared, and her chest heaved mightily when she was out of breath. Was there ever a more mobile and expressive face for comedy than Luba's? It was a triumphant performance. She completely stole the sketch.

Rick and Gord's news vehicles almost always featured two performers. Among them were "News From Away" with Jimmy and Seamus O'Toole (Roger and Don), "English as a Second Language News" with Heikki Flergen Pootz and Svetlana (Roger and Luba), Dave—"No VISA or I kill you!"—the Cabbie (Don) with a passenger commenting from the back seat

(various cast), and Brenda the Bingo Lady (Luba) and her husband Sid (Roger).

Sid was a stellar example of Roger's ability to play second banana roles to the hilt. Luba delivered all the jokes while playing Bingo, as Sid sat beside her, calmly playing his lone card while she dabbed at the dozen cards that covered the table in front of her. The sketch always ended the same way, with Sid shouting "Bingo!" and winning the pot. Roger exuded impishness; you could just sense the mischief at work in his head. A total pro. Luba's Brenda character was bang-on and an absolute delight. You could have encountered her in any Bingo parlour in the country. But reading news jokes was not Luba's strength, and delivering them while simultaneously trying to play a convincing game of Bingo was a big challenge. She'd do retake after retake, providing her own tape rewind sounds and duck talk commentary, always to the audience's delight. The writers should have put up a sign in their office: "Don't ask fish to sing, weight lifters to tap dance, or Luba to deliver news jokes." Ultimately they ceased trying to drive a square peg into a round hole and Brenda the Bingo Lady quietly—and regrettably—faded away.

In "Wendy Report with Wendy Mesley," the writers established a manageable limit of two or three news stories before having Luba consult her panel of experts: usually a politician in the news (Roger), newspaper columnist Jeffrey Simpson (Don), who Wendy always told to shut up, and the real star of the piece, Mike from Canmore (John).

Mike From Canmore, Air Farce's resident idiot savant, was another Rick and Gord creation and became John Morgan's best known and most beloved character—particularly on television. Mike made his first appearance in 1991, during a sketch we taped for radio in Banff, Alberta. It was about an all-beef Alberta radio station, COW-FM, and in a phone-in segment, the first caller announced, "I'm Mike. From Canmore." And no matter what the host asked, that's about all Mike could say, before eventually requesting a song. John infused the voice with just the right amount of brain-dead optimism, and we knew a new character had just been born.

When we made the move to weekly television in 1993, we deliberately chose to leave our radio characters behind, but we knew that Mike had made-for-TV magic, and from his first appearance audiences loved him, in his Calgary Flames cap and goofy grin. As played by John, he was totally charming and unthreatening, yet from his simple mind came many profound truths: "I just heard Time Warner is merging with A-Hole," he told Wendy. "I believe that's A.O.L.," she countered. "That's not what I heard" he shot back, and the audience howled.

Tuesdays began with a full production meeting at 10:00 a.m. The heads (also known as "keys") and their assistants of all the departments working the show gathered in our boardroom, about thirty people in

The Tuesday morning production meeting in 1998 (left) and 2005 (right).

all. Perry ran these meetings in a jocular manner that didn't disguise his underlying efficiency. One of us might offer a comment about the ratings or thank a department for having done especially good work the week before, then Perry took over. Everyone followed along as he went through the script—the rewrites newly printed on pink paper—one page at a time. He might pause to make a special announcement—"I'm pleased to inform you all that once again the employee of the week, for the eighteenth week in a row, is … me!"—or display his grasp of matters technical by asking our technical producer, Dietmar Niemietz, "Dietmar, when you're retrofitting the high-definition sub-editor matrix, do you plan to use the new Model 86 dash XLF dash 4 Gerberfloop or the older Flangwammer Mark 79 Red-Banded Shlingtapper?"—but he covered every production detail in less than an hour. The meetings were a happy blend of professionalism and pleasure, a moment when we felt we had life beat because we didn't know whether we were at work or at play.

Immediately after the production meeting, Perry repaired to a studio with the cast so that they could begin rehearsing the material on their feet, deciding where the actors should place themselves in the set and where he'd position his cameras. Writers attended every rehearsal and made notes. When this brief walk-through rehearsal ended, the cast went to wardrobe to begin costume fittings.

Wednesdays were the second longest day of the week. Staging and lighting crews began arriving at 9:00 a.m. to carry sets up from the basement carpentry shop to the tenth floor studio and hang lights. Wardrobe people shopped, sewed and continued fittings. The makeup department—headed by Linda Fruchtman from day one—shopped and laid out their supplies in the makeup rooms adjacent to the studio. Air Farce's Wig Master, Fredy Duerr, who also held his position from the very beginning, unlocked his cupboards, where wigs sat atop Styrofoam heads stacked three or four deep or lay folded in sandwich bags in drawers, and began selecting character wigs for the actors who'd soon be trooping in one after the other for their weekly fittings. (If you calculate the number of characters that Air Farce actors portrayed during 330 episodes over more than fifteen years, it's no surprise that we owned over 1,200 wigs by the time we finished the series.)

Actors rehearsed with Perry in the afternoon until our technical run-through began in the studio at 4:30 p.m. By this time the sets were up and lit, and with the aid of a couple of cameras to help Perry see his shots, we had our first look at the sets and what was in them—a border crossing, the bridge of a warship, news desks, barns, the prime minister's office, the pope's balcony, Queen Elizabeth's dining room. Whatever Monday's scripts had called for was there in Studio 42 two-and-a-half days later. A weekly miracle. Lights were adjusted, furniture shifted, audio techs pinned microphones onto the actors and rehearsal—minus hair, makeup and wardrobe—got underway. The weekly schedule called for technical rehearsal to end at 7:30 p.m., but it went longer when we had to pre-shoot an item or give ourselves a leg up when we had too many sets or costume changes for Thursday.

Technical rehearsal was followed by a meeting with producers, actors, writers, and the director to identify problem areas. Was a prop the wrong size? Was a chair too low? Were there too many jokes on the same subject? This meeting was made more tolerable by the presence of

(*Left to right*) Wig master Fredy Duerr puts the finishing touches on Lucien Bouchard (Don) in 1996; the beautiful beauty team: Linda Fruchtman was head of makeup and Fredy Duerr was wig master and chief hairdresser for the entire run of the TV series.

pizza, the ultimate television production food (after 2:00 p.m.; before that it's donuts). We aimed to finish by 9:00 p.m., but seldom did in the first few seasons.

Dress rehearsal and two tapings took place Thursday. Crews began arriving at 9:00 a.m.; the second taping ended at 10:30 p.m. A long day by most standards, especially for actors and crews who spent much of it on their feet. Cast arrived at 11:30 to get into makeup and wardrobe; dress rehearsal began in earnest at noon and continued, with a half-hour crew break, during which Perry gave the cast notes, until 5:00 p.m. After more cast notes and a half-hour for dinner—most weeks Perry, the producers, the associate director, and the editor ate standing up on the job—Perry returned to the control room to give camera and audio notes, the cast got into wardrobe and makeup, the studio doors opened and the audience was ushered in. At 6:20 the warm-up band was announced and took the spotlight on the studio floor.

Air Farce's warm-up budget was abysmally small. We wanted music but couldn't afford a multi-piece band, or even a trio. To music directors Marvin Dolgay and Glenn Morley had fallen the unenviable task of finding an appropriate musical act. With a week to go before our very first show, they unveiled their musical offering: the duo of Scott Irvine and Joe Macerollo would entertain the audience on tuba and accordion. We christened them "The Air Farce Symphonette."

Scott's and Joe's individual careers grew increasingly busy and, six years in, they had to give up the Thursday gig. Marv and Glenn went on the hunt and struck gold again, this time with Dave Matheson and Maury LaFoy. Dave played guitar, Maury the stand-up bass, and they both sang.

They became known as The Ground Crew and recorded two albums under that name. Dave composed a great opening tune, "Welcome to Air Farce," that included a humorous tidbit of information about each actor and gave the audience a foretaste of the evening to come. After Dave and Maury played the song, Dave announced, "Ladies and gentlemen, pleased welcome one of the stars of the show, Roger Abbott!" and out Roger popped, just as he had in the radio days. He was protective of his role as host and took the job of welcoming guests to Air Farce's house very seriously. The opening of the show was the only time the warm-up act knew how long they'd be playing. During breaks in the show they never knew if they'd be playing for two minutes or ten; Pat McDonald would signal when we were ready to record another sketch and they'd wrap up whatever they were playing in mid-phrase.

Marv Dolgay and Glenn Morley shepherded us through many a musical quagmire. We were comedy actors, not singers, but if we were impersonating Rita McNeil (Luba), or Leonard Cohen (Roger), or Bob Dylan (Don), we had to deliver the musical goods. Marv and Glenn composed and performed the music tracks we sang to, and Marv worked with us through the entire process of learning a song, from rewriting lyrics and rejigging the tune, to coaching us in the recording booth, to directing us on the studio floor. He focused on the character we were playing, not on the singing, and before we knew it we'd be warbling with enough confidence to get us through a sketch. Our biggest challenge was tempo. Unlike Jessica Holmes, who could sing almost as easily as she could talk, we needed training wheels and a guiding hand from start to finish. When it came time for us to perform a musical number

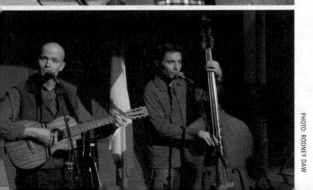

(*Top to bottom*) Our camera crew: Peter Brimson, Carol Gallagher and Dave Doherty in 2004; Manning the battle stations: technical producer Dietmar Niemietz, director Perry Rosemond, associate director Laurie Crawford and second associate director Liz Pettapiece-Phillips in the Studio 42 control room on shoot day in 2007; music director Marv Dolgay coaches Neil Young (Don) while Perry kibitzes in 1997; The Ground Crew: Dave Matheson and Maury Lafoy entertain the live studio audience.

in front of the live audience, Marv would sit cross-legged on the studio floor underneath the camera we were performing into, and conduct us. He'd count us in, give a huge gesture when it was time to start singing, beat time throughout, and mouth the words along with us as we boldly sang what we never thought we could sing. If we performed well, he'd smile broadly and pay the ultimate compliment: "Well, that didn't suck."

Pat McDonald, whose dry wit, solid demeanour, and general aura of calm earned him the respect of everyone who worked with him, proved to be a bit of a ham. To the delight of taping-night audiences, he developed a dull, world-weary, deadpan persona. When speaking what in another person's mouth would have been exciting words—"You're really going to enjoy this next sketch"—he sounded like the Grand Inquisitor sentencing a heretic to death, minus the enthusiasm. He invented his own stock phrases—such as "Standby to laugh"—to set up a sketch just before the cameras rolled, always delivered in the dullest monotone imaginable. The audience ate it up. So did the crew. As Thursday's tapings drew to an end, every stage hand, lighting tech and props person in the studio would be listening intently to every word that came out of his mouth. Part of Pat's routine was to repeat some of his phrases over and over again, which made them even more hilarious to the audience. Unbeknownst to Pat, the crew was running a pool. For a couple of bucks you bought a ticket that had a number from twenty to fifty on it. When the evening began, the pool organizer chose one of Pat's phrases as the phrase of the week. From then on, every time Pat used the line, it was counted. Three hours later, tension mounted. Seventy or eighty bucks could be riding on whether Pat spoke the phrase once more, or twice more, or not at all. The tension could be particularly high if Perry decided he required a last-minute pickup at the end of

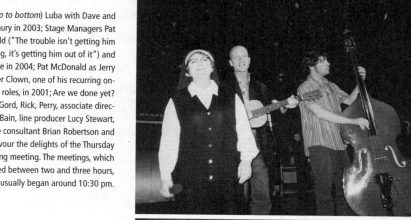

the 9:00 p.m. taping. Whoever had won at the end of the taping might now see their winnings vanish. When Pat finally caught on, he made sure that no one ever told him what the chosen phrase was lest it influence his performance.

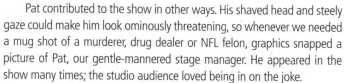

Pat contributed to the show in other ways. His shaved head and steely gaze could make him look ominously threatening, so whenever we needed a mug shot of a murderer, drug dealer or NFL felon, graphics snapped a picture of Pat, our gentle-mannered stage manager. He appeared in the show many times; the studio audience loved being in on the joke.

After the 9:00 p.m. taping wrapped, usually around 10:30, a small group met in a production office beside the studio and discussed the evening's results. The group consisted of Perry, his assistant director (two hold the long-service medal in this role, Linda Bain and Laurie Crawford), Rick, Gord, Don, Roger, line producer Lucy Stewart, and Brian Robertson. The assistant director had timed the sketches in each taping, so we knew the total amount of material available for the show and how long each piece ran.

First up: what worked and what didn't. Universal stinkers were easy to jettison and knockouts were undeniable inclusions, but pieces that fell in the cracks could prompt lengthy discussion. Several factors came into play. Early on, Perry identified the most important criteria: "Funny kills and topical kills, and funny and topical together kill big time."

Second: running order. We recorded the show in an order that Pat McDonald devised to make the show as easy as possible to shoot from a logistical standpoint. Now we had to decide a running order for the broadcast: which sketch should lead off, which one should follow, and so on. If there was a subject that all of Canada was talking about, we'd want to lead the show with it. We also wanted good flow, pace, and variety. And we needed to make sure that one of the cast didn't appear three times in a row in the first act and then disappear for the rest of the broadcast.

(*Left to right*) Friday morning fun: Linda and Perry in the edit suite in 1994; Gord, associate director Susan Hall, Rick and Norm in the Air Farce offices in 1999; Rick must be reading something he wrote.

Next: what worked and didn't within each sketch. After we'd decided the running order, we'd go through the sketches line by line, deciding what to cut and what to keep and whether the better performance and audience reaction was in the first taping or the second. With these decisions made, we wrapped for the night. Once or twice in sixteen years we finished before midnight; most of the time we were done before 1:00 a.m.

From the very beginning of our association, Perry had been strict about ad libbing: do it in rehearsal and we'll put it in the script, but never ad lib during a taping. Why? Because he had to deliver the show to the network with only about six hours of editing time.

During a taping we recorded thirty to forty minutes of sketch material. We used four cameras, three on pedestals and one hand-held, and recorded each camera's output independently. On a fifth machine we recorded Perry's line-cut. That meant that, after two tapings, we had 300–400 minutes worth of tape to sift through. In six hours of editing, there wasn't enough time to even look at everything we'd recorded. So thank you, actors, but please don't screw up the line-cut by ad libbing.

Friday morning at 9:00 a.m., Perry, the associate director, and production editor Grant Ducsharm began assembling the show based on Thursday night's decisions. The three of them worked quickly, the associate director marking the script so it matched the edits as Grant turned Perry's instructions into finished edits as fast as Grant's fingers could fly. Around noon, audio tech Tom Wood wheeled his custom-made magic box of sound effects, music, and laugh cues into the suite and began to set up behind Perry's right shoulder. Any comedy show like

Air Farce needs Tom Wood, not so much to add laughter as to replace audience laughter lost by edits or cut off in mid-roar when we switched from a take in the first taping to one in the second (and vice versa). We also had to replace laughs whenever we did a retake because audiences never laughed as well at a joke the second time they heard it. The associate director made a note of Perry's "wish list" of close-ups that he wanted to add to the show, time permitting. But there was never time. The Friday edit was always done under pressure. We had to cut the show to the right length, replace laughs, mix together music, sound effects, laughter and applause, make a protection copy of the finished show, and deliver both copies to network presentation by 5:00 p.m. so they had time to closed-caption the show before it was broadcast live to the Maritimes at 6:30 p.m. Eastern Time. It was a tall order.

While the edit was going on, Rick and Gord had begun in earnest writing next week's show. John took the day off and wrote on the weekend, often late Sunday night after conferring with them. A frequent source of irritation was that even after conferring, John often wrote on the same topics that they did. One of the job criteria for Air Farce's production secretaries was the ability to read John's hand-written scripts that arrived by fax in the wee hours of Monday morning and had to be typed, duplicated, and distributed by 10:00 a.m. Rick and Gord's scripts arrived by e-mail ready for duplication. By 11:00 a.m. the cast assembled for the first read-through.

And the week began again.

The Fight Over The Farce

IVAN FECAN IN CONVERSATION WITH BILL BRIOUX

The Farce had taken a few other stabs at TV before that. Did you see any of those shows?

Before the late 1980s they'd been on television with specials. Whoever commissioned them or produced them must have felt that they needed to be big affairs, shot in a theatre, stand the test of time ... in other words, not topical. I thought, why would you take them and not make them topical?

According to Brian Robertson, Air Farce had financial backing for a special—they just needed a broadcaster. He says they were turned down by then-head of CBC Variety George Anthony—who found them too edgy—but at the eleventh hour, after a meeting with Ralph Mellanby, you gave the special a green light.

I didn't fully appreciate that George had turned them down. The difference between what they had done before was that this was way more topical. I wanted the satire, I wanted to go right after the sacred cows. Again, that was me from CBC radio [Fecan began his career as a CBC radio producer], feeling one of the roles of CBC is to do things that others wouldn't do and it made perfect sense to me to do something like that. In a big kind of way, that's the role of comedy, to poke fun at the sacred cows.

Robertson says after the go-ahead in mid-November that they only had four weeks to get the show up, running and recorded for New Year's Eve.

And that was great because they couldn't screw it up or over-think it. They just needed to do what they did in radio and move it to TV, make appropriate adjustments but not water it down. I think it was extremely important that they didn't have to censor their voices.

So jump ahead three or four years. At this point you've gone over to what Luba calls "The Dark Side," but what was known then as Baton—correct?

At that time it was Baton, it was not CTV. It was a CTV affiliate and it owned 12 per cent of CTV or something [like that] ...

You were savvy enough to know when Air Farce was up for grabs. Was this always something you considered?

My job there was to build a network ... In order to do that, you need some credible Canadian programming. You need signature shows ... I had heard that the CBC was taking them for granted and not really negotiating fairly for renewal because they felt that [the Farce] had no other options. "Who else would take them," I guess they thought.

I really got mad at that. The idea that Canadian artists actually had huge ratings success and still would not be valued and would be taken for granted in such a way. I felt they had earned a good renewal because they had delivered; they had done everything the CBC had asked and more ... So I just got mad. *Really* mad. I kind of decided, well, fine, we bid against the CBC for sports rights, why the hell wouldn't we bid for these rights? So I picked up the phone.

A Play for the Farce

CTV COMES CALLING, WE LOSE A FRIEND, AND AIR FARCE TV GOES LIVE

Season 15 publicity photo: Don, Craig, Luba, Penelope, Roger, Alan and Jessica.

PHOTO: RUSS MARTIN

The business of television is larded with bureaucracy, intrigue, competition, anxiety--and incompetence. By the middle of our third season, we were CBC's absolute number one show--even beating *Hockey Night in Canada*--so what did CBC do? Instruct all shows, including us, to cut their budgets by 3 per cent. We were already amazingly cheap and had been looking forward to receiving a substantial raise. In three years, we had more than delivered value; we were responsible for transforming CBC's lousiest night of the week--in terms of television viewership and advertising sales--into a winner. Because of our huge success, CBC now led all other networks on Friday nights. We were naïve enough to think they'd offer us a generous increase as a reward. Instead they told us to cut back.

ROGER: It reflected a mindset common to federal institutions, that money should be spread evenly and resources should be shared. But you don't cut spending irrespective of quality. You put your money where you have the best chance of success.

DON: It was the flip side of what we fought against when we tried to assemble a good crew: the idea that unsatisfactory employees should receive the same pay as people who did a good job. That was the CBC culture. There was also a sense of entitlement. Shows with twice our budget had fewer than half our viewers. It didn't make sense. How are you going to achieve excellence if you don't acknowledge it and reward it? We weren't against CBC shows that appealed to fewer viewers. Bring 'em on--but give them the small budgets.

CBC also made a serious mistake: they neglected to renew our contract for a fourth season. But we were behind the eight-ball. CBC was the only broadcaster in the country that made—and broadcast in primetime—Canadian entertainment shows. To our great good fortune, a white knight appeared (and we're not referring to the colour of his hair). Word reached the ears of our original champion, Ivan Fecan, who was now in the process of building CTV into a programming powerhouse. He heard we were unhappy. Would we consider coming over to CTV?

This wasn't a whim or an off-the-cuff suggestion. Ivan believed that strong Canadian programming had to become part of private broadcasters' futures. He later proved the strength of his thinking when *Corner Gas* became a massive hit for CTV, the first sitcom since *King of Kensington* to succeed in a big way with Canadian audiences. Our lawyer, Peter Steinmetz, began negotiating. To keep everything above-board, we informed CBC. To our surprise, there was no reaction. Not even, "Oh, really?"

CBC managers had other things on their minds beside us. The river of money that Ottawa sent every year had started to dry up. For the next six or seven years, there'd be new signs posted beside the elevator banks every week: "Bob is leaving after 22 years. Say farewell Friday after 5:00 at the Lone Star," or "Nancy is calling it quits after 35 years—goodbye drinks Wednesday." It was sad and eerie. Not only did talented, knowledgeable people leave, so did the shared memory of the corporation.

We toured CTV with Ivan to check out their facilities. They had good studios, a large carpentry and paint facility (with a staff of one!—they only hired people when they needed them) and an excellent promotion department. They were in the midst of equipping offices for a slew of new specialty channels. Unlike CBC, CTV was growing. Probably the most fun was watching CTV staffers' heads snap around to look at us in disbelief as Ivan guided us through the premises. He introduced us to Doug Bassett, who as president of Baton Broadcasting was the single most influential member of the CTV family. He was charming. He said, "Come to CTV. We want you. We'll appreciate you. And we take care of our people." In a final dramatic gesture, he got down on one knee and added, "Please. I'm begging you. We really want you."

Negotiations continued with CTV as it became clearer and clearer that CBC was not going to make an offer. There were obstacles to taping at CTV. CBC had brand new control rooms with state-of-the-art equipment and tech stores full of lights and audio equipment; CTV didn't. CBC had tens of thousands of costumes and a warehouse jammed with props and furniture; CTV had zilch. CBC had cupboards full of wigs; CTV's cupboard was bare. We'd have to bring everything in; in fact, we'd probably have to rent most of our costumes and wigs from CBC. CBC was a subway ride for most of us; CTV meant a daily commute along the

Don Valley Parkway and Highway 401. But all signs pointed to Air Farce's future home being CTV.

But there was one sizeable carrot: at CBC we were an in-house production, fully funded by the corporation; at CTV we'd become independent producers, funded by a combination of federal grants (the money that used to go to CBC) and CTV. We'd own our shows and retain the right to sell them elsewhere after CTV had used up their Canadian network broadcast rights. This was another source of income, albeit small, that we didn't have access to at CBC. Having maintained our own offices for all but the past three years of our careers, an arrangement with CTV would be no great stretch for us. We liked the promise of independence.

It was impossible to keep our romance with CTV secret and it became a major source of distraction in our offices. Our staff was excited and anxious. As our season drew to a close, CBC finally began to awaken to reality: we were their highest rated show, a CBC icon still on radio after twenty-three years, and they hadn't signed us to come back next season. Simultaneously, through the intervention of our show's network executive, Kay Soares, the message we'd been trying to send began to penetrate CBC management's consciousness. Air Farce wasn't kidding. It wasn't a bluff. CTV had made a serious offer.

DON: In our hearts, we still felt like CBC people. It may sound corny, but CBC was our spiritual home. All things being equal we preferred to stay.

ROGER: And not have the long drive to CTV! CBC made an offer that was a slight improvement on our previous in-house deal. But it didn't measure up. It didn't nearly match what we wanted and we were

determined to resolve the contract before our final taping, which was in less than a month.

DON: We decided to shake CBC up a little bit. We proposed that we become an independent production. Well, that got their attention. "*Air Farce* not be an in-house production?" After that they sat up and took notice.

ROGER: It still came right down to the wire. It was our final taping week. By now everyone knew our future at CBC was in doubt. Was this the last show we'd do with our crews? We'd become friends and the thought of leaving was wrenching. CBC's downsizing was destroying morale and we felt like rats leaving a sinking ship. Peter Mansbridge came to our studio and told the two of us he really hoped we'd stay. Mark Starowicz phoned Don with the same message. Everybody had the jitters.

DON: Peter Steinmetz decided to have one last crack at CBC. He sat in a room with two executives and went over in detail what we were seeking in a new contract. The execs weren't convinced. Peter was frustrated and asked them to talk it over while he took a short break. When he came back, the CBC people asked to continue discussions tomorrow. Peter agreed. The next day, CBC came through. It was a miraculous turnaround. Not only did CBC give

us what we wanted, they also added a sweetener that CTV couldn't possibly match: ownership of our first three seasons. That was the deal clincher. If we'd gone to CTV, CBC would have permanently owned our first sixty-three shows and three New Year's Specials; staying gave us control of those programs as well as ownership of all future shows. From top to bottom, we'd be masters of our own destiny.

ROGER: We'd already scheduled a signing meeting with Ivan at my house at eleven the next morning. Don and Peter and I knew that CBC's offer was unbeatable. Ivan arrived with the CTV contract. And something else. With typical flare he opened his briefcase, took out four cheques totalling $200,000--$50,000 for each of the cast as a signing bonus--and slapped them down on the table. "Well boys!" he said, "are we still in?" It was a tough meeting for all of us, but CBC had played the one card that Ivan couldn't. Ivan was disappointed and we felt a little sheepish, but soon we were laughing and Don insisted on getting a picture. Somewhere in our files there's a photograph of Ivan and us laughing and holding the four cheques.

DON: We never told John and Luba that we'd turned down fifty grand for each of them on their behalf. But going with CBC was the best decision.

ROGER: Before we began Thursday's taping--the last of the season and nearly our last at CBC--Peter, Don, and I met CBC vice-president Jim Byrd in his seventh floor office and signed the new deal. Jim had found a way to keep us at CBC and we were grateful. We still are. Then we went up to our studio and told the audience that we'd just signed to stay at CBC for another five years. You could practically feel the roof lift off the building when the crew heard our announcement. It was a very happy night.

DON: We'd made a bit of television history, because it was the first time that two networks had competed for a Canadian entertainment property. It was a watershed moment for Canadian productions.

ROGER: There's a footnote to this saga. Peter Steinmetz remembered later that when he'd left the CBC execs in the conference room that fateful day, he'd also left behind his briefcase containing his working papers. Among them was the CTV offer. Had the execs snooped when he was out of the office?

Had they found the offer and taken a peek? We never asked. We don't know.

DON: Second footnote. After signing the new deal, five of us went out and bought cars. They were all second-hand.

For a while we invited politicians to participate in the show. Naturally, some were better than others. The most successful were those who trusted us, took our advice and followed our instructions. Paul Martin, finance minister at the time, did exactly that. It was impressive to watch the second most powerful man in Ottawa pay close attention and respond intelligently. His boss, on the other hand, was his own show.

Pamela Wallin had an interview scheduled with Jean Chrétien in the Broadcasting Centre and had helped set up his appearance with us. Our costume designer, Tulla Nixon, had checked to see what Pamela would be wearing and dressed Luba identically; Roger wore a navy suit to match the PM. When Pamela completed her interview with the prime minister, she brought him upstairs to do a short sketch. The prime minister's security detail and press handlers entered the studio, followed by Pamela and Chrétien himself. He was a whirlwind of energy. He and Pamela took their places in the set. Could they read the autocue monitors? "No problem,"

 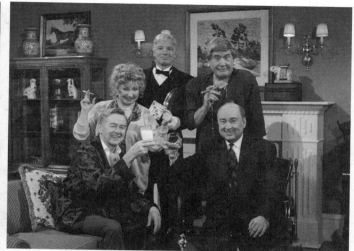

PHOTOS: RODNEY DAW

said Pamela. We started recording. Chrétien didn't look at the monitors once. He ad libbed every line, made up his own script as he went along, pounded Roger on the back, laughed, joked, clowned around, and somehow Roger managed to bring proceedings to an appropriate end. The audience applauded and the prime minister, like the Tasmanian Devil in a Warner Brothers cartoon, swept out of the studio with his entourage in pursuit.

Jean Charest, head of the federal Conservatives before being summoned to Quebec to run for premier, was the best actor of all. He delivered his lines in a natural, unaffected way and knew just the right amount of inflection to place on a word to get the desired result. He was a writer's dream. When he finished reading a monologue, there wasn't a chuckle left in it. He found every last laugh and coaxed great reactions from the audience.

If we took a vote among the cast and writers, the winner for best guest would probably be Preston Manning. Like Paul Martin, he listened attentively and took direction well. He also had a delightful sense of humour. He took his politics seriously, but not himself.

DON: I played Preston on the show, making exaggerated fun of his voice and the name of his political party: "Reforrrrmmmmmm!" Rick and Gord came up with a great premise for his first appearance: I began the sketch playing Preston hosting a talk show, and after making a joke or two brought out my first guest--Preston Manning. Big surprise for the audience--the last guest they'd expect was the real Preston Manning.

Preston came prepared. He tried to memorize his script but I said, "Don't worry about that, just read your lines in the autocue monitor over my shoulder. You'll give a much better performance if you don't have to worry about remembering your next line. And keep your eyes fixed on the autocue monitor, don't ever look at me after you've read your lines because the camera will catch your eyes moving and you'll literally look shifty-eyed, which is not recommended for politicians."

We rehearsed it. Preston did fine. Come show time, we did it the same way, he got a huge reaction when he appeared and an even bigger one when we finished. I asked afterwards what was the strangest thing about doing the sketch. "Calling you Preston," he answered. "I've never met anyone named Preston in my life."

* * *

(*Left to right*) 1998, writer Wayne Testori breaks up Roger;
1997, more happy faces: writers' assistant Rob Lindsay
and line producer Lucy Stewart.

John left Air Farce in 2001. Over thirty-four years, he had probably written 4,000 sketches for radio, stage, and television. During two decades as head writer of *Air Farce* on radio, he earned his wings as the most prolific comedy sketch writer on the continent; for twenty-six episodes a season, he single-handedly wrote half the script for every episode. He'd arrive at the office every other Monday moments before rehearsal with a thick stack of sixty or more pages, whack it down on the photocopier and proclaim, "Never mind the quality. Feel the width."

But never mind the width. He had the ability to take the blank landscape of radio's "theatre of the mind" and paint it with words and sound effects and music and character voices, so that listeners saw performances with a vividness that no stage or television screen could ever match.

He had a love-hate relationship with television. He could never understand why special effects took so long, and he was generally impatient with the slow pace of TV production. Film production, with its endless tweaking of lights and fiddling with flags and reflectors, drove him round the bend. He described your typical film set with characteristic bluntness: "A wanker's paradise."

Our schedule didn't leave a lot of time to enjoy life, and John was a man who definitely enjoyed living. On May 8, 2001, the four of us spent the day in Burlington, Ontario, on the set of Steve Smith's movie, *Red Green's Duct Tape Forever*. As an in-joke, the Air Farce donut-shop quartet was appearing in the background of a scene in a diner. Just before we got into the car to leave Toronto, John quietly said that he'd decided not to return to the series next season. He'd said five years earlier that he'd likely be gone by this time, but we hadn't thought he really meant it. Now we knew he did.

* * *

It wasn't possible for Rick and Gord to write the entire show themselves. Maybe they could have eight years earlier when they were fresh—in fact, there were many episodes when they all but did; their accomplishments throughout radio and TV were nothing short of phenomenal—but their creative powers had peaked and their energy was flagging. During the first two or three seasons they created the bulk of their great characters and concepts; the Donut Shop, the Chicken Cannon, and News from Away came to the screen in our first year. We asked Rob Lindsay, who was our writing intern, and Wayne Testori, our associate producer, both with proven writing talent, to begin submitting sketches on a regular basis. Rick and Gord, in their capacity as head writers, agreed to work with them. But what we understood by head writers was not quite what Rick and Gord understood. We expected them to continue to write, but also to lead an expanded writing team by encouraging and developing talent. They understood head writers to mean they would continue to write most of the scripts and exert control over the junior writers' ideas, even if it meant—as the junior writers reported to us—stifling the junior writers' creativity. We'd hoped they would extend the same creative freedom to the juniors that we'd extended to them twenty-five years earlier, but it took a long time for them to sort out that relationship.

(*Left to right*) Divas on parade in 2004: Liz Taylor (Luba) embraces Liza Minnelli (Jessica); wrestler Trish Stratus puts the squeeze on Celine Dion (Jessica).

Without John in the cast, we had a big hole to fill. We'd been together for three decades and we didn't expect to find a replacement quickly or easily, so we began hiring a different guest star every week. It was fun. We got to work with a lot of people whom we'd admired for years but hadn't ever met. But we knew we'd have to choose sooner or later; it was tough on the writers never knowing from week to week who the fourth cast member would be. Even when we booked stars far in advance, there was still a huge knowledge gap between what we needed for the show and what we knew they could do.

After a year we settled on two actors, both of whom had been guests, but before we could ask either, both committed to other productions. One was Shaun Majumder, who went to *This Hour Has 22 Minutes*, the other was Jessica Holmes, who went to CTV to star in her own show. Back to the drawing board. We kept our powder dry and launched another season with guest stars. Our patience was rewarded. The following summer Jessica Holmes's show came to an unexpected end and she became available. We hired her six weeks into Season Eleven, in November 2003, the first new Air Farce cast member in thirty years.

ROGER: Jessica was a star right out of the box. She could look glamorous and goofy at the same time and, like Luba, she had something you can't learn: star quality. She had explosive presence; audiences loved her.

DON: I remember a conversation we had early on about the pressures of joining an existing team. She wasn't worried. She said, "I have brothers. So you can't embarrass me, I know how to throw a ball, and I love fart jokes." She oozed confidence, fun and goodwill.

Jessica brought a couple of her established impersonations with her, Liza Minnelli and Celine Dion, and soon added others as Rick and Gord tapped into her talent: Britney Spears, Michael Jackson, and politicians Belinda Stronach and Rona Ambrose. Wayne Testori and Rob Lindsay created an editorializing fictitious character for her, Sister Bessie, who someone wisecracked was, "Jock McBile in a habit"—great description. Like Jock, Sister Bessie expressed strong opinions. Audiences loved that sort of thing and we strongly believed that part of Air Farce's job was to say out loud what polite people would only think. Whatever the writers might put on paper, Jessica was very talented at turning the words into a character. One of her best was a scientist, Dr. Ramona Ick. If you never saw Jessica's Dr. Ick, imagine what the result might be if Mad Magazine's Alfred E. Newman had a granddaughter.

Jessica's rapport with the audience caused some envy, but a fact of show business is that actors don't decide who's going to be the audience's favourites—audiences decide that for themselves and actors have to accept it. Like the proverbial customer, the audience is always right.

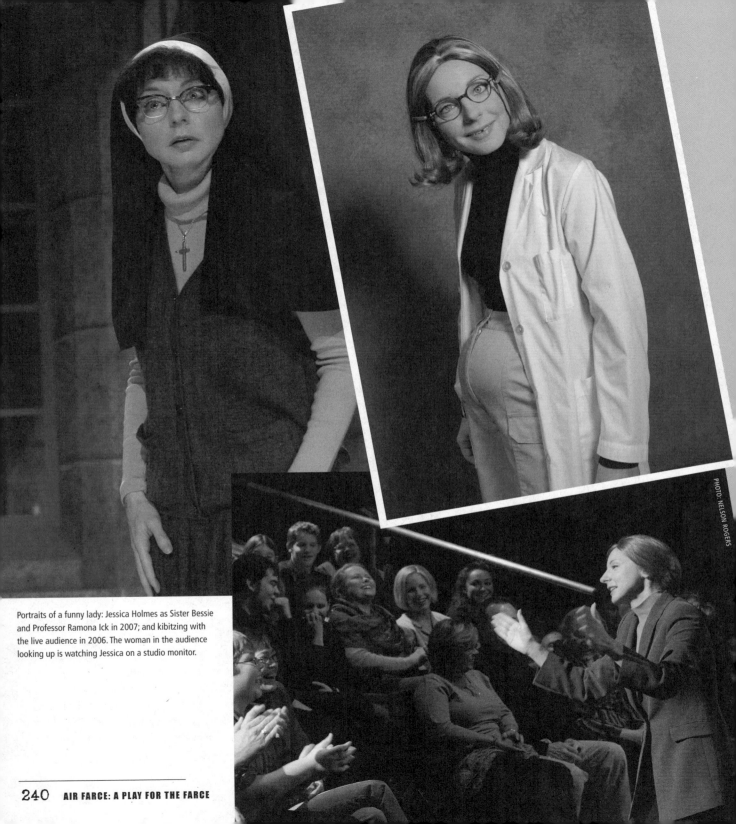

PHOTO: NELSON ROGERS

Portraits of a funny lady: Jessica Holmes as Sister Bessie and Professor Ramona Ick in 2007; and kibitzing with the live audience in 2006. The woman in the audience looking up is watching Jessica on a studio monitor.

A Healing Experience

JESSICA HOLMES IN CONVERSATION WITH BILL BRIOUX

The call to join the show came at a particularly tough time in your life. Were you looking to do another series?

The Holmes Show ended not by my choice, and it ended very abruptly and in a way that I would describe as ugly. I felt like a wounded bird showing up to Air Farce. I felt like they had these kid gloves and they just took me in. It took me years to even accept that gentleness. It took me years to realize that when they smiled to me, there was nothing behind that smile except for genuine love. The second you start to work with them, that's when their loyalty kicked in.

Did the Farce experience restore your faith in show business?

It took me six seasons. I felt like they had nursed me back to emotional health. I've been honest with Don and Roger, wrote them letters over the years telling them how much I loved them like uncles and brothers, how they took care of me emotionally at a time I really needed it.

What was it like the first time you performed with them?

It was great but I sensed a real difference. I had just come off of The Holmes Show so I was fresh from a comedy club sensibility where they just want you to dick around in front of the camera. If I could memorize lines, awesome, if not, no problem. Then I came to their show. I remember I was playing Jennifer Lopez and I would giggle every now and then. And [director Perry Rosemond] came to me and said, "Don't giggle, it's not in the script. If you want giggling, we'll put giggling in, but we need to know where you're going to giggle." I said I didn't know, I might just feel it in the moment and Perry said, "Feel it in the moment during rehearsal." That went against my sensibility. I always felt like the best I could ever give would be 80 percent because the other 20 percent was improv.

Did you not have some idea that that was the deal going in?

Yes, absolutely. My agent said to me, "I want you to know before you get there that this is a well-oiled machine, and it was a well-oiled machine before you came along and if you do your job right it continues to be a well-oiled machine. You're not there to rock the boat, you're there to do your best. You aren't there to change anything."

I was glad that he told me that. Air Farce lasted forty years because it is true to its principles, which are political commentary, a certain style of humour, a style of jokes. I got to get my oddities out on The Holmes Show. When I came to Air Farce it was time for me to try their comedy. So it was a good lesson.

They did need someone who could play J-Lo and Britney. It had been all Luba up until you arrived. Did you sense that was a difficult transition?

I think she handled it with such grace and did the very best she could and did better than most people could do. I only felt it a couple of times, and both times when I felt it she came to me later and said "I'm sorry". . . . I grew up the only girl in my family. It's special, you're the princess. So to have somebody thirty years younger show up and be the new princess, it's a big deal. She made it seem like it wasn't a big deal and I appreciated it. She could have made it torture. She kept her ego in check.

(*Clockwise from top*) Craig Lauzon will do just about anything for a laugh: Jenna Bush enjoys a cocktail in 2005; Prime Minister Harper has a wig malfunction in 2008 ("Honest, it was mistake!"); CBC's George Stroumboulopoulos is way-y-y cool in 2006; the Lakota guy hustles herbal remedies in 2005; Hockey player Radek Bonk models a sexy new NHL uniform in 2007.

Air Farce had established a comedy standard that prevailed for a long time but a new generation of comics was moving beyond Air Farce boundaries; they were sharper tongued, more cynical, and less engaged with politics. The boomer generation was now heading for the horizon and we needed to appeal to new viewers. Slawko Klymkiw, our boss at the network, suggested that we "contemporize" our writing. However, Rick and Gord still felt strongly that they could write the bulk of the show, so we focused on tweaking the cast. We looked for performers who weren't yet known to television audiences.

We had Craig Lauzon as a guest three times in Season Ten (2002–2003) and we invited him back when we opened Season Eleven with an hour-long special in Saint John, New Brunswick. In October 2004, at the beginning of Season Twelve, we added him to the permanent cast. We hired him for his acting skills—and his teddy-bear personality—but he proved very adept at impersonations. He played Stephen Harper as a robot—when Craig's Harper wept he said, "I'm leaking!"—and Justin Trudeau as a vain heir apparent. His George Stroumboulopoulos was the spitting image of CBC's real one, and he perfectly lampooned Foreign Minister John Baird's alternating personae of simpering softie and rabid pit bull. He also did a killer version of U.S. President George W. Bush's daughter Jenna. But Craig was first and foremost a terrific comic actor. He had what John once identified as the essence of any true comedy performer: you looked into his eyes and saw the circus in the head. He became one of Rob Lindsay's favourite actors in our "FarceFilms," in which his nervous, timid, accident-prone Jenkins character became a staple.

(*Left to right*) The FarceFilms creative team in 2007: writer Wayne Testori, writer Kevin Wallis, director/producer Rob Lindsay, editor Nicolas Kleiman; The FarceFilms crew in 2006: director of photography Nelson Rogers, Rob, Don dressed for a business meeting with Rob, audio recorder David Best; Kevin Wallis lays on the charm for production secretary Kristine Yanoff in 2006.

(*Right, clockwise from top*) Stand-up comic Alan Park becomes the Grand Impersonator. Here he is as Cabinet Minister Tony Clement in 2007; Lady Gaga in our 2010 New Year's special; newly elected president Barack Obama in 2008; and as Liberal leader Michael Ignatieff, New Year's Eve, 2009.

FarceFilms were a Season Thirteen innovation. In the summer of 2005, Rob Lindsay approached us with a proposal—he wanted to make short comedy films, not shot in front of an audience, over which he would have artistic control. He'd write, direct, edit and produce them with his own team, functioning almost as an independent unit within Air Farce. (Rob is funny and charming and could probably talk the underpants off a nun—although as far as we know that's something he hasn't tried yet.) "Show us what you have in mind," we said, and he was off and running.

Another change in our creative team was Kevin Wallis. When we met, he was a 20-year-old CBC tech who operated our autocue in Studio 42. He didn't fancy himself working as a tech forever and approached us at the end of the season, hoping to find work on the creative side of production. The only job we had open was receptionist. He took it. Within six months he was making short animations on his computer. We put them on the air. He began writing, and now he's one of the producers of our New Year's Specials.

Somewhere along the line we held talks with the enormously talented Sean Cullen and came close to a deal. We loved working with Sean—not only had he guest starred with us recently, he'd also been a guest on our second episode in the year we began our series—and we got along well. But ultimately he decided a full season with us was not what he wanted at this point in his career. Sean would have brought an element to the show that we lacked after John left—a strong, slightly (or maybe not-so-slightly) manic, highly individualistic presence.

When John left the show so did Jock McBile, and despite Sister Bessie's spirited comments we continued to lack a vehicle for strong personal opinion. We held auditions. One of the people who came out was Alan Park. We liked the fact that he was issue-oriented and had a distinct point of view. Rick and Gord didn't write that kind of material; Alan was born opinionated and spent a lot of time on the web researching politics. As far as resistance to his views was concerned, he saw confrontation as an opportunity to sharpen his wits.

We gave him a regular stand-alone slot in Season Twelve, but the more we saw him in that role the more it seemed weird. He was part of the cast but also wasn't because he didn't perform with any of the other actors. We decided to try him in a couple of sketches. He proved to be a competent actor, but the big surprise was his ability to impersonate. He quickly mastered surprisingly good versions of Stephane Dion, Michael Ignatieff, and Barack Obama. His Barack Obama is still head and shoulders above anyone else's we've ever seen, in Canada or the United States. It was thrilling to watch him discover and develop a skill that he hadn't even been aware he possessed.

Air Farce had been a tight, compact group for so many years that we'd become accustomed to each other's individual foibles and moulded ourselves to fit together as a single entity. We all took turns in the doghouse but were committed to each other as if in a multiple-partner marriage. Dealing with new egos was a novel and unnerving experience. What had once been a stable, if occasionally neurotic, group of seven—Roger, Don,

PHOTO: ADAM DOUGLAS

PHOTO: ANDREW MACNAUGHTAN

DANTE'S INFERNO

John, Luba, Dave, Rick, and Gord—was becoming a larger group where the strong glue of a shared past didn't exist.

Penelope Corrin was the last new cast member we hired. In 2006, before Season Fourteen began, Jessica became pregnant and we needed to find a temporary replacement for her by the end of the year. We held two rounds of auditions in Toronto; there were some very good talents but nobody quite clicked. We didn't know Penelope, who lived in Vancouver. Alan told us about her, and at his urging she shot a short videotape as an audition piece and sent it to us. It was very good so we asked her to come to Toronto to audition in person. When we met her we were even more impressed, and hired her. And just in time, because even though Jessica would be coming back for Season Fifteen, we were definitely going to need seven performers.

<p style="text-align:center">* * *</p>

Season Fifteen was the last year of our contract and while our ratings still topped all other entertainment shows except *Little Mosque on the Prairie* and *Rick Mercer*, our annual budget increases had made us expensive. Creative change had to happen now or never. We'd done radio live and the notion of doing television live intrigued us. We took a deep breath, added four young writers who would hopefully bring fresh ideas, and leaped into the unknown—we decided to do all of Season Fifteen live to air.

"Five . . . four . . . three . . . two . . ." A pause, then Pat McDonald waved his arm and the opening credits rolled. Friday, October 12, 2007. Air Farce Live was on the air. The regular Thursday evening tapings of our first fourteen seasons were casual kick-throughs compared to this. We had a large, digital, time-of-day clock with a bright red display mounted

on a stand between us and the audience. Everyone in the studio—audience, cast and crew—was acutely aware of the minutes and seconds moving inexorably to the magic five digits, 7:00:00 (8:00 p.m. Atlantic Standard Time) when we went live to Atlantic Canada. We had to watch the clock even more intently at the end of the show so we'd know to say goodnight before we went off the air. Live-to-air was a huge difference from live audience tapings. No more fine tuning in the edit suite on Friday morning. No retakes, no fix-ups. Now what happened, happened forever. Stumble over a joke? Too bad. Wig knocked askew in the middle of a sketch? Share it with the nation.

LUBA: I hated it. You have to be *flying* from the set backstage, getting into costume so quickly, the makeup and hair people and the clothes. It was just difficult because if you make one mistake-- and because I am so dyslexic when I read the teleprompter and there are so many fast lines-- if you make one mistake and you feel like you've let down the whole show. If you say "was" instead of "wasn't" or whatever, or you are not reading the teleprompter and you think you know the line and then you go dry--it's very challenging. It's challenging but fun for the audience.

It was also fun for the young people who found it so easy. They would breeze through it. I thought that they did very well. They could read without a problem. It was exciting in that you got it over and done with and you could go home. There was no second show, but I always loved the second show and I always loved the fact that they could mix and match and take the best of, because if you screw up a line there's no going back.

The best moment we had was with Craig and Penelope in a sketch called "Vomit Virus." Jessica played CTV News anchor Lisa LaFlamme interviewing a British medical doctor (Craig) about a nasty virus. With the help of Wardrobe and Hair, our special effects expert, Tim McElcheran, had run a plastic tube up Craig's back and concealed the end in Craig's wig just above his ear. Off camera, at the other end of the plastic tube, Tim crouched with a pump beside a large container of fluid. In response to Jessica's questions, Craig spoke reassuringly about the virus, pooh-poohing any concerns about its virulence. And every so often he'd vomit. It was comedy vomit, a yellow stream that looked like watered-down pineapple juice. Craig ignored it as if it were no more than a cough. Beside him, Penelope as his assistant became visibly woozy. She swallowed heavily and swayed. Craig noticed and started aiming at her. This was not in the script. Then his moustache flew off. He sprayed Penelope's lab coat and landed a few spots on her eyeglasses. The three of them, Craig, Penelope, and Jessica, fought— just this side of unsuccessfully—to keep a straight face. It was an absolutely hilarious few minutes of madness and what you pray live television comedy can be.

John Morgan

1930-2004

Three years after leaving Air Farce, John died at the age of seventy-four. He'd had a great life. He was irrepressibly exuberant. He was opinionated. He could be irascible and short-tempered but outbursts were short-lived. He was fun, generous with people, canny with money, and had a great sense of humour.

He drove a sports car and flew his own small aircraft. He loved to travel; Australia and New Zealand were late discoveries. On November 15, 2004, the day before flying to Bermuda for a vacation with his son and then on to Europe, where he intended to tool around Portugal on his own in his sports car, John died at home in Toronto, a book in one hand, a cigarette in the other, and a cup of tea beside him.

He wanted no fuss. No funeral-home viewing, no religious service, no memorial. But he'd be fine with a party. His son Christopher and daughter Sarah organized a humdinger at a local bar. Air Farce was in the middle of production and the entire crew came over after work. Old friends arrived and the 200 or so in attendance swapped riotous stories for hours. We recalled the co-worker whose workday wasn't complete without a Daily Rave that might be triggered by anything from dripping metal teapots to the lack of zeppelins for trans-Atlantic travel. We reminisced about the writer who sprinkled his scripts with instructional acronyms such as "P.F.F.I.T.S.I."—"Pause For Filthy Implication To Set In," and "G.A.O.T.N."—"Go Apeshit On The Night." And we revisited those moments in front of an audience, when Morgan The Performer would read a line written by Morgan The Writer and be unable to contain his laughter. The party was a fine conclusion to a great life in comedy.

Sarah Morgan took this photo of her father in 1995. It's our favourite photo of him. After he died we hung it in the entrance lobby of our offices. Gone but not forgotten.

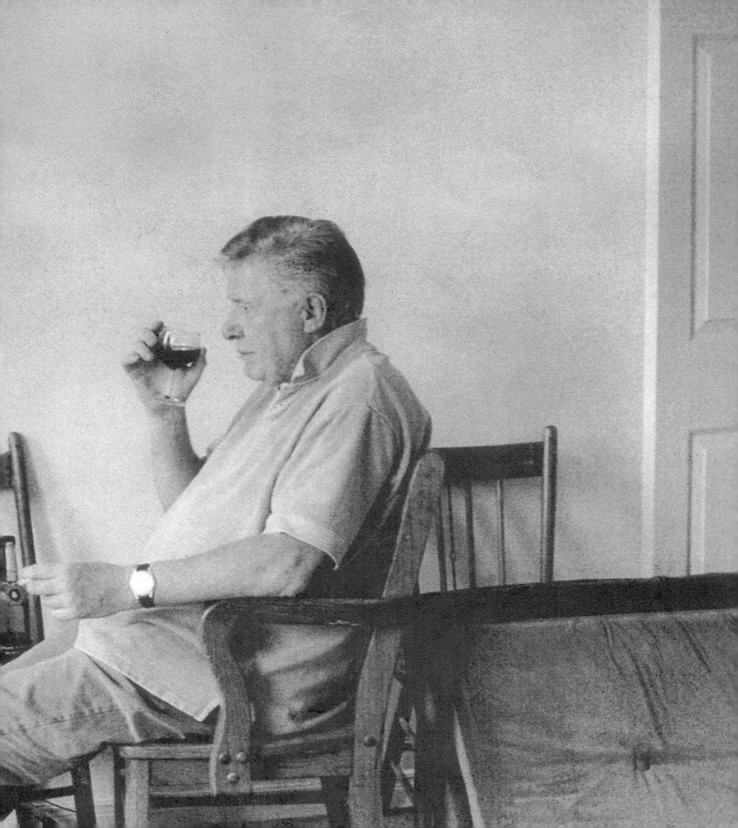

CHAPTER 18

Turbulence
END OF AN ERA

December 2008. Vice-president Richard Stursberg presents us with a plaque renaming Studio 42 the "Air Farce Studio."

The live telecasts of Season Fifteen in 2007-08 were stimulating and exciting for the performers and the production crew, but occasionally frustrating for the writers, who were seeing some of their material go to air without the buffing and polishing they felt it deserved.

The poster for our final run.

Admittedly, *Air Farce Live!* was flawed. But it had two very positive effects: it proved to us that we were still adaptable to change and, best of all, as the season progressed and we got better at "Live," the ratings began climbing. We were still one of the top shows on the network. Making it even more of a triumph, we were doubling our lead-in numbers, an important measure in television flow.

In television, February is traditionally the month of green lights and pickups, when networks contract new series for next fall's season and when existing series are "picked up" for yet another season. The final months of our latest three-year contract were ticking away. Having heard nothing by the end of January 2008, we invited Anton Leo, the head of comedy, to discuss how our season would end. As the contract expired, would we say goodbye with a farewell special, or would we begin the transition to a new generation of Air Farce—featuring Jessica, Craig, Alan, and Penelope—who would keep the franchise going for years to come? Anton delivered our message to his boss, Fred Fuchs, the head of Arts & Entertainment.

December 2008. Roger watches himself in the monitor playing Billy Two-Willies. (*Right*) Peter Mansbridge joins Jimmy and Seamus O'Toole for the final edition of "News From Away." Peter is a great sport.

96.3%
LET'S GET
THE F*** OUT
OF QUEBEC

It was hard to predict which direction CBC would favour. The entire executive suite had changed in recent years, and we no longer had our "champions"— executives who had been involved in our success and who intimately understood the role we played in the public broadcasting schedule.

Three and a half years earlier, in the fall of 2004, Richard Stursberg had succeeded executive vice-president Harold Redekopp, who had lived and breathed public broadcasting since his earliest days as a radio music producer in Winnipeg, and had been a long-time supporter of Air Farce on both radio and television. Richard had a non-CBC background. He'd been an assistant deputy minister for broadcasting in the federal civil service, a lobbyist for the Canadian Cable TV Association, CEO at satellite company Star Choice, and executive director of Telefilm. He'd never worked at CBC and had never been a broadcaster.

In his first year on the job, with negotiations not going well with CBC's largest union of technicians, journalists, and production staff, he pre-empted a possible strike by ordering a surprise lockout.

Employees felt betrayed and Stursberg's attitude didn't help. Instead of following protocol and asking, then waiting, to cross the picket line and enter the building, he barged across, showing no respect for the thousands of forced-out workers. This was never forgotten, and long after the two-month lockout was settled, Media Guild workers maintained an

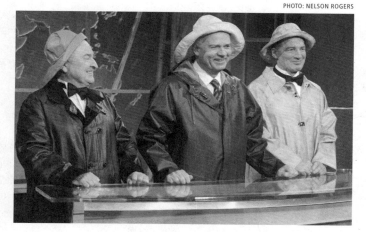

PHOTO: NELSON ROGERS

almost irrational hatred for the man. It was the most toxic time that anyone had ever seen at CBC.

In August 2005, executive director of programming, Slawko Klymkiw, long one of our champions, left after twenty-four years as a journalist, news director, and programmer, to become executive director of the Canadian Film Centre. His successor was Kirstine Stewart, a bright, charming, and capable executive who'd recently been in charge of lifestyle content at Alliance Atlantis specialty channels and had previously worked in the United States as programming vice-president for Hallmark Entertainment's seventeen international cable and satellite channels.

Soon after, the head of CBC Arts & Entertainment, Debby Bernstein— another *Air Farce* champion—left the corporation and was replaced in April 2006 by Fred Fuchs, who'd had an impressive career in the United States as a television and film producer, and was executive vice-president of Peace Arch Entertainment Group, overseeing the international co-production *The Tudors*, the sexy serial about Henry VIII and his wives.

Like Richard Stursberg and Kirstine Stewart, public broadcasting— and CBC—was not territory that he'd tread before. For the first time in our television career, we were dealing with an executive who, more or less, had never heard of us.

Part of the new executive mandate was to concentrate on female-friendly programming with high international sales potential. Both Kirstine

and Fred had publicly stated that their interest in sketch comedy was low—partly because there was already enough on the network (*Air Farce, 22 Minutes* and *Rick Mercer*), but largely because there was no international market. CBC was moving from producing popular Canadian programs for Canadian consumption to producing more generic shows with potential for offshore sales.

Shortly after Fred's arrival, one of the network's Business Affairs people quietly gave us an early warning. "If they renew your contract," we were told, "it won't be on the same terms you've had until now. They're looking for lower overall budgets."

We'd reached our peak in terms of viewership and income, and—even with new ideas supplied by the headlines every week—fifteen years on television is an eternity. We could walk away with our heads held high, but a team of people counted on us—the performers, writers, production staff, and technicians—and *Air Farce* had turned into a career for them, one that they hoped would last forever. Alas, television is not that kind.

In February 2008, shortly after our meeting with Anton Leo and about six weeks before Season Fifteen—and possibly our entire series—was due to end, we sat in Fred Fuchs' office with Anton and his comedy development executive, Jo Ann Davis.

Fred was ready to roll, and after a few pleasantries, he began his pitch. Instead of a discussion, he offered us a scenario.

"You've been on CBC almost thirty-five years, that's amazing, a real accomplishment. We can't possibly let the next six shows be your final ones," said Fuchs, nodding and smiling. This sounded good.

"Thirty-five years on radio and television, no comedy show in the world has run that long, or been that successful. Just amazing," he reiterated. "You started in 1973, so let's wrap it up at the end of this year for a nice round thirty-five years. Let's wrap it up with a farewell run of ten shows."

Giving us a beat to absorb this, he quickly added, "Now we'll have to reduce the budget a bit." Then he turned to check e-mails on his computer.

We waited to see if there were any further shoes to drop. "We hoped the franchise could continue with the younger cast," we offered.

"They're terrific, no doubt about it," he enthusiastically responded. "But we're moving our focus away from sketch and topical. We're thinking international. We want narratives with strong female leads." Then he went back to reciting his positive mantra: "Thirty-five years, just amazing, what an achievement. I know the final ten shows will be fantastic." We laughed on the way back to our offices: the irony of having *Air Farce*'s walking papers delivered by an American struck us as a good cosmic joke.

A few days later, we had coffee with Kirstine Stewart. Fred had only mentioned ten final half-hours, but we thought that the 2008 New Year's Eve show would be the proper focus for a Farce farewell, so we added that to the mix and Kirstine agreed the network would make an appropriate fuss about our final season. We repeated our pitch for a show that would continue featuring the younger cast, but she deflected the topic and suggested we think instead about concepts with a story arc.

Three weeks later, after poring over the proposed reduced financing and determining that we could afford to do the show, we confirmed the deal with the network to return for a "Final Flight" in the fall of 2008. On Saturday, we sent an e-mail to our team, sharing the information with them. For most it was a crushing disappointment. Although we'd tried to prepare them for the end of the series, hope always soars, and this was a sudden reality check.

We ended the e-mail this way:

Amid the much-hyped new CBC comedies and dramas launched in January, *Air Farce Live!* scored top

Cast and crew gather in the studio to say
a final goodbye to our fans.

three (after *Rick Mercer* and *Little Mosque*) among
the eleven new and returning series during the
first ten weeks of 2008, also scoring higher in
the age 25–54 category than any of the new younger-
targeted shows. So, thanks to everyone for turning
Air Farce Live! from a scary challenge into a
successful accomplishment. And let's look forward
to doing it again this fall.

At an unrelated media event on March 31, our publicist David
McCaughna whispered the news to TV columnist Bill Brioux and 680 News
Radio entertainment reporter Gloria Martin. Bill posted it to his blog, and
Gloria blasted it across morning radio as an exclusive on—appropriately—
the morning of April Fool's Day. It was across all media within minutes

and it took CBC—and us—completely by surprise. Because everyone in
the entertainment business works on contract, we frequently referred to
ourselves as "pre-fired." Ever since our first contract—the one we signed
for a single Air Farce radio taping in December 1973—we'd known that
one day there'd be a final contract and one day the final contract would
end. But we'd survived for 35 years!

Air Farce Final Flight turned into a combination of swan song, victory
lap, and love-in. We drew even bigger audiences than the previous season
and climbed rapidly back up the ratings. Doing the show live the previous
season had shaken everyone out of their routines. The return to Thursday
night tapings felt natural, but with the discipline of live taping under our
belts, we did them better. This was our last kick at the can. Rick and Gord got
their mojo back and the production crew performed like a crack drill
team; we all enjoyed knowing that we were doing some of our best

December 2008. Final show, final hugs.

work ever. The end was coming, not of our own choosing, but we'd finish the way we wanted to—with the ratings up 24 per cent, we were still one of the highest rated shows on the network.

In November 2008, halfway through the final ten shows, Don bumped into Richard Stursberg outside our studio.

RICHARD: Hi Don, how are you doing?

DON: Good. You?

RICHARD: You know, busy. Hey, the *Air Farce* ratings are great!

DON: They are.

RICHARD: Looks like maybe we made a mistake.

DON: Yeah, looks like.

RICHARD: Well, have a good show.

We did have a good show. In fact, all of the last ten shows were terrific. And so was December's New Year's special. *Hockey Night in Canada*'s Ron MacLean helped us fire the final Chicken Cannon. Peter Mansbridge teamed up with Jimmy and Seamus to deliver the last "News From Away." Dave Broadfoot joined us in the final Donut Shop. It was a night of mixed emotions. Some sadness, for sure. But as far as we're concerned, no regrets, only happiness at what we achieved. *Air Farce* had a great run.

And although the series may have ended, the show goes on—Air Farce still comes back every December with our annual New Year's special. All in all, not bad for a couple of boys from N.D.G.

Final Flight

PHOTO: CYLLA VON TIEDEMANN

Roger Abbott (1946–2011) One of our favourite
photos of him. We hung a 4' x 8' print above
the stage at his memorial wrap party.

It was around 6:00 p.m. Saturday, March 26, 2011.
Dr. Laura Hawryluck, Roger's ICU doctor, asked
all of us to leave so she could talk to Roger alone.
He was intubated, a hospital term that means he
had a breathing tube down his throat that was
attached to a machine that breathed for him, and
he was unable to communicate except by blinking
to indicate "yes." If an answer to a question was
"no," he didn't blink. He was too weak to raise his
fingers off of his bed or to squeeze someone's hand.

Roger had received the news of his diagnosis the night before and his time was drawing near. Laura had lots of experience communicating with ICU patients who couldn't speak and, when she was alone with him, she explained the options he had remaining, one of which was to remove life support. He chose it. Did he have any last wishes? With careful questioning, Laura understood that Roger wanted to see where he was and also to see the sky. So with the help of a couple of orderlies, his bed and breathing machine were pushed out of the bay where he had lain since his emergency surgery the previous week, and into the corridor. She took him on a tour of the Intensive Care Unit, which is a much bigger place than even those of us who'd been with Roger through the past nine days realized, and to an empty room in the southwest corner of the ICU where, propped up in bed, he could see the last of the day's light fade from the darkening sky.

Thirteen days earlier, I had spent a couple of hours on Sunday afternoon helping him ready his condo for his return from hospital. We transformed his study into a guest bedroom, which is what it had

originally been before he set up his home office in it. Between us we carried the table he used as a desk into his bedroom, but afterwards he was too tired to continue and had to sit down to rest. I continued moving his office—computer, pencil jars, stapler, various files and papers —while he gave instructions from a chair or, when he felt strong enough, while he padded along behind me in his slippers. Then I made up the Murphy bed that would be used by a few of his close friends while we took turns staying with him after he was discharged on Thursday. The next day, Monday, he was going to Toronto General Hospital to have his spleen removed.

He was apprehensive, but neither of us was particularly worried. The laparoscopic surgery would be minimally invasive and, in a week, he'd feel better. He'd been diagnosed with chronic lymphocytic leukemia in 1997, and had initially told only his sister Jackie, his niece Johanne, one or two very close friends, and me. In 2003, and again in 2008, he'd undergone several months of chemotherapy (in summer so it wouldn't interfere with *Air Farce* tapings and so he could keep his CLL a secret), and he was scheduled to begin chemotherapy again in 2011, as soon as

his red blood cell count returned to normal. Roger was a private man, and he possessed innate dignity. He didn't want people to see him as a sick person. He had a long association with Easter Seals, and during Telethons and other public events he had constantly repeated a key Easter Seals message: when you meet a child with a physical disability, see the child first. Look past the disability and see the person. Like the Easter Seals children for whom he volunteered, Roger didn't want people to view him through a filter. No sympathetic looks, please. No easy passes, no kid gloves, just treat me as Roger.

The previous August, he caught a bad cold during a trip to Paris; in September, it developed into pneumonia that lingered through the fall and his red blood cell count began to drop. He got a transfusion, as he'd done several times before; as soon as his blood returned to normal he could go back on chemo. In November, he said to me, rather bewildered, "You know, I find I'm no longer interested in the things that I used to care about most—details." I knew then that his condition was serious. For forty years, a guiding principle of Roger's life and work was, "Take care of the fundamental details." It was a shock to hear him say that he didn't care.

When we finished prepping the condo, we sat for a few minutes at his dining room table. Was there anything we'd overlooked? What food would he like in the fridge when he came home? Would he bring his BlackBerry to the hospital? Not to worry, he'd be fine. Tomorrow was also the deadline for the first part of the Air Farce book manuscript that we'd begun to write together. I loaded what he'd written onto a USB key to take home; tomorrow I'd read it over before e-mailing it to the editor along with my contribution. The hospital had said no visitors for the first twenty-four hours, they only get in the way; we'd see each other Tuesday. At the door, we hugged. I wished him luck. "I'm sure everything will be okay," he said. "And if not, enjoy the book."

That night he sent a light-hearted e-mail to his close friends entitled, "Farewell to my Spleen," and the next morning—efficient as always—an e-mail to his lawyer confirming changes he'd made to his will. He checked into Toronto General Hospital at 11:00 a.m., and had his spleen removed late that afternoon.

Along University Avenue, windows began to light up as the outlines of the buildings they were in began to lose definition against the deepening purple sky; night was fast overtaking what remained of twilight. The weather beacon atop the Canada Life building flashed its white and green message: the temperature was falling, tomorrow would be clear. At 7:00 p.m. the ICU nurses had changed shift; a new team was now on duty. Jackie, Johanne, and I stood beside Roger's bed. He had asked to be taken off of life support and we knew this was the end.

The night before, when the results of Roger's bone marrow test became known, we'd phoned the small group of Roger's intimate friends whom he'd allowed to receive daily e-mail updates but not allowed to visit. Their needs had suddenly become paramount. They longed to say goodbye to a man they loved and, in the past twenty-four hours, the ICU waiting room had filled with those for whom the thought of living without him was unimaginable.

On Saturday afternoon the ICU staff, a beyond-wonderful group of professional, kind, and caring people, felt our collective heartache and kindly bent the rules to allow more than two people in to see Roger at a time. The room next to his was temporarily empty and we wouldn't be disturbing anyone. Present were Johanne and her husband Derek and their two children, Jacob and Zoe, who were Roger's grandnephew and grandniece; he loved them as if they

were his own and his love was returned. Roger's nephew Mark, who had been in and out of Toronto throughout the ordeal, flew in again from Ottawa. Jackie and her husband Vince brought Roger's mother Betty, ninety-five years old and in a wheel chair while recovering from a broken femur, from her convalescent hospital in Oakville. Dave Broadfoot and his wife Diane Simard came by, as did Brian Robertson and his wife Jo, and Perry Rosemond.

Within this gathering of family, intimate friends and old colleagues, doom and gloom lifted as people recalled happier times: "Long faces don't belong here," someone said. "Let's celebrate the happy times!" The mood turned festive and an impromptu party began. Roger's condo was one subway stop away; Derek and Mark fetched a few bottles of fine red wine from Roger's collection, poured it into plastic glasses and moistened a cotton swab with it so Roger, too, could toast his life.

But joy was short-lived; as the afternoon progressed Roger's condition deteriorated, and now friends and family sat forlornly in the room just outside the ICU, awaiting the word that none wanted to hear.

Night enveloped the world outside Roger's window. Doctor Laura stood nearby. Roger's final request—that he not be kept alive when all hope was gone—was about to be granted. It was time. As I looked at him, wondering what any of us could possibly say that we already hadn't, a thought suddenly lit up my mind. One of the effects of long sedation and heavy medication was confusion. Patients were told things and immediately forgot them. Roger had asked for a tour of the ICU. Did he really know where he was? Did he know how long he'd been in hospital? Did he know how he came to be here? Did he know what had happened after he'd gone in for surgery? Did he want me to tell him? His eyes bulged wide: yes, yes, please tell me. My God, he was about to die and he had no idea what had happened.

I quickly recounted the events of the past thirteen days. His splenectomy had started on Monday as planned, but after beginning the laparoscopic procedure, the surgeon discovered that Roger's lymph nodes interfered with the spleen's removal and switched to traditional open surgery. The next day, Roger seemed to be recovering normally, although he was woozy from medication and indicated he felt pain in his abdomen. Wednesday, the post-surgical resident became alarmed. Roger was having trouble finding words. Had something precipitated a neurological deficit? Wednesday night, he suffered severe cardiac arrhythmia and after midnight his vital signs went haywire. By 3:00 a.m., he required emergency surgery to save his life. Jackie signed the permission form and we waited through the night. At 7:00 a.m., the surgical resident told us what had happened: at 4:00 a.m. Roger's surgeon re-opened the incision beneath the left side of Roger's ribcage and discovered that, unrelated to his original surgery, Roger's bowel had perforated; he had gone septic and was drowning in infection. The surgical team cut a new, larger incision from chest to abdomen, sectioned his bowel and washed his abdominal cavity. He was moved to ICU, administered massive doses of antibiotics, placed on life support in an induced coma, and given only a 50 per cent chance of surviving the next 24 hours.

He did survive, and on Friday the ICU team removed him from sedation. He was expected to return to consciousness within a few hours but didn't. The weekend came and went and still he slept. His heart suffered repeated bouts of cardiac arrhythmia. His body, assisted by blood transfusions and antibiotics, struggled to combat the near-fatal infection. Wednesday, his eyes flickered open for the first time and he recognized us. He could communicate by blinking. But no combination of antibiotics in ICU's arsenal could subdue his infection and he continued to require blood products. His temperature

soared and remained high. Thursday, he required more support from the breathing machine. He had yeast in his urine and infection filled his lungs. Friday morning he had a bone marrow test. When the results arrived, they were devastating: his leukemia had completely invaded his bone marrow and rendered it incapable of producing any healthy blood cells at all. The infections could not be controlled. He was dying and would not survive the weekend.

Roger had heard enough. He indicated to Laura that he wanted the life support removed immediately. "Are you sure?" she asked softly. "Once we take this step, there's no turning back." His eyes said it all: get me the hell out of here. She administered a sedative so the breathing tube could be removed and he began drifting away. To say that Jackie, Johanne, and I were grief-stricken can't even begin to capture how we felt. Daggers pierced our hearts. I stood closest to his head. I kissed him, told him I loved him, and as his eyes flickered shut, whispered, "Good night, sweet prince." And that was it. The three of us stepped back, the nurses stepped in to remove his breathing tube, and we stood silently at the foot of the bed, watching as his breathing became laboured and the machines monitoring his vital signs displayed less and less activity, until finally all activity stopped.

8:57 p.m., March 26, 2011.

We went to the waiting room to deliver the news. Friends and family, who had been crying all week, cried a little more. Hollow-eyed and exhausted, people hugged and embraced and the group began to disperse. We asked that all remain silent about the day's events until an official announcement could be released tomorrow. Because Roger had guarded his privacy so diligently, news of his death would come out of nowhere and a tsunami of shocked reaction was certain to follow; family needed time to grieve alone in peace.

Until the day before Roger died, none of us expected this outcome. We'd been prepared by hospital staff to expect a long and arduous recovery—months not weeks in hospital, followed by a recuperation at home that would be measured in seasons. But never this.

In the office on Monday, CBC told us they intended to air a tribute to Roger the next night—a repeat of the recent New Year's special. We balked. Roger had been sick and had not had a significant presence in the show; a special featuring some of his best *Air Farce* moments would be more appropriate. CBC agreed, if we could pull it together in time. *Air Farce* line producer Lucy Stewart negotiated the paperwork, CBC staffer Liz Pettapiece-Phillips, who'd worked the *Air Farce* series in its closing years, arranged for editing facilities, and two of our New Year's co-producers, Rob Lindsay and Kevin Wallis, volunteered to put the show together without pay. They worked 24 hours straight, and with the help of CBC technical and support staff, aired an amazing tribute to Roger on Tuesday night. Unexpected and unheralded, it still drew 663,000 prime-time viewers. Roger, a ratings maven, would have been pleased.

The next weeks raced past in a blur. Former Air Farce staff appeared out of nowhere to help organize a memorial. They volunteered their time and worked weekends and from home. On April 11, more than 500 people came to the Artscape Wychwood Barns in Toronto to reminisce, bond in mutual sorrow, celebrate Roger's accomplishments and life, and at his explicit request, have as much to drink as they wanted. From a stage erected along one wall, a small number of family members and intimate friends offered words of tribute; I have no idea how anyone got through it. I spoke last. I looked at the people who had gathered together to fill this room in Roger's memory—Dave, Luba, Rick, Gord, Perry, former radio technicians and producers, our TV crews, our entire cast, current and former network executives, former *Air Farce* staff, Roger's family, and

a vast array of friends and colleagues—and felt an overwhelming sense of gratitude: for them being here, for Roger being here in spirit, and for all that we'd experienced together when he was alive. When I finished speaking, I didn't think I had the strength to leave the stage. The journey that Roger and I had begun in 1959 had ended. Four years earlier I'd lost another good friend from our high-school years, Henry Sobotka. The two friends with whom I could share memories of my youth and talk about anything were gone. Parts of my past were disappearing, swallowed up by death and time, but for some reason I was still here. I was lucky. I had a wife I loved and a daughter I cherished. As I looked around the room from my vantage point on the stage, hearing the buzz of voices around me crying and laughing and talking, I realized we were all lucky. And Roger would agree: the great thing about life is that it goes on.

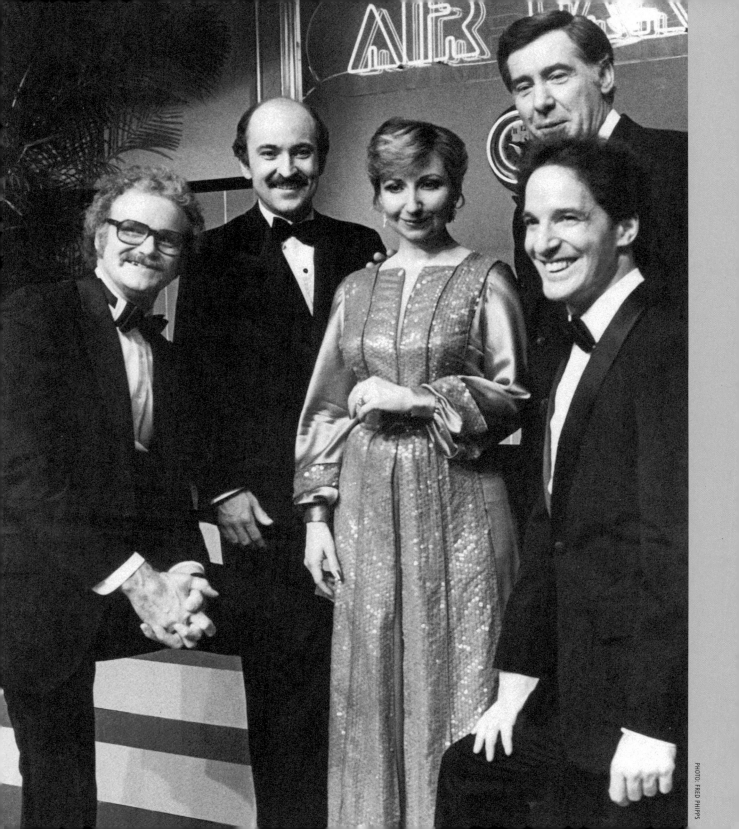

EPILOGUE

Like Canada itself, Air Farce owed much to immigration. Three of its members—Roger, John, and Luba—were immigrants, and the remaining two—Dave and Don—were the children of immigrants. Journeys that began in England, Wales, Ukraine, Montreal, and North Vancouver intersected in Toronto, where the Farceurs met and coalesced into a group. Oddly, the only thing we all had in common—apart from a love of comedy—was that at one time or another we'd all lived in Montreal.

We found our artistic home in Toronto, which welcomed and embraced us and also provided us with Toronto natives Rick and Gord a few years later.

We'd love to be able to say that our success was due to good planning, but if it was due to anything, it was luck. We were lucky that we met, lucky that our individual talents fit together well, lucky that our time was ripe. We worked hard and kept alert for opportunities. Even when Air Farce was at its most successful, our only plan, really, was to make the current week's show as good as possible. We took the initiative when we could, but basically we listened to our audiences, consulted with our colleagues, and did whatever was required to keep Air Farce flying.

* * *

The passenger jet was ready for take-off. The last passengers had boarded and taken their seats. From the back of the cabin, two blind pilots, both wearing dark glasses, one using a guide dog and the other a cane, tap-tap-tapped their way down the aisle. They entered the cockpit, closed the door behind them, and in a moment the jet's engines whined into life. The passengers laughed nervously and glanced around for some sign that this was a joke, but none was forthcoming.

The plane began rolling down the runway. As it gathered speed, passengers realized it was headed straight for some warehouses at the edge of the airport. It rocketed towards them faster and faster. Panicked screams filled the cabin. At that moment, the plane lifted smoothly into the air. The passengers collectively let out a huge sigh of relief. Some laughed sheepishly. Soon they retreated into their magazines and relaxed, secure in the knowledge that the plane was in good hands.

In the cockpit, one of the blind pilots turned to the other and said, "You know, Bob, one of these days they're going to scream too late and we're all going to die."

For forty years flying by the seat of our pants, it was like that.

INDEX

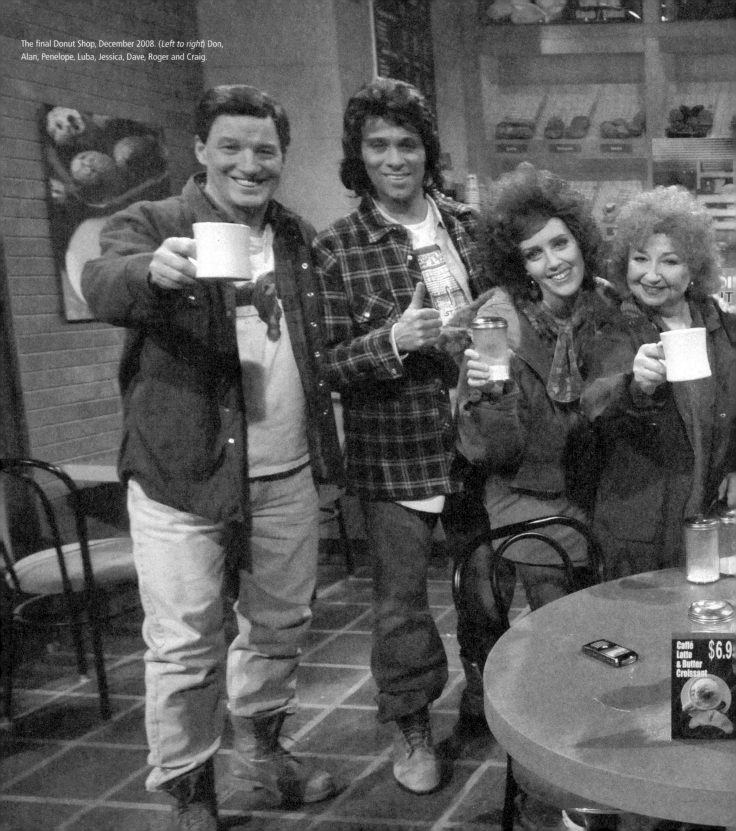

The final Donut Shop, December 2008. (*Left to right*) Don, Alan, Penelope, Luba, Jessica, Dave, Roger and Craig.